THE ART OF ZEN

STEPHEN

ADDISS

Harry N. Abrams, Inc.

Publishers

Paintings

and

Calligraphy

by

Japanese

Monks

1600–1925

THE ART OF ZEN

ACKNOWLEDGMENTS

One of the pleasures of research is the opportunity to consult with friends whose scholarship I deeply admire. I would therefore like to express my deep appreciation to Jonathan Chaves, Kono Motoaki, Maruoka Muneo, John Stevens, Melinda Takeuchi, Norman Waddell, Wan Qingli, Matthew Welch, Wong Kwan-shut, Akira Yamamoto, and Fumiko Yamamoto. I also must thank Joseph Seubert for his assistance in locating research materials; Tanaka Daizaburo for sharing his pure sense of the Zenga spirit; Jon Blumb for his excellent photography; Charles Miers for his editorial expertise; and Elissa Ichiyasu for her elegant book design. The entire project would have been impossible without the kindness and cooperation of the Japanese, Canadian, European, and American owners of the Zen paintings and calligraphy discussed and illustrated in this book.

I am also delighted that an exhibition of the works in this book has been possible, and I am most grateful to Belinda Sweet, who conceived the idea of the exhibition and shared with me in the selection of the objects, and to the International Exhibitions Foundation for its initial support of the project. Further, I must thank the staff of the Spencer Museum of Art, especially Patricia Fister, who curated the exhibition and gave many helpful comments on the manuscript.

Finally, I would like to acknowledge the Metropolitan Center for Far Eastern Art Studies, the Hall Center for the Humanities, and the University of Kansas General Research Fund for research funding, and the National Endowment for the Humanities, the National Endowment for the Arts, and the Commemorative Association for the Japan World Exposition (1970), for their support of the exhibition.

—STEPHEN ADDISS

EDITOR: CHARLES MIERS
DESIGNER: ELISSA ICHIYASU

*Library of Congress
Cataloging-in-Publication Data
Addiss, Stephen, 1935–
The art of Zen: paintings and
calligraphy by Japanese monks,
1600–1925 / Stephen Addiss.
p. cm.
Bibliography: p. 214
Includes index.
ISBN 0–8109–1886–2 (cloth)
1. Painting, Zen.
2. Calligraphy, Zen.
3. Buddhist art and symbolism—Japan.
I. Title.
ND2071.A328 1989759.952—dc19 88–27499
ISBN 0–8109–2774–8 (paperback)*

*Clothbound edition published in 1989 by
Harry N. Abrams, Inc.*

Printed and bound in Japan

 *Harry N. Abrams, Inc.
100 Fifth Avenue
New York, N.Y. 10011
www.abramsbooks.com*

*On the cover: Tōrei (1721–1792). ENSŌ.
See page 135
Frontispiece: Nantembō (1839–1925). HAND.
See page 197*

CONTENTS

Zen is an awakening.

Full of paradox, Zen is beyond words, but has occasioned countless books; Zen is individual, but usually requires a teacher; Zen is everyday and down-to-earth, yet is traditionally practiced in remote monasteries; Zen is profoundly serious, but full of humor; Zen demands being rather than representing, yet has inspired many different kinds of art. Zen teaches us not merely to hear, but to listen; not just to look, but to see; not only to think, but to experience; and above all not to cling to what we know, but to accept and rejoice in as much of the world as we may encounter.

Zen art is also an awakening.

In other Buddhist sects, accomplished craftsmen have produced images with care and precision to be radiant, idealized, and awe-inspiring. The art of Zen masters is rough, spontaneous, and often irreverent. Created by monks who have transcended individual egos, it is nevertheless an expression of personal character. Zen masters spend long years in study, but their works are clear, simple, and direct.

This book is devoted to *Zenga,* the word the Japanese use to describe painting and calligraphy by Zen monks from 1600 to the present.¹ The works were created neither "for art's sake" nor at the bidding of wealthy patrons, but rather to aid meditation and to lead toward enlightenment. Zenga is a form of teaching: in painting, the most common subjects are Zen masters and exemplars of the past; in calligraphy, Zen poems or conundrums are usually transcribed. The style of the brushwork, unlike that of almost all other religious art, is dramatically bold, seemingly impetuous, and bluntly immediate in effect. The translation from mind and spirit to paper was spontaneous. These works distill the essence of the Zen experience into strokes of the brush: the intensity of meditation is palpable in the few lines used to render the fierce scowl of a Zen patriarch; the logic-destroying potential of a Zen riddle (*kōan*) becomes visible in the dancing movement of roughly brushed calligraphy. Zenga is thus the outward expression of the inner lives of Zen monks.

Zen is said to have begun with a visual allusion. According to legend, the historical Buddha did not give his usual verbal sermon to his followers one day, but simply held a flower in his hand. A single disciple understood this wordless message, and Zen (which comes from an Indian word meaning "meditation") was born. This emphasis on individual meditation, rather than the study of written sutras or devotional rituals, was given impetus a millennium later in East Asia when the Indian Buddhist monk Bodhidharma (known to the Japanese as Daruma) went to China in the sixth century A.D. He was first invited to the palace of Emperor Wu of the Liang dynasty, a fervent Buddhist. According to Zen history, the Indian monk refused to praise the emperor for his material support of Buddhism, nor would he answer questions in an intelligible way. Instead, he left the bewildered emperor, crossed the Yangtze River to northern China, and meditated in front of a wall at the Shao-lin Temple for nine years. Having achieved satori (total enlightenment), Bodhidharma thereupon accepted a disciple, and thus began the mind-to-mind transmission of Zen principles that has continued to the present day.²

Zen differs from most traditional Buddhist sects. By the time Buddhism had spread to East Asia, it had become primarily a devotional religion with a vast panoply of deities who could help the faithful attain enlightenment, or rebirth in paradise. The historical Buddha's teachings had the purpose of

Introduction

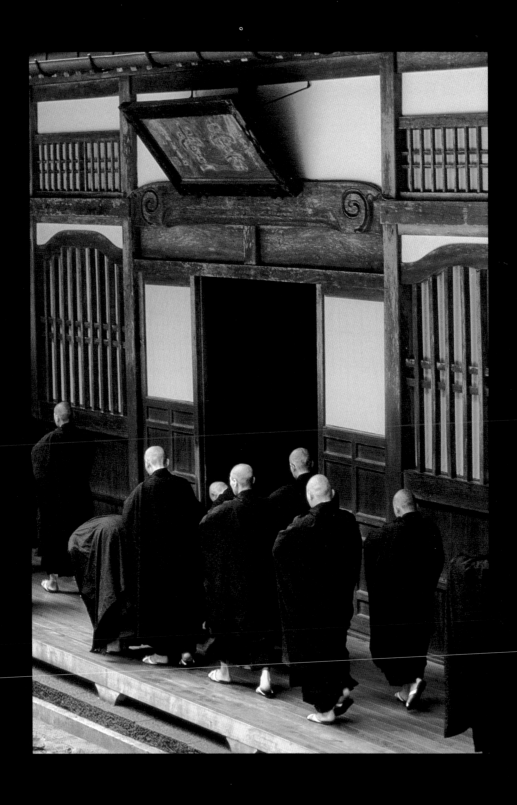

1. Monks in walking meditation.
Eihei-ji.
Photograph by Graham Harrison

helping his followers achieve satori on their own, but the commitment needed for this task proved too difficult for most participants in what was now a mass religion.

Although Zen was not directly a revival of the earliest Buddhist principles—by contrast with other sects it stresses that individual enlightenment can be achieved in this life through meditation and through inner discipline—Zen teachings have consistently emphasized that both desires and methods of rational thought are illusory, clouding over the inherent Buddha-nature. The task for each individual is to awaken to his or her own true nature. In order to succeed, total personal commitment and the guidance of an enlightened teacher are vital. A Zen monk undergoes a long and strict training that includes years of meditation before it is possible to experience enlightenment—which may occur suddenly upon hearing the sound of a temple bell or as the result of a well-timed whack from a teacher's staff.

Zen was not for everyone; the strict discipline and intense concentration required was even more rigorous than the training regimen of a samurai. Typically, an aspiring monk might have to wait three days at a monastery gate before being admitted, after which he entered into a demanding schedule of meditation, sutra chanting, and manual labor at the temple. The structure of Zen life was such that monks in training had little time for sleep and none at all for any personal activities. The object was to transcend ego in order to achieve satori, and the more strict, stubborn, and difficult the teacher, the more likely that the pupil would break through to enlightenment.

Zen art, as a part of Zen training, has a long history. More than one thousand years ago, Chinese Zen masters occasionally used painting as a teaching tool, drawing a circle in the air to suggest more than words could explain or creating ink paintings for their pupils to meditate upon. Although they seldom had any direct training in painting, long years of calligraphic practice gave the monks enough control of brushes and ink to express themselves freely. Calligraphy was practiced by almost all leading Zen monks. With every word in Chinese requiring a separate ideograph, there were more than fifty thousand different characters within the calligraphic repertoire, each of which could be written in five different script forms. The wide range of characters, scripts, styles of brushwork, and compositional possibilities offered an artistic medium in which the individual's expressive potential was enormous; Zen masters utilized these elements to the full. In the process of pouring water on the slate inkstone and grinding the ink from sticks of charcoal, a monk would have time to contemplate before setting brush to paper; then the work would be done with spontaneous freedom. The flexible brush, which was held in the fingertips, responded to every movement of the fingers, wrist, elbow, and shoulder. There could be no corrections, because they would be immediately visible on the absorbent paper. Since brushwork was considered a direct expression of personal character, the ability to write and paint with clarity and spiritual intensity became a prerogative of early Zen masters.

Zen art had a double function: it was a form of active meditation for the creators of the works and a method of visual instruction for those who received them. Although China was dominated by Confucianism, Taoism, and other sects of Buddhism, Zen and Zen art flourished as a counterculture with strong ties to the literati class of officials, scholars, and poets. Long after other forms of Buddhism waned, Zen remained an active force in China until the success of Neo-Confucianism (which incorporated some Taoist and Zen principles) led to its decline in the fourteenth and fifteenth centuries.

Arriving in Japan in the thirteenth century, Zen found acceptance during an age when the refined sensibility of courtiers (exemplified in the love affairs, poetry contests, and incense-identification games that are related in the *Tale of Genji*) was being supplanted by the severe disciplinary code of samurai warriors. Two sects of Zen soon became widespread. The larger of these was the Sōtō sect, whose temples were concentrated in the countryside. Sōtō monks stressed to their followers the benefits of sitting in meditation for its own sake, not just for the goal of satori. The Rinzai sect, by contrast, was centered in the cities, and its adherents emphasized meditation in order to prepare for sudden enlightenment. Over the centuries, it was the activist Rinzai sect that produced the largest number of monk-artists, but some masters of the Sōtō lineage also created outstanding Zen brushwork. A third major Zen sect, known as Obaku, did not arrive in Japan until the middle of the seventeenth century. It quickly spread through the country, in part because its syncretic doctrines included elements from other Buddhist sects, and it carried with it artistic traditions from Ming dynasty China.[3]

During the Muromachi period (1392–1568), Zen became what it had never been in China, the predominant religious and cultural force of the country. Supported by the ruling Ashikaga shogunate, Zen provided the emphasis upon inner strength that was needed in a society predicated on the samurai ideal of discipline, loyalty, and service. Consequently, the principles of Zen strongly influenced education and governmental policy as well as poetry, architecture, music, theater, calligraphy, and painting. The result was a great flowering of Zen culture, but also a professionalization and to some extent a standardization of Japanese arts. Instead of monks who expressed their Zen vision in painting, there emerged a group of painters who were also monks. The famous Sesshū (1420–1506) traveled to China more to improve his brushwork than to study Zen; upon his return to Japan, he set up a studio and became the most renowned painter of his time. His primary subject was landscape, not the depictions of Zen patriarchs that had formerly been the focus of Zen painting. Sesshū's training as a monk no doubt influenced his art, but he was one of many professional or semiprofessional painters whose lives were devoted more to the brush than to meditation and teaching.

After the century of civil wars between rival clans that lacerated Japan at the end of the Muromachi period, the three warriors who successively reunited Japan during the Momoyama period (1568–1600) did not promote Zen. The third of these leaders, Tokugawa Ieyasu (1542–1616), was a devout Buddhist. Nevertheless, his regime established Neo-Confucianism as the dominant ethical code during the Tokugawa era (1600–1868; also known as the Edo period because Ieyasu moved the capital from Kyoto to Edo, present-day Tokyo). Confucian scholars rather than monks were put in charge of education, especially for the training of the children of samurai-officials, who constituted the highest social class. Furthermore, it was now scholars who advised the shogunate on questions of administration, justice, and even matters of business and trade, all of which had been the prerogative of Zen monks during the Muromachi period. Since Confucianism is basically an ethical system defining human relations and obligations toward the state, it proved efficacious for the governing of Japan, but it brought about a concomitant loss of religious practice among the Japanese. Buddhism remained important for its administrative and social functions; fearing potentially subversive Christians, the shogunate decreed that every Japanese register with a Buddhist temple. But the importance of Buddhism as a penetrating influence on the spiritual life of the country gradually declined.

These changes dealt a serious blow to the Zen establishment and profoundly altered the course of Zen art. Shoguns, daimyo (feudal lords), and wealthy samurai had once turned to artist-monks to decorate their palaces and homes. Now, large-scale commissions from government leaders were given to professional ateliers, such as those maintained by the Kano and Unkoku families. In this loss, however, there was also a gain. Because official patronage was given to secular painters, there was no longer a steady stream of commissions for semiprofessional artists at temple workshops. Instead, important Zen masters began to create their own artworks. Rather than painting for shoguns and warlords, they utilized brushwork as a form of meditation and gave their works to pupils and lay followers as visual sermons showing the path toward enlightenment. With Zen artists relieved of high-level patronage, a new tradition named Zenga was born. Through brush and ink, the intensity of each monk's own inner spirit was conveyed directly to his followers.

Like most new art forms in Asia, Zenga was in part a revival of the past. By taking up the brush, outstanding monks of the early Edo period began to restore earlier Zen traditions of China and Japan, when Zen masters had first created artworks. Exemplars of enlightenment once again became the most popular subject matter for Zen painters, replacing the evocative landscapes of the Muromachi period. Furthermore, during the Edo period the elaborations of technical skill that had been achieved in the fifteenth and sixteenth centuries were supplanted by sturdy simplicity and directness. These trends recalled the models of earlier Chinese masters, as well as those of Japanese fourteenth-century monk-artists such as Kaō and Mokuan Reien, but they also led to a style of Zen brushwork never seen before.

Zenga was a response to the social changes that were taking place in Japan: the advent of Neo-Confucianism, the increasingly restrictive regulations of

2. Stone and sand "dry-landscape" garden. Ryōan-ji

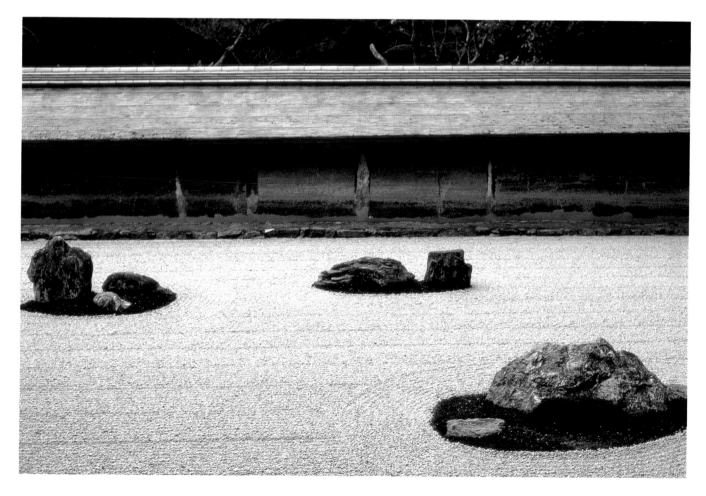

3. Zen scroll
in a temple tearoom.
Sangen-in, Daitoku-ji

the Tokugawa shogunate, the closure of the country to the outside world, the rise of a mercantile economy, the general weakening of religious beliefs, and later the dramatic opening of Japan to the West. Through all these changes, Zen art not only survived but flourished; lacking strong support from the government, monks were free to use art for both personal and public purposes. Some Zen masters attempted to establish connections with the leaders of society through such means as tea ceremony meetings, which bestowed cultural prestige on the guests by allowing them to display a sense of personal and artistic refinement. Other monks rejected the world of the elite and painted merely to express their own Zen vision, giving their works to followers and pupils. Most Edo-period masters, however, used art as a means of reaching out to the public, popularizing Zen in ways not attempted before. Realizing that painting and calligraphy could have a more immediate impact than sermons or rituals, teaching monks took up the brush to express their experiences of meditation and enlightenment. The eighteenth-century master Hakuin wrote that the arts reveal elusive but universal aspects of the human spirit:

We say that someone has the wondrous ability to play the zither or the lute, but if we ask where that art resides, not even the wisest man can answer. . . . This art, produced by something we cannot fully know, is like the innate nature of the mind that operates in all our daily activities.[4]

Edo-period monks created Zenga for their followers as visible expressions of the inherent Buddha-nature. As the medium developed, many entirely new subjects were depicted, sometimes with references to Japanese daily life or folklore. Monk-artists added their own poems to their paintings, and Zen philosophy was often combined with wit and humor. Calligraphy was brushed in a variety of scripts and styles, often with a rough power that might have been considered crude or inelegant in earlier centuries. Direct and succinct communication became the single most important feature of this new artistic distillation of the Zen spirit.

By contrast with the ink paintings of the Muromachi period, the profound simplicity of Zenga is its most salient quality. Simplicity itself, however, would not be enough. It is the intensity of the works, derived from the inner

experiences of the monk-artists, that gives them their combination of immediacy and long-lasting flavor. Through painting and calligraphy one can learn and absorb the inner history of Zen, including the major themes that have been explored over the centuries in the search for enlightenment.

One of the most profound subjects in Zenga is the *ensō*. It would seem that nothing could be more simple than this circle, usually depicted in a single brushstroke. Did the monk take merely a few seconds to create this quintessential Zen statement? Might we also count the time he spent staring at the empty paper and preparing his mind and spirit? Or should we say that it took the monk eighty years, the span of his life, to produce it? If we consider the entire history of Zen, passed on directly from master to pupil for generations, we may even decide that the *ensō* took many hundreds of years to create.

These issues can be pursued in their cultural context: what has been the meaning of the *ensō* in Japan? Experts tell us that the circle has been seen as the all, the void, and enlightenment itself. Very few *ensō* stand alone; they are usually accompanied by an inscription that may be part of an arcane Zen text or by a line from a poem, such as "My heart is like the autumn moon," or, most simply of all, by the invitation "Have a cup of tea!" None of these, however, does more than hint at the indefinable richness of the Zen circle. The meaning of the *ensō,* therefore, is not fixed, finite, or static. Instead it becomes a form of activity that continues through time. The monk-artist has merely begun a process that is reactivated when the painting is seen, leading to various levels of communication and understanding. Because the viewer has a vital role in completing the work in his or her spirit, true Zenga embodies the actual experience (rather than merely the influence) of Zen.

Although the most direct cultural statement of Zen ideas is contained in the brushwork to which this volume is dedicated, Zen has also influenced many other Japanese arts, from poetry to the tea ceremony. Those who visit Japan can experience the strength and elegance of Zen principles in temple architecture, in the haunting notes of the bamboo flute *shakuhachi,* and in the evocative sparseness of Noh drama. Zen ideals of refinement and serenity continue to play a part in Japanese aesthetics, helping to temper the commercial and sometimes tawdry aspects of everyday life in a modern economic superpower. Walk around the corner from a skyscraper in Tokyo and you may find an alley where delicately pruned miniature trees (bonsai) are being aired by their owner, or you may glimpse a few flowers being arranged with deceptive simplicity in a ceramic bowl. Leave the crowded cities and you can discover peaceful temples nestled in the hills where monks are chanting sutras as in ages past.

Many Japanese and an increasing number of Westerners study the ritual drinking of tea. *Cha-no-yū* has been deeply influenced by Zen masters for hundreds of years, and the combination of discipline, naturalness, and intuitive elegance that distinguishes the tea ceremony at its best can lead to a profound meditative experience. The objects utilized in the ritual, which takes place in a context of refined rusticity *(plate 5),* are very similar in spirit to the brushes, ink, and paper of the Zen painter and calligrapher *(plate 6).* Furthermore, a vital element in *cha-no-yū* is the Zen scroll that is hung in an alcove *(tokonoma) (plate 3).* By its bold simplicity, a painting or calligraphy can invigorate the meditative experience of the tea ceremony.

Another art that may be compared with Zenga is garden design, particularly the "dry-landscape" gardens created from sand and stone. Again, the Zen influence is very strong; in fact, some of the finest gardens were originally designed by leading Zen masters. The salient qualities of a "dry-landscape"

garden such as Ryōan-ji *(plate 2)* include extreme sparseness; sometimes nothing more than sand or gravel and a few rocks are used. These elements, like the brushwork in Zen calligraphy and painting, are placed asymmetrically within a rectangular format. A sense of universality is imparted through the garden's nonspecificity of meaning (like the form of an *ensō*), although some commentators have strived mightily to explain that each rock is a symbol, such as a tiger, rabbit, or deer. Like Zenga, "dry-landscape" gardens suggest more than they define; the viewer becomes an active partner in the act of creating meaning from the forms. Like brushwork, the garden serves as an aid to meditation, quieting the mind and concentrating the spirit.

The power of all Zen art lies in its elimination of the nonessential. A Zen scroll, like a garden of stone and sand, achieves the greatest impact with the least of means. Compared with other art forms, however, Zenga is the most concentrated expression of Zen principles, primarily because of its direct link to Zen masters. It is a remarkable fact that the most important monks of the past four centuries took up the brush, usually in their final years, to express their inner vision through painting and calligraphy. Japanese have considered these "ink traces" of the masters to be nothing less than visible records of their individual personalities. We can sense the living presence of Takuan, Fūgai, Ingen, Hakuin, Tōrei, Ryōkan, Sengai, and Nantembō in their scrolls. The flexibility of the oriental brush brings us a visualization of the Zen experience in its original flavor and resonance.

For many decades, Americans and Europeans have known Zen mainly through books. Gradually, however, a number of Buddhist centers have opened in the West, offering the direct experience of religious practice. Prepared in part through an ever-increasing exposure to the principles of Buddhism in general and Zen in particular, many Westerners have developed an interest in exploring the visual heritage of the Chinese and Japanese Zen masters. Artists, as so often, have led the way. Whether or not they know of such powerfully concentrated ink traces as are reproduced in this volume, a number of contemporary painters reveal the influence of the Zen aesthetic in their works. Furthermore, such movements as Abstract Expressionism, Action Painting, and Conceptual Art have helped prepare Westerners for the drama and simplicity of Zen painting and calligraphy. As a result, in recent years Americans and Europeans have responded positively and intuitively to Zen brushwork. Private collections have grown rapidly in size and importance, and exhibitions including Zenga have become increasingly popular.

Part of the appeal of Zenga in the West lies in its spontaneous visual impact. Although it comes from a different culture, Zenga often communicates without any advance preparation. For many people, if the effect of the works is not immediate, it is unlikely to occur at all. Of course, like all art, Zenga is more clearly understood in its own cultural context. It can be clarified by (just as it helps to clarify) Zen history. The biographies of monk-painters, which are often extraordinary, add a special richness to our understanding of their brushwork. The meanings of the words and images the monk-artists created form a primal course in Zen. The literal message of the calligraphy and the artistic expression of the images provide a fascinating counterpoint. Nevertheless, it is the direct and intuitive experience of the works that counts the most. Through the mysterious ability of art to communicate beyond words, we can sense the spiritual force inherent in the calligraphy, the painting, and even the simple circles of the brush created by enlightened Zen masters.

Paradoxically, we may be more ready to accept the artistic experience of Zenga than many contemporary Japanese who have so successfully adapted

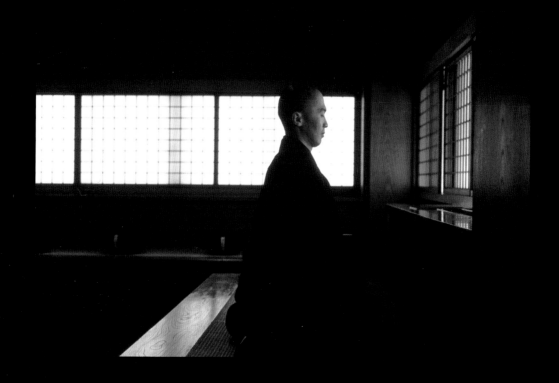

4. Monk seated in meditation.
Eihei-ji.
Photograph by Graham Harrison

their cultural values to those of Western pragmatism. Some Japanese have questioned whether Zen brushwork can even be called "art," since it goes beyond the kind of aesthetic enjoyment that they expect from painting. A few more experienced connoisseurs, however, find themselves coming back to the monks' brushwork when their eyes have become weary of more elaborate and colorful artworks. It is curious that several of the most celebrated painting dealers in Tokyo and Kyoto keep only one form of art in their own private collections: Zenga. Some of these works are included here, but more than half of the Zenga reproduced in this volume is now in Western collections; almost all of these works have left Japan within the past twenty years. This trend may not continue, since some of the leading Japanese art historians and museum curators have been taking a serious interest in Zenga lately, but it is one of the features of modern life that the ebbs and flows of intercultural influences are never simple and one-sided. As oil paintings by Van Gogh move to Japan, ink paintings by Hakuin come to the United States.

Ultimately, geography matters little. It is not merely as a cultural artifact from a foreign land that a Zen painting is to be appreciated, but rather as an instantly energizing work that can be a focus of meditation. This is surely what venerable Japanese Zen masters would have wished. Retired from their temple duties, they no longer composed lengthy Zen sermons or abstruse commentaries on famous works of the past. Instead, they made paintings and calligraphy as their ultimate visualizations of the serenity of meditation and the joy of enlightenment.

Over the past four hundred years, Zenga has continued to be created by Japanese monks. At once a representation of its particular subject and mere brushstrokes on paper or silk, it can be studied as art as well as utilized as an aid in meditation. Today, Zenga is also a means of communicating with the great masters of the past, whose works convey their profound understanding of Zen. Their gestures with the brush remain with us as their final teachings in direct visual form. Whether preserved in Japanese temples or exhibited at American museums, Zen paintings and calligraphy continue to act as sermons, hints, suggestions, and guides that not only represent, but can lead toward satori. These "ink traces" have the power to reach us in a different country, a different time, and a different world; the act of enlightened communication through brush and ink is the art of Zen.

5. Implements of the tea ceremony: ceramic teapot, tea caddy, and water holder; bamboo tea whisk and ladle. Photograph by Jon Blumb

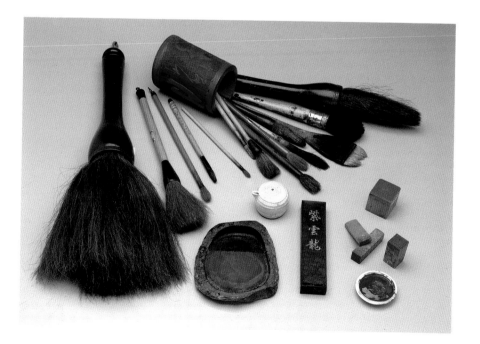

6. Implements of calligraphy: animal-hair brushes with wood and bamboo handles; carved bamboo brush pot; ceramic water dropper; ink stone and inkstick; stone seals and cinnabar seal ink. Photograph by Jon Blumb

THE
CREATION
OF ZENGA
AT
DAITOKU-JI

What comes from brightness,

I strike with brightness.

What comes from darkness,

I strike with darkness.

From the fourteenth to the sixteenth century, Zen Buddhism was the dominant cultural force in Japan, and its monks had great social prestige. Supported by the shogunate and practiced by samurai, Zen influenced many aspects of Japanese life. Daimyo (feudal lords) and their leading followers were educated in Zen precepts, large monastery complexes were constructed in the major cities as well as in towns and villages, and monks fulfilled a number of different roles in the world around them.

The traditional duties of Zen monks included maintaining their own Zen practice (focusing on meditation), holding ceremonies for their parishioners (the most important of which were funerals), and responding to the social welfare needs of the community. Leading masters were also expected to teach, thus continuing the tradition of transmitting Zen principles from one generation to the next. Now, however, they were given additional responsibilities. An abbot of a major temple was required to become an efficient administrator not only of his own monastery with its various subtemples but also of affiliated temples in the countryside. Leading Zen masters advised the government on matters ranging from policy to foreign relations and trade, while the Zen aesthetic of self-discipline, simplicity, and naturalness inspired the arts of Noh drama, Chinese-style poetry, garden design, ink painting, and calligraphy. Some Zen temples were particularly allied to the emperor, who held little actual power but a great deal of social and cultural prestige. Others were sponsored by the shogunate or powerful feudal lords. Although the Japanese actually practicing Zen (rather than other Buddhist sects) remained a minority, they wielded influence much greater than their numbers might suggest.

Essential to the samurai code that dominated the Muromachi period (1392–1568) was loyalty to one's clan. The fatal flaw, however, was that there was nothing in this code to prevent warfare between rival clans vying for power. Without a true national constituency, the central government was gradually weakened until it could no longer even pretend to control the rambunctious daimyo in the provinces. During the latter part of the sixteenth century, recurring civil wars between rival clans devastated much of the country, including the capital of Kyoto, where temples were not spared the ravages of fire and warfare.

When military strongmen finally began the process of reuniting Japan under a central government in the Momoyama era (1568–1600), they no longer turned to Zen monks for advice and support. Instead, they initiated changes that profoundly affected almost every aspect of Japanese life. The first task of the new leaders was to establish control over Japan after such a prolonged period of political and social dislocations. This was accomplished in a number of ways. Significantly, the Tokugawa shogunate decided in the early seventeenth century to foster Confucianism rather than Zen Buddhism as the philosophical and ethical basis of their rule. This system, which was effective in China for two millenniums, encouraged a sense of moral obligations both within the family and toward the government. Confucianism stressed duty toward society rather than the personal spiritual quest of Zen. Worldly success achieved within the limits of responsible behavior was a legitimate goal, and participation in secular cultural activities became the hallmark of the civilized man.

Attempting to stabilize Japanese society, the Tokugawa regime moved the capital to Edo (Tokyo), distancing themselves from the politically powerless but culturally influential emperor and his court. Next the shogunate closed off Japan from the rest of the world. Japanese were not allowed to leave their country. Only traders from Holland and China were allowed to visit Japan, and they were confined to the port city of Nagasaki. Christianity, which had

attracted enough converts and potential political power in southern Japan to frighten the government, was soon totally proscribed. Every Japanese was required to register at a Buddhist temple, which then kept all family records for the government. In addition, the regime created four classes of citizens: samurai-officials, farmers, artisans, and merchants. Each class had its own obligations, and it became very difficult for an individual to move from one class to another. Although this system generally proved effective, the merchants, who were theoretically at the bottom of the social structure, soon became the most wealthy members of society. But political unrest was kept to a minimum, and the Tokugawa shogunate remained in power until the restoration of the emperor in 1868.

In many ways the changes that took place in Japan after 1600 diminished the political importance and social influence of Zen. Monks no longer educated the ruling elite, nor did they advise the government on matters of state. For most people, the strict discipline and unworldliness of Zen seemed irrelevant to their needs and desires during an era of peace and prosperity. The increasing commercialism and materialism of the Edo period led to a preference for secular rather than religious values. In the field of art, professional painters produced golden screens for daimyo and wealthy merchants, while wood-block designers created prints (ukiyo-e) of favorite actors and courtesans for the popular market.

In this cultural climate, Zen was no longer part of the establishment, but conversely it could once again flourish as a counterculture. Without the support of the government, Zen's only practitioners were those genuinely committed to its precepts. Lacking commissions from the elite, semiprofessional artist-monks had no role in society. Zen masters responded to these changes with a new brushwork tradition called Zenga, stressing simplicity of presentation and depth of spiritual expression, that has continued to the present day.

It is through the lives of the major monk-artists that the course of Zenga can best be traced. Coming from the various social classes, they usually entered Buddhist orders before adolescence and spent many years in training before they reached enlightenment. Typically, they had to undergo strenuous regimens in special temple training halls (sōdō), arising before dawn and continuing until late at night with regular sessions of chanting and meditation. Monks would usually meditate in silence, sitting in the lotus position and clearing their minds by not clinging to any thoughts that might arise. Occasionally the Zen master might give a talk based on a well-known Zen text. There might also be walking meditation sessions to break the long hours of sitting. The training of novice monks included manual labor, ritual begging, and Buddhist studies in which calligraphy (usually learned for copying religious texts) was an integral part of their lessons. Later in their training, they often undertook long pilgrimages to various monasteries to test their understanding of Zen with other aspirants as well as with Zen masters.

The teachers of novice monks gave them Zen conundrums called kōan to solve: "What was your original face before your parents were born?" and "What is the sound of one hand clapping?" are notable examples. Since there were no logical answers to the kōan, the mental struggle of the young monks was intense. Under the strict tutelage of their masters, they endeavored to break through dualistic thinking in order to arrive at a unified understanding of life—the answers to the conundrums could only be reached through enlightened vision after a long period of meditation. When their teachers were satisfied that satori had been achieved, monks were allowed to become abbots

of small branch temples, and eventually they might be given charge of the major monasteries of their sect. A few, however, preferred to avoid the responsibilities of satisfying patrons and the administrative duties that were never absent from Zen life in the larger cities. Such monks usually chose to live at smaller temples in order to concentrate upon their own practice and teaching.

The system of direct master-to-pupil transmission has always been vital to Zen, but it had been somewhat modified during the Muromachi period by the government's support. At this time Zen tenets were widely promoted among the ruling elite, but the official sanction of Zen did not always benefit individual spiritual attainment. Because abbots of major temples often spent much of their time advising the government, teaching the sons of daimyo, leading trading missions, and administering their monasteries and domains, they had little time for training their own followers. Furthermore, the high social prestige attached to Zen encouraged its study by those not fully committed to its principles.

By contrast, during the Edo period, when government support waned, Zen teaching became more important than ever before. The strict instruction of their followers—and through them the perpetuation of Zen—became the primary mission of many Zen masters, and the status of monks within society had diminished sufficiently to discourage all but the most serious of acolytes. However, teaching their direct pupils was not enough for many leading monks. Believing that the Buddha-nature resides in each being, they went out more and more often to large Zen meetings that were open to the public. Without the support of the elite, Zen thus moved in two new directions: monks both intensified their work with individual pupils and reached out to a broader audience. For both these purposes they utilized painting and calligraphy as aids to meditation and guides to enlightenment. Beginning about 1600, Zenga began to play a vital role in the transmission of the Zen spirit.

The intensification of Zen painting and calligraphy first began in Kyoto at the major Rinzai sect monastery of Daitoku-ji. Traditionally allied with the emperor rather than the shogunate, Daitoku-ji contained a number of subtemples within its sprawling complex in northern Kyoto and was also affiliated with a number of smaller countryside temples. It was at Daitoku-ji one hundred and fifty years earlier that the iconoclastic monk Ikkyū (1394–1481) had endeavored to break through the somewhat stultifying artistic professionalism of his own day. His influence, which was never lost, encouraged Daitoku-ji abbots to maintain a tradition of creating powerfully individualistic and expressive "ink traces." Furthermore, Daitoku-ji was the temple to which followers of the tea ceremony, who typically hung Zen scrolls in their tokonomas to enhance the meditative experience, turned for artistic guidance.

Ikkyū, most probably the illegitimate son of an emperor, was such an interesting and controversial monk during his long and eventful lifetime that only a few aspects of his personality and achievements can be mentioned here.[1] Although he had been extremely critical of the Zen hierarchy because of what he proclaimed to be its loss of spiritual values, he was asked at the age of eighty-two to revive Daitoku-ji after warfare had devastated much of Kyoto. His major tasks were to train monks thoroughly and to raise funds to rebuild many of the buildings and subtemples that had been lost to war and fire. He also undertook to invigorate the arts connected with Zen, influencing everything from painting and calligraphy to garden design and the tea ceremony. His own brushwork was blunt, angular, often rough, and above all boldly idiosyncratic. This style ran counter to contemporary taste, which favored

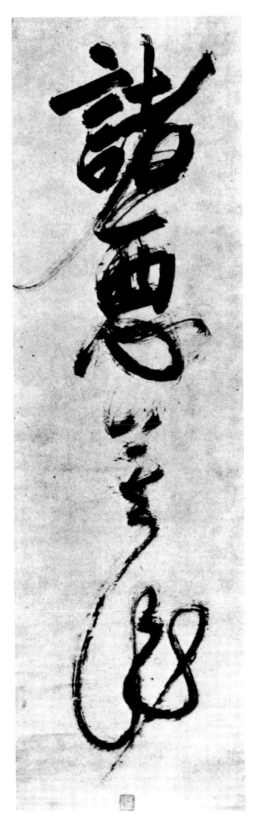
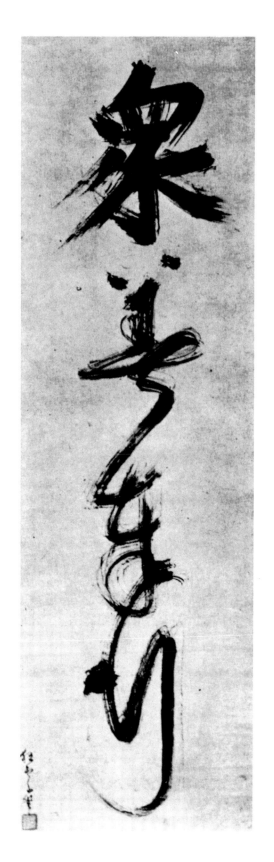

7. *Ikkyū (1394–1481)*

CALLIGRAPHY PAIR

Ink on paper, each 52 1/2 × 16 1/2"

Daitoku-ji, Kyoto

ever greater technical skill and smoothness of effect. Indeed, in his calligraphy Ikkyū displayed disdain for overt charm or attractiveness; instead he offered dynamic, craggy, sometimes wildly tumultuous dry-brush gestures.

In a pair of hanging scrolls (*plate 7*) urging people to "Do Good and Refrain from Evil," Ikkyū began each line with characters brushed in regular (standard) script, akin to our own printed words. As he continued down the paper, his overflowing energy bade him to work faster and faster, and the characters changed to running and finally to cursive script in which the many strokes of each character are reduced to a basic minimum. Calligraphers seldom alter their script forms so drastically in the middle of a line of writing, but here the effect is of frenzied inspiration replacing attempts at conventional beauty with the spontaneous force of a whirlwind.

Both artistically and personally Ikkyū was a maverick genius. Although ultimately he was not able to alter the historical progression of Zen in his day from a counterculture to a government-supported institution, he did create a long-lasting iconoclastic tradition at Daitoku-ji. It was the legacy of Ikkyū that bore fruit artistically in the early Edo period, when Zen became a spiritual alternative to the increasingly materialistic currents of the day.

Most of the leading masters of Zen brushwork in the first decades of the seventeenth century were connected with Daitoku-ji. Through their biographies we can learn not only about their life and art, but also about Zen itself as it evolved during the Edo period. Konoe Nobutada was an aristocrat and calligrapher, but from his studies of Zen with Daitoku-ji abbots he developed a boldly simple painting style quite unlike the elaborate courtly traditions of the past. His works must have seemed revolutionary in their time, particularly because they were created by a man who commanded great prestige at the imperial court. Takuan Sōhō became abbot of Daitoku-ji in 1609, but his attempt to resist shogunal interference in temple matters eventually led to his exile in northern Japan. Ironically, he regained favor with a succeeding shogun and thereafter spent much of his time as an administrator and fund-raiser, rebuilding temples that had been destroyed in the warfare of the previous decades. He nevertheless found time to create paintings and calligraphy; his powerful vision and incisive brushwork made him the heir to Ikkyū's mantle. Kōgetsu Sōgan followed Takuan as an abbot of Daitoku-ji. He helped restore the temple, and he brushed extraordinarily powerful examples of brusque, angular "Daitoku-ji–style" calligraphy. Shōkadō Shōjō was a monk of the esoteric Shingon sect rather than of Zen, but his friendship with monks at Daitoku-ji such as Takuan inspired him to become one of the masters of evocative ink paintings. His depictions of Zen figures, simply portrayed without landscape backgrounds, were especially appropriate for the increasingly popular tea-ceremony gatherings of the early Edo period. Isshi Bunshu was Takuan's leading pupil; of aristocratic birth, he became a favorite Zen teacher of courtiers. He produced elegant paintings and calligraphy that express his refined, poetic spirit. Seigan Sōi represents the continuing strength of the Daitoku-ji tradition. As abbot of the temple, he carried on a strongly gestural style of brushwork, conveying the inner power of his Zen spirit directly and forcefully.

KONOE NOBUTADA (1565–1614)

One of the first artists to create Zenga in the early seventeenth century was not a monk at all, but the court noble Konoe Nobutada. He came from a distinguished family, a branch of the ancient Fujiwara clan, that had long served the

8. Nobutada (1565–1614)
MEDITATING DARUMA
Ink on paper, 13³/₈ × 22¹/₄"
Private Collection

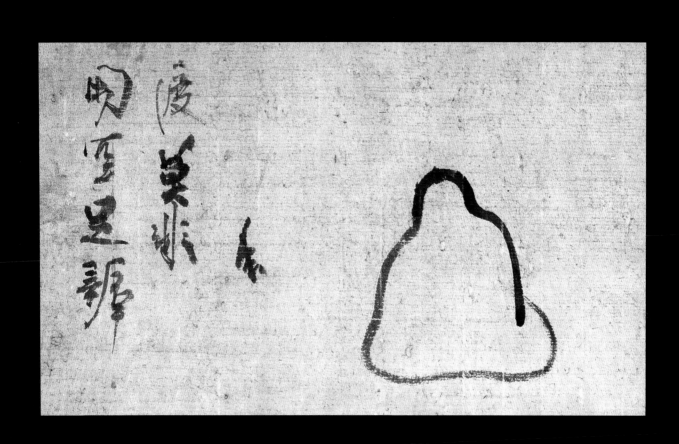

imperial court. Nobutada's younger sister Sakiko was chosen to be the concubine of Emperor Goyōzei; she became the mother of Emperor Gomizuno-o, the poet-calligrapher Konoe Nobuhiro, and three imperial princes. Nobutada's father was a courtier and aesthete who amassed a collection of more than ten thousand pages of calligraphy. His collection included a number of early manuscripts, books of poems, rubbings of Chinese carved inscriptions, and Buddhist sutras that had been broken up into individual sheets and mounted on scrolls or pasted into albums. The study of calligraphy was a fundamental part of being educated, and such collections enabled students of elegant writing to examine and copy a number of masterpieces in a variety of styles. It was through extensive copying that control of the brush could be mastered, after which a personal style would emerge naturally.

The opportunity to study his father's collection stimulated Nobutada's creativity. He not only learned the fashionable Son'en style of writing, popular at court for its elegantly brushed thinning and thickening lines, but he also studied classical Chinese calligraphy of the T'ang dynasty and the works of earlier Japanese masters such as Kōbō Daishi (also known as Kūkai, 774–835) and Ono no Michikaze (896–966). As the son of a high-ranking courtier, Nobutada had the finest quality brushes, ink sticks, paper, and silk at his disposal. It is therefore especially telling that he gradually developed a somewhat rough and forceful style of writing. Furthermore, he often preferred crudely textured paper rather than the usual pristine or elegantly patterned paper or silk for his painting and calligraphy.

As a youth, Nobutada was both talented and intelligent. He was given his first court position at the age of thirteen, and by the time he was twenty-one he had reached the exalted ceremonial rank of *Sadaijin* (Minister of the Left). While serving at court, Nobutada studied Zen at Daitoku-ji, first with the abbots Shun'oku Sōen (1529–1611) and Kokei Sōchin (1532–1597) and later with Takuan. In 1592 Nobutada asked Emperor Goyōzei's permission to join the army for Shogun Hideyoshi's invasion of Korea, but permission was denied. Undaunted, the young and hot-blooded Nobutada traveled to military headquarters in Nagoya and tried to persuade the commander to accept him into his ranks. He was considered mad; not only was his request refused, but he also received an imperial censure and was banished in 1594 to the farthest part of Japan from Kyoto—the village of Bō-no-tsu on the island of Kagoshima in southern Kyushu.

During his exile, which must have been the nadir of his life, Nobutada wrote a number of poems. These include one remarkable *kyōka* (a humorous verse satirizing the traditional five-line *waka* poetry style) making fun of his predicament. Contrasting the elegant life of a court minister with the more humble existence of those carried upon *kago* (small sedan chairs or palanquins), it contains two puns on place-names; the first is *Kagoshima,* which could also mean "palanquin island," and the second is *Bō-no-tsu,* which could mean "pole harbor":

Daijin no	*No longer in the*
kuruma ni wa arade	*oxcart of great ministers,*
aware ni mo	*woe is me, you see—*
nosuru Kagoshima	*riding Palanquin-shima*
ninau Bō-no-tsu	*carried by Pole-no-tsu!*

Nobutada was pardoned in 1596. He returned to Kyoto and soon regained imperial favor; five years later he was once again awarded the rank of *Sadaijin,*

and in 1605 he achieved the highest court position of *Kampaku* (Senior Regent). This post carried great prestige, but it no longer held any serious political significance due to the thorough consolidation of power by the Tokugawa shogunate. Nobutada, who wished to contribute to the future of his country, was rewarded merely with ceremonial titles.

Since Nobutada did not have a son, Emperor Goyōzei allowed him to adopt his own fourth son, Nobuhiro (who in fact was Nobutada's nephew), in order to continue the Konoe family line. Despite this kindness, Nobutada could not continue in a lofty court position that was essentially empty of meaning, so he resigned as *Kampaku* in 1607 and traveled to Edo (Tokyo). There he took up the free life-style of a literatus. He wrote poetry in formal *waka,* humorous *kyōka,* and linked-verse *renga,* as well as in Chinese styles; he lectured on classical literature such as the *Tale of Genji;* and he became known for his love of the Japanese rice wine, sake. He was most celebrated for his calligraphy. Eschewing the grace and elegance expected from the hand of a court noble, Nobutada achieved a bold and sometimes rough simplicity derived from a combination of the early models he had studied and from his Zen practice. He initiated a new, vigorous "Konoe style" that had an enduring influence upon his followers. Nobutada was also a remarkable painter. Ignoring the colorful and delicate style of court artists of his day, he brushed simple ink paintings of Zen avatars on coarse, sometimes recycled, paper. Like his new style of calligraphy, these paintings were revolutionary. Who was his audience for such works? He certainly did not sell them, giving them instead to friends and followers. Nevertheless, they must have been well known since his style was taken up by painters both within and outside the court, including several women artists.

Nobutada's *Meditating Daruma (plate 8)* depicts the Zen patriarch during his nine years of meditation in front of a wall at the Shao-lin Temple. Upon the dark and rough-textured paper, Nobutada has merely suggested the seated figure with an even, sure line; it is an image for meditating on the nature of meditation. The painting is accompanied by a single line of Chinese-style poetry in two columns, followed by Nobutada's cipher signature. The seven-character line of verse was written from left to right, unlike most non-Zen calligraphy, to lead the viewer's eye toward the figure of the patriarch. Nobutada's characteristic brushwork, seemingly awkward but masterfully controlled, reinvents the character shapes in varied tones of gray ink, so that they tilt slightly to the left or right. The poetry reinforces the meditative pose of the image:

Quietness and emptiness are enough
to pass through life without error.

Nobutada's portrait fulfills the literati ideal of combining painting, poetry, and calligraphy, the "three treasures of the scholar," while expressing the inner vision the artist had achieved through his Zen studies. The simplicity of conception, the controlled spontaneity of brushwork, the deliberate avoidance of overt technical skill, and the asymmetrical balance of the composition combine to produce a powerful expression of the fundamental Zen act of meditation.

During his later years Nobutada frequently painted images of Tenjin, the deified courtier-poet Sugawara Michizane (845–903).[2] After being falsely accused of misconduct by jealous rivals at court, Michizane had been exiled to Kyushu, where he died in poverty. His spirit was thereupon supposed to have

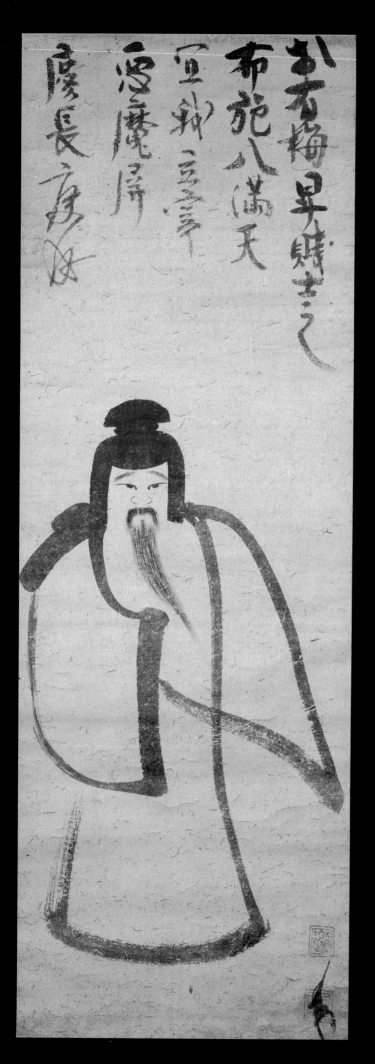

9. *Nobutada (1565–1614)*
TENJIN
Ink on paper, 36¹/₂ × 18³/₈"
Private Collection
Cambridge, Massachusetts

haunted his former enemies until the Kitano Shrine was built for him in Kyoto, and he thus became a Shinto deity of literature, scholarship, and calligraphy. Tenjin was also revered as a Zen master: a legend emerged during the Muromachi period that the spirit of the courtier had flown to China, studied Zen, and returned to Japan carrying a plum branch, representing the first blossoming of spring. The plum branch became his symbol, and Tenjin became a frequent subject for painters of various schools and traditions.[3]

There were many reasons why Nobutada was attracted to this theme, including his veneration of the scholarly arts as well as the memory of his own banishment to Kyushu. Over the years, Nobutada utilized many different inscriptions over his portraits of Tenjin, including Zen sayings and his own poems. One painting of Tenjin (plate 9), brushed in Nobutada's characteristically simplified manner on rough paper, includes a couplet written in five columns of bold calligraphy:

With my plum trees, supported by the donations of everyday people,
I serve as a barrier against the demons of the entire world.

The figure of the deity quizzically peers out from under his courtier's hat; his robes are depicted with broad, decisive lines that suggest a giant calligraphic form. Although he is placed slightly to the left side of the scroll, Tenjin's beard, sleeves, and robe lead diagonally down to the right, creating a sense of gentle movement. The poem is nestled above, reinforcing the even curve of the figure. The calligraphic characters, placed closely together, are themselves enlivened by strong diagonal strokes that echo the shapes of Tenjin's beard and robe. This highly focused image, created with a minimum of brushstrokes, was a deliberate rejection of the professionalized and elaborate paintings that had developed during the late Muromachi period. The portrait of Tenjin, like the *Meditating Daruma,* shows Nobutada's ability to use the simplest of means to maximum effect.

His health perhaps undermined by too much drinking, Nobutada died in 1614 at the age (by Japanese count) of fifty.[4] He was subsequently honored as one of the "three great calligraphers of the early Edo period."[5] His contributions to Zen painting, although not yet as celebrated as his calligraphy, were significant for their emphasis upon classical simplicity and purity of expression. Yet his consolidation of personal experience makes his art a part of its own era. It is this combination of the timeless and the timely that makes Zenga so fascinating.

TAKUAN SŌHŌ (1573–1645)

The central figure in Japanese Zen in the early seventeenth century was the Daitoku-ji abbot Takuan. Not only were painting and calligraphy among his many attainments, but he was a teacher and friend to most of the other important Zenga pioneers of his time. His experiences reflect some of the major historical changes facing Zen at the beginning of the Edo period.

Born to a farming family of samurai ancestry in the village of Izushi in Tajima (now in Hyogo prefecture), Takuan (then named Gorō) entered Buddhist service at the age of nine. In a society in which a person's future course was usually set in childhood, this was not an unusual age to enter a temple, and for a farmer's son the life of a monk carried with it a considerable amount of prestige. Takuan first served in a temple devoted to "Pure Land" Buddhism, a sect that emphasized the importance of faith in Amida Buddha.

If a believer could recite the chant "*Namu Amida Butsu*" ("Praise to Amida Buddha") with perfect faith, at his death he would be reborn in the "Pure Land" of Amida's Western Paradise. This form of Buddhism, which seemed to offer the easiest road to salvation, had become the most popular sect in Japan, but it did not seem to satisfy the young Takuan.

When Takuan was thirteen, he began to practice Zen. He studied at Sukyō-ji in Tajima, which like all smaller Japanese temples was allied to a major monastery. Sukyō-ji originally belonged to the Tōfuku-ji branch of Rinzai Zen, but with the arrival of the master Tōho Sōchū in 1592 it became allied to Daitoku-ji. When Tōho returned to Daitoku-ji in 1594, he took with him his young pupil Takuan, who now received the name of Sōhō. Takuan thereafter traveled with his master, who was soon organizing the construction of another branch temple, Zuigaku-ji. After Tōho's death in 1601, Takuan returned to Daitoku-ji to study under Tōho's own teacher, Shun'oku Sōen (1529–1611), one of the leading abbots of the day.

Developing an interest in literature and the arts, Takuan copied manuscripts in order to earn enough money to buy lamp oil so that he could read deep into the night. He also journeyed to Daian-ji, near Nara, to study with the Sōtō sect monk Bunsei Seidō, who eventually bequeathed Takuan his entire library. Takuan became highly skilled at Japanese-style *waka* and *renga*, completing a collection of one hundred poems by 1602. After Bunsei's death the following year, Takuan became a pupil of Ittō Jōteki (1539–1613) and moved to Nanshū-ji in the city of Sakai. Ittō recognized his pupil's satori (enlightenment) in 1604 and gave him the name by which he is now remembered.

In 1607 Takuan was awarded the first monk's position at Daitoku-ji, and two years later he became the 153rd abbot of the temple, the youngest monk ever to succeed to this prestigious post. The abbotship was essentially a rotating position, and Takuan stayed at the monastery for only a short time (according to one account, three days) before leaving to gather money for rebuilding Daitoku-ji and other temples that had been devastated during the wars of the previous centuries. Although this was the same task that had occupied Ikkyū one hundred and fifty years earlier, both monks would undoubtedly have preferred to spend their time in Zen practice, teaching, and the arts. A great deal of Takuan's life was devoted to travel, raising funds, and supervising the construction of temple buildings; of the hundreds of Takuan's letters still extant, the majority refer to these matters, asking or thanking patrons for their help. Nevertheless, he refused many offers to stay at the temples of the highborn; he declined invitations from the warlord Toyotomi Hideyori in Osaka as well as from powerful daimyo such as Hosokawa Tadaoki and Kuroda Nagamasa. In 1620, tired of fund-raising, Takuan went back for a time to Sukyō-ji, writing that he could no longer endure a life in which he felt he was expected to "flatter people for the love of wealth, sell Buddhism for a living, and drag the teaching of the patriarchs down into the mud."[6] The tension between his own Zen practice and his feelings of public responsibility was to persist throughout his life.

Despite his many duties, Takuan had time to give Zen instruction to numerous followers. He became famous for the strictness of his teaching methods, demanding total commitment from his pupils. He also put forth a steady stream of literary works, including seven poetry collections, diaries, commentaries on Chinese and Japanese Taoist and Buddhist texts, and works on medicine, swordsmanship, poetics, Zen practice, and the tea ceremony.

One of his letters to the tea master Sen Sotan included a quotation from Daitō Kokushi, the founder of Daitoku-ji, suggesting that to be quiet within the hubbub of this world was like being cool in a fire.[7] For Takuan, attaining such inner tranquillity was a crucial goal. It was not enough to practice Zen at a remote monastery; his life carried him into the worlds of governmental politics as well as mercantile wealth, and his Zen was constantly tested by the pressures of a society in flux. Daitō's metaphor was particularly appropriate for Takuan because of its relevance to the tea ceremony, which begins with a fire but has the effect of calming the spirit. Just like grinding the ink before beginning painting or calligraphy, the time spent preparing tea was a meditative experience.

Takuan's interest in the tea ceremony was no doubt stimulated by the opportunities it offered him to meet with military leaders and wealthy merchants who could assist the cause of Zen. To be invited to a small tea gathering by a distinguished monk was a cultural badge of honor, and he could bring together the elite of Japan for informal discussions that might not take place under other circumstances.[8] More important, however, the tea ceremony offered Takuan and his guests the chance to develop a sense of serenity through simple but ritualized behavior; an island of calm could be created even in the bustle of a big city.

Takuan seems to have made a deep impression on all who met him; he became the teacher and friend of intellectuals and poets in Kyoto such as the courtiers Konoe Nobutada (to whom Takuan dedicated one of his poetry collections) and Karasumaru Mitsuhiro (1579–1638). Although he was extremely busy, Takuan's life was peaceful until he became embroiled in one of the major political and religious issues of the day, the "purple robes" controversy. The shogunate had long controlled five Zen temples in Kyoto known as the *gozan*. Of these five, only at Nanzen-ji was the abbot allowed to wear a dark purple robe; the other abbots wore violet or yellow. Nominally signs of rank, these robes also signified the historical roles of the different temples. Traditionally, the abbots at Daitoku-ji and Myōshin-ji, which were not part of the *gozan,* were granted the purple robe by the emperor; Ikkyū had once defended this right although he personally scorned worldly honors and ranks. The shoguns of the early Edo period, however, were determined to control as many aspects of Japanese life as possible so as to assure themselves of an orderly rule. Thus in 1604 a law was proclaimed that revoked the imperial mandate granting the purple robe to Daitoku-ji and Myōshin-ji abbots, who were now obliged to obtain permission from the shogunate. This edict was not observed, however, and in 1615 much harsher laws were enacted. These stated that to become an abbot of Daitoku-ji or Myōshin-ji, a monk had to have practiced for at least thirty years and to have solved at least 1,700 of the riddles (*kōan*) given by Zen masters to their pupils to meditate upon. Because these regulations were a direct intrusion by the government into religious matters, they were once again ignored. Consequently the shogunate took action in 1627, invalidating "illegal" imperial mandates and divesting many abbots and former abbots of their purple robes.

Although there were some monks at both temples who were willing to accept the government's policies, most were aghast at this usurpation of the prerogatives of their temples and deeply distressed by the disruption of their close relationship with the court. The monks were not alone. The shogunate's action so angered Emperor Gomizuno-o that he resigned in protest, relinquishing his throne to his seven-year-old daughter, Meishō, who thus became

the first empress in Japan in almost a thousand years. Monks at Daitoku-ji and Myōshin-ji protested the government order in no uncertain terms; Takuan and his Daitoku-ji colleagues Kōgetsu and Gyokushitsu were leaders of the protest. The shogunate could not ignore this defiance. Takuan was summoned to Edo in 1629, and as punishment for his protest he was banished to Kaminoyama in northern Japan.

This banishment was by no means an unmitigated disaster for Takuan. Relieved of official duties, he could concentrate upon his Zen practice and follow his literary bent. He completed his largest poem collection over the next four-year period and also continued his Zen writings, focusing on the actual moment of transformation from delusion to reality that constitutes enlightenment. He compared the tranquillity that comes from recognizing the inner Buddha-nature with the suffering attached to the deluded belief in a self distinct from other sentient beings on earth.[9] The moment of enlightenment, Takuan concluded, is the understanding of unity with all creation, in which there is no need for individual desires. Even the Buddhist clergy were not immune to worldliness, and therefore Takuan criticized ambition among monks—ironically, he derided the purple robes that had been part of his protest to the shogunate. Although he felt that it was incumbent upon monks to regulate their own practice of temple succession, he insisted that they should not thirst after honors or high positions. Indeed, his writings suggest that he had developed a far-reaching understanding of how the inherent Buddha-nature is covered over by such attachments and discriminations:

What is called desire is not simply attaching oneself to wealth or thinking about one's fancies for silver and gold. When the eye sees colors, this is desire. When the ear hears sounds, this is desire. When the nose smells fragrances, this is desire. When a single thought simply germinates, this is called desire. . . . When a single thought arises, both good and evil are there. . . . Because of the skandha of consciousness, we discriminate between good and evil, right and wrong, and ugly and beautiful, thoughts arise concerning acceptance and rejection, and, just as these thoughts arise, the carnal body is born. . . . This body has been solidified and produced by desire, and it is in the nature of things that all men have a strong sense of it. Although there is a desireless nature confined within this desire-formed and produced body, it is always hidden by hot-bloodedness.[10]

The problem of responding to the world without being submerged in it occupied Takuan's attention in verse as well as in religious writings. He wrote poems covering a great variety of themes, including lyrical depictions of nature that celebrate the immediacy of experience rather than confining it to a conceptual framework. Many of his poems are composed (like most Zen verse) in Chinese characters, but his mastery of the Japanese *waka* form of five-line poetry was one of his most notable achievements, showing his skill at what was considered a refined courtly tradition. Although he wrote out Chinese-style verse on plain white paper, his *waka* were frequently brushed on traditional Japanese decorated *tanzaku,* tall, narrow poem-cards. The paper on which he wrote "The Warbler in the Pines" has a design of delicate pine needles with sprinklings of gold leaf, adding an asymmetrical glow to the calligraphy *(plate 10).* The title, made up of three Chinese characters, is set off from the poem, which thereupon flows down the *tanzaku* with relaxed confidence. It is the combination of poetry, calligraphy, and decorated paper that gives this small work its powerful impact:

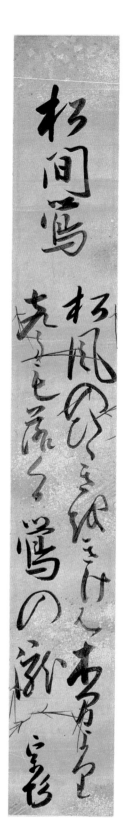

10. *Takuan (1573–1645)*
THE WARBLER IN THE PINES
Ink on decorated paper, 14 × 2"
Private Collection

Matsukaze no	*When among the pines*
hibiki o kikeba	*you hear the rustle of wind*
konoma yori	*whistling through the trees,*
koe mo ochikuru	*a voice also comes falling—*
uguisu no taki	*the bushwarbler's waterfall*

A work such as this *waka* written on elegantly decorated paper would surely have been appreciated by Takuan's friends among the nobility, but it goes beyond the sometimes vapid court poetry and calligraphy of the day. The connection between the sound of a waterfall and the descending cadence of the warbler's song points out the Zen moment of unity that comes from deep listening, from full attention and awareness. While utilizing both Chinese characters for the title and a few other words and Japanese *kana* syllabary for most of the poem, Takuan's calligraphy shows a deep understanding of composition and a firm rather than soft touch with the brush.

Other poems by Takuan are more direct statements of Zen insight. One *waka* expresses the mystery that lies behind sensory experience:

Ji ni fureru	*Vibrating within*
sono koegoe no	*the ear are many voices*
mina moto o	*but their origin*
mushō on to zo	*has a source which may be called*
kore o iu nari	*the sound of no sound*

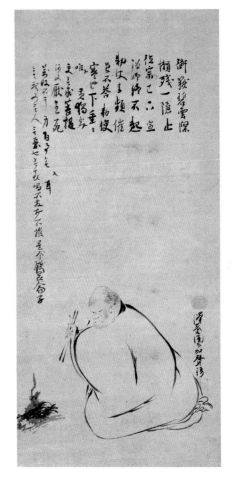

11. Takuan (1573–1645)
RAIZAN ROASTING YAMS
Ink on paper, 26 ¹/₈ × 12″
Murray Smith Collection

The "sound of no sound" expresses the Zen task of penetrating through the distinctions of everyday life to the "not one thing" or "abundant emptiness" of the Buddha-nature. In his *Mysterious Record of Immovable Wisdom*, Takuan explained how attachment hinders the realization of enlightenment:

The mind of attachment arises from the stopping mind. So does the cycle of transmigration. This stopping becomes the bonds of life and death. . . . Stopping means the mind is being detained by some matter, which may be any matter at all. . . . If there is some thought within the mind, though you listen to the words spoken by another, you will not really be able to hear him. This is because your mind has stopped with your own thoughts. . . . When facing a single tree, if you look at a single one of its red leaves, you will not see all the others. When the eye is not set on any one leaf, and you face the tree with nothing at all in mind, any number of leaves are visible to the eye without limit. . . . Similarly, the wheels of a cart go around because they are not rigidly in place. If they were to stick tight, they would not go around. The mind is also something that does not function if it becomes attached to a single situation. . . . The mind that stops or is moved by something—this is the affliction of the abiding place. . . . To be called, to respond without interval, is the wisdom of all Buddhas.[11]

Although he found this period of peace and quiet to be fruitful, Takuan's banishment did not last long. He was summoned to the capital of Edo after the death of Shogun Hidetada in 1632, but he was not immediately allowed to return to Daitoku-ji. He wrote a *waka* at this time with several wordplays, indicating his feelings at being asked to remain in Edo:

Gyoi naraba	My banishment
kaeri takuan	has been ended, and I think
omoedomo	I'd like to return—
Edo wa iyaiya	but I don't much like Edo,
musashi yo no naka	the hub of the squalid world

In the second line, the word *takuan* is not only the poet's name, but can mean "I would like" (*taku aru*), while *musashi* in the final line is another name for Edo as well as suggesting *musakurushii* (squalid). For a Zen monk, the world is of course impure, but here Takuan has obliquely registered his disgust with politics as well. In one of his Chinese-style poems of the following year, Takuan expressed his desire to return to Kyoto to see the blossoming plum trees, a symbol of noble purity that may have also represented the court, as distinct from the shogunate. Yet paradoxically it was Takuan's own ability and character that kept him from the peaceful life in Kyoto that he would have preferred.

Life in Edo, although not of his choice, offered new challenges and possibilities to Takuan. The new shogun, Tokugawa Iemitsu, officially supported Confucianism but was highly impressed with Takuan's intelligence and religious understanding and often invited him to Edo Castle to lecture on Buddhism. Takuan complied with these requests, but he refused invitations to live at the castle. In 1638 Iemitsu asked him to open the temple of Tōkai-ji in Edo, which he did the following year after a lengthy return visit to Kyoto and Daitoku-ji. While in Kyoto, Takuan was frequently invited by the retired Emperor Gomizuno-o to speak at court. After one lecture, Gomizuno-o expressed his admiration by sending various gifts to Takuan, including a fine inkstone and a celadon incense burner. The gifts no doubt also commemorated Takuan's steadfast loyalty to the emperor.

Takuan spent most of his later years in Edo. He not only influenced the shogun to rescind the harsh temple laws (fourteen years after they had been promulgated), he also instructed Shogun Iemitsu and other officials in Zen practice. Like Ikkyū before him, however, Takuan never granted any of his pupils *inka,* the certificate of enlightenment that served as a form of graduation document in Zen training. The strictness of his spirit never wavered despite the unexpected directions his life had taken over the years.

In the midst of his eventful career Takuan continued to make time for brushwork. Not only did he write many hundreds of letters, now valued as fascinating examples of his most personal form of calligraphy, but he also brushed poems, Zen aphorisms, and a limited number of paintings bearing his own inscriptions. One of the most interesting of these scrolls is *Raizan Roasting Yams (plate 11).* Considering Takuan's buffeting in the world of political change, it is significant that he depicted a Zen recluse of the T'ang dynasty who refused government service and became a monk by the name of Raizan (Chinese: Lai-tsan), which means "Lazy Scavenger."

Deep in the emerald cloud of Meng Peak
The recluse Raizan dwells alone.
Emperor Te-tsung himself addressed words to him
But the Zen master never even rose.
Imperial messengers came and urged him repeatedly:
Not once did he answer them.

His face glistening with cold tears,
His world was that of the wild yam;
Beyond that he did not seek enlightenment
Nor did he shun birth and death.
Nothing whatever bothered him,
No vexatious matters entered his ears.
There was no self and no others;
No troubles. No good.
No shouts issued from his mouth,
No blows from his fists.
He was one dark hard son of a bitch.[12]

Despite its apparent simplicity, this scroll conveys Raizan's inner power and tension, and it is all the more fascinating when we consider Takuan's complex relationships with the governmental forces of his day. On a political level, he had opposed the shogun and been banished, then ironically had been so favored by the succeeding shogun that he had to spend most of his final years in Edo. Personally, he would doubtless have preferred a more reclusive life devoted to Zen practice, poetry, and brushwork, but he felt the responsibility to teach laymen as well as monks, to work for governmental support rather than to risk its interference in religious matters, and to raise money for temple reconstruction. Seen from this vantage point, it is clear why this painting and poem have such a concentrated power: this is the life Takuan would have liked but could not emulate, except in his inner spirit.

Takuan painted with sharp, decisive curving lines and varied tones of ink; the hermit's face, shaped like a potato, has eyes radiating a special intensity. In this spare representation, the obdurate solitude of the Chinese recluse and his total concentration on roasting yams in the fire are clearly conveyed. Takuan's calligraphic inscription begins in a normal fashion high above the figure but continues down to the left until wisps of it too point toward the fire. The artist's signature, seeming to hold up his bowl-shaped seal, is placed behind the figure of Raizan as if to support the old Zen master in his dedication to the task of preparing his simple meal.

It is interesting to note that Takuan himself took an interest in vegetarian food; he is still known in popular culture for the *takuan daikon,* a form of

12. Takuan (1573–1645)
KIKAN
Ink on paper, 13³/₈ × 32¹/₂″
Eisei Bunko Museum, Tokyo

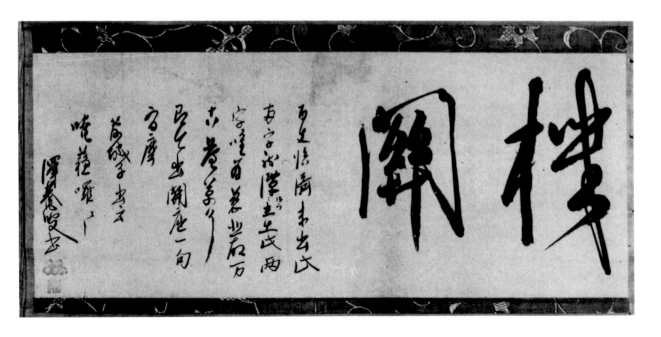

pickled white radish. Over the past three hundred and fifty years, this has not only remained a staple part of vegetarian temple diets, but it has also become a popular food in most Japanese homes. Appropriately, its flavor has an astringency much like Takuan's brushwork.

One of Takuan's most famous and most complex works is the calligraphy *Kikan (plate 12)*. The two large characters have the meaning of "device" or "apparatus," suggesting the way that everything functions in this world, including the relationship of a master to his pupil. The second of the two characters by itself means "barrier," which Takuan also alludes to in his inscription on the left about famous earlier Zen masters:

Hyakujō and Rinzai never went beyond these two words,
Ryūtan and Tokuzan never went beyond these two words;
It was only from their great compassion
That they fell into the weeds eternally.
Right now, do you have a phrase that goes beyond the barrier?
The writing brush comes forward and says:
Daba-daba-daba-daba . . .

The fourth line alludes to the 34th *kōan* from the *Hekiganroku* collection, in which Zen masters are said to have fallen into the weeds by trying to talk about Zen to their disciples. Takuan must have written this work for one of his pupils, as it is a great challenge to understand and interpret; how can the follower go beyond the great masters of the past? The brushwork shows Takuan's uniquely sharp, decisive style, with its brisk angular strokes occasionally exploding in long verticals and diagonals. It is for masterly works such as this, combining powerful writing with a rich and complex text, that Takuan is esteemed as a teacher and calligrapher.

Falling ill late in 1645, Takuan knew his death was near. Gathering his disciples at Tōkai-ji, he told them, "Bury my body in the mountain behind the temple, cover it with dirt and go home. Read no sutras, hold no ceremony. Receive no gifts from either monk or laity. Let the monks wear their robes, eat their meals, and carry on as on normal days."[13] Instead of composing the customary Zen monk's death poem, Takuan picked up his brush and wrote the word "dream." This may be understood in light of a declaration he made:

When one truly dies and leaves his own body . . . he can go freely wherever he likes. In the midst of profound darkness or when the doors and windows are shut, one enters a state of freedom. . . . The body is like a dream. When we see this and awake, not a trace remains.[14]

Although much of Takuan's life was spent in administrative and political matters, he nevertheless left an important legacy of teachings and artistic expression. His books, paintings, calligraphy, and poetry have continued to inspire and encourage those who follow the road of Zen.

KŌGETSU SŌGAN (1574–1643)

Almost an exact contemporary of Takuan, Kōgetsu was also one of the leading monks and calligraphers of the Daitoku-ji school. His father, a wealthy merchant, tea master, and patron of Zen from Sakai named Tsuya Sōkyū (d. 1591) took Kōgetsu at the age of six to study at Daitoku-ji.[15] The following year Sōkyū built the temple Daitsū-an in Sakai and invited the noted monk Shun'oku Sōen to become its abbot. At this time Kōgetsu began his studies with Shun'oku, later accompanying his teacher to Nanshū-ji and Daitoku-ji. Kōgetsu advanced quickly in his Zen studies. He formally entered the priesthood in 1588, and seven years later he was invited to become abbot of Zuigan-ji in Ōmi (Shiga prefecture). During the next decade the wealthy Kuroda family first built the subtemple Ryōkō-in at the great monastery complex of Daitoku-ji and then restored Sōfuku-ji in Chikuzen (Fukuoka prefecture), both times inviting Kōgetsu to become abbot. Kuroda Shōgen became one of Kōgetsu's most important friends and patrons. Another influential friend of Kōgetsu was the most noted tea master of the era, Kobori Enshū (1579–1647).

In the following years Kōgetsu worked hard to reestablish temples that had been destroyed or abandoned. One of his most important tasks, after being made the 156th abbot of Daitoku-ji in 1610, was to rebuild the Buddha Hall, which had burnt down some years earlier. Kōgetsu eventually founded or renovated seven subtemples at Daitoku-ji, as well as more than fifteen temples and subtemples in nearby provinces. His interest in and knowledge of the arts also made him a patron of many of the finest craftsmen and painters of the day, notably Kano Tan'yū (1602–1674), whose extensive wall paintings for Daitoku-ji were made at Kōgetsu's behest.

Along with his colleagues, Kōgetsu protested shogunal interference into temple matters, but he was not exiled by the government. This may have been due to the fact that, unlike Takuan and Gyokushitsu, he apologized; it may also have been that his patrons wielded their considerable influence on his behalf. As a result he faced some disapproval from those who opposed the shogunate, but he successfully continued his activities propagating Zen. He went on to have many important monk pupils, several of whom became abbots of Daitoku-ji during the seventeenth century.

Kōgetsu was known as a connoisseur of painting and calligraphy, and his annotated copies of important works he had seen comprised forty volumes collectively entitled *Bokuseki no utsushi*. His own brushwork, as can be seen in the powerful *Single-Column Calligraphy (plate 13)*, exemplifies the bold, blunt Daitoku-ji style that began with Ikkyū and was revived during the early Edo period. The tall, thin format of the work is appropriate in size for hanging during the tea ceremony; the text is based upon a humorous saying:[16]

When the follower of Zen
 is in doubt,
 his eyebrows droop!

This scroll displays the rough, scabrous style of calligraphy that reached its zenith in the works of Kōgetsu. If the heavy dark lines with occasional breaks in the ink lines suggest eyebrows, then they are certainly beetlebrows, tightly clenched from the first character *Zen* to the final word *droop*. Kōgetsu's use of regular script makes the work easily readable, but the forcefulness of his

13. *Kōgetsu (1574–1643)*
SINGLE-COLUMN CALLIGRAPHY
Ink on paper
Tomioka Museum, Tokyo

rough black lines emblazoned on the white paper creates an almost abstract graphic rhythm.

In 1630, as part of his Zen duties, Kōgetsu visited Hirado in the southern island of Kyushu at the behest of the local daimyo. Spanish and Portuguese traders had brought Christianity to Kyushu, and its rapid success led the shogunate to view it with alarm. Ever vigilant to any trend that might undermine their power, Tokugawa officials feared that the Christian daimyo in Kyushu might plot a rebellion against the central government, perhaps in league with the Portuguese. Edicts against the foreign religion finally led to the tragic uprising in 1638 at Shimabara, where 38,000 Christians lost their lives in futile resistance against the shogunal forces besieging them. The government was so intent on erasing any trace of possible dissent that even Kōgetsu was treated with some suspicion because he had visited the area, but he was able to clear his name and spent his final years at Daitoku-ji.

Kōgetsu died in the twelfth month of 1643 (by today's calendar, it was early in the year 1644) at Ryōkō-in, the subtemple he had founded some years before. Unlike Takuan, he wrote a final poem, which celebrates *Katsu,* the untranslatable Zen shout used by masters to awaken their followers spiritually:

Katsu, Katsu, Katsu, Katsu—
One and all, pay attention!

SHŌKADŌ SHŌJŌ (c. 1584–1639)

One of the pioneers of simplified, Zen-style painting during the early Edo period was the calligrapher and tea expert Shōkadō. Although he was a monk of the esoteric Shingon sect rather than a Zen practitioner, he maintained close connections with Nobutada, whom he served as a youth, and with Takuan and Kōgetsu, who inscribed many of his ink paintings. Born in the Yamato (Nara) area, Shōkadō was trained from the age of seventeen at the Hachiman Shrine on Mount Otoko, near Kyoto, where he learned not only Shinto practices but also the complex esoteric rites of Shingon Buddhism. He advanced quickly in his studies, and in 1627 he was put in charge of a subtemple patronized by the Konoe family, the Takinomoto-bō. There Shōkadō was able to live in partial seclusion. He could devote himself to painting, poetry, and calligraphy, and he was near enough to Kyoto to participate in the artistic world centered at Daitoku-ji. He became a master at many arts, including flower arrangement, garden design, and the tea ceremony; many of his paintings were created specifically to be hung in tokonomas during the ritual presentation of tea.[17]

The interconnection among monks, artists, and tea masters in the early seventeenth century was one of the most influential features in the revival of Zen painting. Shōkadō, for example, studied tea with his brother-in-law Kobori Enshū, who along with Takuan and Kōgetsu had been a Zen student of Shun'oku. It was Enshū whom Kōgetsu commissioned to build a teahouse at Ryōkō-in and Shōkadō who was asked to add paintings to its walls and *fusuma* (sliding paper doors). A skilled tea master himself, Shōkadō also commissioned Enshū to build a teahouse at Takinomoto-bō. Shōkadō's tea diary, *Shōkadō Shōjō chakaiki,* is still extant, recording thirty tea meetings at which he served as host between 1631 and 1633.

Shōkadō's brushwork is not as intense as that of Nobutada or Takuan, but it has a charm that derives from its adroit combination of linear mastery and subtle ink tonalities. Although there is a legend that he studied painting with the professional artist Kano Sanraku (1554–1635), the majority of Shōkadō's extant work demonstrates that he was interested in reviving the earlier Zen style of Chinese and Japanese monks such as Mu-ch'i (1127–1239) and Mokuan Rei'an (flourished 1323–1345). Shōkadō kept scrolls attributed to both of these artists in his own collection.

Shōkadō painted a number of different subjects, but he seems to have specialized in lively figure studies depicting Zen eccentrics such as Fuke (Chinese: P'u-hua, died c.860). What little is known of this Chinese monk comes mainly from the *Rinzairoku* ("The Records of the Zen Master Lin-chi"), where Fuke is admired as a free spirit. When asked intellectual questions about Buddhism, Fuke kicked over the dinner table; when called a donkey, he brayed loudly; when scolded for his coarse behavior, he replied, "What does the Buddhist dharma have to do with coarse or fine?"[18] Fuke was most famous for roaming the streets ringing a small bell and calling out:

What comes from brightness, I strike with brightness,
What comes from darkness, I strike with darkness;
What comes from all directions, I strike with the whirlwind,
What comes from the empty sky, I strike with a flail.

One day Fuke walked around asking for a one-piece robe. He refused all offers until Lin-chi, who alone understood his request, had a coffin made for him. Fuke told the townsfolk that he was going to take the coffin to the East Gate and depart this life, but when after three days he had not done so, the people stopped paying attention. He then went to the East Gate by himself, lay down in the coffin, and asked a passerby to nail it up; when the townsfolk heard the news and came to open the coffin, it was empty. Only the sound of his bell remained, ever more faintly chiming: ding . . . ding ding.

In *Fuke Ringing His Bell,* Shōkadō captured Fuke's characteristic buoyant eccentricity by emphasizing his lively pose *(plate 14)*. One foot is up, the other rests firmly on the ground; one hand stretches out, the other holds the bell directly before his eyes as he leans forward to concentrate. The lines outlining Fuke's body are more sinuous than those by Nobutada or Takuan, and an expert use of wash defines the garments, but the overriding effect is of simplicity and intensity. The cartoonlike elements in this form of painting enable the artist to concentrate his efforts upon strong composition and evocative line work while eliminating all nonessential elements. In this way the viewer can focus his or her attention upon such Zen principles as unity of subject and object, concentration of spirit, and avoidance of overt emotional displays. *Fuke Ringing His Bell* demonstrates that Shōkadō was one of the pioneers in the revival of early Zen painting. Fuke's gnarled and lumpy face suggests the influence of the Sung master Liang K'ai; the curving lineament, however, is typical of Shōkadō and is derived from his calligraphic style.[19] As is characteristic of Zenga, more is suggested than pictured. In this evocative ink painting, one can almost hear the ringing of Fuke's bell in the empty sky.[20]

Although many of Shōkadō's paintings are accompanied by the calligraphy of Takuan or Kōgetsu, the inscription on this painting is an example of the influence of the Chinese literati world on cultivated Japanese circles during the early Edo period. The verse is by the immigrant Chinese poet and mathemati-

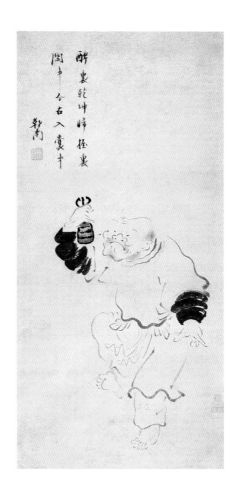

14. *Shōkadō (c.1584–1639)*
FUKE RINGING HIS BELL
Ink on paper, 21 × 10¹/₂"
Private Collection

cian Wang Chien-nan (d. 1645). Having come to Japan in the early years of the seventeenth century, Wang became friends with a wide range of educated Japanese, including Confucian scholars and tea masters. He occasionally added inscriptions to ink paintings, including one by the Rimpa (decorative) School master Tawaraya Sōtatsu.[21] Here Wang has brushed out a couplet in sharp, clear, regular script:

When intoxicated, everything in the universe can be grasped;
When at leisure, the old and the new can be savored.

Shōkadō's ink paintings have long been highly regarded, especially by connoisseurs of the tea ceremony.[22] He is even more celebrated, however, as one of the three great calligraphers of the early Edo period, along with Nobutada and Hon'ami Kōetsu (1558–1637). His most familiar name comes from the *Shōkadō* (Pine Flower Hall) to which he retired in 1637, two years before his death. Although somewhat more eclectic in his painting and calligraphy style than Daitoku-ji abbots such as Takuan and Kōgetsu, Shōkadō joined with them in the creation of Zen paintings in which the expression of spiritual intensity was favored over elaborations of technical skill.

ISSHI BUNSHU (1608–1646)

Among Takuan's many monk and lay followers, his chief pupil was Isshi Bunshu. The scion of a noble family, Isshi became a page for the empress at the age of seven and began to study Buddhism when he was twelve. He became particularly interested in the lives of earlier Zen monks, studying the riddles (*kōan*) that they had meditated upon. One day he went to his elderly Zen teacher and offered him an answer to one of these *kōan*. The old monk accepted the answer but gave Isshi another question. Isshi told the monk that "the ancients said that if you can gain enlightenment by solving a single *kōan*, then everything is enlightened." However, since his one answer was not true enlightenment, Isshi left the temple for further study.

After meeting Takuan, Isshi showed him his "answer." Takuan laughed and said, "I don't like to trouble the monks by such words." Isshi thereupon decided to study with Takuan, soon becoming one of his most dedicated followers. Isshi first practiced under the master at Nanshū-ji in Sakai. When Takuan was exiled to the north, Isshi accompanied him but returned to Kyoto after one year.

In part because of his courtly background, Isshi was favored by several high-ranking nobles. One of these was Konoe Nobuhiro, the son of the Emperor Gomizuno-o, who had been adopted by Nobutada and thereupon risen to high court positions. Nobuhiro first met Isshi when the young monk was studying with Takuan at Nanshū-ji; the courtier later invited Isshi to his home to discuss Buddhism. Highly impressed by Isshi, Nobuhiro told Gomizuno-o, that he had never met so remarkable a monk. After being invited by the retired emperor to lecture at the palace, Isshi was asked to establish the temple Reigen-ji in Kyoto in 1638. When Takuan's exile was ended, Isshi traveled to Edo to continue his Zen practice with him, impressing everyone who met him. Years later, the shogun Tokugawa Iemitsu asked Takuan why he had never granted *inka* (a certificate of enlightenment) to Isshi in order to have a spiritual heir for his teachings. Takuan replied that his human feelings for his pupil were strong, but they could not overcome his decision never to give a certificate of enlightenment to any of his followers.

After a period of study in Edo, Isshi returned to the Kyoto area, but he did not feel comfortable with life in the city. Quietly leaving with a few of his pupils, Isshi retired to a mountain hut in Shiga, where he practiced meditation and wrote poetry. Aware that he had tuberculosis, he lived every moment to the full. One day, while passing a citron tree near his hut, he reached enlightenment. He wished to go to China to find a monk who could understand this satori, but due to government policy he could not leave Japan. He eventually journeyed to Myōshin-ji in Kyoto to meet the monk Gudō Toshoku, who questioned Isshi in detail, recognized his enlightenment, and wrote a Buddhist poem in his honor.[23] In the meantime, Isshi lived a sheltered life in the mountains, devoting himself to Zen.

Emperor Gomizuno-o, missing Isshi's company, sent the courtier Karasumaru Mitsuhiro to find him. According to one story, Mitsuhiro (wearing a disguise to avoid trouble with the ever-suspicious shogunate) was searching for Isshi in the villages of Shiga when he came across a young boy practicing calligraphy. The model he was copying was so elegant that Mitsuhiro knew it must be by Isshi. Questioning the youth, Mitsuhiro learned the boy's teacher was a monk in a nearby mountain hut and thus was able to locate Isshi in his seclusion. Following the monk's wishes, the emperor and a local daimyo built the temple Hōjō-ji in 1641 at the site of the mountain hut, and Isshi lived there briefly, perhaps in his life's greatest contentment. The temple, with its rustic thatch-roofed gate, is still one of the most beautifully situated and serenely peaceful oases in Japan (*plate 15*).

At Hōjō-ji, Isshi wrote a series of ten Chinese-style poems for the emperor in which he utilized images of nature to express the depth of his commitment to Zen; Gomizuno-ō responded with ten Japanese *waka*. Despite his distress that he was not fulfilling his obligation to instruct followers in Zen teachings, Isshi's quatrains reveal his contentment with life far from the cities:

15. ISSHI'S TEMPLE GATE

The fuel in the tea brazier is burnt out, so I collect pine needles,
The fields of medicinal plants are empty, so I cut vegetable roots.
I'm always afraid that guests will come to disturb this pleasure;[24]
When I hear the knocking "kotsu kotsu," I don't open the gate. (V)

Naturally dull, I've forgotten my Zen activities,
My gate is darkened at noon by the shade of ancient trees.
Sure that monks elsewhere are leading followers to enlightenment,
I can't prevent tears from moistening my hemp robe. (VIII)

White clouds impart a sense of peace to my Zen meditation,
Green grasses suffice to make a rug for my guests.
What I have collected is a hundred years of leisure—
When I meet people I'm too lazy even to raise an empty fist. (IX)

This peaceful life was not to last for long. Desiring Isshi's company, Gomizuno-o entreated him to return to Kyoto, first building him a temple in the north of that city and then asking him in 1643 to restore the important temple of Eigen-ji in the nearby mountains. Isshi, despite poor health, obeyed these requests, instructing not only monk pupils but several notables at court, including Karasumaru Mitsuhiro. Following the instructions of Isshi, the courtier meditated upon the *Mu kōan,* one of the most fundamental texts in Zen. A novice monk had asked the master Jōshū (Chinese: Chao-chou, c.778–897): "Does a dog have the Buddha-nature?" Despite the Buddhist belief that

all beings possess this nature, Jōshū answered, "*Mu*" ("Has not"). What did he mean? Monks have meditated on the nothingness of that *Mu* for hundreds of years, often considering this conundrum to be the most significant gateway to satori.

After a great deal of meditation, Mitsuhiro broke through the barriers of dualism, solved the *Mu kōan,* and attained enlightenment. It must have been a very joyous moment, and shortly thereafter he composed a poetic quatrain for Isshi as evidence of his satori. The answer to a *kōan* may be as perplexing as the question, but in this verse Mitsuhiro stressed both the difficulty and inner richness of *Mu,* writing that when it is understood, all thoughts and problems disappear. Isshi at first sent back the poem with further suggestions, but he accepted a second version and wrote it out for his courtier pupil as the *Inka for Mitsuhiro (plate 16):*

THROUGH TOTAL CONCENTRATION ON THE "MU" KŌAN
LORD MITSUHIRO HAS ENTERED ENLIGHTENMENT WITH THIS POEM

When he chews on "Mu," even his teeth disappear,
Biting on its suchness, there is an inexhaustible store.
A kōan *like "Buddha is Mind" is a million miles away*
Like the wind blowing on a horse's ear, or a painted plum fragrance.

The calligraphy of this poem, while strongly articulated, is more fluid and elegant than the typical blunt Daitoku-ji style. Although written in Chinese characters, it shows the influence of the Japanese *kana* tradition with its gracefully thickening lines, fluent curves, and extended verticals. When he came to the end of a column, Isshi occasionally added another word to the left, breaking the even rhythm of the composition. The character *Mu* [無] occurs as the third word of the third major column (from the right) and as the second character of the fifth column, each time flowing directly from the word above it and snaking down toward the word below. The combination of irregular surging rhythms and elegant brushstrokes gives this work its special flavor.

Isshi has long been recognized by connoisseurs as an excellent poet, writing with a combination of aristocratic sensibilities and Zen depth, as well as adding an affecting personal awareness of ill health and mortality. Isshi wrote many verses about nature and also composed poems in honor of monks, including Takuan and Ungo (see Chapter Two), and courtiers such as Mitsuhiro and Konoe Nobuhiro. In addition, Isshi brushed a few paintings; he is said to have learned this art from Shōkadō.[25]

Among Isshi's finest works are several portraits of Daruma, each with a different poem. One such example, *Daruma Meditating,* was rendered in Isshi's characteristic style of thin, modest curving gray lines *(plate 18).* This painting approaches the "one-stroke Daruma" tradition but has a few additional delicate lines showing a portion of the patriarch's face appearing from behind his robe. There is a great deal of empty space separating the figure from the calligraphy above him—and the brushwork from the edges of the scroll— giving the painting a quiet elegance that is a feature of Isshi's work.[26] In this case, the artist added a quatrain referring first to Daruma's meeting with Emperor Wu of the Liang dynasty and then to his nine years of meditation:

Ah! Just look at the thorns and briars covering the Emperor Wu;
Daruma returned to sit, facing an old wall.
He wasn't just obstinately maintaining a deep silence—
It all relies upon something that can't be fathomed.

This is truly a subtle work; the refined brushstrokes in both the painting and the calligraphy create a sense of repose, solitude, and spirituality. One may understand from this scroll why Isshi was so admired both in the Zen community and at court. The rigors of his intense life took a toll upon him, however. His health, which was never strong, began to fail in 1646. Hearing the news, Gomizuno-o sent a palanquin to transport Isshi to a hot springs, but Isshi died before he could be nursed back to health.

Isshi was given the posthumous name of Butchō Kokushi by Emperor Reigen. An interesting anecdote is attached to this name. Since Isshi was a handsome and well-born monk, he was very attractive to women, and it is said that he developed a very stern expression so as not to encourage any thoughts of romance. Since his time the Japanese phrase "*Butchō-zura*" ("Butchōface") has come to mean a fierce scowl. Isshi's more enduring legacy is his artistry in poetry, painting, and calligraphy, to each of which he gave a personal touch. His nobility of spirit shines forth clearly in his remaining works, which are especially appreciated by those who value grace, courage, and refinement.

SEIGAN SŌI (1588–1661)

Monk-artists centered at Daitoku-ji dominated the world of tea, painting, and calligraphy in Kyoto for the rest of the seventeenth century. Among the many abbots of the temple who were excellent calligraphers, Seigan Sōi represents the continued development of the Daitoku-ji style. This style became increasingly characterized by a preference for straight and angular strokes over continuous curves and the use of blunt brushwork with "flying white" (areas where the paper shows through the ink) in large-scale writing—an intriguing balance between disciplined simplicity and powerful expressionism.

Seigan was born in Ōishi, a village in the province of Ōmi (Shiga prefecture), not far from Kyoto. After moving to the old capital at the age of nine, he studied first with Gyokuho Shōsō, the 130th abbot of Daitoku-ji, and later with Ken'ya Sōryō, the 159th abbot. On the tenth day of the eleventh month of 1625, Seigan became the 170th abbot, by the order of Emperor Gomizuno-o, and third head of the famous subtemple Kōtō-in. Deeply committed to teaching both monks and laymen, Seigan eventually served as head of seven different subtemples of Daitoku-ji, working diligently to continue the restoration of the great monastery. He also founded more than ten temples and subtemples in other provinces, including Rinkō-an at Nanshū-ji (the temple in Sakai at which Takuan, Kōgetsu, and Isshi had served a few decades earlier).

Seigan was known for the breadth of his interests. He was not only a famous tea master, writing the *Saji jūroku jō* ("Sixteen Points of the Art of Tea"), but he also became close friends with people in many walks of life, including potters, aesthetes, and warriors. In 1649 Shogun Iemitsu asked Seigan, then more than sixty years old, to become second abbot of Tōkai-ji in Edo, a position that had remained vacant since the death of Takuan. Thus in many ways Seigan can be seen as a successor to Takuan, although he was not his direct pupil.

Jigoku (plate 17) is a depiction of the word meaning "hell." Seigan's calligraphy demonstrates the strength of the Daitoku-ji style; the characters are clearly written in regular script, but they have the force and power that hark back to the spirit—as well as the technique—of Ikkyū. Especially notable is the horizontal thrust of each character. The first word is composed of two equal

sections; the left side has been made more vertical than usual by the abrupt "open-tip" endings of the two horizontal strokes, where the brush was pulled rapidly away from the paper, leaving the rough edges of the strokes visible. The second of these strokes, however, continues by a fine brush-hair's width to the right side of the character, itself composed of three movements that extend and hook back, swing down, and then circle in a wide sweeping gesture that ends with a turn upward. The dynamic composition of this graphic shape, however, is surpassed by its neighbor to the left. This character, made up of three vertical sections, is even more creatively distorted by the artist. The first two elements on the left and center are squeezed close together so that the form on the right can expand outwards. These are then balanced by the rich fullness of the dot and the dramatic long diagonal, with its bold use of "flying white," of the final hooking stroke. Here is Daitoku-ji–style calligraphy at its most expressive. Seigan has stretched and extended the character shapes while leaving them perfectly clear and legible to even the most unsophisticated viewer.

The idea of hell may seem foreign to Zen, which abjures the punishments and rewards of a future life in favor of attaining awakening in one's immediate existence. The tortures of hell were used to frighten believers into good actions by advocates of Pure Land and other forms of Buddhism, but what was the concept of hell to a Zen master like Seigan? Although he may have written this calligraphy for a follower of another sect, it is more likely that he wanted one of his pupils to contemplate this very question. Was his own answer akin to that of the existentialist philosopher Jean-Paul Sartre, that hell was ultimately the state of being endlessly confined to the (unenlightened) self? Is hell what we confront in order to awaken to the Buddha-nature within?

Seigan died on the twenty-first day of the eleventh month of 1661, a month after he had been granted the Buddhist name Seijō Honnen Zenshi by Emperor Gosei. Seigan's death poem celebrates joyfulness rather than doctrine, hints at the secret of satori, and concludes with the Zen shout:[27]

Joy of living,
Living joy. . . .
Zen doctrine is null.
Before I die,
Here is the secret of my teaching—
My staff nods in agreement.
 Katsu!

Since Seigan's time, Daitoku-ji has remained a major Zen center, retaining its influence in such matters as the tea ceremony to the present day. It has produced many notable monks and abbots through the years, a number of whom have been outstanding calligraphers and, more rarely, painters. The close connections that Daitoku-ji abbots tried to establish with the leaders of society and government, however, did not enable them to reverse the decline of official support for Zen. Instead, the monastery became a bastion of cultural and intellectual conservatism during a period when Zen masters began to have more impact in the countryside than in major metropolitan centers. The efforts of such abbots as Takuan, Kōgetsu, and Seigan spurred the creation of an art that was direct, intuitive, and provocative. Zenga, however, was to be developed more freely by individualist monks during the succeeding decades of the seventeenth century.

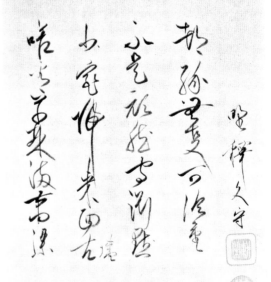

18. *Isshi (1608–1646)*
DARUMA MEDITATING
Ink on paper, 48³/₈ × 10³/₄"
Private Collection

17. *Seigan (1588–1661)*
JIGOKU
Ink on paper, 12 × 35¹/₂"
Private Collection
Cambridge, Massachusetts

THE EARLY EDO PERIOD: FŪGAI UNGO GESSHŪ AND BANKEI

In the midst of nothingness

There is a road that goes directly

to my true home.

Although the creation of Zenga in the Edo period began in the Kyoto area, four remarkable monks who spent most of their lives in the countryside made significant contributions to the history of Zen and Zen art. They lived in an age when monks had to respond to new conditions, including the imposition of strict government controls on temples, the enforced rigidity of feudal class structures, and the gradual demise of spiritual values in an increasingly mercantile culture. These individualists represent four different responses to the turbulent era in which they lived, four different attitudes towards the practice and teaching of Zen, and four different approaches to Zenga.

Fūgai Ekun renounced the traditional Buddhist path; he gave up temple life to live in a cave and painted intensely personal depictions of Zen masters of the past that he gave to local farmers in return for rice. By contrast, Ungo Kiyō reached out to a wider public. He revived Zen in northeastern Japan in part by introducing doctrines from other Buddhist sects, and he brushed calligraphy in easy-to-read, standard script. Gesshū Sōko worked for reform within the Sōtō sect by stressing the teachings of its patriarchs, and he encouraged his followers by writing basic Zen texts in powerful large-scale calligraphy. Bankei Yōtaku in his youth rejected the normal course of Zen training to find his own path to enlightenment; he eventually promulgated his concept of the "unborn" Buddha-nature within all beings, giving new life to the Rinzai sect while creating bold calligraphy and a few paintings that reveal his distinctive personality.

The four monks may be considered respectively a recluse, a revivalist, a reformer, and a rebel. They each had a different approach to art, ranging from personal to popular subjects and from traditional to visionary conceptions. In some ways their brushwork anticipated future directions in Edo-period art, such as the bold compositions and clearly defined sense of artistic personality seen in the works of such diverse masters as Taiga, Hokusai, and Hiroshige. What the four monks had in common, however, was a deep commitment to rejuvenating the fundamental Zen tenets of meditation and enlightenment and the ability to express their inner vision through painting and calligraphy. Their brushwork clearly conveys the strength of their religious experience.

FŪGAI EKUN (1568–1654): "OUTSIDE THE WIND"

The paintings of Fūgai Ekun, simply brushed with ink on paper, convey a depth of spirit that makes them unique even within the sphere of Zen art. His works are imbued with a haunting intensity; the eyes of the figures he depicts penetrate deep into the human spirit, providing a sense of direct communication with the artist. Yet Fūgai has not received the recognition that other Zen artists have been given, in large part because he lived far away from the major cultural centers, had no pupils, and founded no school.

Historically, Fūgai was the first important Zen monk-painter of the Sōtō sect, and in the eyes of a few connoisseurs he remains the greatest master of ink painting in the Sōtō lineage. Artistically, he represents a transition from earlier brushwork traditions to those of the Edo period, and his work presages many of the important features of later Zenga. Fūgai's style of painting was rooted in the past, especially his use of gray-wet brushstrokes with small accentuations in black. This style of figural depiction, known as "apparition" or "ghost" painting, was favored by Chinese Zen artists of the Sung dynasty as well as by early Japanese monk-painters.

Fūgai's choice of subject matter was also traditional. The Zen patriarch Daruma and the wandering monk Hotei were his favorite subjects, although

he occasionally attempted portrayals of other Zen masters as well as birds and plants and landscapes.[1] Fūgai's emphasis upon Zen figures, painted simply and without background detail, was part of a significant trend in Edo-period monk painting; exemplars of enlightenment were chosen because they were good models for those who wished to follow a Zen life. Fūgai also anticipated future directions in Zenga by inscribing his own poems on his paintings—a practice that was rare before his century—and by brushing informal self-portraits quite different from the elaborate *chinsō* (colorful and detailed depictions of monks) that had long served as Zen portraiture *(plate 37)*.

Fūgai's life was as individualistic as his artworks. He did not follow tradition by residing in temples, nor did he rise to a position of prominence in the Zen hierarchy. Instead he spent many years wandering, living at times in caves and eventually settling in a hut in a mountain village. His final years were spent in nomadic travel; he died almost literally "on the road." Details about Fūgai's life are incomplete and sketchy, in part because he has long been confused with two other Sōtō Zen monks who used the same name, which literally means "Outside the Wind."[2] Fūgai Ekun was born in the small village of Higishio, not far from the famous Tōkaidō Road that connected the new capital of Edo (Tokyo) with the old capital of Kyoto. Higishio was an agricultural village in the mountains of Kanagawa province, and Fūgai probably came from a farming family. At the unusually early age of four or five he entered the village temple, Kansō-ji, of the Shingon sect. After a few years, Fūgai moved to the larger temple Chōgen-ji, several valleys distant, where he formally joined the Sōtō Zen priesthood.

At about the age of sixteen Fūgai traveled to the leading Sōtō temple in eastern Japan, Sōrin-ji (in present-day Gumma prefecture), where he studied under Jizen Gen'etsu (d. 1589) and Ketsuzan Gensa (d. 1609). Since there is an early Daruma scroll in the Sōrin-ji collection that undoubtedly Fūgai was able to see, it is possible that he began to develop his interest in brushwork at this time. After more than a decade of Zen training, Fūgai left the Sōrin-ji, perhaps in 1596, to begin an extended period of journeys in search of further Zen experience, including the ritual challenge of questioning and being questioned by masters of different temples. This form of pilgrimage was common, but few monks maintained an unsettled way of life for as long as Fūgai; he traveled for more than twenty years. Although this period of his life is almost undocumented, one source suggests that Fūgai visited the noted Rinzai monk-painter Motsugai Jōhan (1546–1621) and his pupil Isen Shūryū (1565–1642).[3] Sojourns at Rinzai temples may well have stimulated Fūgai's interest in brushwork, since the Sōtō sect had little history of artistry.

In 1618, at the age of fifty, Fūgai accepted an invitation to become abbot of Jōgan-ji, a small Sōtō temple in Sagami province not far from Odawara Castle. He did not find this position to his liking, however, and after a few years he abandoned the temple to live in caves in the nearby mountains.[4] What made Fūgai decide to turn his back on the traditional Zen way of life and adopt such a primitive existence? Was he influenced by tales of eccentric Chinese monks and Taoist recluses of the past? Was he unhappy at the increasing materialism of Japanese culture or suspicious of the new shogunal government, which did not hesitate to intervene in religious matters? While there were often social and political pressures weighing upon abbots of major monasteries in urban settings, at Jōgan-ji Fūgai would certainly have been able to administer his small country temple without much outside interference. Perhaps the position was not stimulating enough; more probably, Fūgai needed to live completely on his own in order to achieve his Zen goals.

Judging from the fierce and lonely spirit he displayed in his paintings and poetry, he was ready for greater challenges than temple life offered.

Whatever his reasons may have been, Fūgai left Jōgan-ji; with only a single bowl and his monk's robe, he moved to the nearby mountains. At first he lived in a double-cave (plate 20) that had been a prehistoric burial site. Nestled low in the foothills of the mountains near the small village of Tajima, this cave still exists within a copse of trees and bushes. After a year or two, Fūgai moved to another small cave in the Kamisoga mountains, which is now almost forgotten in a grove of tangerine trees halfway up a mountainside; in Fūgai's day the mountain was covered by trees and brush. He may have chosen the cave because its opening faces south to a clear view of Mount Fuji.

By living in a cave Fūgai emulated Daruma, who is supposed to have meditated in front of a wall for nine years. Referring to his senses, which would only delude him, Fūgai wrote that he kept "his windows deeply shut." What food he could not gather himself he obtained from local villagers. It is said that when he needed rice he would brush an ink painting of Daruma and hang it outside his cave.[5] Anyone who wished could then leave rice and take the painting home. These works were venerated by local farmers and wood-gatherers as expressions of Fūgai's extraordinary personality; many of his paintings still remain in local village houses, darkened by smoke from incense and cooking fires.

While living this simple and primitive existence, Fūgai seems to have reached a state of empathy with nature comparable to that of the "immortals" of Chinese Taoism.[6] He wrote in his poems that "after surveying the world, it is difficult to leave this valley," and "even when fire threatens, I will not move from my mountain home; Wind stirs the peaceful locust tree, underneath it I dream." In another quatrain, Fūgai wrote that he was distracted from his Zen practice only by visitors:

This old monk meditates and rests in the empty mountains
In loneliness and stillness through the days and nights.
When I leave the pure cliffs, I am distracted by callers—
The world of men is first and always the world of men.

It is difficult to establish a chronology of Fūgai's art because so few of his works are dated; one painting remains, however, that must have been done either while he was still at Jōgan-ji or shortly thereafter, during his early years of cave dwelling. The intensity that is the hallmark of his brushwork can be seen in this small portrait of Daruma (plate 19). Four thick gray strokes, the upper two reinforced with black, define the patriarch's hood and robe. Within the cell created by these broad strokes, thinner gray lines depict Daruma's forehead, eyes, nose, and cheeks, while scratchy gray brushwork suggests his thick eyebrows, mustache, and beard. Black accents bring the Zen master to life, accentuating his tilting eyelids, bold, staring eyes, wide nostrils, and frowning mouth. These few brushstrokes are all Fūgai needed to create a personalized image of remarkable power. The painting is also unusual in that some drops of gray ink were spattered upon the paper. Although accidental, two of the gray dots have fallen into the patriarch's beard and one into his eye, adding a distinctive and slightly humorous touch to the work. In Fūgai's painting, Daruma is portrayed as a human being, not an icon, and yet the patriarch's spiritual strength is clearly conveyed.

The painting bears a poetic inscription by Nisshin Sōeki (also known as Sōeki Gashō; 1557–1620), whose death date allows us to establish the portrait

19. Fūgai (1568–1654)
DARUMA
Ink on paper, 8¹/₂ × 7⁵/₈″
Private Collection

架鄂然箭射聖諦
廓鳥若不端的
所賺胡僧

嘯松後拜書于
菴栗二玉

20. FŪGAI'S CAVE

as Fūgai's earliest known work. A monk from Kanagawa, Sōeki became the 162nd abbot of Daitoku-ji in Kyoto; late in his life he retired to his homeland, where he lived in the Ten'yū-an subtemple of Sōun-ji, not far from Fūgai's temple and caves. Sōeki's inscription, in small, sharply defined regular script, is composed within a shape that creates an upside-down mirror image of the form of Daruma, while his signature extends down to the lower left. The poetic quatrain suggests the total concentration needed to achieve enlightenment:

Notch the arrow of emptiness
To shoot the hawk of ultimate meaning;
If you're not right on target,
You will be deceived by this barbarian monk.

Fūgai's solitary life, centered in meditation, further refined the Zen spirit transmitted so clearly in his brushwork. He brushed a number of self-portraits, which usually show him leaning on a staff and looking very much like Daruma, an indication of Fūgai's sense of identification with the patriarch. In one such work, *Self-Illumination (plate 21)*, Fūgai utilized his favored combination of broad gray outlines for the robe, thinner gray lines for the head and face, and black accents for drawing attention to the mouth, nose, and especially to the eyes. By the placement of these accents, the monk created an individualized self-portrait unlike any that had come before. His expression is a mixture of ferocity and sadness. He is inward-looking, wise, and lonely, as though he had taken all of life's burdens upon himself. The broad lines of his robe seem to encircle his face, emphasizing the sense of his spirituality.

The calligraphy in Fūgai's unique curvilinear style adds greatly to the total artistic effect. The composition of the title, poem, and signature both hovers over and balances the figure. The calligraphy's rhythmically fluctuating thin lines contrast with its thicker brushstrokes and gray ink tones, just as in the painting. Occasional strong diagonals point down to the left and to the right, until the final swing of the brush leads directly to the figure. Fūgai's poem offers us an additional insight into his character:

Yearning for friends in my rocky cave, I am captivated by the singing of small birds;
The wind entering deep into the grotto mingles with the voice of the stream.
Awakening from a dream, this hermit exists beyond the world—
A quiet life, off by myself, fulfills my spirit.

If this work did not bear the title of "Self-Illumination," we might wonder whether it was meant to portray Fūgai or Daruma; here, the two become one.[7]

Although there is little specific information about Fūgai during his cave years, one anecdote relates that a respected monk from Edo named Bundō visited Fūgai.[8] Seated high on a cliff, the two engaged in conversation all morning until it was time for a midday meal. They then descended to a hearth where Fūgai cooked some rice. There was only one bowl, so Fūgai served his guest's food in a dried animal skull. This was shocking to Bundō; he exclaimed that the skull was unclean and he would not eat from it. Fūgai chided him, at which point Bundō left without another word and never visited again. The idea of Fūgai serving rice in an old dried skull is a clue to his independent spirit in keeping with the depth of expression revealed in his self-portrait.

Fūgai's life was extremely spartan. Both of his caves are just large enough to stand upright in; the cave in the Kamisoga mountains has a raised rock floor

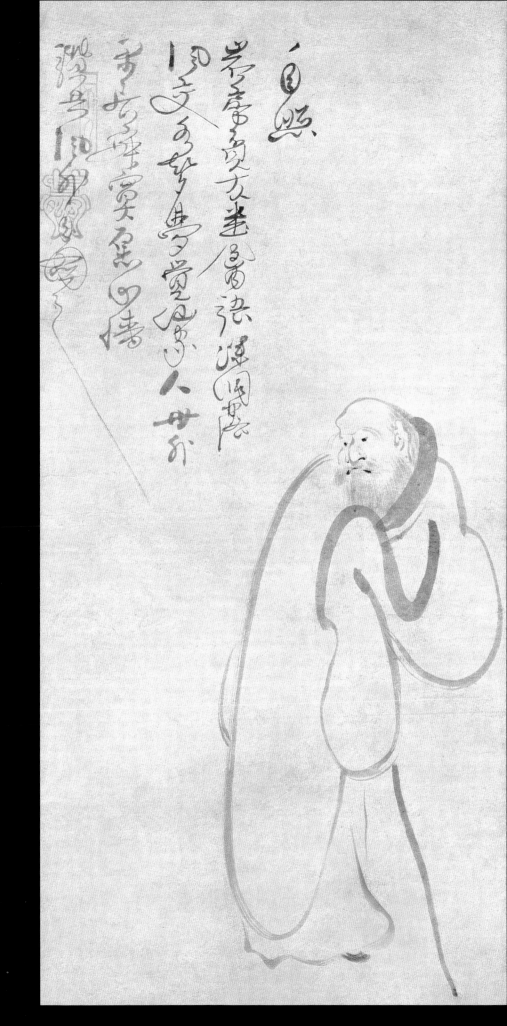

21. Fūgai (1568–1654)

SELF-ILLUMINATION

Ink on paper, 22⁵/₈ × 10³/₄"

Private Collection

where he might have slept. This life-style lasted for less than a decade. The story of an eccentric Zen monk living in a cave gradually spread through the region; when Fūgai left the mountains in 1628, it was probably to avoid the interruptions, no matter how respectful, of visitors. Shortly after he moved away from the area, a group of local farmers installed three stones engraved with inscriptions honoring Fūgai and his parents in the Kamisoga cave. As far as we know, he never returned there.

Fūgai spent the next twenty-two years of his life in the mountain village of Manazuru, about fifteen miles south of Odawara. This was a poor community even by the standards of the time; most of the people earned their living by fishing or by quarrying rock. At first Fūgai may have lived in a cave or small hut, but he soon became friendly with the village headman, Gomi Iyemon, who built a simple cottage for the monk next to the local Tenshin shrine in 1630. This was to be Fūgai's home for the following two decades. His friends were the village children, with whom he would play and for whom he would paint. According to a well-known anecdote, one day when it began to rain, Fūgai picked up a large, flat rock and held it over his head like an umbrella. He then walked through the streets, to the children's joy and the villagers' amazement. A folk song originated in Manazuru about this incident:

Ame konkon futte kita	*The rain has started to fall* konkon—
Tenshindō no bōsan ni	*Let's take a straw raincoat and hat*
minokasa motte yukō	*To the monk of Tenshindō.*

With his penchant for wandering, playing with children, and refusing official positions in the Buddhist hierarchy, Fūgai resembled Hotei, the semi-legendary monk and "god of good fortune." Identified as the Chinese monk Ch'i-tzu from Chekiang, Hotei (Chinese: Pu-tai) died in the early tenth century. After his demise he is said to have reappeared walking through the area, a famous nonattached being who predicted the weather, slept out in the snow but was never covered with flakes, ate meat, and drank wine. Carrying his huge bag (*Hotei* means both "cloth bag" and "round belly"), a staff, and a fan, he became celebrated as the god of merchants (who believed that the bag was full of goods) and children (whom he preferred to adults). He was considered an incarnation of Maitreya, the Buddha of the future, and was often depicted in paintings and sculpture.[9] In Japan Hotei became a special favorite of Zen artists, ranking next to Daruma as a traditional subject.

Fūgai depicted Hotei in a number of different guises. Often the roly-poly monk is shown wearing a happy smile, but in *Hotei Wading a Stream* he walks through the water with a sad expression on his face *(plate 22)*. The image reminds us that Zen does not ignore happy or unhappy feelings but clings to neither one. Gray ink tones have been reinforced with black, blurring effectively on the robe, while the round shape of Hotei's head is echoed by the bag, the fan, and particularly his round belly. From these circles, ripples of energy spread out in vibrant pools, enlivening not only the figure but also the empty space around him. Although there is no poetic inscription, the two twisting lines representing the ties of his robe echo the calligraphy of Fūgai's signature. Touches of black ink dramatize Hotei's face, particularly his eyes, which are widely spaced, slightly tilted, and wondrously sad. In works like this Fūgai transcended most painting of his time by giving a sense of personality to his subject.

In Fūgai's *Hotei Pointing to the Moon (plate 23)* we see an image that in Zen teachings carries the admonitions not to mistake the pointing finger for the

moon itself and to understand that moonlight is only a reflection, just as our minds are reflections of thoughts, actions, and feelings. When, like a mirror, we freely accept and release these reflections, the moon becomes a symbol of life's treasures, which are actions and appreciations rather than possessions.

Fūgai himself was a master of the "three treasures" of the scholar and the educated monk: painting, poetry, and calligraphy. Each is an important art in itself, and combined they produce more than the sum of their parts. In *Hotei Pointing to the Moon* Fūgai has adroitly arranged image and empty space and employed calligraphy that echoes the brushstrokes of the painting. Not only does the sweeping flourish of the bag-string cross the scroll horizontally, but the rhythm of Hotei's pointing finger and the roundness of his sack are repeated in the verticals and curves of the inscription.

These linear relationships within Fūgai's works demonstrate that the most meaningful Zen paintings go beyond free brushwork; they encompass the formal traditions of an art that relies on composition, brushwork, and ink tones. The intensity of Fūgai's paintings ultimately derives from his inner experience, but it is expressed through line, shape, and tone, each of which can be analyzed and appreciated for its artistic merits. Fūgai not only had his depth of experience to communicate but also a full command of the brush with which to express his Zen spirit. Here, the soft, thick gray brushstrokes that suggest Hotei's robes curve in a reverse "S" shape but are divided by the contrasting long, incisive strokes that define and surround the emptiness of his bag. We can sense the balance and weight of the figure even as he points to the sky. By creating points of emphasis over the gray ink with the slightest touches of black, Fūgai has evoked an enlightened state of being. His poem emphasizes how Hotei exemplifies the joys of nonattachment:

His life is not poor,
He has riches beyond measure.
Pointing to the moon, gazing at the moon,
This old guest follows the way.

Needing no home, appreciating each moment, the legendary figure travels through life with a smile. Is this how Fūgai himself lived? In three other poems that he inscribed on paintings of Hotei, Fūgai further demonstrated his intuitive understanding of this unique wandering monk:

What moon is white, and wind high?
His life is just this chant of meditation.

—

How can he smile so happily?
Do not compare him with others;
His worldliness is not worldly,
His joy comes from his own nature.

—

Who in the world can discuss him,
With his oversize body full of good luck.
How laughable—this old guest
Is the only one traveling the road.[10]

Hotei travels alone; perhaps because no one else understands his joy. He smiles; it may be at his own laughable self. Fūgai's paintings and poems suggest the paradoxical nature of enlightenment.

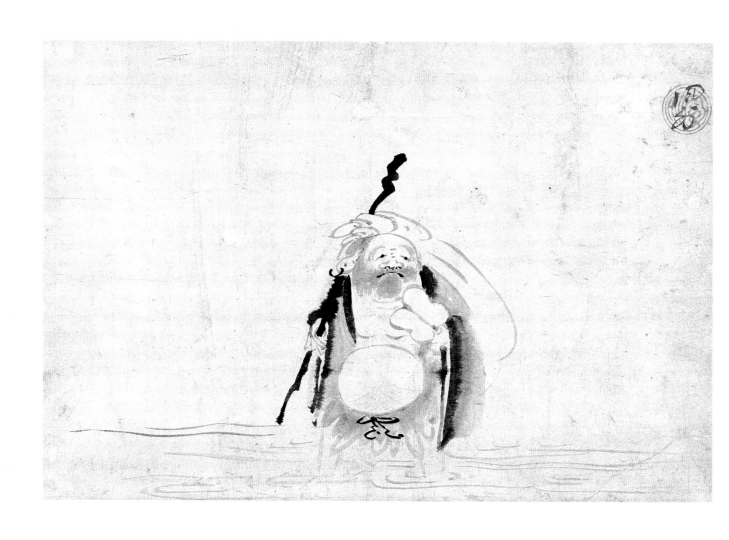

22. *Fūgai (1568–1654)*
HOTEI WADING A STREAM
Ink on paper, 12¹/₄ × 18⁵/₈″
Private Collection

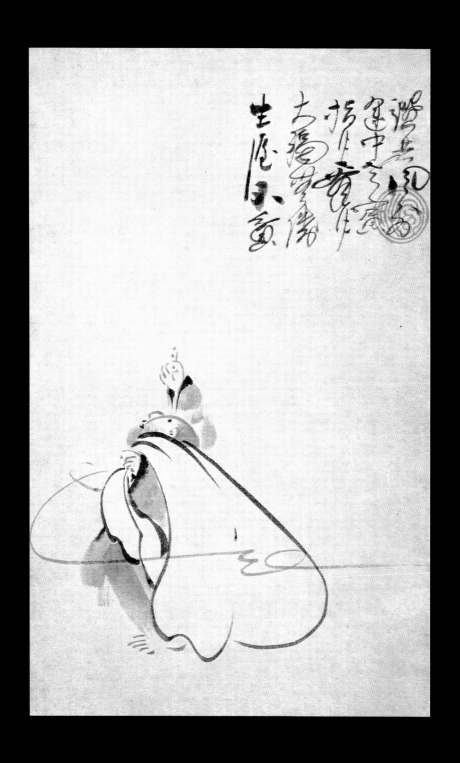

23. *Fūgai (1568–1654)*

HOTEI POINTING TO THE MOON

Ink on paper, 9¹/₂ × 15⁵/₈″

Murray Smith Collection

24. Fūgai (1568–1654)
SCULPTURES OF FŪGAI'S PARENTS
Stone
Kōfuku-ji, Tokyo

As well as representations of Hotei, Fūgai continued painting portraits of the first patriarch. These follow tradition: in *Daruma Meditating (plate 26)* the patriarch's head is bald and lumpy, his ears are long, and his hands are clenched beneath his robe. This garment is depicted by strong dark lines with "flying white," where the paper shows through the rapid, dry brushstrokes. These create a bold contrast to the gray curving lines of varying width, enlivened by black accents, that describe Daruma's forehead, nose, cheek, and ear. It is the eyes, however, focused intently to one side, that seem to stare deeply into us and will not let go.

What was Fūgai's intent in producing such fierce images? What did he wish to communicate through his brushwork? In poetic inscriptions on Daruma paintings, Fūgai emphasized the remarkable inner vision of the first patriarch:

This old barbarian sat face to the wall,
Everyone in the Zen tradition is left confused.
One thousand years, ten thousand years —
Will anyone ever understand?
—
This wall-gazing old barbarian monk
Has eyes that exceed the glow of the evening lamp;
His silence has never been challenged —
His living dharma extends to the present day.

In his poems as in his paintings, Fūgai concretely expressed the understanding that Daruma achieved enlightenment by total concentration of his spirit. In another quatrain, Fūgai compared the intense meditation of the patriarch to the ferocity of a hawk:

High in the void, a hawk dances in the empty wind;
Sparrows cannot rely on the hedge for protection —
The hawk swoops down like a stone
And frightens every being throughout the land.

The image of Daruma in Fūgai's poems is as fierce as in his paintings. The patriarch is frightening and dangerous; the only way to understand him is to match his spiritual concentration. Fūgai did not teach pupils in the usual Zen style; but by living in a manner similar to that of the patriarch, he could communicate through his art the intensity needed to reach enlightenment.

Remarkable as his achievements were in brushwork, Fūgai was not limited to calligraphy and painting. His other artistic accomplishments included carving his own seals from cherrywood; these bear legends such as *Fūgai* and *Fujin* (No Person). While in Manazuru he also sculpted bold portraits of his parents out of rock *(plate 24)*.[11] Just as his brushwork emphasizes the nature of ink and paper, Fūgai's sculptures convey a sense of the rock from which they were carved. He retained the round boulderlike forms of the stones, which evoke a feeling of massive strength and endurance. Furthermore, since many people in Manazuru made a living by quarrying rock, the images also increased the bond of solidarity between Fūgai and the townsfolk. A folk superstition developed that if a child had whooping cough, prayers to the stone images of Fūgai's parents would help to cure the disease. This belief continued even after the sculptures were removed from Manazuru by the daimyo of Odawara, Inaba Masanori (1623–1696), and taken to a temple in Edo.

Although Manazuru was a poor mountain village, its scenic beauty occasionally attracted visitors. In 1643 one of Japan's most important feudal lords, Mito Yorifusa, visited Manazuru and stopped for lunch at the Gomi home. Fūgai was present at this occasion and wrote a formal account of the visit, noting that Yorifusa chanted poems and made a flower arrangement for his host.[12] As the most educated person in the area, Fūgai was called upon several times thereafter to compose texts, probably at the behest of his friend Gomi. In 1645 Fūgai wrote the *Iwaya engi* ("A History of Iwaya") for the local Kibune (Shinto) shrine, and in 1650 at the age of eighty-two he wrote out two more texts in hand-scroll form. The first was the *Kibune Dai-myōjin engi* (History of the Grand Deity of Kibune) and the second was a list of the names of donors to the shrine. Fūgai also brushed a set of twelve panels of large calligraphy, probably for the local temple, Ryūmon-ji, where they now remain. These convey proverbial phrases such as "Always leave a few grains of rice for the rat; for the sake of the moth don't burn the lamp," and "When the road is long, we learn the strength of the horse; as years pass, we understand the human heart." Fūgai also wrote out the chant "*Namu Amida Butsu*" several times for devotees of Pure Land Buddhism. Despite his reclusive tendencies, it is clear that he was kind and helpful to the villagers of Manazuru, and his firm commitment to Zen did not prevent him from encouraging other Buddhist or Shinto religious beliefs. He also brushed a few secular texts from time to time. One calligraphy states that "one thousand barrels of refined wine do not equal a cup of thick sake," suggesting that Fūgai may well have been fond of the older form of rice wine, which was not strained and purified.

In 1648 Gomi built a shrine called Temangu for Fūgai next to his rustic cottage. Fūgai thereupon erected a stone death stupa and inscribed it with a poem about himself:

Leaves fluttering before the wind—
How to convey their splendor?
I know this stone pagoda with my entire body,
And laugh at the changes of earthly life.

This poem is difficult to translate and interpret, but it expresses Fūgai's understanding of life's transitions, which are both beautiful and laughable when seen from the perspective of nonattachment.

One of the most famous stories about Fūgai, often repeated but unverified, concerns a visit to Manazuru by the daimyo Inaba Masanori and the young monk Tetsugyū (1628–1700). It is known that Masanori came to Manazuru in 1645 and twice in 1648; if the visit with Tetsugyū actually took place, it was probably in 1650. At this time Masanori was twenty-seven years old, Tetsugyū twenty-two, and Fūgai eighty-two. According to the story, Tetsugyū questioned Fūgai about the Zen life. Fūgai replied, "Becoming a monk is easy; becoming a monk is hard," a cryptic way of saying that entering the priesthood may be easy, but truly living a spiritual life is very difficult.

Tetsugyū was supposed to have been inspired by this statement, and after Fūgai's death he had a notable career as one of the leading Japanese monks of the Chinese-derived Obaku sect (see Chapter Three). During his many travels, Tetsugyū maintained his connections in the Odawara area, consulting with Inaba Masanori at Odawara Castle in 1660 and visiting the Gomi family in Manazuru in 1667. In 1669 Masanori invited Tetsugyū to become the first abbot of Shōtai-ji, a temple built in Odawara, and Tetsugyū later also opened Kōfuku-ji in Edo for Masanori. It was at Kōfuku-ji that Fūgai's stone portraits

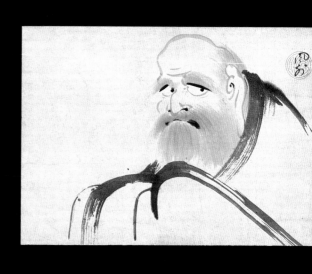

梁江水不将淺
芒鞋泊游船
一葦見様玄
遠伝之三尊子
丁未竹林六
臨濟正宗三尊玄画様
賣薬鐵牛様

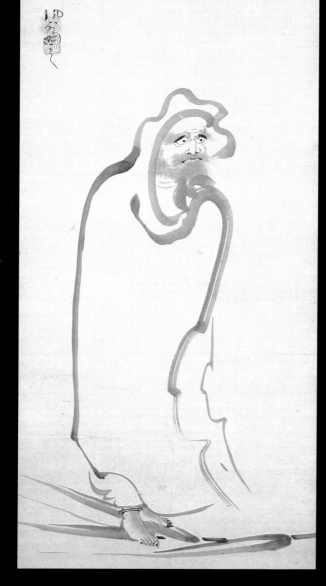

25. Fūgai (1568–1654)
DARUMA MEDITATING
Ink on paper, 10¹/₄ × 14¹/₈"
L. Wright Collection

of his parents were maintained in a special shrine. Thus, whether or not Fūgai and Tetsugyū ever actually met, their lives were intertwined.

One of Fūgai's largest and most important extant scrolls, *Daruma Crossing the River (plate 25)*, bears an inscription by Tetsugyū dated to the winter of 1667, which by the Japanese calendar was the one hundredth anniversary of Fūgai's birth. Tetsugyū's fluent running script shows the influence of the late Ming dynasty calligraphic style, which had been brought to Japan by Chinese Obaku monks:

The water in the Liang River becomes shallow,
There is no place to moor a large boat.
Watch him go by on a single reed—
His legacy continues to increase and increase.

Fūgai's paintings, which were given away to villagers and children, are usually small in size and often exist today in a poor state of preservation. *Daruma Crossing the River* provides an unusual example of a large work by the artist in excellent condition. The subject is traditional: with his robe extending to form a hood over his head, Daruma crosses a river on a reed. As a rule, Zen has had little use for miraculous deeds, stressing instead the enlightenment of the everyday world. In this case, the Chinese character that had once meant both "reed boat" and "reed" lost its first meaning over the course of time. This inspired the idea that Daruma had crossed on a reed rather than in a reed boat, giving rise to the legend here depicted.[13]

Fūgai always painted Daruma staring intensely, but these portraits have subtle differences. Here the two lines of the neck echo those of the forehead, while the heavier gray lines under the chin resemble the Chinese character for "mind" or "heart." These lines create a frame for the face, which is rendered in pale gray ink dramatized by Fūgai's uniquely expressive dashes of black. The body of the patriarch, by contrast, is merely the empty paper surrounded by thick, sweeping lines. Daruma's hairy feet add a touch of the earthy Zen humor that is often seen in the art of Edo-period monks.

Fūgai's last years were spent away from Manazuru. Masanori was fascinated by the reclusive Zen master, whom he twice invited to live at Odawara Castle; in 1651 Masanori extended a request that the old monk was unable to refuse. Moving from his life of "one cup and one robe" in a village hut to the splendors of a daimyo's mansion, Fūgai soon realized that Masanori lived a dissolute life. In the Muromachi period, when Zen was so closely allied with the elite, a monk might have remained in the castle, but in the seventeenth century Fūgai had no reservations about following his own path. One night after a lavish banquet attended by several concubines of the daimyo, Fūgai wrote a poem on a blank screen and left the castle. In this quatrain he made it clear that Masanori was not ready for the direct transmission of Zen:[14]

You govern an entire province—
I merely exist beyond the wind ["fū-gai"].
You were not a proper host for this unexpected guest;
Expedient teachings, not ultimate truth, are right for you.

In order to avoid the daimyo, and perhaps fearing that Masanori's wrath might fall upon his friends in Manazuru, Fūgai did not return to the village but wandered into the mountains of Izu province. According to legend, Masanori soon realized his mistake and hastened to Manazuru in order to ask

26. Fūgai (1568–1654)
DARUMA CROSSING THE RIVER
Ink on paper, 50¹/₈ × 18³/₄"
Spencer Museum of Art
Lawrence, Kansas

Fūgai to return, only to find him gone. Fūgai stayed at Chikukei-in, a small temple in the town of Baragi in Izu, for the next two or three years. His death, like his life, was unique. As related in one of the earliest accounts about him, he walked into the countryside near Ishioka on the shores of Lake Hamana. Coming across some village workers, he paid them to dig a deep hole. When they were finished, he examined it and said he wished to be buried there. He climbed into the hole and died standing up, at the age of eighty-six.[15]

Fūgai chose to live a solitary life. Unlike most notable monks, he did not accept Zen students, did not lecture on Zen texts, and had no spiritual heir. Although he must have had a remarkably deep grasp of Zen, his only teachings are found in his poetry, calligraphy, and paintings. These works, revered for generations in local homes in the Sagami and Manazuru areas, have only slowly come to public attention, but they are now highly admired by connoisseurs of Zenga. It is the intensity of vision conveyed in his brushwork that has become Fūgai's legacy to the world.

UNGO KIYŌ (1582–1659)

The life of Ungo, one of the most prominent Rinzai monk-artists of his time, represents how the unsettled and warlike atmosphere of the early Edo period affected the fates not only of samurai and daimyo but also those of Buddhist priests. Ungo's family served Ichijō Kanesada (1543–1585), the leader of the Tosa Ichijō domain, who led an adventurous and ultimately tragic existence. Due to the influence of his wife's father, Kanesada became a Christian and was baptized "Don Paulo" in 1575.[16] In a fruitless effort to defend his family lands against a rival clan, he refused to retreat in battle and was seriously wounded. Ungo's father, Kohama Sakyō, although his wife was pregnant, immediately sent her to nurse Kanesada. She had traveled as far as the Bishamon Hall in the village of Miya, in Iyo on the island of Kyushu, when Ungo (then named Soyō) was born. As soon as she and the baby could travel, she journeyed on to care for Kanesada, but he never fully recovered from his wounds and died three years later.

When Ungo was nine, his father feared that the victorious daimyo might persecute the Kohama family because it had served Kanesada, so Ungo was sent to the Shingon-sect temple Taihei-ji in Nakamura to study with the monk Shiseidō. Ungo's father died shortly thereafter, and Ungo formally entered the Buddhist priesthood at Taihei-ji at the age of fifteen. Shiseidō himself, however, was not immune to the violent politics of the day; he was a member of a samurai family serving a daimyo who had surrendered to Toyotomi Hideyoshi when Shiseidō was a young man. Soon after the surrender, the daimyo's son had died. Deeply disturbed, the feudal lord ordered many of his followers, including Shiseidō's family, to commit ritual *seppuku*. Seven of Shiseidō's relatives followed these orders, but Shiseidō, after writing a death poem, was allowed to live and become a monk. Nevertheless, his connection to the daimyo remained a cause for concern, and in 1597 he decided to leave Kyushu. Taking the young Ungo with him, Shiseidō went to Kyoto and entered Eimyō-in, part of the Rinzai temple complex of Tōfuku-ji. Shiseidō went on to have a distinguished career as a monk at Daitoku-ji, becoming the second abbot of its famous subtemple Kōtō-in. Ungo, however, moved to Myōshin-ji in 1600, where he studied at the subtemple Kentō-in with Itchū Tōmoku, a younger cousin of Toyotomi Hideyori.

Although peace was established in Japan in 1600, the early years of the seventeenth century were fraught with political upheavals and conspiracies. In

particular, the forces still loyal to the family of Toyotomi Hideyoshi plotted to depose the Tokugawa shogunate. A young samurai named Bandan Naoyuki, who favored the Toyotomi forces, came to Myōshin-ji for secret meetings during the time Ungo was in training. Admiring Ungo's dedication, Bandan became friends with the young monk, who knew few other people in Kyoto because he devoted himself to his studies. As part of his Zen practice, Ungo spent some time making pilgrimages, often with other young monks.[17] On a pilgrimage journey to Shizuoka, Ungo was surprised to meet Bandan, who had been sent out from Kyoto by the daimyo Katō Yoshiaki as a messenger to other feudal lords allied with the Toyotomi. Hiding in a temple from rival Tokugawa forces, Bandan was delighted to see Ungo again, and making a temple offering, he promised to be Ungo's protector in the future. At this time Bandan also gave his helmet and armor to Ungo for safekeeping, probably so that the samurai conspirator could travel incognito.

After returning to Myōshin-ji, Ungo completed a total of seven years of study with Itchū and received his *inka* in 1614 at the age of thirty-three. His adventures, however, were far from over. The following year, the decisive Osaka Summer Battle took place, in which Tokugawa Ieyasu defeated the last of his major enemies. Ungo learned that Bandan was among the warriors besieged in Osaka Castle by Tokugawa forces, so the monk immediately put on his friend's helmet and armor and traveled to the castle. One of the Tokugawa samurai named Inaba spotted the fine quality of Ungo's armor and thought he had encountered a high-ranking warrior of the opposing forces. Inaba challenged Ungo to a duel and instantly defeated him; Ungo's helmet came flying off, and to his amazement Inaba saw the shaved pate of a monk. When Ungo explained that the situation had developed from his deep friendship for Bandan, he won Inaba's sympathy; loyalty was a cardinal virtue for samurai. Taking the armor, Inaba hired a boat for Ungo and sent him to a nearby temple for safety from the ever-suspicious shogunal government. The shogunate, however, heard about this episode, and Ungo was summoned to Kyoto for a cross-examination.[18] The young monk spoke freely about his friendship. Since his good intentions were apparent, he was allowed to return to Myōshin-ji. The abbot there, however, was worried about possible reprisals and sent him away to the mansion of a friendly patron in Fukuda. When a monk at Myōshin-ji died soon thereafter, it was Ungo's death that was reported to the authorities; Ungo's earlier name of Soyō was changed to Kiyō, and the Buddhist name of Ungo was given to him at this time.

After a short stay at Kōjō-ji in Wakasa (Fukui prefecture), Ungo was able to open the temple Hōju-ji for Katō Yoshiaki, who had been the friend of Bandan Naoyuki. Ungo stayed in Hōju-ji in Matsuyama for some years; when the Katō family was ordered to move to the northern province of Aizu by the government, possibly because of suspicions regarding its loyalty, Ungo also moved and entered Kōsei-in. His monk friend Daigu Sōchiku visited in 1627 and gave Ungo some criticism that he seems to have taken to heart. Daigu told him to concentrate upon Buddhism and not to spend so much time on Confucian lectures, *waka* poems, and verses in Chinese style. This was not a new criticism in Zen history; reformers often decried excessive interest in poetry as harmful to Zen practice. Perhaps as a result of Daigu's advice, three years later Ungo left the protection of the Katō family and again went on pilgrimage.

During the following years Ungo twice visited Isshi Bunshu, one of the pioneers of Zenga. They discussed many matters, including the difficult position of Zen in the new age and the lowering of standards for monks. Isshi

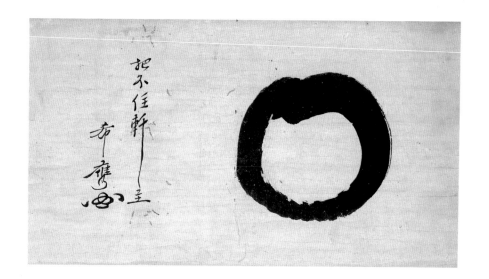

27. Ungo (1582–1659)
ENSŌ
Ink on paper, 10⁵/₈ × 19¹/₄"
Private Collection

wrote a poem in praise of his guest;[19] he felt that Ungo's sincere practice offered a positive model to the "black forest" (a poetic term for monks in traditional black robes):

For a long time I've heard that his virtue influences the black forest;
Ah! How can I repay his twice having come from afar?
We talked at length about the decline of Zen—
In the shadows of the guttering lamp, both our hearts grieved.

Ungo continued to travel through Japan, partly to visit other monks but also to experience the rugged beauties of nature. Throughout his life he seems to have been particularly drawn to mountains. He climbed various peaks, including Mount Fuji, and the temples where he settled were almost always located high in the mountains; furthermore, his deepest enlightenment took place on a mountain peak. In 1632 Ungo climbed Mount Ochi in Fukui, famous for its heavy snow, for a solitary meditation session. He determined to practice *zazen* (strict meditation) intensively for seven days. A monk of the temple Ōtan-ji, which was at the foot of the mountain, gave him a box of boiled beans, but after six days the meager amount of food was gone. Ignoring his hunger and forgetting all else but his meditation, Ungo reached enlightenment on the seventh morning. As he had no teacher to witness his satori, Ungo wrote a poem on a piece of paper and let it float down to the valley beneath him. Twelve years later, when again traveling through the area, he discovered that this piece of paper had somehow been discovered and preserved; Ungo took this as a sign that his enlightenment had been genuine.

Ungo also spent some time at the Shingon-sect temple Shōbi-ji. Although Buddhism tolerates various sects, this visit was unusual for a Zen monk. Ungo, however, had originally entered a Shingon Buddhist temple, and he retained some interest in studying the esoteric incantations and exorcisms of Shingon. He occasionally used these in his later life when responding to requests to pray for rain, disperse evil spirits, and exorcise illnesses.

The feudal lord of Sendai, Date Masamune (1567–1636), who in some ways was a throwback to the military leaders of the previous epoch, was a strong advocate of Zen. He decided to convert the main temple at the celebrated beauty spot of Matsushima from the Tendai sect of Buddhism to Zen, renaming it Zuigan-ji in 1609. He then searched for an outstanding master to become its abbot. He first invited Gudō Tōshoku, who refused, and so he decided that Ungo was the monk who could bring Zuigan-ji to prominence.

28. Ungo (1582–1659)
DARUMA HAS ALWAYS BEEN KANNON
Ink on paper, 13³/₄ × 4⁵/₈"
Private Collection

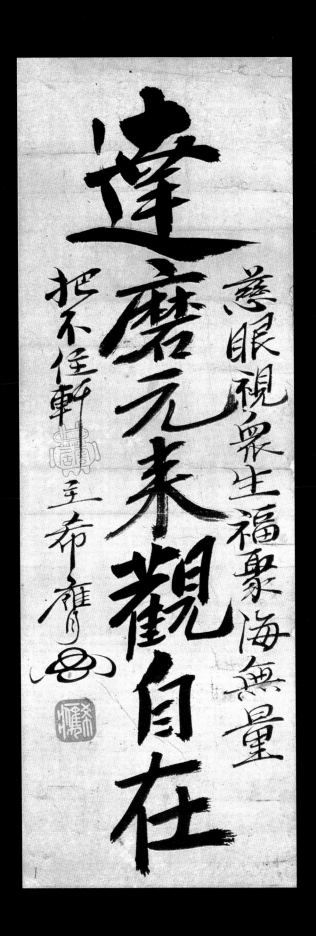

達磨元来觀自在

慈眼視衆生福聚海無量

把不住軒主希齋

Ungo declined this position several times, but after Masamune's death he was again invited by the new daimyo, Masamune's son Date Tadamune, and this time he accepted the offer. Ungo took up his duties as abbot in 1636, and Zuigan-ji thereupon became officially allied to his home temple of Myōshin-ji. Finding that the Matsushima monks were somewhat negligent in their duties, Ungo established a strict code of rules, including the diligent practice of *zazen* and daily reading of sutras. Under Ungo's leadership, Zuigan-ji soon became the leading Zen temple in northeastern Japan.

Ungo's form of Buddhism not only contained elements from the Shingon sect, but it also was known as "*Nembutsu* Zen" because of Ungo's use of the Pure Land Buddhist practice of chanting the name of Amida. In this regard he may have been influenced by Suzuki Shōsan, who was unusual among Zen monks in advocating the *nembutsu*. Ungo was deeply concerned with reaching not only monks and laymen who were willing to undergo strict Zen training but also the populace who needed more accessible forms of Buddhism. As early as 1629 Ungo had written out the *nembutsu* for the consort of Shogun Tokugawa Iemitsu. In Sendai, Ungo became the religious teacher of Date Masamune's widow, Yōtoku-in; she later helped Ungo to establish branch temples throughout the domain. In 1640 Ungo wrote the *Ōjō yōka*, a book about his use of the *nembutsu*, which caused considerable dispute in Zen circles. There were a number of monks who did not believe in mixing elements from other sects into their teachings. One of Ungo's own senior pupils, Nan'mei Tōko, burned his copy of the book; whereas another pupil, Dōsui Tōsho, defended Ungo. The volume became famous enough to be reprinted in 1646.

The main difference between Ungo and most advocates of Pure Land Buddhism was that he taught an "inner *nembutsu*," in which the believer finds the Buddha within himself or herself, rather than praying to the Buddha outside oneself for help. Ungo taught his Zen pupils in a more traditional style, with meditation and *kōan* study; he utilized the *nembutsu* primarily for those who were not part of the Zen tradition. One of Ungo's poems in the *Ōjō yōka* stresses the importance of understanding, not merely faith, in order to reach enlightenment:

If one understands Amida Buddha, his paradise is not far;
But if one has doubt, it is indeed distant —
The compassionate Buddha will not come from the west,
The dying soul will not be taken to the Western Paradise.
It is like the moon shining upon the waters;
It does not sink to the lakes and ponds, nor do they rise to the heavens.
 Pure water reveals the moon,
 A pure mind manifests the Buddha.
If the mind understands and gives praise, it reaches satori —
Death is overcome: praise the enlightened Buddha!

Ungo was certainly aware that his use of the *nembutsu* would invite criticism from his fellow Rinzai monks. In one unusual scroll he deliberately reconciled Zen and Pure Land beliefs by identifying Daruma with the bodhisattva Kannon, the compassionate deity who in Pure Land doctrines is said to carry the soul of the dying believer to paradise. In this calligraphy *(plate 28)*, Ungo first wrote in large characters "Daruma Has Always Been Kannon" (*Kannon* can also mean "innate insight"). On the right side of the scroll he continued: "With compassionate eyes he sees all sentient beings, and his blessings ac-

cumulate like the boundless sea." The scroll, probably written soon after Ungo came to Matsushima, concludes on the left with his residence name, "Master of the Hafujūken," and the signature "Kiyō," followed by his special multicircular cipher. The uniting of Buddhist beliefs was a special feature of Ungo's teachings, which were meant to be available to all people. Ungo's calligraphy shows the same spirit, being brushed with bold forcefulness in easily understood regular script. Ungo's special characteristics include the use of angular strokes with strong horizontals and diagonals and a decisive boldness enlivened by contrasts between sharp and blunt endings of strokes. Until the final cipher, however, there are no elegant curves or flourishes; Ungo chose to write in a plain and simple form of calligraphy, which nevertheless fully expresses the individual personality of its author.

Ungo wrote out a number of calligraphic works during his thirteen years as abbot of Zuigan-ji. He continued to stress the inner nature of religious experience, even for those who held the Pure Land beliefs in heaven and hell. On one scroll Ungo simply wrote, "Thinking Good and Evil is Heaven and Hell." Another calligraphy, beginning with the large character that means "heart" or "mind," continues, "The four types of saints and the six states of enlightenment are all within this [heart or mind], so be very careful."

Although his calligraphy is bold and dynamic, Ungo was primarily concerned with its ability to communicate directly. There is an anecdote that a pupil once brought the work of a famous calligrapher to Ungo for his comments. Ungo merely said that calligraphy was good when it was easy for people to read. Indeed, almost all his works are written strongly and clearly in standard script. For his Zen followers, however, Ungo penetrated more deeply, in one case brushing the mysterious Zen circle, *ensō (plate 27)*. This form has many meanings in Zen art. Going beyond words, it becomes an aid to meditation in which the mind reaches the fullness and emptiness symbolized by the circle.[20] Sometimes an *ensō* is accompanied by a line or two of poetry or a Buddhist aphorism. Here there is no inscription, but merely Ungo's residence name, signature, and cipher alongside the full, rich, slowly brushed circle.[21] Ungo began his *ensō* at the top left, curving down clockwise. As he reached the bottom of the circle, his brush wavered slightly, then moved up more quickly on the left to touch, slightly overlap, and rest upon the beginning of the stroke. The contrast between the soft gray band that creates the Zen circle and the small, sharp black lines of the signature gives this work a sense of internal drama that is ultimately concluded by the interlocking curves of Ungo's cipher at the lower left.

Although Ungo certainly must have practiced calligraphy throughout his life, almost all of his extant works were created between 1636, when he entered Zuigan-ji, and his death twenty-three years later.[22] He occasionally inscribed paintings, including portraits of himself, but most of his works are calligraphy either in single lines (usually the names of deities) or in horizontal formats (poems and aphorisms). He also wrote out Buddhist names for his followers when they "graduated" from his instruction and were ready to become abbots of their own temples. These works could be hung as proof of their teacher's approval, while giving the followers a vibrant reminder of Ungo's personal spirituality. Even these scrolls, however, were written extremely simply and boldly in regular script. Ungo maintained this style until his death.

In 1649, after thirteen years at Zuigan-ji, Ungo retired as abbot in favor of his pupil Dōsui. The daimyo Date Tadamune and his mother, Yōtoku-in, did not want to lose Ungo; fearing that he would travel to other parts of Japan (and

knowing his love for mountains), they built him a small temple named Eian-ji on a tall peak near Sendai Castle. A statue of Bishamon was installed, reminding Ungo of his birth in Bishamon Hall. In his new home he continued to practice Zen and write calligraphy; he also grew mountain vegetables and occasionally drank rice wine. His pupil Daiki later wrote, "As for Ungo drinking sake, he was a rather strict person, difficult for people to feel comfortable with; he drank sake as an expedient when people visited him."[23] Ungo is also said to have once cured himself of a sudden stomach attack while traveling by drinking thick sake.

Although this latter part of Ungo's life was tranquil, he was forcefully reminded of the warrior ethic that still dominated the minds of many samurai. One of Ungo's Zen pupils, Etsu Seidō, had been a follower of Date Tadamune. After studying with Ungo for some time, Etsu traveled to Nagasaki, meeting Obaku Ingen (see Chapter Three), and eventually founding the temple Kantoku-ji in Shiga prefecture. Hearing that his former lord, Tadamune, was seriously ill in 1658, Etsu returned to Sendai, declaring to Ungo that he would obey the samurai code by following his daimyo in death. Ungo's remonstrances were in vain; less than a month after Tadamune died, Etsu committed ritual suicide. There is nothing in Buddhism to support this action; the warrior ethic prevailed.

In the eighth month of 1659, Ungo summoned his pupils by repeatedly ringing his temple bell; he then meditated before the Bishamon image. At sunset, when his followers had gathered, he told them that the end of his life was near. His pupils asked him for a final poem, and on the following day he gave them a sealed envelope with the request that it not be opened until after his death. It contained a poem referring to the historical Buddha and the Buddha of the future:

Born after Sakyamuni,
Dying before Maitreya—
Although my life begins and ends between the two Buddhas,
Birth is not birth, and death is not death:
Katsu!
—In the compassionate radiance of perfect absorption,
Ungo, the old pine resting serenely in the clouds.

GESSHŪ SŌKO (1618–1696)

Known as the "Restorer of the Sōtō Sect of the Edo Period," Gesshū was born to the Harada family in Higo (present-day Kumamoto prefecture), not far from the port city of Nagasaki. At the age of eleven he became a monk at a temple of the Shingon sect. Perhaps because he was not satisfied with Shingon's esoteric doctrines, the following year he began to practice Zen under the monk Kagaku at Ennō-ji. At the end of the year he returned home for a short respite, and his mother overheard him saying to a friend that if he were granted a large stipend to be lord of the province, he would give up being a monk to be a nobleman. His mother cautioned him, saying that in the past emperors had even given up their thrones to become monks. Gesshū later felt that the diligence of his subsequent training owed much to that chiding; he returned to Ennō-ji and redoubled his efforts.

Gesshū set out on pilgrimage at age sixteen. It was during this period that he heard his mother had died, and he wrote a poem in her memory:

29. Gesshū (1618–1696)
MOON
Ink on paper
L. Wright Collection

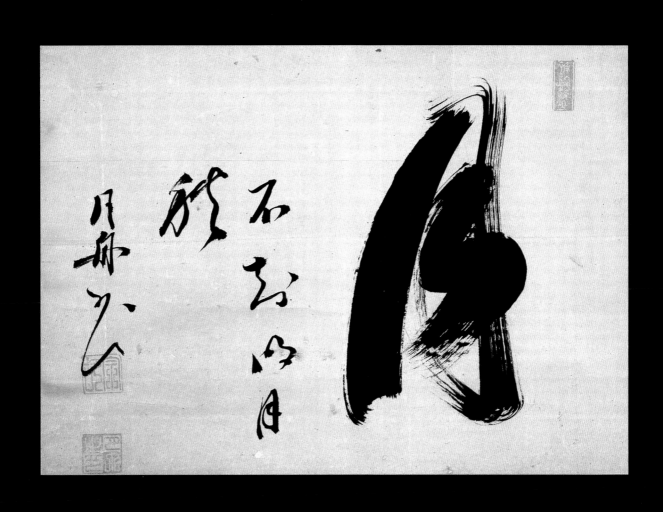

There is no way to describe the bond between mother and child—
Hearing of her death, my entire life is darkened.
Over the years we have been woven together like a reed basket;
To the empty sky I answer her spirit with the smoke from one stick of incense.

Gesshū studied for a time with Ban'an at Zuigan-ji near Kyoto. There he struggled over the meaning of the phrase *mushin* ("without heart or mind"): Was the human spirit to be as empty as a tree or a rock? One day he came across the phrase "When you arrive at *mushin* you can see your own nature." Gesshū pondered this day and night and achieved his first awakening:

Sitting in an outhouse, I concentrated upon this doubt, and as time passed I forgot to leave. Suddenly a violent wind came, first blowing the outhouse door open and then shut again with a loud crash. My spirit instantly advanced and ripped apart my previous doubt; it was like suddenly awakening from a dream, or remembering something forgotten. I began to dance in a way I had never learned, and there are no words to convey my great joy. [24]

This first awakening, however, was not recognized by Ban'an, and several years later Gesshū had another and greater enlightenment, based upon piercing the great obstacle *Mu*. This time, his satori was acknowledged.

Gesshū then settled at the important historical Sōtō temple Daijō-ji in Kaga (Ishikawa prefecture) to practice under Hakuhō Genteki. At the age of thirty-one Gesshū received *inka* from Hakuhō, but he still wished to continue his Zen studies. He returned to Kyushu to visit his former teacher Kagaku in Hizen and later traveled to Nagasaki to study with the immigrant Chinese scholar-monk Dōshagen (Chinese: Tao-che Ch'ao-yuan, 1599-1662) of the Obaku sect. Dōshagen was also a fine calligrapher, and it may be that Gesshū studied brushwork under him.

His training complete, Gesshū became abbot of the small mountain temple Takugen-ji in Settsu. He led a quiet life, writing poetry about his solitary contentment:

Searching for praise and honor keeps mankind restlessly moving,
But in the warm sun and peaceful wind, things renew themselves naturally.
Needing no human control, the spring brightness is both pale and deep;
In the mountains of endless rest, there is a single tranquil man.

Gesshū's peaceful existence at Takugen-ji lasted only for a few years. In 1655, at the request of the feudal lord Itakura of Suo (present-day Yamaguchi), Gesshū became head of Chōen-ji in Mikawa (present-day Aichi). Deeply concerned with the declining strength of Zen amidst the secularism of the Edo period, Gesshū determined to revive the strength of the Sōtō sect. In this regard he chose a different course from that of his Sōtō predecessor Fūgai, who had concentrated upon perfecting his own practice. The problems both monks faced were the same; not only was the populace increasingly materialistic, but the shogunate often interfered in Buddhist matters. Temples became part of the official bureaucracy of the Tokugawa government. They served as census bureaus because all Japanese were required to register at the local temples. Furthermore, since Buddhist monks of most sects were allowed to marry, monks were able to inherit their positions rather than to earn them,

30. *Gesshū (1618–1696)*
DEATH POEM. *1696*
Ink on paper
Daijō-ji, Kyoto

which tended to make religion a profession rather than a calling. As a result, Buddhist training became increasingly perfunctory.

Gesshū's restoration of Sōtō Zen took several forms. He trained his pupils by reviving the strict and orderly practices of the sect's patriarchs, Dōgen (1200–1253) and Keizan (1268–1325). This method of training continued into future generations; several of Gesshū's followers became influential abbots during the latter part of the seventeenth century and continued his revival of the Sōtō tradition. In addition to his direct teachings, Gesshū also published revised editions of the works of Dōgen and Keizan, reestablishing principles that remain the basis of Sōtō Zen practice today. Particularly in Dōgen's writings, all aspects of monks' daily lives are regulated and organized into a strict code; furthermore, *zazen* is stressed for its own sake and not only as a means to enlightenment.

Gesshū's own lectures and poems on dharma were published in the *Gesshū Oshō iroku* ("The Monk Gesshū's Posthumous Record") and *Gesshū yawa* ("Gesshū's Evening Talks"). He stressed that a vital part of Sōtō teachings was accepting rather than choosing, and that having and not having, proclaiming and denying, are ultimately the same. Each one of us, Gesshū wrote, should examine life with the eye of a master horse trader (a reference to a Taoist story of Lieh-tzu); everyone is born with this visionary eye, but it is lost in the clouds of desires. Having become a model for his followers, Gesshū was later praised by his former attendant Tekisui for being "as compassionate as the harmony of spring, and as dignified as the frost of autumn."[25] Tekisui wrote that Gesshū would not take off his Buddhist robe even when the heat was fierce enough to melt gold nor put on additional clothing when it was cold enough to crack glue. Furthermore, he would not use a fan, even when mosquitoes and sand flies bit him until his blood flowed.

In 1671 Gesshū succeeded to the abbotship of Daijō-ji, the Sōtō temple of his teacher Hakuhō. The strictness and depth of Gesshū's teachings attracted a number of pupils, bringing the temple to new prominence in the Sōtō tradition. Several examples of Gesshū's calligraphy, which are otherwise somewhat rare, are still kept in the temple, along with a portrait of the master bearing Gesshū's inscription.

Gesshū's calligraphic style is both spontaneous and strongly articulated. His mastery of Chinese-style verse is matched by the vigor of his brushwork, as in his *ichijikan* (large, single-character calligraphy) of *Moon (plate 29)*. The main character, which in standard script is depicted in four strokes of the brush, is here rendered in two bold strokes. One is the thick, strong vertical line that curves slightly at the left of the character. The second stroke begins lightly and

quickly at the top of the form, thickens into a vertical line, sweeps upward—with the brush almost leaving the paper—and ends with two connected short diagonals in an S shape. The asymmetrical contrast between the first thick heavy line and the lighter effect of "flying white" makes this "moon" come alive. The five-word inscription in running script to the left of the large character also includes the word "moon" (at the bottom of the column) in a slightly different composition but with a similar sense of balance. The work concludes on the far left with Gesshū's signature, which begins with yet another version of the word "moon."

The autumn moon is a symbol of radiance, but it can be the cause of delusion. In Gesshū's calligraphy, the small five characters literally read "not know bright moon autumn." If the large character for "moon" on the right is the first word of the poem, then the moon does not need to know that it shines, even during its autumn fullness; by extension, enlightenment need not be conscious of itself. However, since much Chinese-style poetry is composed of five-character lines, one might also consider the large character as the title, in which case we, the viewers, may be the subject, not knowing the bright moon of autumn and therefore blind to enlightenment.

Gesshū wrote a number of poems that were later published in his *iroku*. Many of these celebrate anniversaries of earlier Zen masters, but there are also poems of a less formal nature, often used as inscriptions. One of these, entitled "The Monk Hotei," refers both to the moon and to the concept that Hotei is considered an avatar of Maitreya, the Buddha of the future:

HOTEI OSHŌ

His finger points to the moon,
 but the finger itself is not the moon;
If you wish to know his heart,
 ask the moon in the sky!
In heaven there is Maitreya,
 on earth, Hotei—
May I presume to ask everyone:
 are they the same or different?

Gesshū also wrote poems to be inscribed on portraits of the first patriarch, Daruma. He clearly enjoyed a sense of paradox, which is a vital part of the Zen spirit. One couplet again refers to the moon:

Bah! This Daruma didn't understand "Zen" at all!
The fresh breeze never ceases, the bright moon is alone in the sky.

A quatrain develops the paradox of Daruma's understanding (and the world's misunderstanding):

This Indian monk couldn't even speak Chinese!
He faced the wall in silence for nine years.
Doing nothing, totally inactive, he sat quietly,
Causing the world to mistakenly call this "Daruma Zen."

Many of Gesshū's poems follow the Chinese-style rhyme schemes of verses by his chief pupil, Manzan Dōhaku (1636–1715).[26] Other poems celebrate images of Buddhist deities that he had seen, including Japan's largest Buddha, which he viewed on a special journey to Nara, the ancient capital:

Already cast in bronze more than nine hundred years ago,
It has already been burned twice in this great temple hall.
This majestic deity's power can be seen by all mankind;
Its ancient golden body rises up to the blue sky.

Gesshū was clearly impressed with the giant bronze image in Nara's Tōdai-ji, but one of his most affecting poems is more personal. He wrote how the world of nature proceeds at its own pace, how it is vast beyond our grasp. Man is but a small element in this larger universe. Yet the world of nature, including our own human nature, is itself part of the Buddha-mind:

Under the trees welcoming spring, things take care of themselves;
After all, the appearance of a monk is strange to ordinary people.
The dharma of the new year is not outside the mind;
Filling the eye, there are green, green mountains in every direction.[27]

In 1680 Gesshū retired as abbot of Daijō-ji, turning the position over to his pupil Manzan, who continued the revival of the Sōtō tradition.[28] Gesshū moved to Zenjō-ji near Uji, where he spent his final two decades in study and meditation. Just before his death he wrote a final poem that sums up the teachings and understandings that he had developed during his life. The calligraphy *(plate 30)*, although modest in size, shows that Gesshū's inner vigor remained strong even when he knew his end had come:[29]

Breathing in, breathing out,
Moving forward, moving back,
Living, dying, coming, going—
Like two arrows meeting in flight,
In the midst of nothingness
There is a road that goes directly to my true home.

BANKEI YŌTAKU (1622–1693)

Perhaps the most individualistic of all seventeenth-century Zen monks was Bankei Yōtaku. Compared with his contemporaries, he relied less on past traditions and more on his own initiative, sometimes seeming to choose a course of action just because it was different.[30] Bankei was born in Hamada, on Japan's inland sea, to a Confucian doctor's family of the samurai class. His father died when Bankei was very young, and perhaps as a consequence Bankei had a somewhat unruly personality. He was the village champion at rock fighting and other mischief. At the age of eleven he caused problems in his family by refusing to attend the customary calligraphy lessons for children of the samurai class; ironically, he was to become one of the master calligraphers of the early Edo period.

During his Confucian studies, Bankei was not content to memorize the classics in the time-honored manner but repeatedly questioned his teacher about the meanings of the texts. In particular, he was not satisfied with the explanations he received about Confucianism. Bankei was finally told that Buddhist monks might help him to understand, so he left school, and at the age of eleven he first studied Pure Land and Shingon Buddhism. Finding these sects unsatisfactory, he switched to Rinzai Zen at the age of sixteen.

After three years of training with Umpo Zenshō (1568–1653) at Zuiō-ji, a temple of the Myōshin-ji line in Akō, Bankei began a series of journeys that lasted for four years but did not bring him to enlightenment. Umpo told him he could never find satori outside his own mind, so Bankei sequestered himself in a tiny dwelling and became totally immersed in *zazen*. He sat doggedly day and night until his buttocks festered; he also contracted tuberculosis. One day Bankei spat out a mass of black phlegm. As he saw it roll down the wall in front of him, he came to a great realization that "all things are perfectly resolved in the unborn."[31] His fourteen years of striving were now repaid, and his health gradually returned.

Bankei achieved further enlightenments, which he described as "like the bottom falling out of a bucket," including one moment of satori that came when the scent of plum blossoms reached him in the morning breeze.[32] Returning to Umpo, he announced his satori, to the great joy of his teacher. Umpo thereupon suggested that Bankei study further and obtain verification of his experience from other masters. Bankei first traveled to visit Gudō Tōshoku, who was absent on a journey, and then continued on to see other abbots, but they disappointed Bankei by their own lack of attainments.

Hearing of the arrival in Japan of the eminent Chinese Zen master Dōs-hagen, Bankei journeyed to Nagasaki in the autumn of 1651. Dōshagen confirmed Bankei's satori with the words, "You have penetrated through to the matter of the self," but then he continued, "You have still to clarify matters beyond, which is the essence of our school."[33] Bankei at first refused to accept this evaluation. Eventually, he decided to continue his studies with the Chinese master at Sōfuku-ji, one of the major temples in Nagasaki. As Dōshagen could not speak Japanese nor Bankei Chinese, they communicated through calligraphy. Bankei did not become a regular student, however, as he saw no need to conform to Chinese customs (such as different methods of sutra recitation). The following spring he experienced another enlightenment, which Dōshagen recognized. This caused some jealousy among the more orthodox students, so Dōshagen advised Bankei to leave; the young monk thereupon began a long period of practice, travel, and teaching.

Bankei fervently wished to communicate his realization not only to monks but to the general populace. He spoke at many public gatherings, using everyday language rather than complex Buddhist terminology. From this time on, Bankei pursued a very strenuous life, reaching an ever-wider audience of daimyo, samurai, merchants, farmers, and monks. In 1672 he became the 218th abbot of the prestigious temple Myōshin-ji in Kyoto, but rather than remaining there, he was active in more than forty other temples, including Ryūmon-ji in Harada. He became most celebrated for conducting semiannual public meetings for thousands of followers.

Bankei's teachings centered upon his understanding that each one of us is already enlightened, with an inherited Buddha-mind that is unborn. This "unborn" is the source of our being but is covered up by notions of selfhood, desire, and partiality. A single thought or concept can be enough to obscure the Buddha-mind, but Bankei taught that thoughts have no substance: if they arise, let them arise; if they stop, let them stop. Don't pay any attention to them, he said; when you have no attachment to self, there are no illusions. The unborn Buddha-mind is like a mirror, reflecting everything without intention and without clinging. Don't try to please yourself, but live in the unborn, just as you are, you're a living, breathing, firmly established Buddha: "The true unborn has nothing to do with fundamental principles and it's beyond becoming and attaining. It's simply being as you are."[34]

Bankei's methods of instruction were highly original. For the farmers in Yoshino, for example, he composed Buddhist songs, using the word "unborn," which was so vital to his experience. Unlike other masters, he did not cite the words of the Buddha from sutras or the teachings of earlier Zen patriarchs. Instead, he preferred to speak directly to the people before him. Studying a well-known *kōan* was "trailing doggedly after other people's words. Feeding on their dregs. . . . When worthy Zen masters of the past dealt with those who came before them, every word and every movement was appropriate to the moment. It was a matter of responding to their students and their questions face to face."[35] Since the earlier Zen patriarchs had reacted to particular situations rather than having formalized responses, Bankei also responded to each occasion as it occurred. He did not even stress *zazen,* stating that the only thing necessary was to realize the unborn Buddha-mind: "You need do nothing else—no practice, no precepts, no *zazen* or *kōan* study . . . if the Buddha-mind is clearly realized, that's enough."[36] At a time when women were often told they could not enter nirvana unless they were reborn as men, Bankei said: "I understand that women feel very distressed hearing it said that they can't become Buddhas. But it simply isn't so! How is there any difference between men and women? Men are the Buddha-body and women are the Buddha-body too."[37]

With such an unorthodox approach to teaching, it is not surprising that Bankei should have also developed an individualistic style in his artistic endeavors. Although a few paintings and sculptures are attributed to his hand, his greatest contributions were in calligraphy. In *Leisurely Clouds,* Bankei demonstrates the vigor and fluency of his style *(plate 31).* The first (right) character, "leisure," has twelve strokes in standard script, but Bankei renders it here in three. Despite the cursive nature of the writing, the strong vertical stroke and the placement of the two large dots keep the character firmly balanced. The negative spaces formed around the lines and dots are also masterfully controlled to suggest a repose based upon harmony and inner strength. Nevertheless there is a sense of movement created in this form that points toward the second character, "clouds." In contrast to the first word, this character avoids a symmetrical sense of balance. Instead, each of the three strokes (again abstracted from an original twelve) seems to float on the scroll, an effect achieved by curves within the strokes, varied widths of the lines, and "flying white" where the brush hairs separate. The character seems to lean to its left as if turning back toward "leisure."

The work is neither signed nor sealed; there are only two large characters facing each other.[38] This totality at first seems asymmetrical; the solidity of "leisure" is opposed by the relaxation of "clouds." There is an internal symmetry, however, in which the inner sections of the characters coincide with dry circular shapes, while the outer edges are balanced by the hook at the far left and the curving dot at the bottom right. Furthermore, there are similarly shaped beginnings to each character and similar endings as the brush pulls away from right to left.

Despite its varied contrasts and asymmetrical balances, the strongest feature of the work is its seemingly effortless simplicity. Bankei has evoked the constantly changing and yet serene leisure of clouds as they float through the sky. This was a metaphor for how Bankei himself lived. After his death, someone asked a pupil about Bankei's daily activities. There was no fixed pattern, the pupil replied, "he just remained in a state of *buji* [peacefulness]. But when he was responding to various different circumstances as he dealt with students, his limits were truly unfathomable."[39]

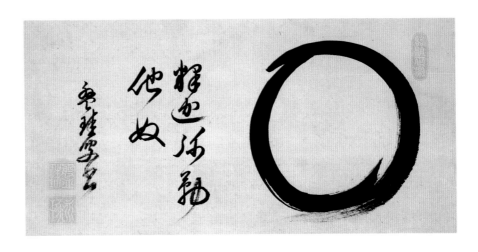

How did Bankei evolve his personal calligraphic style? He had disdained lessons as a child, but the strong fluency of his teacher Dōshagen's calligraphy had an influence upon him; somewhat similar styles can be seen in the work of Chinese monks of the Obaku sect.[40] Yet Bankei imposed his personal touch in brushwork as in every aspect of his life. A clear example occurs in that ultimate Zen subject, the *ensō (plate 32)*. Other monks have made this circle with a single stroke, symbolizing the all, the void, and the moment of enlightenment when samsara, this world of sorrow, becomes nirvana. Bankei, ever the individualist, used two strokes, each strongly and quickly articulated. The effect is to give an entirely new meaning to the form; the strokes enclose each other like an embrace yet still suggest both emptiness and completion.

Bankei's inscription in cursive script says, "Sakyamuni and Maitreya are servants." This refers to the forty-fifth case of the *Mumonkan* (a rare example of Bankei utilizing a classical Zen text) in which the statement is given in full: "Even Sakyamuni and Maitreya are servants of someone else. I ask you: whom?" To this *kōan,* Mumon added the comment, "If you can see this 'someone else' clearly, it is like meeting your own father at a crossroads. Why need you ask if you recognize him or not?"

Ungo had placed himself in his death poem among the Buddhas of the past and future, beyond birth and death. Bankei also obviated time as a linear progression by naming both Sakyamuni and Maitreya, not as gods, but as serving someone right at this moment. Since the unborn exists in the eternal present, Bankei told his followers to uncover their own unborn Buddha-nature and accept things as they are: "Any interpretation that you set up and fix as the truth becomes meaningless phrases."[41]

Bankei's message was carried to large numbers of people. In his final years, he is said to have had more than four hundred monks and two hundred and seventy nuns under his tutelage, as well as over five thousand lay students. He continued to travel from temple to temple and from meeting to meeting until his health, never strong, failed at the age of seventy-two. In his typically unorthodox fashion, Bankei refused to compose a death verse in his final days, saying to his followers, "What I've been telling you every day . . . is my death poem. I'm not going to make one now, before I die, just because everyone else does it."[42] One of his poems sums up his teachings in this regard:

CHANT OF PRAISE

Searching for words, hunting for phrases, when will it end?
Esteeming knowledge and gathering information only maddens the spirit.
Just entrust yourself to your own nature, empty and illuminating—
Beyond this, I have nothing to teach.

OBAKU ZEN

*There's no need to discuss
the principles of* KŌAN *study;
Just listen carefully to the wind
outside the pines and cedars.*

One of the most significant events for later Japanese Zen history was the emigration of a group of monks from the temple Wan-fu-ssu in southern China to the open port of Nagasaki in the mid-seventeenth century. Political events in China were partly responsible. The fall of the native Ming dynasty to the Manchu invaders in 1644 deeply distressed many Chinese, particularly in the south. Zen monks were not immune to feelings of loyalty toward their emperor and ethnic roots. Disturbed by the submission of their country to rulers they considered foreigners, almost one hundred monks left their homeland over the next few decades. They were welcomed by Chinese merchants and seamen living in Nagasaki, as well as by many influential Japanese. Although these monks considered themselves followers of the Lin-chi (Rinzai) tradition, their syncretic tenets were different from those of Japanese Rinzai monks, and thus they formed a new sect called Obaku.

The émigrés had a significant impact upon their new country. Encouraged by both the shogunate and the emperor, Obaku spread rapidly and soon became one of the three main sects of Japanese Zen, along with Sōtō and Rinzai.[1] Led by their abbot Ingen, monks such as Mokuan, Sokuhi, and Dokutan brought with them not only Chinese conceptions of Zen practice, sutra chanting, and temple construction but also Chinese styles of brushwork that were to have a considerable influence on their Japanese counterparts. The detailed manner of figure painting and the broad and fluent style of Obaku calligraphy arrived in Japan at a time when Neo-Confucianism had prepared the way for renewed interest in Chinese arts. Professional painters studied Obaku portraits and depictions of Zen avatars, while scholars and poets were eager to learn more about the Chinese ink-painting and calligraphy traditions. Indeed, Obaku had more influence upon professional artists and literati than on the native Zenga tradition.

The first generation of Obaku masters were Chinese immigrants who stayed for the most part in Nagasaki or at their new headquarters in Uji. It was their Japanese pupils who promoted Obaku throughout the country; by the beginning of the eighteenth century there were more than four hundred Obaku temples in Japan. The later masters who made significant contributions to Obaku-style calligraphy include the Japanese monk Tetsugyū, who studied the Chinese immigrants' examples and applied his lessons to free-wheeling painting and calligraphy with a distinctly Japanese flavor; the talented and dedicated nun Ryōnen, who excelled in poetry and calligraphy; and the Chinese immigrant Taihō, who specialized in painting the scholarly and gentlemanly subject of bamboo. The Sōtō sect monk Shin'etsu also emigrated from China in the later seventeenth century, becoming abbot of a temple in Mito, where his skills in poetry, music, calligraphy, seal carving, and painting influenced many followers.

The arrival of the Chinese monks came at a time when Japan was almost entirely closed to the outside world. A few Dutch traders were permitted to live on a small man-made island in Nagasaki harbor, while Chinese merchants were allowed to move about more freely in that city. Travel within Japan was severely restricted, however, and other foreigners were totally forbidden. Nevertheless, the increasing trade with China led to the immigration of a number of merchants and their families during the early seventeenth century. For religious and social purposes, they set up three temples in Nagasaki: Kōfuku-ji was established in 1620 by traders from Nanking, Fukusai-ji in 1628 by merchants from Changchou, and Sōfuku-ji in 1629 by settlers from Fukien. These temples were somewhat eclectic in their Buddhist practices. Kōfuku-ji and Fukusai-ji, for example, contained statues of the

goddess Matsu, who was believed to protect travelers on sea voyages, while Fukusai-ji also had a branch temple honoring the bodhisattva Kannon. The monks at these temples, however, came primarily from Chinese Zen (or "Ch'an") sects; the third abbot of Kōfuku-ji, for example, was the Zen monk Itsunen (Chinese: I-jan, 1592–1668). He had emigrated from China in 1644, the year the Ming dynasty fell to the Manchu forces.

Itsunen was highly respected in Japan, both for his religious accomplishments and for his skillful figure paintings in the late Ming style *(plate 33)*. Although these works did not have the force and intensity of Japanese Zen paintings, they showed a new, more graceful and elaborate manner that particularly influenced professional artists of the Kano School. Impressed with the warm reception he had received in Nagasaki, Itsunen repeatedly wrote to the temple of Wan-fu-ssu in Fukien, inviting the Zen master Ingen (Chinese: Yin-yuan) to come to Japan. After a few years, his offer was accepted, and for the next one hundred years monks from southern China emigrated to Japan.

INGEN (1592–1673)

Ingen was the leader of the Chinese monks who established the Obaku sect in Japan. He was born in Fu-ch'ing, Fukien province, and was the youngest of three brothers; when he was six, his father left on a journey and never returned. The family was poor, and Ingen received little formal education while he and his brothers worked at farming and wood-gathering. At the age of sixteen, he decided to become a monk, but at first he did not feel he could leave his family. Five years later, when his mother was considering remarriage, Ingen reproved her, saying that his father might still be alive. Ingen thereupon began a three-year journey in search of his father, which proved unsuccessful. Coming to the realization that all desires were in vain, he entered a temple, where he was given a lowly position serving tea to monks. After some months, he returned home and soon converted his mother to a much more fervent belief in Buddhism than she had previously held. He received her permission to become a monk, but on his journey to a temple he lost his money and had to give up his plans. When his mother died a few years later, he went to the temple Wan-fu-ssu on Mount Huang-po (Japanese: Obaku) and entered the Buddhist priesthood. He was twenty-nine years old.

After hearing an inspiring lecture at the temple, Ingen told the Zen master Mi-yun (Japanese: Mitsuun, 1566–1642), "I'm a beginner at Zen and don't know how to practice, please show me." Mi-yun replied: "There is no need to make a 'practice.' When you need to go someplace, just go; when you want to lie down, lie down." "What shall I do when I can't sleep at night because of the mosquitoes?" asked Ingen. "Hit one of them," Mi-yun answered. Ingen bowed and left, but he could not overcome his doubt, so he meditated day and night. Seven days later Mi-yun passed by the meditation hall; Ingen happened to glance at him and at that moment reached enlightenment. He said to Mi-yun, "Now I understand what you told me." "Show me," Mi-yun replied. Ingen gave a Zen shout, but Mi-yun repeated his request, and Ingen again replied with a shout. This was not enough to demonstrate his satori, so Mi-yun then asked, "After several shouts, how about you?" "This year the salt is very expensive, just like rice," Ingen answered. "You may go now, but be careful and never obstruct people," Mi-yun finally told him. Ingen bowed and left, writing a poem to commemorate the occasion. This verse was recognized as an enlightenment poem by his teacher:[2]

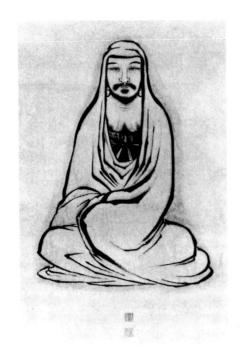

33. Itsunen (1592–1668)
DARUMA *(detail). 1656*
Ink and color on silk, 44 × 18"
Kimiko and John Powers Collection

Within the waters is the entire world;
There is nothing in its depths but reflections of mountains and rivers.
A fish breaks the surface and then disappears again—
What need is there to borrow the wind and thunder?

When Mi-yun's pupil Fei-yin (Japanese: Hi-in, 1593–1661) became abbot at Wan-fu-ssu, Ingen went there to meet him. Ingen soon became "first monk" at the temple, and in 1632 he was "allowed to convey the teachings" of Fei-yin—meaning that he had completed his studies. When Fei-yin left Wan-fu-ssu in 1637, Ingen became abbot of the monastery. Over the next few years he raised enough money to have several of the temple buildings renovated. With Mi-yun, Fei-yin, and Ingen installed as abbots of temples in southern China, it was a time of spiritual prosperity for Zen. However, political events soon intervened. When the Ming dynasty fell in 1644, Ingen was deeply unhappy at the prospect of a government run by Manchus rather than ethnic Chinese. He left the temple to undertake extensive pilgrimages, not returning to Mount Huang-po until two years later.

In 1652 Ingen received a letter from Itsunen inviting him to come to Nagasaki. At first Ingen declined, citing his advanced age. A second letter of invitation was lost at sea, but when a third letter arrived in 1653 Ingen sent one of his monks to Japan to investigate the situation. Receiving a favorable report, Ingen agreed to journey to Nagasaki, at first planning to stay for only three years. Accompanied by a group of thirty monks and artisans, he left China in the sixth month of 1654. They arrived in Nagasaki after a sea journey of two weeks and settled in Kōfuku-ji.

Almost all the Chinese monks in Japan quickly recognized Ingen as their spiritual leader, but Japanese monks had more varied reactions to the arrival of a Chinese prelate. Without exception, those monks who journeyed to Nagasaki to meet Ingen seem to have been impressed with his spiritual strength. Others, perhaps out of jealousy, did not wish to meet him and would not recognize his Zen teachings as part of the true Rinzai tradition. This was partly due to external differences; Ingen and his followers chanted the sutras in a Chinese version of Sanskrit, practiced a continental version of the tea ceremony (*sencha*), wore sandals on the stone floors of their temples, and had many other customs different from those of Japanese monks. There were also

34. MAMPUKU-JI FOUNDER'S HALL

35. Ingen (1592–1673)
MEDITATION HALL
Ink on paper, 22⁷/₈×63³/₄″
Mampuku-ji, Uji

more serious religious variances. Obaku monks, following middle and late Ming dynasty traditions, taught a form of Buddhism that was highly syncretic. Their Zen contained a strong admixture of elements from other sects, including Pure Land practices—such as chanting the *nembutsu*—as well as mantras and incantations from esoteric Buddhism. While these practices were not new in Japan (monks such as Bankei and Ungo had also utilized the *nembutsu*), the Chinese monks were criticized in some quarters for not teaching "pure" Zen doctrines. Therefore there were mixed reactions in Zen circles to the arrival of the Chinese immigrants, but the strong support Ingen received from monks such as Ryūkei (1602–1670) and Teishū (b. 1582), encouraged him to remain in Japan.

In the winter of 1656 Ingen was invited by Teishū to travel to several temples in Kyoto, including Daitoku-ji and Myōshin-ji. While visiting historic monasteries (which were much better preserved in Japan than their counterparts in China), Ingen particularly admired the calligraphy of the temple founders, commenting that the essence of Buddhism was contained within these lines written by early Zen masters. Ingen also commemorated his visit to each Kyoto temple by composing a poem in honor of the occasion.

Ryūkei, who had been a pupil of Isshi, was one of the Zen teachers of Emperor Gomizuno-o and served as a liaison between Myōshin-ji and the imperial court. He was also a confidant of the shogun Tokugawa Ietsuna, and he told the shogun that Ingen's Zen teachings had attracted a large number of followers. The shogun, although he officially supported Neo-Confucianism as a governmental philosophy and ethical system, was himself a Buddhist. He was curious about the religious credentials of the Chinese monk, so he asked the daimyo Matsudaira Nobutsuna of Takatsuki to interview Ingen on behalf of the shogunate. "Why have so many monks gathered around you—what is your great virtue?" Matsudaira asked. Ingen replied with a laugh: "I don't have any virtue, I am just a person the shogunate wants to have questioned." Ietsuna seems to have been impressed, as well as amused, when he was informed of this reply, and he invited Ingen to Edo. In 1659, Ingen was given special permission to construct a temple complex in the mountains of Uji, not far from Kyoto, on land donated by the emperor. A full-scale monastery was planned, utilizing a combination of Japanese and Chinese Ming dynasty styles of construction. Craftsmen were imported from China, including the sculptor Han Tao-sheng, who was commissioned to carve images of various Buddhist avatars.

Ingen named the site on which his temple was to stand Mount Obaku, the Japanese pronunciation of Huang-po; the temple was named Mampuku-ji, the Japanese pronunciation of Wan-fu-ssu. Construction began in 1661, and the opening ceremony was held in 1663. Buildings were added for some years thereafter, and Mampuku-ji now stands as one of the most impressive complete temple compounds in Japan *(plate 34)*.

A particularly striking feature of Mampuku-ji is the widespread use of large wooden signboards on buildings throughout the monastery. This was not a new practice in Japan, but never before had they been used in such a prominent way. Huge wooden panels on almost every building at Mampuku-ji were hung with texts. Some were designations such as "Founder's Hall"; others simply phrases such as "The Roar of the Lion." Calligraphy was an especially important art for the Obaku monks; Ingen had brought over with him many books of rubbings taken from the brushwork of early Chinese masters as well as actual examples of calligraphy (and a few paintings) by Ming dynasty artists.[3] The grandiloquent, large-scale style of writing practiced by Ingen and his followers was well suited to the Mampuku-ji signboards.[4] As a rule the calligraphy for the boards was first written on paper and then carved onto the wooden panels. Only a few of the original works of calligraphy for signboards are still extant. One of these is Ingen's large and impressive brushwork of the three characters for "Meditation Hall" *(plate 35)*; the words literally mean "Select Buddha Place." This is Obaku calligraphy at its finest: bold and massive, yet remarkably fluent. In comparison with Daitoku-ji–style calligraphy, it is much more curvilinear and graceful, yet it does not sacrifice strength and power. Ingen's personal style shows a combination of dignity and spontaneity in which the inner balance of his own character is revealed. In particular, the large central character, "Buddha," majestically anchors the entire composition. Derived from calligraphic styles of the late Ming dynasty, the Obaku plaques that hang on temple buildings at Mampuku-ji have a unique combination of dynamism and calmness that immediately attracted many Japanese admirers. Ingen and his fellow monks were constantly asked for specimens of their calligraphy by their new countrymen. As a result, a large number of fine scrolls survive that testify to the artistic as well as religious impact of the immigrant Chinese monks.

Not only was Obaku calligraphy highly respected in Japan, but the seals used on the scrolls also became objects of emulation. Until this time, Japanese seals were usually carved from wood, and although many were made in attractive shapes (such as those stamped on scrolls by Daitoku-ji monks), seal carving was not regarded as a true art. In China, however, seals had come to be admired both for their carved calligraphy and for their compositional designs. Wood was supplanted as a medium by stone, brass, crystal, jade, and clay. Different kinds of stone, with a variety of interesting colors and textures, allowed the carver to achieve a combination of precision and creativity that

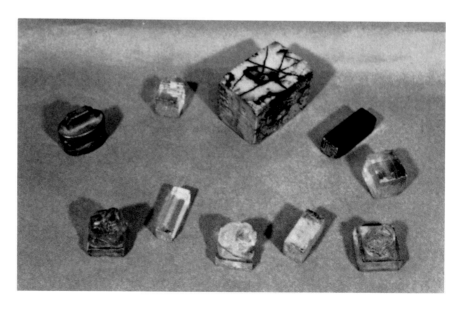

36. INGEN'S SEALS
Stone, wood, and crystal, various sizes
Mampuku-ji, Uji

particularly appealed to the literati. Ingen's seals *(plate 36)* are still preserved at Mampuku-ji, although the characters have been partially sanded down to prevent their possible use on copies and forgeries. Made out of materials varying from stone to crystal to brass, the seals are generally square, rectangular, or oval. Within these basic geometric forms, the characters are arranged with great compositional skill and are carved with boldness and precision. Obaku seals proved to be an important influence in Japan, inspiring the scholar-artists of the next two centuries; from Ingen's time onward, seal carving was considered a literati art.

The impact of the Chinese visitors on their new homeland extended to many other spheres. One was medicine. Several Obaku monks were learned in Chinese herbs and medical lore, and they were welcomed especially for their expertise in treating smallpox. This was the deadliest epidemic disease in Japan; more than half of those afflicted died. Obaku monks were invited to teach and demonstrate their methods of treatment at court and in various provinces. Ingen's monks also brought with them new forms of vegetables; the names *saiyai Ingen* for edible pea pods and *Ingen mame* for butter beans are still used by the Japanese. Furthermore, the immigrant monks had a strong influence upon *sencha,* a form of tea drinking that was to be very popular with Japanese literati. A small amount of Ingen's actual tea still remains at Mampuku-ji; it is "red tea" that was dried and roasted rather than Japanese-style powdered or flaked green tea.

Because Obaku Zen in its many aspects fascinated the Japanese, it spread quickly through the country. Mampuku-ji was traditionally headed by Chinese immigrant monks for the next century, but they sent their Japanese followers to found other temples in many provinces of Japan. The Japanese often carried a portrait of their teacher with them to their new assignment. Over the years, more than a dozen *chinsō* (portraits) of Ingen were painted, usually by artists who specialized in the portraiture of Obaku monks. These *chinsō* could serve as a kind of graduation certificate, showing that Ingen had acknowledged the religious understanding of the follower to whom they were given. A *chinsō* allowed the follower, as he took charge of a temple far from Mampuku-ji, to feel a continuing sense of connection with his teacher. After Ingen's death, his portraits were hung during memorial services at many Obaku temples. In order to fulfill all these functions, a *chinsō* had to convey the spiritual as well as physical representation of a Zen master, and therefore religious portrait painting became an important element in Obaku art.

Compared with earlier Japanese *chinsō,* Obaku portraits have a sense of three-dimensional volume that ultimately may have derived from Western influence on Chinese art. Jesuit painters were popular at the Chinese court at this time, and a new kind of realism is seen in the works of professional Chinese painters of the seventeenth century. An anonymous *Portrait of Ingen (plate 37)* demonstrates the great care that was taken in representation, particularly in the rendition of the abbot's face. It seems as though every wrinkle, each subtle tonal gradation of the skin, and every hair in Ingen's mustache and beard was portrayed with precision. The light wash around the head and the subtle shading within the face create a sense of volume, although the head is rather small by comparison with the figure of the patriarch. Ingen holds a whisk, a sign of his rank, in one hand and a wooden stick in the other. The stick is the long *keisaku* favored by Obaku monks; it was utilized gently (or not so gently) to prod a student into transcending his conscious mind.

Neatly arranged around the end of the stick, the calligraphy was written by Ingen's chief pupil, Mokuan, in 1676, three years after Ingen's death. The

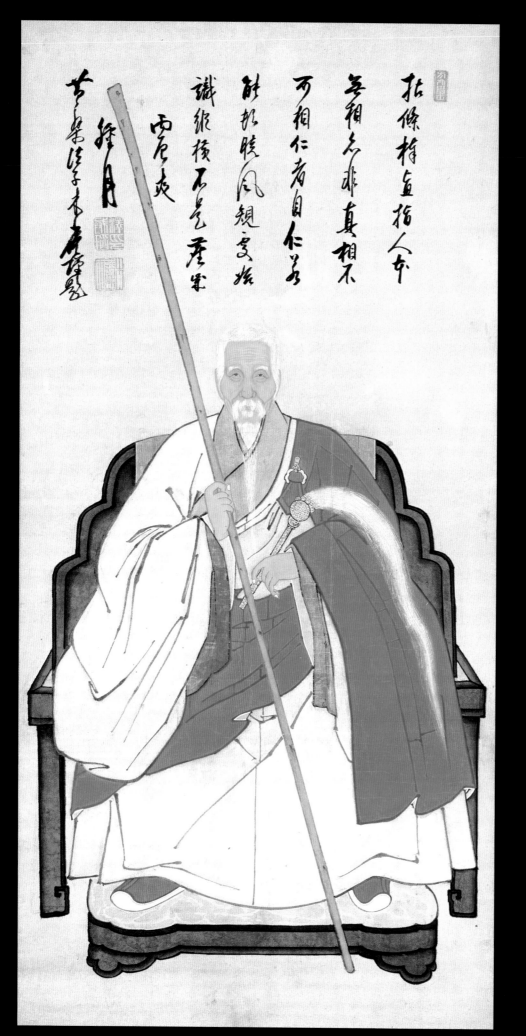

37. Anonymous
PORTRAIT OF INGEN
Ink and color on paper, 47 × 22³/₄″
Private Collection

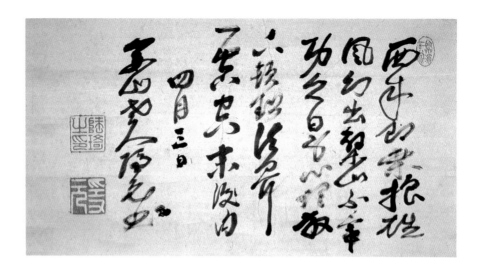

poem is a commentary on the dual nature of reality. Just as this painting can be understood either as a portrait of Ingen or merely as ink and color on paper, so everything that people accept as reality is at once truth and illusion. Mokuan's verse begins with an allusion to a couplet attributed to Daruma: "Pointing directly at the human heart, see your own nature and become Buddha":

Holding his staff, he points out
That humans were originally without form,
Otherwise, true form could not be formed.
Benevolent people are naturally humane,
For if you suddenly understand and abide in the teachings,
You begin to understand that discriminations are empty.

By viewing the many extant portraits of Ingen, one can see him gradually aging. In the first depictions his hair is gray-black and his beard is short; in this *chinsō*, however, the patriarch is represented with white hair and a long beard, indicating that he is reaching the end of his life.

While founding a new sect of Zen in Japan and supervising the construction of a major temple complex, Ingen also fulfilled his obligation to train followers to continue his teachings. After having instructed thirty-three future Zen masters, of whom three were Japanese, Ingen officially retired as abbot of Mampuku-ji in 1664, leaving his disciple Mokuan in charge of the monastery. Ingen, however, continued to assist in planning the construction of new buildings until 1669. Living quietly at a subtemple at Mampuku-ji, he became seriously ill toward the end of the third month of 1673, almost two decades after he had first arrived from China for what he thought would be a stay of three years. Gomizuno-o, who had long admired Ingen, sent him a letter awarding him the Buddhist title *Daikō Fushō Kokushi*. Realizing that death was near, Ingen gathered his disciples together and gave them his final instructions. He concluded with a poem that he wrote to serve as his death verse *(plate 38)*. The calligraphy reveals Ingen's firm will, despite his wavery hand, and has the special flavor that Japanese admire in the final poems of great monks. In his last verse Ingen recognizes that his deeds are of no meaning in the great void, yet he accepts death with equanimity:

Coming from the west, Buddhism is fecund as a chestnut tree,
But I, living at Mount Obaku, have done nothing to help.
Today my body and heart are dying,
I'll soon cross over to emptiness.

MOKUAN (1611–1684)

Mokuan (Chinese: Mu-an) became a monk at the age of eighteen in his native Fukien province. Two years later, he went to a temple in Hangchou and asked the abbot Hsueh-kuan, "How can one overcome birth and death?" The abbot replied that he must seek the answer within himself, but Mokuan could not understand this, so he traveled on to study with the abbot Mi-yun. One day he went to his teacher with a question about a *kōan*. "What is that?" Mi-yun asked as he hit him with a stick. Mokuan was bleeding, but since he still did not understand, he went to another teacher, Yung-chio, who told him, "Don't part from Mi-yun's *kōan*. Concentrate on it like food and drink, and enlightenment will come." Mokuan intensified his meditation, forgetting to eat and sleep; after thirteen days, he suddenly reached satori while chanting a sutra with other monks.

Mokuan continued to study; in 1638 he went to Fei-yin, who questioned him but did not accept his answers as sufficiently enlightened. After further meditation, Mokuan returned to Fei-yin the following year, and this time his satori was recognized. In 1648 Mokuan met Ingen and two years later was "allowed to convey his teachings," indicating that his training was complete. He did not travel with Ingen to Japan in 1654, however, staying instead in China at his teacher's behest until the following year, when Ingen summoned him to Fumon-ji near Osaka. One year later Mokuan helped Ingen to found Mampuku-ji. Upon Ingen's retirement in 1664, Mokuan became the second abbot of the temple and thus the second Obaku patriarch in Japan. Until his own retirement in 1680, Mokuan tirelessly supervised the construction of new buildings at Mampuku-ji. He also spent a great deal of time teaching, sending pupils to found temples in other areas of Japan, and writing extensively; his texts on Buddhism totaled thirty-seven volumes.

Because of his sharp features, grand demeanor, and slightly buck-toothed visage, which made him resemble some portraits of the original Zen patriarch, Mokuan was known as *"Daruma-san"* (Mr. Daruma) among the populace in Uji. Mokuan's individuality, as well as his artistic heritage, is revealed in his calligraphy, which has been highly admired ever since his arrival in Japan. His smaller-scale writing, such as the inscription on the *Portrait of Ingen (plate 37)*, shows how he transformed the influence of the Chinese Yuan dynasty master Chao Meng-fu (whose style Mokuan had absorbed in his youth) into more vigorous writing in his maturity. The variety of tilts and balances to the different characters, the thick and thin lines, and the contained yet forceful rhythm of the writing reveals the personality of the calligrapher, just as the portrait reveals the personality of Ingen.

Mokuan was most celebrated for his large-character calligraphy. When he wrote the words *Tenno Den* ("Hall of Heavenly Kings") for a signboard at Mampuku-ji, he is supposed to have been so elated that he ran around the corridors of the temple shouting, "I did it, I did it!"[5] Mokuan's bold approach, blunt and powerful brushwork, and compositional skill were especially effective in single lines of writing, where each stroke, each character, and the total balance of characters are immediately apparent to the viewer. One strong example of his brushwork is a *kōan, Why Did Daruma Come from the West? (plate 39)*. Each of the five main characters has its own sense of equilibrium. The first ("original") is firmly balanced by its closing horizontal stroke; the second ("teacher") is begun by a moist dot and ends with a dry-brush flourish; the third ("West") has a horizontal emphasis and leans down to the left; the fourth ("come") balances diagonals moving up to the right with a final strong

downward diagonal stroke; and the fifth ("meaning") bends its ever-changing horizontal strokes into a series of different angles until its final stroke hooks back toward the center. The strong central column is balanced by thinner columns. On the right, Mokuan inscribed that he is the thirty-third generation in a direct line from Rinzai, while on the left he signed, "Written by Obaku Mokuan." The three large seals are designed in the Obaku tradition, and the entire work gives an impression of confident, spontaneous forcefulness. The *kōan* that Mokuan has written is a famous one in Zen, equivalent to asking about the essence of Buddhism. Often translated as "What is the meaning of Bodhidharma's coming from the West?" the phrase occurs several times in the early Chinese *kōan* collections *Mumonkan* and *Hekiganroku*. Varied answers to the question were given by early Zen masters after long hours of meditation, including "Sitting long and getting tired" and "Pass me the cushion." Perhaps the most celebrated answer, from the thirty-seventh case of the *Mumonkan*, is "The oak tree in the garden." Clearly, none of the answers depends upon logic! Mumon's own commentary on this *kōan* was "If you understand the answer clearly, there was no Buddha before you and there is no Buddha still to come." Mumon then wrote the verse:

Words cannot express things;
Speech does not convey the spirit.
Swayed by words, one is lost;
Blocked by phrases, one is bewildered.[6]

A Zen student was expected to meditate on this *kōan*, including the question, the answer, the commentary, and the verse, until he could offer his teacher evidence of his understanding beyond words. The calligraphy by Mokuan itself becomes part of the question and part of the answer; the art of the brushwork, like the *kōan*, utilizes words to go beyond words.

Mokuan also created a number of ink paintings, usually depicting plant subjects such as orchids, lotus, and peonies in a simplified style.[7] Many of his works were brushed during the four years he lived in retirement after resigning as abbot of Mampuku-ji. In the first month of 1684, he sensed that his death was approaching and summoned his disciple Nangaku, asking him to take care of matters after his death. Nangaku begged Mokuan to live a bit longer, but Mokuan replied that the Buddha had been content to leave when his time had come, and so he too had no wish to live longer than his span of days. Nangaku then asked for a death poem, and Mokuan said, "Everything is nothing, all rules are also nothing, that is my death poem." He expired peacefully that night.

Mokuan had more than fifty disciples who spread his teachings; through his followers, through his writings, and through his art he did much to propagate Obaku Zen in Japan. He is said to have converted the shogun Tokugawa Ietsuna as well as many lay persons, and his influence extended even more widely than that of his teacher. Although Ingen had founded the Obaku sect in Japan, it was Mokuan who brought it to the height of its power.

SOKUHI (1616–1671)

The third of the famous "Three Brushes of Obaku" was Sokuhi (Chinese: Chi-fei), whose calligraphy is at least equal to the brushwork of Ingen and Mokuan. Sokuhi was born in Fukien to a family that wanted him to become a

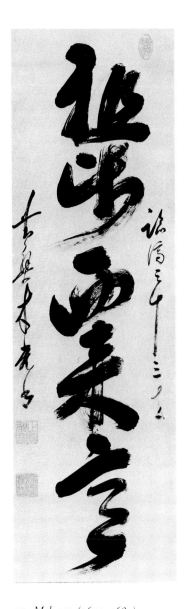

39. Mokuan (1611–1684)
WHY DID DARUMA COME
FROM THE WEST?
Ink on paper, 51 3/8 × 15 3/4"
The Saint Louis Museum of Art

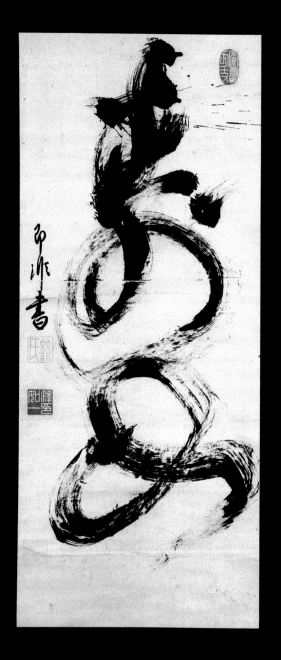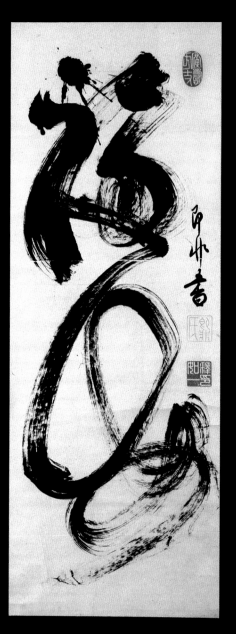

scholar; at thirteen, when his father died, Sokuhi decided to follow a religious life. After entering a temple at the age of eighteen, he made pilgrimages to various monasteries. At one of these, the monk Shih-yu assigned Sokuhi the *Mu kōan,* but after meditating upon it for seventy-three days and nights, he could not solve it. He traveled on to meet various Zen masters, including Ingen, and then settled in a hut to practice concentrated *zazen.* When he thought he had reached enlightenment, he returned to Ingen. After questioning him, Ingen told Sokuhi that he could not recognize his satori. Sokuhi practiced hard for the next three years. Finally, while walking down a temple corridor, he happened to stumble, and at that moment he reached enlightenment. This time Ingen recognized the satori but urged Sokuhi to continue his practice.

A deeper enlightenment came to Sokuhi in 1650 after a forest fire on Mount Huang-po. Sokuhi was helping to fight the fire, which was fanned by a strong wind, when he burned his face, arms, and legs and fell into a trench. His colleagues came to rescue him, and at that moment he experienced his satori. When he presented himself to his teacher, Ingen said, "You have had the experience of a great death and have come alive." The first month of the following year, Ingen gave Sokuhi a whisk in recognition of his understanding, and Sokuhi declared, "With the power of this whisk I will work for the Buddha by going out to teach." Ingen composed a poem for Sokuhi, and from that time on the young monk was considered a Zen master.

When Ingen journeyed to Japan, Sokuhi at first wished to accompany him. Since he was not allowed to do so, he went on pilgrimage, climbing Mount T'ien-t'ai and visiting many famous monks. One of these was Fei-yin, who questioned Sokuhi and recognized his enlightenment. When Sokuhi left, Fei-yin presented him with a large calligraphy, "The Lion Roars," which was later carved into a signboard for Mampuku-ji.

In 1657 Ingen summoned Sokuhi to Nagasaki, where he became abbot of Sōfuku-ji. Mokuan was presiding over Fukusai-ji, so the period became known as the era of "two great monks in Nagasaki." Sokuhi journeyed to Mampuku-ji in 1663 for its opening ceremony, in which he was given an important role, but he did not stay at the monastery; the following year he decided to return to China, as several monks had done. This may have been because Mokuan had been designated as Ingen's successor; Sokuhi may have felt that he did not have a vital part to play in the development of Obaku Zen in Japan.

On his way to Nagasaki to seek passage to China, Sokuhi stopped at the mansion of the daimyo of Kokura (present-day Fukuoka and Ōita prefectures). After the short visit, Ogasawara Tadamasa, his host, pleaded with him to remain in the province. Sokuhi agreed to live there at the Kinritsu-en until a temple could be built for him. Ogasawara thereupon had the Fukushū-ji constructed, and Sokuhi became its first abbot. He stayed there for four years, strengthening Buddhism in that part of Japan.

Sokuhi was noted for his calligraphy, which was influenced by the vigorously angular style of the late Ming master Wang To (1592–1652). There were so many requests for his writing that Sokuhi sometimes refused, admonishing people for their greed. Nevertheless he brushed a great many works, including a few ink paintings. His surviving scrolls show the dynamic brushwork and lively sense of composition that make him one of the most significant Obaku calligraphers.

The most dramatic extant work by Sokuhi is a huge pair of scrolls, *Ocean of Good Fortune, Mountain of Longevity (plate 40).* Written in cursive script with an

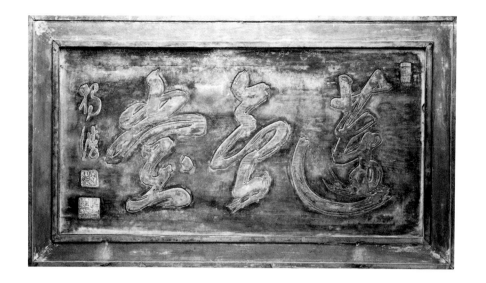

41. Dokutan (1628–1706)
LOTUS FLOWER HALL
Ink, color, and gold leaf on wood
26 × 45 ¹/₂"
Spencer Museum of Art
Lawrence, Kansas

oversize brush, this calligraphy shows the energy and forcefulness of the artist at his peak. Ink from his brush splattered across the paper at the first stroke on each scroll, and a sense of rapid movement animates the characters as though he wrote them in a frenzied burst of creativity. As the brush ran dry at the bottom of the scrolls, the line was hooked back toward the center of the scroll, adding a sense of balance to the dramatic verve of the calligraphy. Nevertheless, the overwhelming impression is of raw, uninhibited energy. This kind of explosive force was not to reappear until the beginning of the twentieth century, when Nantembō attacked paper with brush and ink with similar abandon (see Chapter Seven).

In 1668 Sokuhi retired from Fukushū-ji and returned to Nagasaki, where he lived quietly at his old temple of Sōfuku-ji. Three years later, at the age of fifty-six, he became ill. On the sixth day of the fifth month, he asked his disciples to stay with him for the day. They asked him why, and he said, "The sun is in the south, has the coffin been made?" When his followers asked him to inscribe something for the coffin, he wrote out a large *Ju* (the character for "long life"). When they demanded a final verse, he asked, "Can't I die without a death poem?" Nevertheless, they entreated him until he complied. He then discarded his brush, drank a cup of tea, opened his robe over his chest, and said, "*kaikatsu, kaikatsu*" (fine, fine). A little later he asked, "Is it noon?" One of his disciples replied, "Not yet." At noon, Sokuhi sat up in his bed and died peacefully.

DOKUTAN (1628–1706)

Born in Hsinghua in Fukien province, Dokutan (Chinese: Tu-chan) became a monk as a child and eventually studied at Mount Huang-po with Ingen. In 1654, he accompanied his teacher, along with thirty other monks and artisans, on the great journey to Japan. After completing his studies with Ingen in 1664, Dokutan helped to propagate Obaku Zen in his new homeland, overseeing the construction of Hōrin-ji in Kanasashi (Shizuoka) and of Kokuzui-ji in Shikoku eighteen years later. Dokutan was summoned to Mampuku-ji to become its fourth abbot in 1682, a position he held for ten years.

To adherents of traditional Japanese Zen, one of the most controversial features about the Obaku sect was its admixture of other Buddhist elements, particularly those from Pure Land practices. Dokutan was especially famous for his use of the chant *Namu Amida Butsu,* and he was known as "*Nembutsu* Dokutan" to the populace. In teaching the general public, Dokutan doubtless

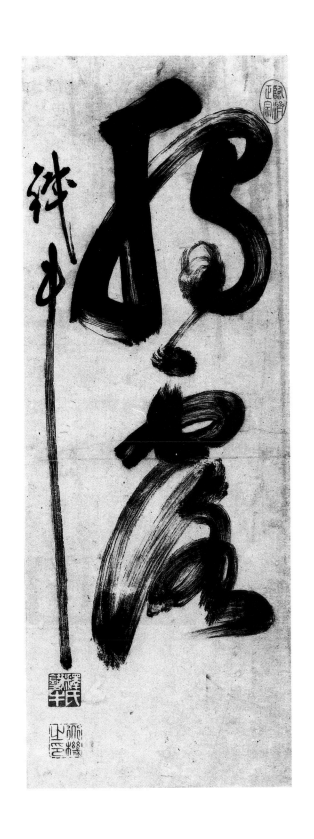

42. Tetsugyū (1628–1700)
SELF REVEALED
Ink on paper
Genshin Collection

found the use of the *nembutsu* helpful for those who could not undertake strict Zen meditational practices. Dokutan also conveyed his Buddhist message through art, painting Buddhist figures such as Amida and Sakyamuni, and he brushed powerful calligraphy in the broad and fluent Obaku style.

Late in his life Dokutan opened Hōfuku-ji in Osaka. Following Obaku practice, he prepared large-scale calligraphy to be carved on wooden plaques for the temple. Although these signboards are rarely seen outside the temples for which they were made, Hōfuku-ji was adapted to another form of Buddhism in recent years, and one of its plaques for the Lotus Flower Hall eventually reached an American museum *(plate 41)*. The calligraphy, in characteristic Obaku style, is broad, massive, and fluent. The slightly varying tilts and balances of the characters, the slender composition of the central word (which seems ready to jump off the board, restrained only by the larger characters to either side), and the expert carving of the cursive script contribute to the total effect.[8] Although the board is weathered from hanging for decades outside a temple hall and the paint is mostly worn away, it retains its majestic presence. Dokutan's energetic calligraphy belies the fact that he was seventy-seven years old when he brushed the signboard. He died two years later at a subtemple of Mampuku-ji.

TETSUGYŪ (1628–1700)

Born to the Namita family in Nagato (present-day Yamaguchi prefecture), Tetsugyū began his studies of Rinzai Zen at Ryūhō-ji with Teishū at the age of eleven. Three years later he formally entered the Buddhist priesthood, practicing under both Teishū and Ryūkei. Tetsugyū may also have been inspired by the Sōtō monk Fūgai, but this is uncertain (see Chapter Two). Teishū and Ryūkei were among the first Rinzai monks to welcome the news of Ingen's arrival; Tetsugyū journeyed with them to Nagasaki in 1655 to meet the Chinese prelate, with whom he decided to study. When Ingen went to Fumon-ji in Osaka the following year, Tetsugyū continued his practice in Nagasaki with Mokuan. Later, he also had the opportunity to study with Sokuhi. Thus Tetsugyū was one of the first Japanese to become an Obaku monk, practicing under the three leading masters (and noted calligraphers) of the new sect.

Because the immigrant Chinese were still restricted in their travel, the task fell upon Japanese monks to spread Obaku teachings throughout the country. Tetsugyū tirelessly performed this duty, opening seven major temples and restoring many others. In 1659 he went to Shōtai-ji in Kanagawa at the behest of Inaba Masanori, daimyo of Odawara. The connection with Masanori, a counselor to the shogunate, was to prove fruitful throughout Tetsugyū's career. In that same year, for example, Tetsugyū persuaded Masanori to arrange permission for Mokuan to visit Ingen in Osaka. When the shogunate gave Ingen permission to build the large temple complex of Mampuku-ji later in the year, the future of Obaku in Japan became secure.

While living in Kanagawa, Tetsugyū pursued his interests in poetry and history as well as in mastering difficult Zen texts. He once called himself "a bookworm in a huge pile of wastepaper," but his manifold activities testify to his sense of religious responsibility.[9] In 1667 he journeyed to Mampuku-ji and received *inka* from Mokuan, who was now prelate of the sect. Tetsugyū also assisted his fellow Japanese Obaku monk Tetsugen (1630–1682) in having woodblocks carved to publish the entire Buddhist canon of scriptures, an immense task that has been accomplished only a very few times.[10]

Zen monks often felt they had social responsibilities, but few were as active as Tetsugyū. One of his most famous accomplishments was in helping to provide new farmlands for cultivation. The most celebrated of these feats was the "Tsubaki New Land" project in Chiba, which involved draining a lake that was more than twenty-five miles wide. The story of Tetsugyū's success offers a revealing look at Japan—as well as at the role of monks—in the seventeenth century. As early as 1639 a man in Edo named Sugiyama had petitioned the shogunate to have this lake drained for cultivation, but since a senior minister opposed the plan, it was denied. Later another entrepreneur named Shirai made a similar request, but he too was unsuccessful. Shirai then went to the chief carpenter for the shogunate, Osabe Saemon, and enlisted his cooperation. With the assistance of the Kuwana daimyo a new petition was made, and this time the shogunate agreed to investigate the area in question. However, the farmers and fishermen living by the sides of the lake feared the new idea, and the shogunate decided against the petition.

Saemon must have been a persistent fellow; he went next to Tetsugyū for assistance. Understanding how many people could be supported if the land were to be cultivated, Tetsugyū approved the plan and brought it to the attention of Masanori. Trusting the Obaku monk, the daimyo used his position as counselor to the government to advance the project, and in 1667 an official survey was made showing that the lake was about fourteen feet higher than the ocean, so the drainage was possible. In 1668 permission was given to a group including Shirai and Saemon, and one year later construction began. Shirai soon ran out of money and withdrew from the project, leaving it to Saemon to construct a drainage canal that had to extend eight miles from the lake to the ocean. In order to dispel the opposition of those living on the shores, Tetsugyū traveled around the lake and assured them of the increased prosperity they would enjoy if the project succeeded.

Before the canal was completed, Saemon became ill and died, leaving the task to his son-in-law Zen'uemon. The costs continued to escalate, however, and the young man appealed to Tetsugyū for help. Again enlisting the aid of Masanori, Tetsugyū was able to raise a large enough sum to insure the continuation of the project.[11] In 1670 lake water began flowing to the ocean, and by the next spring the lake bed was dry. A series of wells and irrigation ditches was then built, and construction was completed in 1674. In total, more than eight hundred *koku* (enough to produce 4,000 bushels of rice yearly) were added to cultivation. Becoming famous for this work of social welfare, Tetsugyū later helped the people of Matsuoka (Shizuoka) to create several thousand new *koku* of rice fields. He also assisted poor farmers in negotiating with officials over land disputes and taxes.[12]

Tetsugyū seems to have spent most of his life in the midst of furious activity. He helped to edit the Buddhist texts of Mokuan for publication, as well as writing several books himself; he lectured to the shogun; he taught more than one thousand followers (thirty of whom became Zen masters); and still he found time for Zen art. He gradually developed a strong and idiosyncratic calligraphy style, based upon that of Mokuan but with his own sense of compositional freedom. One of the boldest examples of his brushwork is *Self Revealed,* a dynamic calligraphy in cursive script *(plate 42).* The two large characters individually can mean "solitary dew," but they are part of the Zen phrase "Self revealed among the myriad things," representing the state of enlightenment. According to Buddhist belief, the life of an individual is no more than a single drop of dew, but within this impermanence exists the inherent Buddha-nature, which needs only to be awakened and brought forth.

Tetsugyū's powerful calligraphy embodies this message in no uncertain terms; his curvilinear brushwork is given weight by occasional strong verticals, including those in his signature, while the breadth of the line is activated by the speed of the brushwork in which "flying white" adds texture to the dynamism of the ink-play. Large, boldly carved seals in Obaku style complete the sense of robust confidence that this calligraphy embodies. Although Tetsugyū certainly was influenced by the skillful brushwork of the Chinese Obaku monks, his dramatic Japanese flair makes his calligraphy unique.

The name "Tetsugyū" literally means "iron bull" and suggests a famous Zen phrase, "The mosquito bites the iron bull." These words describe the sustained effort needed in Zen practice. They also suggest something of Tetsugyū's indomitable character. According to one anecdote, while Tetsugyū was at Dainen-ji in Sendai he was asked by a monk, "What do you do when a mosquito bites you?" Tetsugyū then pretended to hide from the monk, and the monk said, "I understand." Tetsugyū immediately hit him with a stick so hard that the monk temporarily lost consciousness. Tetsugyū thereupon wrote a Buddhist poem for the monk, who found himself enlightened when he revived.

When he sensed his death approaching in the fall of 1700, Tetsugyū put his belongings in order and requested that his ashes be interred in a cave at Jōjū-ji's Mount Yōshitsu. His final poem sums up his irrepressible spirit:

For seventy-three years killing my father, murdering my mother,
Reproaching the Buddha, abusing the patriarchs,
my sins have piled up to the heavens.
If you want to know where my wicker trunk will end up,
Tetsugyū will be sleeping in a rocky cave on Mount Yōshitsu.

SHIN'ETSU (1639–1696)

Tōkō Shin'etsu (Chinese: Hsin-yueh) was a Chinese monk of the Sōtō (Chinese: Ts'ao-tung) sect, but as he too emigrated to Japan, he is often included in general discussions of Obaku. Born near Hangchou, Shin'etsu became a monk at the temple Pao-en-ssu at Wu-wen. After some preliminary Zen practice, he was given the *Mu kōan* to meditate upon by the monk K'uo-t'ang. When Shin'etsu came to his master to try to answer the *kōan,* K'uo-t'ang gave a great shout without listening to him. This happened time after time; finally Shin'etsu went to his master's room, and just as he entered, K'uo-t'ang shouted again. Shin'etsu achieved satori in that instant, received *inka,* and was given a poem from his teacher in commemoration; the year was 1671.

Shin'etsu later stayed at the Yung-fu-ssu temple at West Lake and became known for his artistic talents. He was gifted at poetry, calligraphy, seal carving, painting, and playing the Chinese *ch'in,* the seven-string zither beloved by poets and scholars. By his late thirties, he was accepted as a leading literatus and noted Zen monk in southern China.

Despite his many accomplishments, Shin'etsu was unhappy under the new Manchu rulers of China, and after he received an invitation in 1677 from a monk at Kōfuku-ji in Nagasaki, he decided to emigrate. When he arrived in Japan, he was welcomed by Mokuan, but since he would not acknowledge the primacy of the Obaku leaders, Shin'etsu seems to have been kept in a form of temple confinement, reportedly at the behest of several monks, including Tetsugyū. When Mitsukuni, the daimyo of Mito in northern Japan, heard of

this unfortunate situation, he invited Shin'etsu to come to his domain. Special permission had to be obtained for any Chinese to leave Nagasaki, however, and five years passed before Shin'etsu was allowed to travel to Mito in 1683. There the daimyo had the temple Tentoku-ji enlarged and renamed Gion-ji, and Shin'etsu became its first abbot in 1692 at a grand opening ceremony attended, it is reported, by seventeen hundred monks.

Shin'etsu was a religious leader of some consequence, but his influence in musical and artistic matters was even more important. He personally trained a large number of pupils on the *ch'in,* which had first been known in Japan during the Nara and Heian eras but had lost its popularity during the Kamakura epoch. Shin'etsu almost single-handedly revived the playing of this instrument in Japan; it remained popular among literati until the beginning of the twentieth century, when it again fell from favor. In its heyday, *ch'in* playing was considered in Japan to be a form of musical meditation that could lead to enlightenment.[13]

Shin'etsu is also known, along with Obaku Dokuryū (Chinese: Tu-li, 1596–1672), as one of the fathers of Japanese seal carving. Shin'etsu was not only highly skilled at the technique of carving, he also brought with him Chinese books of seal-script forms that were far more extensive than those known in Japan prior to this time. With a greater variety of character forms to choose among and a larger range of materials to carve, including stone and crystal, Japanese monks, artists, and scholars welcomed seal carving as a cultivated art.

In his calligraphy, Shin'etsu practiced an elegant form of running script derived from the late Ming dynasty style of Tung Ch'i-ch'ang, and he also excelled at the formal style of clerical script, which was little practiced in Japan. Shin'etsu was an accomplished painter too, rendering figure subjects in an elaborate late Ming style. His portrait of *Daruma Crossing the River (plate 44)* displays his expert brushwork. The detailed portrayal of the patriarch's face, the curly mustache and beard, the bending ear, the wrinkles around the eyes, and the use of shading all show some influence from the *chinsō* tradition. Compared with Fūgai's painting of the same subject *(plate 26),* this style lacks simplicity, but its high quality of refined brushwork makes it worthy of admiration. Shin'etsu's verse inscribed over the painting ends with a reference to a poetic line attributed to Daruma, "One flower opens to five petals":

In the Liang Imperial Palace he would not explain who he was,
But crossed the river with sealed lips and piercing eyes
Until he arrived at complete tranquillity:
A single flower, five petals together in the spring.[14]

Despite his skill in figure subjects, Shin'etsu's most important contribution as an artist was in his renditions of the "four gentlemen" themes: bamboo, orchids, chrysanthemums, and plum blossoms. These had been developed as sophisticated forms of ink-play in China, but after an initial flurry of interest in the early Muromachi period, Japanese artists had not found these subjects very appealing. Since the brushwork utilized in depicting them was strongly calligraphic, the subjects were enjoyed by the scholar-amateurs (literati) in China and were revived in Japan during the seventeenth century by Obaku monks and Shin'etsu. Each of these plants had symbolic values; bamboo, for example, remained green through the winter and bent but did not break in the wind. A gentleman was likewise supposed to remain steadfast even in hard times, flexible in his views but loyal to his ideals.

One of Shin'etsu's finest paintings is his *Bamboo in the Wind (plate 43)*. The brushwork is crisp. Leaves ranging in size from short and thick to long and thin are rendered in two tones of ink. The composition is also organized in dualities, with a vertically arranged clump of leaves on the left and a horizontal clump on the right. Two culms reach down at a strong diagonal; their leaves both echo this diagonal motion and create a counterbalancing diagonal to the left. This sense of movement is strengthened by the calligraphy that emphasizes thickening and thinning diagonal strokes of the brush. Shin'etsu's poem evokes the spirit of his painting:

Many stalks and many leaves in the rain,
Sometimes sparse, sometimes dense in the wind.

Although pictorial composition, ink tones, and the placement of the calligraphy are all vital to this kind of literati painting, the brushwork itself is the most important element. Here the technical mastery is matched by a vigor and clarity that display Shin'etsu's character.

In 1696 Shin'etsu became ill, and Mitsukuni came to visit him. The monk asked the daimyo to continue his support of Buddhism and then prepared his death poem. On the thirtieth day of the ninth month he sat in his abbot's chair and told his disciples:

I have lived for more than fifty years,
Floating in the sea of birth and death—
There is nothing to grasp.

Although Shin'etsu died at the relatively early age of fifty-eight, his influence remained strong in Japan throughout the Edo period. His poems and other writings were published in the two-volume *Tōkō zenshū,* which also included examples of his seal carving and illustrations of his paintings. He compiled a book of *ch'in* pieces, which was used by his pupils and then by several generations of their own students. Ultimately, Shin'etsu's cultural impact was stronger than that of his religious teachings; during his almost two decades in Japan he was able to bring the ideals of a Chinese literatus to fruition in his new homeland.

43. *Shin'etsu (1639–1696)*
BAMBOO IN THE WIND
Ink on paper, 25 1/4 × 11 1/2"
Mr. and Mrs. Myron S. Falk, Jr.

梁皇殿上不戡緘唇
怒合杭津直坐安心
已竟乙苓五葉果督

東皐越枯多寫前

44. Shin'etsu (1639–1696)
DARUMA CROSSING THE RIVER
Ink on silk, 39¹/₄×13⁵/₈"
Private Collection

45. *After Hishikawa Moronobu*
(c.1618–1694)
RYŌNEN BURNING HER FACE. *1844*
Woodblock-printed book
6³/₄ × 10³/₄″ (image size)
Private Collection

RYŌNEN GENSO (1646–1711)

Although Zen nuns were not uncommon, Ryōnen Genso was one of the few to achieve renown, becoming celebrated both for her spiritual and artistic achievements. She was born in a mansion just outside the gates of Sen'yū-ji, an imperial temple in Kyoto, to a noble family that traced its ancestry back almost a thousand years.[15] Her father, Katsurayama Tamehisa (1600–1673), a descendant of the famous warrior Takeda Shingen (1521–1573), was a cultured layman of the Rinzai Zen sect. He was known for his expertise in calligraphy and the tea ceremony, as well as for his knowledge of old paintings. Ryōnen's mother, who died in 1685, came from the courtly Konoe family and served the imperial concubine Tōfukumon'in (1603–1674).

As a child, Ryōnen was considered intelligent as well as beautiful, and she followed her mother's lead in serving at court. From ages seven to twelve she was a companion of Tōfukumon'in's granddaughter and grandson. She also learned various arts and accomplishments at this time, including calligraphy and *waka* poetry. While Ryōnen was in service at the imperial court, both her younger brothers became Zen monks. Umpō Genchū (1647–1712) entered an Obaku-sect temple at the age of seven, while Daizui Genki (1652–1717) entered the Rinzai temple of Nanzen-ji (where both his parents were to be buried) and later received a certificate of enlightenment in 1690 from Obaku Kōsen (1633–1695).[16] It is curious that Ryōnen and both her brothers died upon reaching the (Japanese) age of sixty-six.

Returning home from court for her adolescent years, Ryōnen continued her studies of poetry. At the age of sixteen or seventeen, as was customary at the time, she entered into an arranged marriage; the go-between was Konoe Motohiro, a grandson of Tōfukumon'in who had been her childhood companion. Her new husband was the Confucian scholar and doctor Matsuda Bansui (also known as Ju'an, 1630–1703). They had several children; accounts differ, but the correct number is probably four, one of whom may have died in infancy.

After ten years of marriage Ryōnen became a nun in 1672, perhaps by prior agreement with her husband. She seems to have arranged for a concubine to

take care of her family and thereupon entered the imperial Rinzai temple Hōkyō-ji in Kyoto, which was led by Emperor Gomizuno-o's daughter Princess Zen'ni. After six years at this "women's temple," Ryōnen traveled to Edo for further Zen study. She first visited Kōfuku-ji to have an audience with Obaku Tetsugyū, who told her she was too beautiful to enter his temple because she would become a distraction to his followers. Ryōnen then went to the Zen hermitage Daikyū-an. There she met Haku-ō Dōtai (d. 1682), who had been a pupil of Obaku Mokuan's with Tetsugyū, receiving the certificate of enlightenment in 1675. Haku-ō, however, also told her that he could not admit her, whereupon Ryōnen resorted to the drastic action that made her famous.

One of Ryōnen's calligraphic works *(plate 47)* tells her story in her own words, followed by poems she composed at the time in both Chinese and Japanese styles:

When I was young I served Yoshino-kimi, the granddaughter of Tōfukumon'in, a disciple of the imperial temple Hōkyō-ji. Recently she passed away; although I know that this is the law of nature, the transience of the world struck me deeply, and I became a nun. I cut my hair and dyed my robes black and went on pilgrimage to Edo. There I had an audience with the monk Haku-ō of the Obaku Zen sect. I recounted to him such things as my deep devotion to Buddhism since childhood, but Haku-ō replied that although he could see my sincere intentions, I could not escape my womanly appearance. Therefore I heated up an iron and held it against my face, and then wrote as my brush led me:

Formerly to amuse myself at court I would burn orchid incense;
Now to enter the Zen life I burn my own face.
The four seasons pass by naturally like this,
But I don't know who I am amidst the change.

 In this living world
the body I give up and burn
 would be wretched
if I thought of myself as
anything but firewood.

46. *Ryōnen (1646–1711)*
OAK-TREE KŌAN
Ink on paper, 10³/₄ × 16¹/₄"
Borsook Collection

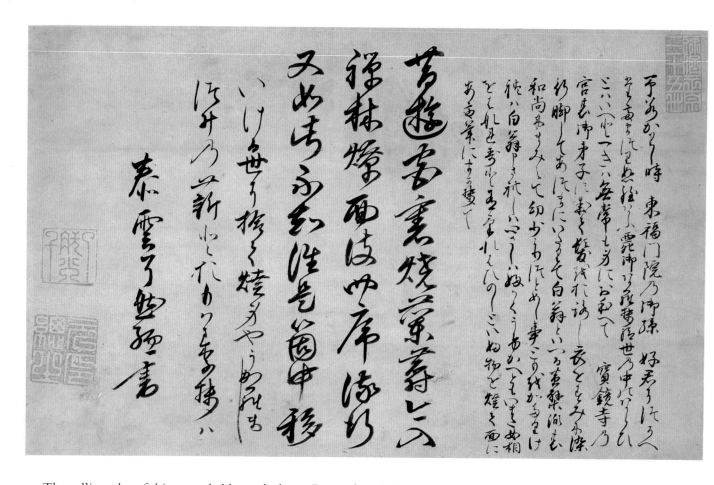

The calligraphy of this remarkable work shows Ryōnen's training at court in the Shōkadō tradition (see Chapter One) and her practice of Chinese T'ang dynasty models, but it also displays the fluency derived from the style of the Obaku monks. Ryōnen combined these different influences into a personal method of brushwork, alternating darker and lighter, wetter and drier strokes to impart an individual rhythm to the characters. A few diagonal lines join characters together, and many words end with circular shapes. The overall impression is of calm yet inexorable movement from one stroke to the next, as though the extraordinary event she describes was as natural and inevitable as the continuous flow of life. There is nothing obviously appealing in this scroll; the work is small in size, but its rich meaning is expressed with an equal depth of artistry.

The story of Ryōnen burning her face with an iron became famous and was depicted in the woodblock book *Kinsei meika shogadan* ("Famous Calligraphers and Painters of Recent Ages"). In this nineteenth-century print, onlookers rush forward in dismay as she calmly disfigures herself *(plate 45)*. The drastic action of the nun was successful; Haku-ō was so impressed with her dedication to Zen study that he allowed Ryōnen to enter the Daikyū-an. She became his leading pupil, and he granted her a certificate of enlightenment in 1682, the year he died.

Ryōnen wished to construct a temple in honor of Haku-ō, but this was almost impossible since the shogunate at that time would not allow anything more than the renovation of old temples; and even for that, permission was difficult to obtain. It took some years before her requests were granted; in the meantime Haku-ō had died, but this responsibility only became the more important for Ryōnen. She was given land in Ochiai, just outside of Edo, in 1693, and she renovated a ruined temple named Renjō-in by overseeing the construction of a new Kannon Hall. Haku-ō was posthumously named founder of the new Renjō-in, and Ryōnen became second abbot. In 1701 the

47. *Ryōnen (1646–1711)*
AUTOBIOGRAPHICAL POEMS
Ink on paper, 11 × 17 1/2"
Private Collection

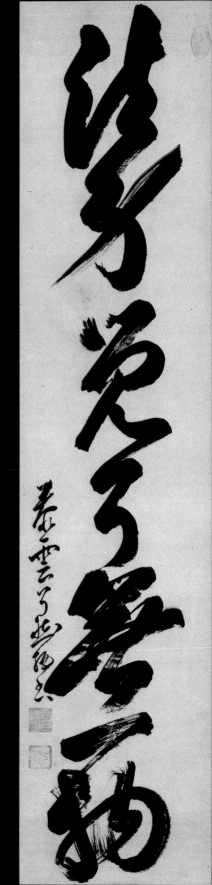

48. *Ryōnen (1646–1711)*
THE COMPLETELY
ENLIGHTENED DHARMA BODY

Renjō-in was expanded and became a full monastery, the Taiun-ji. Ryōnen had been planning this expansion for some years, having commissioned a calligraphic plaque reading "Taiun-ji" from Obaku Mokuan, who died in 1684.[17]

As temple abbot, Ryōnen was known for her good deeds, which included building a bridge over a nearby canal. She was also famous for her scholarship: the Taiun-ji became known as a center for Obaku learning, and children from nearby villages received their education at the temple. She was most celebrated, however, for her cultural achievements, which included poetry, calligraphy, and painting. The *Kinsei meika shogadan* reproduces one of her Chinese-style poems in her own distinctive hand. The poem describes her sadness in leaving a friend:

SEARCHING FOR THE BEAUTY OF THE SPRING MOON,
FOLLOWING THE STYLE OF AN AUTUMNAL POEM

As old age draws near, inclined towards melancholy as the seasons pass,
I patiently live on, watching the blossoms fall—
As we part, I know it will be difficult to meet again;
Instead I must comfort myself with travel as I face the end of springtime.

Talented in traditional Japanese poetry as well as in Chinese-style verse, Ryōnen completed a *waka* collection entitled *Wakamurasaki* ("Light Purple") in 1691, but unfortunately it is no longer extant. Her diary also no longer exists; it was lost in a great fire of 1811, when painted and sculptural portraits of Ryōnen were also destroyed.

Ryōnen's skills included painting; among her works are portraits of the early Obaku patriarchs in Japan, such as a triptych of Ingen, Mokuan, and Sokuhi that is now in the collection of the Hōden-ji.[18] These portraits followed the orthodox Obaku *chinsō* style and are doubtless direct copies of works Ryōnen had seen, since she probably had not met the earlier Obaku masters in person.

Ryōnen was considered by some of her admirers to be the most talented woman of the early Edo period. In replying to a letter she had sent him, her younger brother Umpō wrote in part:

The mountain blossoms spread their brocade, the orioles tune their ch'in, and I sit myself at the window with a view of pines. Suddenly I am brought your precious missive; I jump up and respectfully read it out. . . . Humbly I consider that the land of Japan for nearly three hundred years has gone without a woman of wisdom. Now that you have taken on this weighty position, it can be said to be like a lotus blossoming in the midst of fire, or a unicorn or phoenix appearing in this world.[19]

Other contemporaries also wrote about Ryōnen. For example, in 1689 the poet Bō-okushi (dates unknown) published a book entitled *Sayogoromo* ("Night Covering"), which included the following *waka* poem:

Mi o sutete	*Body discarded*
bodai no michi ni	*for the road to Buddhahood—*
iriai no	*the evening bell*
chishin ga an ni	*sends its resounding peal to*
hibiku kane no oto	*the wise heart in the temple*

The word *chishin*, meaning "wise heart," is also the pronunciation for one of Ryōnen's names, adding an even more personal touch to the poem.

Ryōnen's own calligraphic works are rare, but one scroll has as its text the *kōan* that is the famous 37th case from the *Mumonkan:* when a monk asked Jōshū, "What is the meaning of the Bodhidharma's coming from the West?" he answered, "The oak tree in the garden." We have seen Mokuan's bold calligraphy of the question *(plate 39);* Ryōnen, by contrast, wrote the entire *kōan* in small running-cursive script, concluding with the date of midwinter 1702 and the signature "Written by Ryōnen of the Taiun-ji" *(plate 46).* The calligraphy is modest but fully demonstrates Ryōnen's skilled and confident brushwork. She created a unity among the characters not by connecting them directly, but by ending each character with a movement of the brush turning toward the first stroke of the following character. Rhythm is added to this flowing motion by the alternation of darker wet-ink characters and those with lighter touches of "flying white." Since Ryōnen dipped her brush in ink variously after two, sometimes three, and occasionally four characters, the uneven rhythm of heavier and lighter graphs creates a pleasing sense of asymmetry that is bolstered by the five columns of writing. The brushwork itself, despite its modest flavor, repays repeated viewings. Vertically accented characters predominate over those with a horizontal thrust. Shapes are contrasted with occasional blunt and angular lines, and there is no sense of hesitation. Ryōnen conveyed controlled spontaneity with unerring skill; her calligraphy demonstrates a personal fusion of Japanese and Chinese artistic values that she had developed from her court background and her Obaku training.

Ryōnen was also distinguished in larger-size calligraphy. One of the few examples still extant is a single-column rendering of a seven-word poetic line from the "Song of Enlightenment" by Yung-chia (d. 713), *The Completely Enlightened Dharma Body Has Not One Thing (plate 48);* the original Chinese text continues, "the original source of self-nature is the true Buddha."[20] Ryōnen's calligraphy displays the full-bodied Obaku style, combining fluency with strength of brushwork. The first two characters, which mean "Dharmakaya" (spiritual body), are joined together and end with a powerful, sharp diagonal. The next two, "completely enlightened," begin with an interesting use of split-brush technique and are also joined. They lead to a strong *Mu* ("has not"), set off by itself with a powerful horizontal stroke in dry brushwork. The final two characters, "one thing," are joined together, so that as one reads down the scroll there is an asymmetrical rhythm of two, two, one, and two characters, with the single one being the crucial word *Mu.* The flow of the calligraphy and the gradual drying of the brush demonstrate the single gesture with which Ryōnen created the entire scroll; only the signature at the left and the seals were added after the first burst of inspiration. The signature also seems to lead toward the *Mu,* which acts as a kind of barrier, halting the smooth and rapid downward movement of the calligraphy and thus emphasizing the words "not one thing."

In 1703 Ryōnen's former husband died, and she erected a memorial stone at the Taiun-ji. Ryōnen also had a memorial stone inscribed in memory of Haku-ō in 1711, showing her continuing devotion and respect for her teacher.[21] In the late fall of that year, sensing her own death approaching, Ryōnen composed a final poem:

In the autumn of my sixty-sixth year, I've already lived a long time —
The intense moonlight is bright upon my face.
There's no need to discuss the principles of kōan *study;*
Just listen carefully to the wind outside the pines and cedars.

49. *Taihō (1691–1774)*
BAMBOO. *1724*
Ink on paper, 45 1/2 × 14 5/8"
Private Collection

TAIHŌ (1691–1774)

One of the last Chinese immigrants to become abbot of Mampuku-ji was Taihō (Chinese: Ta-p'eng), who was born in Ch'uanchou, Fukien province. He became a monk at the age of sixteen and emigrated in 1722 to Japan, where he completed his Zen studies under Zengan. Taihō became abbot of Mampuku-ji in 1745 but retired three years later. During this era, the transition from Chinese to Japanese patriarchs of the sect was taking place. There were some difficulties and dislocations between the traditionalists and those who favored a more complete Japanization of the sect. Taihō was prevailed upon to resume the abbotship of Mampuku-ji from 1758 to 1765. He was thus both the fifteenth and the eighteenth patriarch of Obaku Zen.

Taihō was a cultivated artist with skills in poetry and calligraphy, but he became especially renowned for his paintings. He was already a specialist in depicting bamboo by the time he came to Japan; a scroll of bamboo done in 1724, two years after his arrival, shows his individualistic technique *(plate 49)*. The culm is unusually thick, although there is a smaller stalk growing beside it. Leaves are clustered in a unique crisscross manner, with occasional large single leaves flying off into space. The concept is dramatic; the strong, confident brushwork and the bold composition based upon slightly curving verticals show why Taihō proved to be popular and influential as a painter in his new homeland. He inspired not only his direct pupils but later artists of the literati school.[22]

Taihō's particular specialty is seen in his mature scroll of *Bamboo in Snow* *(plate 50)*. Painting a gray wash on the silk almost up to the edges of the bamboo leaves and stalks, Taihō left a slightly jagged clear space to suggest snow clinging to the bamboo. The central culms are rendered in Taihō's characteristic blunt brushstrokes, although there is a greater range of tonal contrasts than in his earlier work. The groupings of the leaves, now gently downward rather than youthfully growing upwards, show the artist's predilection for crisscrossing patterns of movement. With a few individual leaves in dark ink adding accentuations to the lower part of the scroll, Taihō displayed great compositional freedom in creating dense and open areas to build up a rich and complex design. Compared with the bamboo by Shin'etsu *(plate 43)*, Taihō's painting has less elegance and more overt dynamism, but this work also shows the subtle touch that the Obaku monk developed in his later years.

As a young child, the literati artist Ike Taiga (1723–1776) was taken to Mampuku-ji to demonstrate his prowess at calligraphy. He became friends with Taihō and followed his style in later years.[23] Other Japanese painters such as Gion Nankai (1676–1751) and Taiga's pupil Kuwayama Gyokushū (1746–1799) followed Taihō's style even more closely in some of their depictions of bamboo, demonstrating the strong influence of the Obaku monk upon literati artists of the eighteenth century.[24] Taihō's religious teachings, however, were not so influential in Japan. The great days of Obaku Zen as a new and stimulating form of religion were now over. After Taihō's era, it became customary for Japanese monks to head the Obaku sect, and eventually the influence of Hakuin (see Chapter Four) was to overcome many of the Chinese elements in Obaku teachings. While Obaku remains the third largest Zen sect in Japan, its power and vigor have declined gradually since the eighteenth century.

HAKUIN
EKAKU

Within the Meditation Hall

I am hated by the thousand Buddhas;

In the company of myriad demons

I am despised by the myriad demons.

Both for his teachings and for his art, Hakuin Ekaku (1685–1769) was the most influential Zen monk of the past five hundred years. He not only revived and reorganized the Rinzai tradition, but he also reached out to every Japanese—Confucian, Buddhist, and Shinto alike—with his writings and paintings. He was able to communicate effectively to a broad spectrum of people, from nobles and samurai to artisans and farmers. His training of disciples was strict and thorough, but he also showed sympathy, humor, gentleness, and encouragement toward those of different beliefs. His acrimony was reserved only for those who taught what he regarded as "false Zen." Hakuin's writings are voluminous, from complex Zen commentaries to verse for folk songs; many of his works have been translated into English, so that the range of his teaching is readily available in the West.[1]

Hakuin's calligraphy and paintings were brushed in the latter part of his life. What are regarded as "early" works date from his sixties, and he continued to develop and deepen his expression until his death at the age of eighty-four. He turned to brushwork more and more frequently in his last two and a half decades, showing his dedication to a transmission of spirit beyond words. In so doing, he thoroughly revitalized the Zen tradition of painting and calligraphy. Hakuin not only poured new energy and vigor into familiar themes, such as portraits of Daruma and Hotei, but he also introduced dozens of new subjects into Zen art. Some of these themes came from his own Zen teachings, others from observation of the world around him, and still others from folklore, often invested with his own wry humor.

Although it is not a feature of most religions, humor has long been associated with Zen. The mind-breaking paradox of the *kōan* is akin to the destruction of logic in jokes, puns, or slapstick actions, all of which require the mind to leap to a fresh viewpoint. Zen masters have often utilized humor over the ages, but none as fully as Hakuin in his paintings and inscriptions, which contain puns, startling images, animal-human transformations, deliberate paradoxes, and parody. The result of his turning to brushwork to express his Zen vision was an unprecedented avalanche of painting and calligraphy that spread his wit and wisdom throughout Japan, profoundly influencing the development of Zenga. More than one thousand of Hakuin's works survive, forming a spiritual and artistic legacy that continues to inform and delight Zen practitioners and lay viewers alike.

Hakuin began and ended his life in the village of Hara, near Mount Fuji on the famous Tōkaidō Road, which connected the new capital of Edo (Tokyo) with the ancient capital of Kyoto. Hakuin's father was adopted through marriage into his mother's family; the future monk was the last of their five children, born on the twenty-fifth day of the twelfth month of 1685 (corresponding to early 1686 in the Western calendar).

Hakuin's mother was a devout Buddhist. She took her son when he was seven or eight years old to a temple in Hara, where they heard Nichigon Shōnin, a famous traveling monk of the evangelistic Nichiren sect, give a lecture that must have equaled the fire-and-brimstone sermons of fundamentalist preachers in frontier America. In Hakuin's words:

People came from far and near, flocking in like clouds. . . . We heard him describe, in graphic detail, the torments of the eight burning hells. He had every knee in the audience quaking. Their livers froze in icy fear. I was only a small child, but I was surely no exception. My whole body shook with mortal terror.[2] . . . Returning home, I took stock of the deeds of my short life and felt that there was little hope for me. . . . From this time on I determined to myself that I would leave home to become a monk.[3]

At first Hakuin's parents would not consent to their son's desire to be a monk, but after he climbed Mount Yanagizawa to meditate when he was thirteen, they became aware that his wish to enter the Buddhist priesthood was not merely a childish fancy. Hakuin began his Buddhist studies at Tokugen-ji in Hara at age fourteen; soon after he moved to the Shōin-ji, also in Hara, where he took part in a ceremony for acolytes and received the name Ekaku. The following year, 1699, he moved to the Daishō-ji in nearby Numazu to study with Sokudō Fueki (also known as Nyōka; d. 1712), who was to be Hakuin's master for four years. At this time, the young monk studied not only Zen but also the Confucian classics and Chinese literature, which were standards of education in his day.

At age nineteen, Hakuin attended Buddhist lectures at Zensō-ji in Shimizu, but hearing that one famous Zen monk had met a violent death at the hands of bandits, he was greatly troubled. If an enlightened monk could be assaulted by bandits while still alive, what would happen to an ordinary monk like himself when he died? Although Hakuin had chosen the path of Zen, he was still expecting Buddhism to provide an escape from his fears of hell, and when it did not, it seems he lost much of his faith in religion. He finally decided that if he could not avoid the tortures of hell, he would leap into the fire with every-one else.

With his trust in religion at a low ebb, Hakuin turned his attention to literature and calligraphy. "I resolved to gain universal praise as one of the master artists of the age," he wrote later.[4] He studied the major poets of the T'ang dynasty, while practicing the calligraphic styles of Prince Sōn'en (a master of the Kamakura period whose works had become standard models of elegant writing in Hakuin's day) and of Terai Yōsetsu, an Edo-period practi-tioner and teacher of Chinese literati calligraphy.

Hakuin did not, however, abandon his religious quest; in fact, he redoubled his efforts to seek out Zen masters who could help him to reach enlighten-ment. At the age of twenty he went on pilgrimage with a group of other young monks. Reaching the Zuiun-ji in Hino, Hakuin decided to remain there in order to practice under the learned but extremely strict monk Baō Sōchiku (dates unknown). Living in poverty without complaint, Hakuin practiced Zen while continuing his literary studies. He realized, however, that even if he became a great poet, he would still not escape suffering in his future lives. During the next two years, Hakuin traveled to hear lectures by noted monks and to attend Zen meetings, but he returned to Zuiun-ji periodically until he eventually ran out of funds. At this point he heard that at the small temple Shōshū-ji in Matsuyama even a penniless monk could survive on the dona-tions of prosperous local farmers. He settled at this temple and continued his Zen and literary practice.

On a visit to a military retainer of the local clan, Hakuin saw a calligraphy by Ungo (see Chapter Two).[5] Its simplicity and power deeply impressed him, and Hakuin realized that it was not skill that mattered, but rather the inner character of the writer shining through in the calligraphy. When he returned to the temple, Hakuin burned his meager collection of brushwork, including the works he had written. From that time forward, he abandoned his artistic ambitions and devoted himself totally to Zen.

Beginning the next year, at the age of twenty-four, Hakuin started to have enlightenment experiences as he continued to travel. His concentration was so deep that when he visited his home he could give only unresponsive grunts in answer to questions from his family. His first satori came when meditating on the *Mu kōan* at Eigan-ji in Echigo (Niigata):

Night and day I did not sleep; I forgot both to eat and rest. Suddenly a great doubt manifested itself before me. It was as though I were frozen solid in the midst of an ice sheet extending tens of thousands of miles. A purity filled my breast, and I could neither go forward nor retreat. To all intents and purposes I was out of my mind and the Mu *alone remained. . . . This state lasted for several days. Then I chanced to hear the sound of the temple bell and I was suddenly transformed. It was as if a sheet of ice had been smashed. . . . All my former doubts vanished as though ice had melted away. In a loud voice I called, "Wonderful, wonderful."*[6]

According to his own account, Hakuin's first enlightenment experience made him proud and arrogant; he felt that he had reached the ultimate in understanding. He soon discovered that this was not the case. When he visited the Shōju-an in Iiyama (present-day Nagano), the monk Dōkyō Etan (1642–1721) asked him, "What about the dog and Buddha-nature?" "There's no way for hand or foot to touch it," Hakuin replied. The master then reached out and grabbed Hakuin's nose in his hand and gave it a sharp push. "How's that for a firm touch!" he declared. Hakuin could not speak a word. He was disheartened and frustrated.[7] At his new teacher's urging, he meditated ceaselessly on another *kōan,* finally achieving a deeper enlightenment while begging in a village below Iiyama Castle. In a trance, he suddenly penetrated the *kōan;* laughing and clapping his hands, he frightened the villagers who had gathered around him. Dōkyō recognized the awakening, urging Hakuin never to be content but to practice continually in order to deepen his enlightenment.[8] Hakuin revered Dōkyō for the rest of his life, often recalling the strictness and strength of his teachings. The year before his death, Hakuin wrote of his former master:

He was a blind old bonze filled with deadly venom—true and authentic to the core. He was always telling students: "This Zen school of ours began to decline at the end of the Southern Sung. By the time it had reached the Ming the transmission had fallen to earth, all petered out. Now, what remains of its real poison is found in Japan alone. But even here there's not much. It's like scanning the midday sky for stars. As for you, you smelly blind shavepates, you raging little lackwits, you haven't stumbled upon it even in your dreams. . . . You're imposters, the whole lot of you. You look like Zen monks, but you don't understand Zen. . . . What, then, are you really like? I'll tell you. Large rice-bags, fitted all out in black robes."[9]

Over the next few years Hakuin had a number of satori experiences. They came variously while he was reading a Zen text, running through a rainstorm, listening to the sound of snow falling, and practicing walking meditation at a temple. These experiences brought him profound joy, but unfortunately he had developed what is called "meditation sickness," a serious health crisis that both monks and doctors considered incurable. Acupuncture, *moxa,* and herb medicines all failed to help him. Hakuin was advised to rest, but he felt it necessary to care for his teacher Dōkyō, who was himself ill at that time.

Describing his meditation sickness, Hakuin later wrote that he had lost his ability to balance activity and nonactivity. Due to constant meditation, "an unnatural heat had taken hold unnoticed in my heart, sending my blood up; the fever affected my lungs, drying up their essential fluids. Before I knew it, I had developed an incurable condition of the heart."[10] Finally, when another monk came to the Shōju-an to take care of Dōkyō, Hakuin was free to seek some relief from his sickness. After journeying extensively to find someone

who could help him, he heard of a recluse named Hakuyū (1646–1709?) living in the mountains near Kyoto, who was skilled in medical lore. Hakuin later wrote that he visited Hakuyū, supposedly in the first month of 1710, and what he learned profoundly affected his own life and teachings.[11] Hakuin left several extensive descriptions of Hakuyū's diagnosis and treatment; most popular was the *Yasen kanna* of 1757, which includes the following words from the hermit:

Your meditation has been too unmeasured and your asceticism too strict. . . . When the five activities—obtaining nourishment, movement, perception, study, and realization of the purpose of life—are out of harmony, then the structure of the body goes wrong. . . . The man of character looks after the needs of the body in a reasonable way. . . . Facing your previous overmeditation, you are now seeing severe sickness. . . . Gather together the flames of your heart and place them under your navel and below your feet, then your whole chest will become cool. . . . Energetically fill the lower part of your body with spiritual energy, this is essential for nourishing life.[12]

Hakuin adopted this principle of concentrating his attention and breathing from below the navel, calling it "introspective meditation." He taught it to his students and followers as a vital part of their Zen training. This was one of several aspects of meditation that he emphasized. Although he continued teaching the traditional Zen method of meditating upon a *kōan*, he also stressed that meditation in the midst of activity was even more important than meditation in stillness. One could not just renounce the world and live on a mountaintop; it was even more important to carry the sense of meditation into everyday activities. His own sickness was cured completely over the next three years, and his health remained strong until he was in his seventies.

In 1712 Hakuin, still on pilgrimage, was invited to lecture at his original temple of Shōin-ji in Hara; he then continued his travels. He visited many noted Zen masters, not always finding them deeply enlightened but achieving for himself more wondrous satori experiences. The illness and death of his father in 1716 brought Hakuin back to Hara, and as a result he decided to rescue Shōin-ji from its decrepit condition. In 1718 he went to Kyoto, where he became *dai ichiza* (first monk) at Myōshin-ji, but he did not like the administrative, economic, and quasi-political pressures of a major, big-city monastery. He soon returned to Shōin-ji, which remained his home for the rest of his life.

By living in a small temple in the countryside, Hakuin avoided the obligations that monks owed their influential patrons at established Zen monasteries. He also kept himself clear of government interference in temple affairs such as the succession of abbots. Hakuin devoted himself instead to the spiritual well-being of the villagers of his native region and to training the ever-greater number of monks who came to him for instruction. His form of Zen organization would not accept regular donations from wealthy patrons. As a result, Hakuin's temple was poor, but it also remained free from outside social or political influences.

Although he remained for the most part at Shōin-ji, Hakuin did not refuse when asked to lecture at Zen meetings, and over the following years he often traveled to temples in various parts of Japan. His first works had been written a few years earlier; these included a volume of cautionary tales for a profligate friend and a compilation of poems and Zen phrases. By his mid-thirties, Hakuin's writings and his lectures on traditional Zen texts, such as the *Hekiganroku kōan* collection, gained him increasing fame.

In 1737 Hakuin was invited to a lecture meeting at the Rinzai-ji in Izu; as a memento, the *Jōzan hyakuin,* a compilation of one hundred poems by the monks present at his visit, was published. After he returned home, monks as well as samurai, doctors, scholars, and even secret officers of the shogunate came to visit him, despite the isolation of his temple.[13] Perhaps the most significant of Hakuin's lecture meetings took place in 1740 at the Shōin-ji. After great efforts by his disciples to repair the temple and gather food for the occasion, he gave a series of talks on the *Kidōroku* ("The Records of Hsu-t'ang") for more than four hundred monks and laymen. However, when the talks were published three years later, Hakuin wrote deprecatingly about himself:

Thoroughly scrutinizing my life, I can discover nothing worthy of others' respect. I can claim no moral worth for them to esteem. I am ignorant of poetry. I don't understand Zen. I'm as lumpish and indolent a man as can be found. I float heedlessly on. . . . You won't find much resemblance between me and a real Zen teacher. . . . I'm a lost cause.[14]

Why so self-effacing? Hakuin no doubt maintained a true humility that is not always encountered in Rinzai Zen monks, but he may also have been making a kind of Zen joke, in which everything is turned upside-down: the monk who claims to understand Zen is the one to avoid. Hakuin was also specifically warning his followers that they could not expect a teacher to bring them to enlightenment; they would have to achieve it for themselves, or it could not be done.

Whether despite or because of Hakuin's attitude, from this time on so many monks came to study with him that the Shōin-ji could not accommodate them all, and the entire area for three miles around became a training ground for his followers. Many of his major pupils, including Reigen and Tōrei (see Chapter Five), began their studies with him around this time.

In 1741 Hakuin wrote commentaries on both the poems of the Chinese recluse Han-shan (Japanese: Kanzan) and on the *Heart Sutra,* the most popular of all Buddhist texts in Japan. Although this sutra was supposed to have been promulgated by the bodhisattva Kannon, Hakuin attempted to awaken his

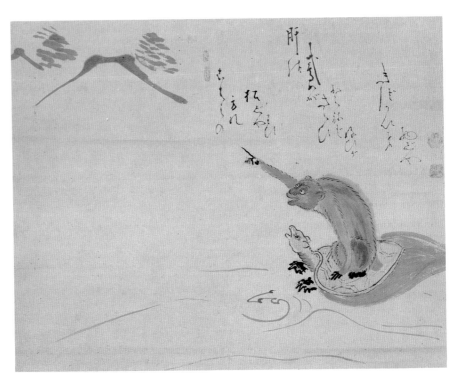

51. Hakuin (1685–1769)

MONKEY AND TORTOISE

Ink and color on paper, 17 1/4 × 21 7/8"

Shin'wa-an Collection

students by pretending to criticize the text, commenting, "What's he saying? He's just making waves . . . Bah . . . Trash! What a useless collection of junk!"[15] Following one of the most important phrases of the sutra: "Form is no different from emptiness; emptiness is no different from form," Hakuin responded. "A nice hot kettle of stew, and he plops a couple of rat turds in and ruins it."

These were shocking words for a beloved Buddhist text. In his annotations, he explained: "I wrote only to help you brothers, cold and hungry in your huts; for unless you find the Way, and transform yourself, you stay trapped. . . . The problem is your own eyeless state. . . . my motive is one: to rouse men of talent wherever they are." Included in Hakuin's commentary are a number of statements that suggest to his readers how their senses and discriminations are deluding them from the truths within their own beings. He encouraged them, exhorted them, perhaps shocked them, all to assist them to awaken. He told them what to do if they came to a phrase they didn't understand:

Bite it at once! Chew it to the pith! . . . The reason those who search for the Way are unaware of its reality is simply because from the first they accept all their discriminations for true. Those have been the very source for birth-and-death. . . . How clear, in a dream, the Three Worlds are. When you wake, all is empty, all the myriad worlds are Mu. . . . Where does this seeing take place? The entire earth is the eyeball of a Buddhist monk. . . . Take one more step!

Hakuin not only wrote texts for Zen students and followers, he also sent letters to men and women from all walks of life, including those taking care of the sick, nuns, scholars, and court nobles; he composed Zen songs for farmers and villagers utilizing the popular slang of the day. One chant he adapted from the street venders includes the following phrases:

Listen to me for a second about the effects
Of a certain medicine.
The pill I'm talking about is called
Penetrating-One's-Nature-and-Becoming-a-Buddha. . . .
Chew it well, chew it well—
Won't you take my pill?[16]

In order to reach more people, and because he realized that words were not the only way to transmit Zen, Hakuin turned to painting and calligraphy more seriously as he reached sixty. His early, more formal study of brushwork had long been abandoned, but after a period of practice and copying he burst forth with a creative explosion in which he invented a new visual language for Zen. Hakuin not only painted familiar Zen subjects in radically new ways, he also depicted a wide range of new themes. The *Monkey and Tortoise (plate 51),* for example, is based on the traditional belief that longevity could be obtained by eating the liver of a monkey. A legend had evolved about a princess at the palace of the dragon king who was sick and wished for the medicine of a monkey's liver.[17] A tortoise was sent across the ocean to find a monkey, whom he persuaded to ride back with him by promising to visit the palace of the sea god. On the way, they met a weeping jellyfish. Asked why he was so sad, the jellyfish told the monkey the truth about his fate. The monkey affected to be deeply regretful and told the tortoise that unfortunately he had left his liver back at home, hanging on a branch of a tree. The tortoise therefore agreed to

the monkey's request to return for it, but when they landed on the island, the monkey jumped off the boat, laughed, and ran away.

In Hakuin's painting the monkey points to a distant pine tree. The composition directs us immediately to the animals, where the intense stare of the monkey is matched by the eager look on the face of the tortoise. Hakuin's poem adds another touch of humor to this charming legend:

From the pine tree over there
I fear that
A crow may have taken my liver!

This scroll alludes to those who look outside themselves for the Buddha-nature when it is to be found within, like the monkey's liver. By utilizing the humor of the legend, Hakuin sought to popularize his message. The work is very simply painted with ink and light colors, with no attempt at elaborate or skillful brushwork. Narrative elements are emphasized, while superfluous details such as the landscape are minimized. If Hakuin had,lavished on the painting a more detailed treatment, his underlying theme might have been obscured. Instead, he brought a new and direct form of expression to this humorous tale so that it could be appreciated even by those with little Zen experience.

A more complex appropriation of folk imagery is found in Hakuin's *Running Fox (plate 53)*. In this large scroll, also from his "early period," the subject is a creature that is both a trickster capable of many mischievous transformations and also the benevolent messenger of Inari, the Shinto god of rice harvesting and fishing. It is said that Inari often transforms himself into a fox, so fishermen listen to fox cries in order to hear Inari's portent of a good or poor catch. Hakuin was sympathetic to Shinto, the native Japanese religion, which stresses purity of spirit and believes that deities live in mountains, trees, rocks, waterfalls, and animals (stone images of foxes are often found at entrances to Shinto shrines). Although in Zen the fox was a metaphor for monks who only pretended to be enlightened, the animal in Hakuin's painting is at once the humorously wicked image of folklore and the benevolent deity of Shinto.

In Hakuin's scroll, the fox is wearing a jacket with the words "red rice" (a sign of good luck) written on it. He carries a bamboo pole slung over his shoulder, to which are tied a gourd for rice wine, a sake cup, and a demon's arm with an attached *tanzaku* (poem card). On the card is the humorous inscription, "Free—slices of pickled demon!"[18] Around the fox's waist is a rope holding a sword made of beans, with a leaf sword guard. The fox plays his dual role as messenger of the gods and trickster. The inscription is written with several puns in eighteenth-century colloquial Japanese and is therefore difficult to interpret and translate.[19] One possible reading translates the word *hokora* as "proud"; it can also mean "shrine":

Byakkora *White foxes!*
bakashite okero no *does bewitching us*
hokora de se *make you proud?*

Although the complexity and humor of the image are Hakuin's own, the style of the painting shows the influence of a kind of caricature called *toba-e,* named after Toba Sōjō (1053–1140), the supposed painter of the Heian-period scroll of frolicking animals *(see plate 101)*. Usually appearing in woodblock

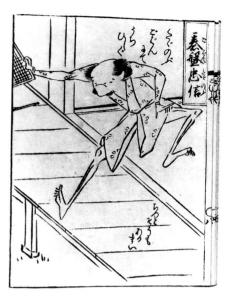

52. *Attributed to Hasegawa Mitsunobu*
(fl. 1730–1760)
TOBA-E ILLUSTRATION. *1772*
Woodblock-printed book
7¹/₄ × 5¹/₄" (image size)
Private Collection

book illustration, *toba-e* often displayed figures in exaggerated poses and lively movement. In one such example from the *Toba-e fude-byoshi* (Comic Pictures in Rhythmic Brushplay, 1772; *plate 52*) attributed to the Osaka printmaker Hasegawa Mitsunobu, the same long, skinny legs, bumpy knees, and clutching toes of Hakuin's fox appear. It was from such popular sources as well as from the Zen traditions of the past that Hakuin drew his inspiration. With these images he could communicate quickly and effectively to the public as well as to his Zen followers.

In *Running Fox,* Hakuin combined folk and Shinto beliefs to point out the foibles of humanity; ultimately the fox can be seen as each one of us, dressed up in ridiculous finery and rushing through life trying to avoid demons while searching for pleasure. The marvelous humor of the image and a certain gentle sweetness in the face of the fox draw us into the scene and suggest that we find our own meaning within its combination of parody and empathy. Hakuin often used such Shinto themes in his painting and calligraphy; his attitude was exemplified by his statement that "there is nothing but the difference of the trough and crest of the waves between what we call Shinto gods and what we call Buddhas."[20]

Another example of Hakuin's use of animal subjects is his depiction of a badger *(plate 54)*. This animal, like the fox, is known as a trickster, capable of dangerous pranks and often pretending to be a monk. In Hakuin's painting, the badger wears a red robe and cap; the inscription makes it clear that Hakuin is lampooning false religious leaders:

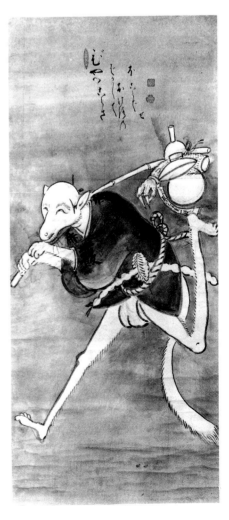

53. Hakuin (1685–1769)
RUNNING FOX
Ink on paper, 50 × 17⁷/₈″

Shin'wa-an Collection

Daruma ja to	*He claims to be Daruma*
iute kurashitaga	*living like a monk,*
mitekuryare	*but look—*
mujina kao shite	*this false priest*
yakan dōshin	*has the face of a badger!*

Hakuin, usually so tolerant of others' beliefs, wrote many times of his disdain for those who pretended enlightenment that they had not achieved and those who taught Zen without full understanding:

Of the monks who move about like clouds and water, eight or nine out of ten will boast loudly that they have not the slightest doubt about the essential meaning of any of the seventeen hundred kōan *that have been handed down. . . . If you press them just a little bit, you will find out that they have in no way seen into their own natures, have no learning whatsoever, and are only illiterate, boorish, sightless men.*[21]

The idea that the unenlightened are sightless led Hakuin to one of his unique painting subjects, *Blind Men Crossing a Bridge (plate 55).* Near the Shōin-ji there was a steep chasm over a river that people could cross only by a dangerous, narrow log bridge. Hakuin saw the parallel with unawakened daily life and painted this subject several times with the same poem:

Both inner life and the floating world outside us
Are like the blind men's round log bridge—
A mind that can cross over is the best guide.

The "mind that can cross over," the enlightened spirit, has no fears of the dangers in this life, clearly viewing and accepting all that comes with equanimity. By contrast, the unenlightened people attempting to struggle across

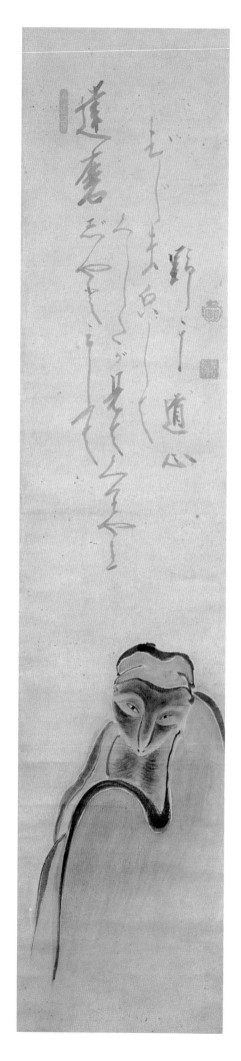

54. *Hakuin (1685–1769)*
BADGER
Ink and color on paper, 34³/₄ × 7³/₈"
Shin'wa-an Collection

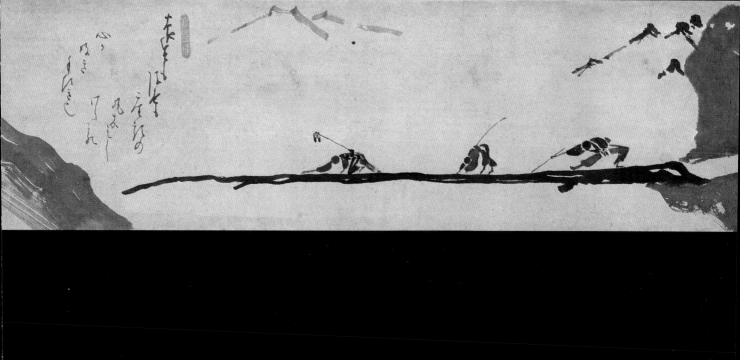

56. Hakuin (1685–1769)
CURING HEMORRHOIDS
Ink and color on paper, 22 × 25 ¼"
Eisei Bunko Museum, Tokyo

the bridge provide a marvelous allegory. One man holds a staff ahead of him and carries his sandals so that he can sense the firmness of the logs with his bare feet. In front, another blind man reaches down to touch the bridge with his fingertips, while a third crawls on his hands and knees; his sandals are hanging at the end of his staff for balance. Small strokes and dots in wet tones of gray are all that Hakuin needed to define the figures against a simple landscape setting dominated by the long horizontal of the bridge. The fact that the end of the bridge does not quite reach the opposite shore lends a touch of ironic humor to the parable. The elegant, rather spidery calligraphy, the novelty and humor of the subject, and the predominance of gray tones are characteristics of Hakuin's "early" works. Nothing like these paintings had ever been seen before, but they were to have a great influence on later Zen art.

A favorite theme of Hakuin during his sixties was Otafuku, the low-ranking courtesan from folklore who represented the virtues of hardworking women with her kind heart and optimistic smile. Out of sympathy for these women, who often were sent into prostitution in order to help support their families, Hakuin compared them to bodhisattvas who forgo nirvana in order to save all other sentient beings.[22] Hakuin depicted Otafuku doing her various activities, in one case *Curing Hemorrhoids (plate 56).* Here she is applying *moxa* to the rear end of her customer; his robe is emblazoned with the character for "money," while her kimono has the character "long life." Hakuin's poem reads:

It seems that he has hemorrhoids—
So I give him a little bit of fire.

Otafuku is portrayed as a homely woman with a friendly disposition; she performs her unpleasant task without complaint. The old man, whose wealth may have led him to too much rich food and drink, submits to "a little bit of fire" in order to cure his body. In popular Buddhism, people must be prepared to accept the pains and infirmities of this world in order to escape the greater flames of the Buddhist hell. In a Zen interpretation, the heat that draws out the pain might be compared with the shout, or administering of a sharp blow, utilized by a Zen master to bring forth his pupil's enlightenment.

The painting, seemingly so casually depicted, was first outlined and then brushed more strongly; some changes are still visible. Color was then added, lightly but effectively. The calligraphy at the upper left follows the same basic triangular composition as the painting. The old man faces up toward the final words (literally "one bit of fire"); the last stroke of the calligraphy points directly down to his squinting eyes, temporarily blinded until the cure takes effect.

It may seem odd that Hakuin chose an aging courtesan to represent the virtues of a bodhisattva, but no other figure in folklore could convey so well the qualities of mercy and compassion in the midst of everyday life. On another painting, Hakuin added the following inscription:

As for Otafuku, although her nose is flat
And her eyelids are puffy, she is a kind woman.
No matter what we call her,
She has been taking good care of men—
Otafuku suddenly appears to guide you;
Otafuku will preach the Buddhist truths.

Hakuin invites our smile; it is not ridicule, but the recognition of our own human foibles, which is part of the self-understanding necessary to enlightenment. Humor has the added effect of surprise, often making a sudden connection that is unexpected but illuminating. In this regard it is like satori. In Hakuin's words:

As for sitting [in meditation], that is something which must include fits of ecstatic, blissful laughter—brayings that will make you slump to the ground clutching your belly, and even after that passes and you struggle to your feet, will make you fall anew in further contortions of sidesplitting mirth.[23]

Humor is an ultimate teacher, providing memorable images rather than dull sermons. Another Hakuin work of this period shows a figure much like the old man of the previous painting. This time it is a *Lame Beggar on a Handcart (plate 57)*. Here, filial piety has not been observed and the lameness is a fitting punishment. Hakuin's inscription has a Confucian moral:

You rich people in every direction,
Please give this cripple one sen!
When I was young I kicked my parents,
Now as divine punishment I have become lame—
Therefore I beg you, "Please give me one sen"
So I can drink the miraculous waters of Kōbō.[24]

Hakuin's more complex Zen teachings did not prevent him from giving moral guidance to his parishioners, to whom the family structure was vital. Buddhists have long preached cause and effect; here an unfilial action is directly tied to its unhappy result. As in the previous work, Hakuin's original sketch lines are visible, and once more the light use of basic colors adds to the visual appeal of the painting. The beggar's lame leg is effectively established by a stronger outline than that which defines the rest of the body; it is reinforced compositionally by the outlines of the handcart. The wizened, potbellied, toothless old man has clearly suffered for his misdeed, and yet he retains a strong visual presence. In the intensity of his gaze, he may have come to an understanding of himself, something which those seemingly more

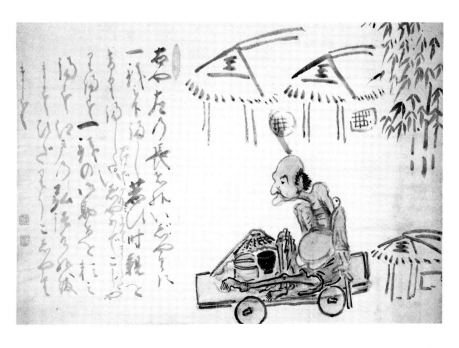

57. *Hakuin (1685–1769)*
LAME BEGGAR ON A HANDCART
Ink and color on paper
Private Collection

fortunate may lack; he is ready to seek the "cure" of the early Buddhist master Kōbō Daishi. Thus this informal painting combines Confucian morality with a hint of Zen wisdom, making it appropriate for a wide range of viewers.

One of Hakuin's most unusual paintings is his version of the ancient theme One Hundred Demons *(plate 58)*. One of the oldest beliefs in Japan is that when night falls, ogres, demons, and goblins parade in the streets until the light of dawn causes them to return to the netherworld. A number of hand-scrolls on this theme have been painted since at least the Muromachi period.[25] Nevertheless, it is curious that a Zen monk was interested in depicting such a subject. Images of demons were utilized in other forms of Buddhism to frighten the faithful (just as Hakuin had been frightened as a child) into good behavior in order to avoid the pains of hell. But Hakuin believed as a Zen practitioner that "we build up our own hells!"[26] Heaven and hell are illusions of the self: "men grasp at the true land of Birushana Buddha's unchanging eternal calm, and in their fear and delusion, cry in pain, believing it to be eternal hell."[27] The enlightened man, by contrast, "sees through both heaven and hell; Buddha worlds and demons' palaces melt away."[28] Yet if this was his belief, why did Hakuin paint this theme?

Perhaps the answer lies in a poem included in his commentary on the *Heart Sutra,* in which after a night of darkness the light of morning comes as satori:

The ogre outside shoves at the door, the ogre inside holds it fast;
Pouring sweat from head to foot, battling for their very lives,
Fighting on all through the night, until the dawn appears
And laughter fills the early light. They were friends from the start![29]

The one-eyed goblins, the demons of musical instruments, the reptilian and bird-beak ogres, and all the assorted weird creatures—are they not ourselves? Their battles and their fears are our own; the dawn from which they hide is enlightenment. When it comes, all that remains is laughter.

Life at Shōin-ji became difficult during the middle 1740s, when several famines devastated the Japanese countryside. Although some of his followers dispersed, Hakuin intensified his efforts to teach and to find food for the local populace. He also continued his writing; at the age of sixty-four he published the *Orategama,* a series of three long letters addressed to a feudal lord, a convalescent monk, and a nun of the Nichiren sect. The first letter, written to the daimyo of Nabeshima, sums up many of Hakuin's primary teachings. He emphasizes that silent meditation is not sufficient to achieve enlightenment; Zen must be practiced during daily activities. "Make your saddle your sitting cushion; make the mountains, rivers, and great earth the sitting platform; make the whole universe your own personal meditation cave."[30]

In his second letter, Hakuin wrote about Hakuyū's medical teachings, adding that even during sickness, correct meditation is important. He also wrote about himself:

When I was thirteen I came to believe in the validity of the Zen teachings. When I was sixteen I destroyed the face that I received from my mother. At nineteen I left home to become a monk, and at thirty-five I concealed myself in this temple. Now I am almost sixty-five years of age. For some forty years I have cast aside all mundane affairs, cut off my ties to the world, and devoted myself solely to guarding [my practice]. Finally, five or six years ago, I became aware that I had attained to the state where I could continuously carry on the real, true meditation practice.[31]

58. Hakuin (1685–1769)
ONE HUNDRED DEMONS
Ink and color on paper, 13⅞ × 146"
Kondai-ji, Kyoto

The third letter was written to a Buddhist nun who was a follower of the Nichiren sect, which places ultimate importance upon the *Lotus Sutra* as the highest form of the Buddha's teachings. Over the centuries this text had become Japan's most widely held doctrine of eternal Buddhahood and human salvation.[32] The nun had asked why Hakuin had lectured that outside the mind there was no *Lotus Sutra* and outside the *Lotus Sutra* there was no mind. Hakuin answered that one must penetrate any teaching to the essence so as not to swallow the prescription rather than the medicine. Meditating constantly on the true lotus, without thoughts of good and evil, is akin to meditating on a *kōan.* The believer can reach the same transcendence: "To see into your own nature is to see for yourself the True Face of the Lotus."[33]

This letter reveals Hakuin's attitude toward other forms of belief. He wrote that the sages of Confucianism, Taoism, and Shinto reached the same place, whether they call it the Ultimate Good, Nothingness, Nature, or the Shinto Heaven. The followers of Pure Land Buddhism with their unceasing devotion to the *nembutsu* and the believers of the Shingon sect in their resolve to penetrate the inherent nature of the deities can also achieve a form of enlightenment.

By his encouragement of such diverse religious efforts, Hakuin was able to transcend the limited popular response to Zen in an increasingly secular age. He encouraged people, whatever their beliefs. For those who followed the Pure Land sect, he did not hesitate to write out *Namu Amida Butsu (plate 59).* In this work of his later years, his brushwork has become more weighty than before; the increasing force of his personality and character is apparent in every stroke of the brush. In bold, single-column calligraphy scrolls such as this, Hakuin utilized a simple and blocky form of easy-to-read regular script. The words are not clearly divided from one another, and there is little space between the individual brushstrokes. The result is massive. To avoid making the writing seem too heavy, Hakuin devised a method of creating slight variations in tones by utilizing ink that had been ground earlier, rather than freshly for the scroll, and by writing upon a heavily sized paper that did not absorb the ink quickly. As a result, the puddling and uneven drying of ink created a sense of richness and depth. This unusual combination of tonal complexity of ink with childlike simplicity of brushwork is unique to the later works of Hakuin.

In a supplement to his *Orategama,* Hakuin answered the question whether the *nembutsu* or the *kōan* is superior. "The duality lies only in the skill or clumsiness, the honesty or dishonesty, of the person. . . . The content of the practices may vary, but what difference is there in the goal that is reached? . . . It all comes down to one thing—seeing into your own nature."[34] Hakuin believed that pure concentration upon the Buddha's name would be more beneficial than impure meditation on a *kōan,* but to his own pupils he stressed that the Zen method was the most direct for achieving enlightenment.

Hakuin often painted the bodhisattva Kannon, who was important to all forms of Buddhism. Variously regarded as an esoteric deity, a goddess of mercy who would carry the soul of a believer to the Pure Land, and an exemplar of concentrated meditation, Kannon appealed beyond sectarianism. One of Hakuin's most dramatic scrolls is *Meditating Kannon (plate 60).* Hakuin seems to have enjoyed imitating the effect of stone rubbings in some of his paintings, setting a figure in white against a black background.[35] Here, the white-robed Kannon, depicted with outlines in light tones of gray, is seated in a relaxed meditating posture on a rock overlooking the waves. The bodhisattva is given a halo, broken by the attribute of a vase containing a willow branch. This was common iconography for Zen depictions of Kannon as early

59. *Hakuin (1685–1769)*
NAMU AMIDA BUTSU
Ink on paper, 54 × 14"
Shin-wa'an Collection

60. *Hakuin (1685–1769)*
MEDITATING KANNON
Ink on paper, 47¹/₄ × 21¹/₄"
Shin-iwa'an Collection

61. *Hakuin (1685–1769)*
ALWAYS CONCENTRATE ON KANNON
Ink on paper, 53 1/8 × 11"
Genshin Collection

62. *Hakuin (1685–1769)*
ONE HAND CLAPPING
Ink on paper, 35 7/8 × 10 5/8"
Private Collection

as the Sung period, but Hakuin has added a plum branch to that of the willow. In this painting, Kannon displays informal charm as well as inner wisdom. The long, gently smiling face recalls Hakuin's self-portraits.[36] The hand supporting the deity's chin bends away in a pose of elegant leisure. The bodhisattva's face has a quiet, inward smile. Although Hakuin presented the enlightenment of Kannon in a dramatic composition, he portrays the deity in a very human manner, creating a figure who exudes warmth and kindness.

As a universal symbol of Buddhism, Kannon was both male and female, a deity who was a model for monks and yet approachable by sinners. Hakuin also brushed calligraphic works in honor of the deity, as in the scroll *Always Concentrate on Kannon (plate 61)*. The first character, "always" [常], written in cursive script, extends down almost the entire length of the scroll, emphasizing its qualities of continuity and permanence. At its base, the word *nen* (attention, concentration) forms the conclusion, or support, for this powerful message. The following characters, however, are rendered in regular script, making them easy to understand even for those who are not expert in calligraphy. Tonal variations are clearly established within the gray black ink so that the work has both dramatic presence and subtleties that repay repeated viewings. Hakuin knew that the continued veneration of Kannon could nurture the spirits of those who were unable or unwilling to delve into more complex Buddhist practices.

There was one danger in the calligraphy of names and the painting of forms of the gods, which is that people might believe them too literally. Hakuin wrote, "Gods and Buddhas in reality have no form. . . . They have been given form because of our necessity. But do not rely on names and forms."[37] Thus he could inscribe some of his paintings of Kannon with the couplet from the *Kannon-kyō* (verse 25 of the *Lotus Sutra*):

She observes all beings with compassionate eyes;
The ocean of longevity and happiness is boundless.

Hakuin also used humor, however, to guide his followers away from standard ideas and conceptions of the deity. On one of his depictions of Kannon, Hakuin wrote:

Who says that her vow to save all beings is as deep as the ocean?
Finding a place far from human ties, she steals away for some relaxation . . .

This unexpected notion that Kannon might wish to forget humans and enjoy some peace and quiet was certainly designed to bring viewers up short, to make them reconsider their idea of a "god" and rethink what they must do for themselves. In Hakuin's ultimate statement on the subject, "If one is truly awake, the whole world is Kannon."[38]

What Hakuin wrote and painted for his own students is quite different from the works he brushed more for the general populace. His teaching was extremely strict, and although he used a variety of expedients in his instructions and admonitions, he felt it was his duty to help his pupils destroy the seeds of ignorance and illusion that clouded their ability to see their own true nature. This illusion, Hakuin wrote, "is one thing with many names, but if you examine it closely you will find that what it comes down to is one concept: that the self is real. Because of this view that the self exists, we have Birth and Death."[39] How then was the disciple to break through this illusory view of self? Hakuin's method was primarily through *kōan* study. If you can "investi-

gate it unceasingly, your mind will die and your will will become destroyed. It is as though a vast, empty abyss lay before you, with no place to set your hands and feet. You face death and your bosom feels as though it were afire. Then suddenly you are one with the *kōan,* and both body and mind are cast off."[40]

Hakuin reorganized a series of *kōan* from Chinese sources for his pupils, with special attention to the study of *Mu.* However, he utilized a *kōan* of his own invention more and more often in his later years. As he wrote in 1753:

Five or six years ago I made up my mind to instruct everyone by saying, "Listen to the Sound of a Single Hand." I have come to realize that this kōan *is infinitely more effective in instructing people than any of the methods I had used before. . . . What is the Sound of the Single Hand? When you clap together both hands a sharp sound is heard; when you raise the one hand, there is . . . something which can by no means be heard with the ear. If conceptions and discriminations are not mixed within it and it is quite apart from seeing, hearing, perceiving, and knowing, and if, while walking, standing, sitting, and reclining, you proceed straightforwardly without interruption in the study of this* kōan, *then in the place where reason is exhausted and words are ended, you will suddenly pluck out the karmic root of birth and death. . . . At this time the basis of mind, consciousness, and emotion is suddenly shattered; the realm of illusion . . . is overturned.*[41]

Hakuin portrayed this *kōan* several times. In *One Hand Clapping,* a Hotei-like figure is standing on his bag, a single hand raised, with a slight smile on his mouth *(plate 62).* He is a bundle of compressed energy, with sparkling eyes. Circular forms are emphasized, including the monk's head, his body, his stomach, and the bag beneath him. The hand, however, points up to the inscription, which is boldly written in cursive script:

All you clever young people —
No matter what you say,
If you don't hear the sound of one hand,
Everything else is rubbish!

Hakuin utilized this *kōan* a great deal, emphasizing the continuous and ever-deeper nature of study and practice that would lead to ever-greater enlightenments. When one of his lay students reached a high level of satori, Hakuin would present him with a form of "graduation certificate" consisting of a painting of a dragon staff and whisk, the symbols of a temple abbot. At first the staff merely hinted at a dragon-head form, but later in Hakuin's life he painted a head with an eye to create an animate image that suggests the sixteenth *kōan* from the *Hekiganroku:* the monk Yun-men held up his staff and asked the assembled monks, "This staff has transformed itself into a dragon to swallow up heaven and earth. Where are the mountains, rivers, and great earth?"

One such dragon staff was painted by Hakuin in 1766 *(plate 65).* It was created for a follower who lived near Edo and shows the lively animism of the metamorphosed monk's staff. Hakuin's inscription is written on either side of the staff in clear regular script:

On an autumn day in the third year of Meiwa, Suzuki Tetsugorō, from the province of Musashi, penetrated my two massive barriers to discover the sound of one hand; I therefore write this certificate to honor this heroic man.
—THE OLD MONK HAKUIN UNDER THE SALA TREES[42]

63. *Hakuin (1685–1769)*
DAITO KOKUSHI
Ink on paper, 51 × 22 1/2"
Eisei Bunko Museum, Tokyo

64. Hakuin (1685–1769)
ENSŌ
Ink on paper, 13 × 21 ⁵/₈"
Private Collection

This is one of the last of Hakuin's certificates; he was eighty-two years old. By utilizing ink that was not freshly ground and sized paper, he created his idiosyncratic variety of tonal values that gives the work a sense of depth. Despite the power of the image, it also has a quality of soft expansiveness that is unique to the final works of the master.

In Hakuin's last years, he taught an increasing number of monks as well as laymen and women. Life at Shōin-ji was spartan, but upon a few occasions there would be special treats and time to enjoy the company of parishioners as well as followers. One of these special occasions was the New Year, when a portrait of Daruma would be hung, a brazier would be set forth to warm the guests, and gifts of food would be received. One of Hakuin's poems describes just such a scene:

Over a hundred cold hungry monks, a Phoenix brotherhood,
Spread their winter fans and offer New Year's greetings;
On the wall hangs a blue-eyed old man with a purple beard;
In a jar are fragrant flowers of the chaste plum;
Cold to muffle even the warbler's bright clear cries,
Warmth rising to the Zen seats from the red-hot coals;
There are presents of wild yams, in plaits of straw,
And for old men, sugared sweets, laid in their wrappers.[43]

Hakuin was said to have been very fond of sweets, and he may even have had a light case of diabetes at one time. Perhaps this led him to the humorous inscription on his remarkable portrait of Daitō Kokushi *(plate 63)*. Hakuin depicted the monk, whose Buddhist name was Shūhō Myōchō (1282–1337), at a time when he lived among the beggars at the Fifth Street Bridge in Kyoto. The emperor wanted Daitō to preach at court, but the monk had rejected worldly honors and preferred an anonymous life of poverty. According to a legendary story, the emperor, hearing that Daitō loved melons, told his messenger to offer one to the beggars in such a way that only Daitō would respond. The messenger called out that he had a melon, could someone come and get it without using his feet? A voice replied that the messenger should offer it without using his hands. Daitō had given himself away, snared by his one remaining desire. He was persuaded to return to court, and soon thereafter he founded the temple of Daitoku-ji at the emperor's behest.

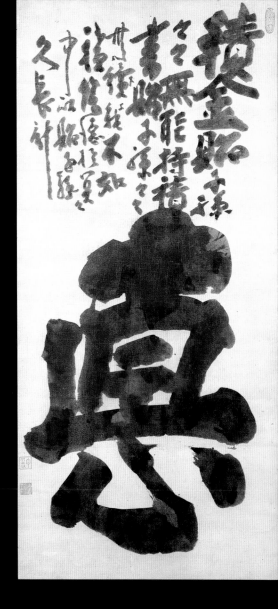

66. *Hakuin (1685–1769)*
VIRTUE
Ink on paper, 46³/₁₆ × 21³/₄"
Man'yō-an Collection

65. *Hakuin (1685–1769)*
DRAGON STAFF. *1766*
Ink on paper, 49¹/₈ × 11¹/₄"
Shin'wa-an Collection

Hakuin's painting shows the monk begging, with wide, staring eyes peering out from under his straw hat. The inscription begins with his moment of discovery and leads to a kind of *kōan* based upon the Daitō story:

Wearing his straw hat, living among beggars,
He was caught because he coveted
Sweet melon!

If you can peel the melon without using your hands,
Certainly I can come and get it without needing my feet.

The use of ink in this work is extraordinary. Roiling gray tones describe the cold and wet weather. Daitō, concentrating intently, seems to ignore the snow hanging from his hat. His bare feet clinging to the cold earth, he leans on his staff and holds one hand out. But has he been able to renounce all worldly desires, or is he still thinking about the melon?

By contrast with this Zen humor, one of Hakuin's depictions of that ultimate union of painting, calligraphy, and meditation, the *ensō (plate 64)*, is deeply serious. This scroll was probably given to one of Hakuin's disciples to meditate upon as a visual *kōan*. Hakuin seems to have brushed very few of these Zen circles, and each surviving work has a different inscription. Here the *ensō* is accompanied by the words, "No space in the ten directions, not one inch of great earth."[44] This cryptic statement comes from the final line of a poetic commentary to the following Chinese *kōan* from the tenth century:

A monk asked Pa-ling, "Are the views of Zen masters the same or different from what is taught in the sutras?" Pa-ling answered, "When a rooster is cold, it flies up into a tree; when a duck is cold, it dives under the water."

This is one of the less complex of the early *kōan*, suggesting that the words of Zen masters and those of the sutras are different ways of responding to the same conditions. However, a verse written about this *kōan* by the monk Wei-chao of the twelfth century is more thorny. It refers to the legend of the birth of Zen, when the Buddha silently held up a flower instead of lecturing to his followers; the poem concludes with the line that Hakuin inscribed upon his *ensō*.

A branch of plum blossoms is enshrouded by rain,
The golden one smiles without speaking.
A bright moon shines on the Water Dragon Palace,
While the moon and stars dance and laugh, dance and laugh:
No space in the ten directions, not one inch of great earth.[45]

Thus the work has many levels of significance. It can be meditated upon both in the simplicity of the circle and in the complexity of the allusions suggested by the inscription.

The circle seems to have been brushed slowly. We can sense the vibration in Hakuin's hand as he rotated his brush, beginning at the lower left. The inscription continues the force of the circle, suggesting an oval as the three columns are progressively smaller. A first *Mu* [無] comes below the words for "ten directions," which are joined together to begin the first column of text; a second *Mu* begins the final column. Each is different in form, although both lead to the next character without pause. The slow movement of the brush suggests the cycles of the seasons, the orbits of planets, the wheel of the

Buddhist law. What does it ultimately mean? Hakuin is saying, look here, right now—wake up, wake up!

In his final years, Hakuin's brushwork became increasingly more powerful, more simplified, and richer in tonal variety. One of his finest works of calligraphy in this period is the large character *Virtue (plate 66)*. The text comes from the Chinese historian and scholar Ssu-ma Kuang (1018–1086). A model statesman, Ssu-ma served his government during the Northern Sung period, and his aphorism is properly moral in tone. Hakuin may have chosen it not only because of its appeal during an era of Neo-Confucian sentiments, but because it also has a touch of Zen humor:

Pile up money for your descendants—
They won't hang on to it.
Pile up books for your sons and grandsons—
They won't read them.
The best thing that you can do is to increase your virtue,
Quietly, secretly—
Pass along this method to your descendants,
And it will endure for many ages.

The large character has a blocky strength that seems to support the seven columns of smaller calligraphy above it. Characteristic of Hakuin's late style, the ink tones are rich and deep, the characters have little or no space between them, and the massive brushstrokes seem to contain all the weight of the monk's years as a Zen master.

The impression of monumentality that this work conveys, however, is enlivened by sprightly variety within the brushwork. The upper columns are not straight, but tilt slightly down toward the main character. The characters range in size, and some are rendered in full regular script while others are cursively brushed in a single stroke. The word *Mu,* for example, is written in architectonic form as the third word of the second column (from the right); while as the first character in the fourth column the same word seems to dance in running-cursive script, ending with a flourish of the brush. The final character of the inscription concludes with ten playful squiggles in its vertical movement downward, like a serrated sword blade that is ready to cut through words to an inner truth. The large character, meaning "virtue" [惪], is made up of the graph for "honesty" above the graph for "mind" or "heart." For Hakuin virtue was certainly the honest mind/heart that could see its own nature without illusion.

Although he invented an amazingly wide repertory of themes, the major subject for Hakuin, as for most Zen painters, was the first patriarch. One of Hakuin's largest and most impressive paintings is his *Daruma in Red (plate 69)*. The huge eyes of the figure, the bold red of the robe (a rare use of color in Hakuin's final years), and the head standing forth against a black background, all make this a riveting depiction of Zen meditation. The darkest ink on the face is reserved for the inner ear, the nostrils, the top of the eyelids, and the pupils of the eyes, focusing our attention upon the inward concentration of Daruma. Hakuin added an inscription, white on black in stone-rubbing style, utilizing the words attributed to the patriarch that sum up the most fundamental message in Zen:

Pointing directly to the human heart:
See your own nature and become Buddha!

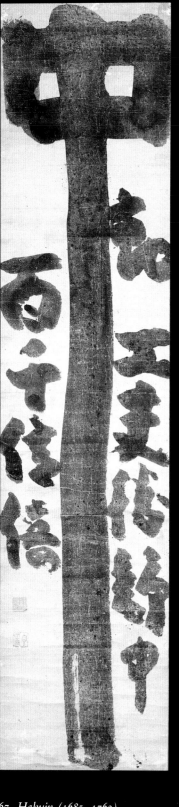

68. Hakuin (1685–1769)
SELF-PORTRAIT. 1764
Ink on silk, 40¹/₈ × 11¹/₄"
Eisei Bunko Museum, Tokyo

67. Hakuin (1685–1769)
WITHIN
Ink on paper, 47¹/₄ × 11¹/₄"
Shin'wa-an Collection

69. Hakuin (1685–1769)
DARUMA IN RED
Ink and color on paper, 75 ⁵/₈ × 44 ¹/₈″
Manjū-ji, Oita

If the depiction of Daruma remains each monk's portrait of his own Zen spirit, then a self-portrait is equally interesting as it suggests the monk's view of his own personality as well as physiognomy. Hakuin did several such self-portraits, which were undoubtedly given to his pupils, and although he had a rather round head in actuality, he usually depicted himself with a more oval head. One *Self-Portrait* by Hakuin was rendered within an *ensō* shape in 1764, four years before his death *(plate 68)*. Rather than using the elaborate *chinsō* style, he painted this simply, showing the subject in a Daruma-like posture but with modestly downcast eyes. The head stands out because of the dark background added behind it, which creates a series of circular shapes that are then continued by Hakuin's robe and his hands in a meditating posture; his rounded mouth and the lids of his eyes add to the compositional unity of the painting. Hakuin's inscription, however, is far less gentle:

Within the Meditation Hall
I am hated by the thousand Buddhas;
In the company of myriad demons
I am despised by the myriad demons.
I crush those who practice false Zen
And annihilate those blind monks who can't penetrate Mu.
This evil worn-out old shavepate
Adds one more layer of ugliness to ugliness.

The inscription is appropriate to the self-portrait, making no effort to be conventionally attractive. It emphasizes the total commitment and inner strength necessary to become a Buddhist teacher. The veils of illusion are not easily pierced; by the use of words such as *hate, despise, annihilate,* and *ugliness,* Hakuin brings home the force of his Zen message.[46]

In his art as well as in his teachings, Hakuin never tired of stressing that meditation should be active rather than passive. As he wrote in one of his final great works of calligraphy, *Within (plate 67),* "Contemplation within activity is a hundred million times better than contemplation in stillness." Here the massive character for "within," made up of a rectangle divided by a strong vertical line, is extended down the entire length of the scroll. It dominates the composition with an insistence that cannot be denied, a sign to all viewers of the necessity for meditation to extend into all facets of life. This monumental work demonstrates graphically what Hakuin wrote in more detail in his *Orategama:*

What is this true meditation? It is to make everything: coughing, swallowing, waving the arms, motion, stillness, words, action, the evil and good, prosperity and shame, gain and loss, right and wrong, into one single kōan. . . . *with the principle of pure, undiluted, undistracted meditation before your eyes, attain a state of mind in which, even though surrounded by crowds of people, it is as if you were alone in a field extending tens of thousands of miles. . . . if at this time you struggle forward without losing any ground, it will be as though a sheet of ice has cracked, as though a tower of jade has fallen, and you will experience a great feeling of joy.*[47]

This sense of joy energized Hakuin's final years, which were full of activity. He revitalized the temple of Ryūtaku-ji in Numazu, within a day's walk from Shōin-ji, and designated his disciple Tōrei as abbot. He led several large lecture meetings at Ryūtaku-ji and other temples, produced paintings and calligraphy

for all who asked, and continued to travel. Toward the end of 1768, however, his health began to fail. Returning to Shōin-ji, he came under a doctor's care on the seventh day of the twelfth month. Three days later, he asked his follower Suiō to take charge of Shōin-ji, and on the following day he died.[48]

Hakuin's ultimate legacy to Zen was the breadth and depth of his teachings. He utilized books, lectures, sermons, letters, poems, folk songs, calligraphy, and painting to communicate his Zen vision. Constantly encouraging people, he insisted that awakening was possible if one concentrated one's spirit to discover one's own true nature. He wrote that people "do not realize that we are all living Buddhas"[49] and lamented that they "are always looking for the Buddha outside themselves — or they look for a patriarch or for a nirvana or a pure land — their method is to look outwards (and not inwards into their own minds) and that is why the more they seek, the further off they get."[50] Hakuin's singular goal was to help people reach their own awakenings.

In the decades after Hakuin's death, his religious influence extended beyond the Rinzai sect, which was soon dominated by his followers, and extended to the Obaku sect as well. As a teacher, he had revitalized Zen during an increasingly materialistic era. Artistically, he had opened the field of Zenga to new subjects, new styles, and a new spirit of openness and freshness.[51] In his art as well as in his Zen teachings, Hakuin was the greatest Zen master of the past half-millennium.

The methods that Hakuin utilized to train his followers were carried on by future generations of monks, eventually dominating Rinzai teachings as well as influencing Obaku Zen. Similarly, the painting and calligraphic subjects and brushwork techniques developed by Hakuin were also continued. The breakthrough Hakuin made into a new form of art was taken even further by some of his followers: the nature of brush, ink, and paper was emphasized in their Zenga as clearly as the meaning of the subject. Among Hakuin's immediate pupils, Tōrei Enji was the boldest artist, known for bristling calligraphy that is unique in the history of Zen art. Suiō had a more gentle and playful approach, as he revealed in his delightful paintings of Zen figures. Reigen Etō added a sense of mystery to Zenga; his works are simple but evocative. Among the following generation of monk-artists, the Hakuin influence still dominated Rinzai brushwork. Noted as a teacher, Gako (Tengen Chiben) produced charming and lively depictions of Zen masters and eccentrics; he followed the lead of Suiō but used a more vigorous style of brushwork. Shunsō Shōjū, on the other hand, was not as deft in his touch, though his conceptions were even more dramatic.

TŌREI ENJI (1721–1792)

Tōrei was born on the fourteenth day of the fourth month of 1721 in the town of Kanzaki in Ōmi (Shiga), along the Chūsendō, one of the five great roads of Japan. His father, Nakamura Zen'uemon, sold medicinal plants; his mother, Tsuyu, was a devout Buddhist even though she came from a family that served a Shinto shrine at the temple Enshō-ji in Nara. This heritage of Shinto and Buddhism was to be an important influence in Tōrei's life.

One of the most significant events in Tōrei's youth occurred when he was five years old. A leading Rinzai monk from Kyushu, Kogetsu Zenzai (1667–1751), traveling up the Chūsendō upon the request of a daimyo in Edo, stopped at the Nakamura house along the way. The young Tōrei, allowed to serve the famous monk at dinner, was so impressed with Kogetsu's serene and noble character that he too determined to become a monk. Tōrei's parents were opposed, as he was their only son, but the young man continued to harbor this ambition as he pursued his education.

According to an anecdote, when he was seven years old Tōrei watched one of his playmates catch a louse in his hair and kill it. Tōrei sympathized with the tiny creature, and when his friend captured another louse, Tōrei took it and put it in his own hair in order to spare its life.[1] Seeing that their son's religious intention was resolute, his parents allowed him at the age of nine to enter the local temple Daitoku-ji in Ōmi. Tōrei's teacher, Ryōzan, was extremely strict and did not hesitate to use his fist upon recalcitrant pupils when they lagged behind in their sutra chanting or in their studies of Zen texts and the Confucian classics.

At the age of seventeen, Tōrei was allowed to fulfill his wish to study with Kogetsu in Kyushu and then with his successor Suigan at Daikō-ji in Sadowara (present-day Miyazaki prefecture). As well as receiving Zen instruction, Tōrei was told by Kogetsu that someday he should seek out the *Daijōkyō,* a repository of Shinto teachings. Because Tōrei's mother's family had served a shrine, he was interested in learning as much as possible about native Japanese religious beliefs.

After three years in Kyushu, Tōrei journeyed to the Kyoto area and received further Zen training under Daidō Bunka (1680–1752) at Hōjō-ji and under Keijū Dōrin (1714–1794) at Tenryū-ji. Still not satisfied with his progress,

THE FOLLOWERS OF HAKUIN

A single flower opens to five petals

And bears fruit according to its

own nature

70. Tōrei (1721–1792)

Ink on paper, 51³/₄ × 21"

Private Collection

Tōrei built a hut on an isolated hill near the small temple Myōraku-ji, not far from his family home in Kanzaki, and resolved to achieve enlightenment or die in the attempt. Sitting upon a flat stone atop a small cliff overlooking a mountain stream, he meditated ceaselessly until finally a moment of satori arrived. He later wrote an introduction and poem about this experience. He concluded with a reference to the Shao-lin Temple, where Daruma had meditated for nine years:

In the autumn of the first year of Kampo [1741], I holed up in the hills of Rengedani in eastern Ōmi and devoted myself to zazen for days on end. I became so exhausted I could hardly keep my body from toppling over and I told myself, "The higher one goes in the Way, the stronger and more numerous the evil demons; I'll never be able to seek the Way in this lifetime." I was about to throw myself backward onto the ground, when suddenly I broke through and saw that the hills and streams and great earth itself were all manifesting the body of the Dharma King!

The body of the Dharma King
The body of the Dharma King
The earth, its streams and hills
Are free of even a mote of dust.
The Buddha's teaching,
The patriarchs' Zen
Have all been within me!
There is nothing whatsoever
That does not take part
In Shao-lin's spring.

Tōrei, however, was still not satisfied with the completeness of his insight. Hearing of the teachings of Hakuin, Tōrei traveled to Shōin-ji in 1743, bearing a gift of *kompeito* candy because he had been told that Hakuin was fond of sweets. Sensing the depth of Tōrei's determination, Hakuin accepted him as a disciple. After five years of assiduous study, however, Tōrei became seriously ill. Deciding that his last days had come, Tōrei worried that he had done nothing useful for the Rinzai sect, so he wrote out a record of his Zen practice, summarizing in an orderly way the stages a Zen student must pass through, from shallow to profound experiences, and describing the psychological states accompanying each stage. He then presented it to Hakuin as a form of last testament, asking him to preserve any parts that were worthwhile and to burn the rest. Hakuin, however, was so impressed with the document that he urged Tōrei to publish it, which he did later as the *Sōmon mujin tōron* ("A Discourse on the Never-Ceasing Light of Faith").

During his long illness, Tōrei lived in the Shirakawa area of Kyoto. One day, after long periods of meditation, he suddenly understood the teachings he had received from Hakuin and realized that life and death were two aspects of the same eternal principle. From this time on his health improved. He wrote to Hakuin, who congratulated him on this enlightened insight and asked him to return to Shōin-ji. When Tōrei arrived, Hakuin presented him with the golden robe in which he had given special lectures on the *Hekiganroku*. By conferring this robe upon his disciple, Hakuin considered Tōrei to be a fully fledged Zen teacher. Staying near his master, Tōrei took charge of two temples in Suruga, reestablishing the dilapidated Muryō-ji and then settling at Ryūtaku-ji in Numazu, which had been formally opened by Hakuin.

At the age of forty-four, Tōrei met Haku-ō, an old man who was very knowledgeable about the famous Shinto text *Daijōkyō*. Tōrei diligently studied this work, which was supposed to have been compiled by Prince Shotoku in 582 at the behest of Empress Suiko. The original text was said to have been burned in warfare, but a copy was secretly owned by the family of a Shinto priest. This transcription was presented to Emperor Momozono in the mid-seventeenth century, but complaints from the high priest at the sacred shrine in Ise succeeded in having the *Daijōkyō* banned at court. Whether or not the text was a genuine document from the sixth century, it was fascinating for Tōrei, and his study of it encouraged him in his efforts to unite the teachings of Shinto, Buddhism, and Confucianism. Although this effort to unify the three creeds had been made before, it became especially significant in Tōrei's life and thought, in part because of Hakuin's teachings and in part because of Tōrei's family background. Among his writings there are several aphorisms that show his spirit of ecumenism:

Shinto teaches people in their youth,
Confucianism instructs them in their middle years,
Buddhism informs them in their final years.

Shinto is the roots,
Confucianism is the trunks and leaves,
Buddhism is the flowers and fruit.

Shinto, Confucianism, and Buddhism,
Each helping the other,
Form a great tree of morality.

One of Tōrei's boldest examples of calligraphy is his scroll bearing the names of three Shinto deities *(plate 70)*. Writing out the titles of *Amaterasu Ōmikami* in the center, *Hachiman Ōkami* on the right, and *Kasuga Daimyōjin* on the left, he followed a practice adapted from Buddhism, where sacred six-character mantras served as objects of meditation. These Shinto "oracles of the three shrines" were a popular theme in calligraphy and had in previous centuries been brushed by emperors as well as priests and monks.[2] Tōrei's calligraphy here seems especially free and impetuous. The shorter right and longer center columns touch, characters often merge into one another, and individual words tilt to either side. Everything seems spontaneous, as though Tōrei brushed these mantras with wild abandon, paying no attention to what the finished result might look like. Yet in fact he has evoked the primordial nature of Shinto beliefs by writing some of the characters in ways that suggest their original pictographic forms. The column on the left, for example, begins with the word that means "spring" [春] written with a "sun" [日] shape under three horizontal and two diagonal strokes that suggested trees in the original form of this character. Next comes the word for "sun" or "day," here written in an ancient rounded form. There follows the word for "large" or "great" [大], represented by the two diagonal strokes of the (stick-figure) word for "man" [人] with one horizontal stroke suggesting his arms are stretching out. Next comes the word for "bright" [明] with a "sun" form on the left and a crescent "moon" on the right, each rendered pictographically rather than in their usual squared-off forms. Finally the word for *kami*, or "god" [神], concludes with a strong vertical stroke, giving the column of characters a conclusion by stretching up to the "bright" and down to the empty space below.

71. Hakuin (1685–1769)
THREE SHINTO DEITIES
Ink on paper, 28 × 10⁷/₈"
Private Collection

Tōrei chose a gray ink, rather than the usual rich black, so that overlapping lines can easily be seen. Below the central column he added his signature with his typical "clam" cipher, a distinctively animistic touch that here provides a firm base to anchor the entire work. Compared to Hakuin's calligraphy of the same subject *(plate 71)*, Tōrei's version is much less orderly and stable, showing an impetuosity quite distinct from the measured weight of his teacher's style. In scrolls such as this, Tōrei demonstrated that although his Zen training and teachings were strict, his individual character was completely free of convention.

When Hakuin became ill in 1768, Tōrei went to Kyoto in his master's place to lecture on Zen texts to more than four hundred monks at Tōji-in. During this meeting Tōrei heard that Hakuin had died; he rushed back to Shōin-ji to help Suiō officiate at the funeral ceremony. To continue Hakuin's mission, Tōrei traveled and lectured on Zen texts, but when Ryūtaku-ji was largely destroyed by a fire in 1770, he heeded a call from Suiō and returned to rebuild the monastery. Five years later, Tōrei completed a major renovation of Ryūtaku-ji, which became his home for twenty years. During this time, he concentrated upon refining the precepts of Zen training. He was called "Strict Tōrei," as opposed to "Generous Suiō." Writing a number of books on Zen subjects, Tōrei paved the way for the expansion of Hakuin's teachings throughout Japan.

Several anecdotes have survived about Tōrei's style of teaching Zen.[3] In face-to-face encounters he was able to modify his approach to suit the recipient. The haiku poet Setchū-an Ryōta had often come from Edo to visit Hakuin at Shōin-ji; after the master's death, Setchū-an journeyed to Ryūtaku-ji to see Tōrei, who gave his teachings on Zen practice to the poet in haiku form:

Tobikonda *From the power of*
chikara de ukabu *jumping into the water—*
 kawazu kana *the frog can float*

This was a variation of the beloved haiku of Bashō:

Furu ike ya *An old pond—*
kawazu tobikomu *a frog jumps in:*
 mizu no oto *the sound of water*

At public meetings, Tōrei was often fierce. One winter day he was giving a lecture at Saga in the Kyoto area; the weather was so cold that everyone was shivering. Tōrei shouted: "Those of you who are afraid of the cold should go back home right away! There's no point in trying to learn about Zen unless you seek it in your own heart. Fish don't know ice even though they live in water; people don't know the wonderful teachings of the Buddha even though the Buddha-nature is within them." This so inspired a listener named Nakazawa Dōji, a student of Shingaku (a mixture of Shinto, Buddhism, and Confucianism), that he reached enlightenment and became a noted teacher himself.

Another anecdote reveals the respect Tōrei inspired. A young monk of Tōji-in fell in love with a prostitute from Kitano. He stole a large sum of money from his temple and ran away with his lover. When they arrived in Osaka, however, he could not find the money; had he left it hanging on a nail by his pillow at Tōji-in? In despair, they both committed suicide. Ever after, the

72. Tōrei (1721–1792)
ENSŌ
Ink on paper, 13 × 17³/₄"
Private Collection

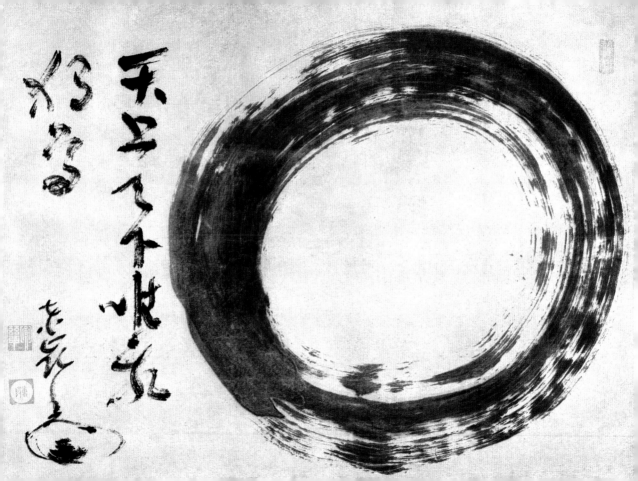

73. Tōrei (1721–1792)
WATER DIPPER
Ink on paper, 24¹/₂ × 11"
Tomioka Museum, Tokyo

sound of his sobbing could be heard at midnight in his room, and ghostly hands were seen reaching for the nail. Sometimes a woman's sobs could be heard as well, so when Tōrei came to lecture at Tōji-in, he was asked to exorcise the two ghosts. Tōrei stayed in the room that night, and thereafter there were no more traces of the ghosts. It seems that only the male ghost was fully exorcised, however. Several days later when Tōrei was due to give a lecture in Mikawa, a monk who had come to hear him speak was approached by a beautiful woman. She told him that she was a ghost, still in anguish after her suicide. She asked the monk if he would intercede for her with Tōrei, so that she could rest in peace. The monk asked her why she did not approach Tōrei directly, but she said he was too virtuous and she was too lowly. When the monk told Tōrei this story, he held a special service for her, and her ghost did not reappear.

These apocryphal tales indicate how Tōrei was viewed by the public and how he was able to help people of widely different backgrounds. Like Hakuin, Tōrei used brushwork as one of his teaching methods; he produced some of the most dynamic works in the Zenga tradition during his years at Ryūtaku-ji. A dramatic example is *Water Dipper (plate 73)*. Utilized in the tea ceremony to carry water to the kettle, the dipper here juts out from a bamboo container like the "Within" of Hakuin *(see plate 67)*.[4] On either side is Tōrei's calligraphy of a *waka* poem by the famous tea master Sen no Rikyū (1521–1591). It is based on the metaphor that just as the dipper moves from the cold water to the hot without care, so humans should consider birth and death without passion. The original reference is the forty-third *kōan* of the *Hekiganroku*, in which a monk who asks how to avoid cold and heat is answered: "When cold, let it be cold until it kills you, when hot, so hot it kills you." Rikyū's poem is particularly suited to lovers of tea:

Kannetsu no	*In the heat and cold*
jigoku ni kayofu	*of going to and from hell—*
cha hishaku mo	*the water dipper,*
kokoro nakereba	*since it has no heart or mind,*
kurushimi mo nashi	*has no feelings of pain*

Tōrei's signature and "clam" cipher are in an unusual position, high and to the left of the scroll. The shape of the "clam" echoes that of the top of the bamboo tube and is suggested again in the calligraphy to the right, creating a pattern of ovals that balances the primary vertical emphasis in the scroll. The vibrancy of the rapid, rough, sinuous brushwork is imbued with a dynamic power that is the hallmark of Tōrei's finest scrolls.

Although Tōrei created a number of powerful calligraphic works as well as paintings of both traditional and less common subjects, the impetuous freedom of his brushwork was especially suited to the ultimate Zen theme, the *ensō (plate 72)*. He brushed this circular form often, each time differently, but always with dramatic force. Here the circle is wide, with rapid brushwork in gray ink and a notable use of "flying white." Beginning at the lower left, Tōrei moved his brush with a remarkable combination of spontaneity and control, producing a circle that conveys both a lively sense of movement and a feeling of universal timelessness.

To the left of the *ensō,* Tōrei added an inscription that consists of the first words supposedly spoken by Sakyamuni, the historical Buddha, at his birth: "In heaven above and the earth below, I alone am the honored one." This saying indicates that the Buddha knew that he would achieve enlightenment,

but it has also served as a Zen *kōan,* since its full meaning is difficult to penetrate. On one level it seems like a boast, but are we not all Buddhas, enlightened if we can only awaken to our own inner nature? Perhaps the statement is a challenge to us, asking us to penetrate the void that the *ensō* symbolizes.

In his final years Tōrei continued to propagate Zen teachings. In 1791 he opened the subtemple Kitō-an at Zuizen-ji in Owari (present-day Aichi); the following year he returned to his home village to become abbot of Reisen-ji. It was here that he died on the nineteenth day of the second month at the age of seventy-two. His importance among the followers of Hakuin, both in the transmission of Zen and as a monk-artist, is second to none.

SUIŌ GENRO (1717–1789)

Born in Shimotsuke (present-day Tochigi), Suiō may have been the illegitimate son of a daimyo.[5] He became a pupil of Hakuin at about the age of thirty and studied with the master for twenty years. Nevertheless, he did not reside at Shōin-ji but lived some distance away in Nishi-aoshima. During these years, Suiō came to Shōin-ji only when there was a Zen meeting, and as he practiced *zazen* at night, no one knew of his diligence but his teacher, Hakuin.

Suiō had a free and untrammeled spirit. One day, as he left Shōin-ji after a meeting, a fellow pupil ran after him and said that Hakuin had called for him to return. Suiō paid no attention and continued on to his home. He was also fond of the board game *go* and of drinking sake.[6] Nevertheless, the mutual admiration between Hakuin and Suiō was very great. Suiō once commented that "even a strongly egocentric monk will practice hard and reach enlightenment if he studies with Hakuin. This is because there are many thorny bushes surrounding the Way of Hakuin; one cannot attack and cannot retreat, so one puts down the helmet and takes down the flag. Other masters do not have these thorns, so they cannot stop the monk's egocentricity."[7]

The most famous story about Suiō concerns his return from a Zen meeting given by Hakuin at Tenshō-in in Kuwana. On his way home, Suiō's boat capsized in Shichiri harbor during a violent storm. Suiō thought that he had sunk a great distance under the sea, but just at that moment he rose to the surface as though lifted by invisible hands. A fishing boat then rescued him from the roiling waters, and he believed he had escaped death by a miracle. This story later grew into a legend in which Suiō calmly meditated at the bottom of the Bay of Ise for several days after the shipwreck until he was hauled up in a net by fishermen who thought they must have captured a giant octopus. When they discovered the monk sitting in *zazen,* the fishermen were naturally amazed.

Hakuin greatly respected Suiō and appointed him his successor at Shōin-ji; at Hakuin's funeral, Suiō and Tōrei conducted the memorial services. It was Suiō who initiated the restoration of Ryūtaku-ji after it had been burned, and he persuaded Tōrei to return and take charge of the temple and its rebuilding program. Yet Suiō told prospective Zen pupils who came to him that he was just a lazy monk, and he recommended that they go to Ryūtaku-ji to study with Tōrei; he did take on some pupils, however, and over the course of their careers both masters trained a number of followers. On the seventh anniversary of Hakuin's death, Tōrei and Reigen asked Suiō to conduct the commemorative meeting, which more than two hundred monks and laymen attended. Suiō went on to lead other large meetings, and he became famous as a Zen teacher not only of monks but also of the general public.

It was Suiō's character to be both spontaneous and generous. He once told his followers that an old proverb says that it is better to fail because of slowness rather than quickness, but he believed the opposite: if one must fail, it would be better to fail from quickness. Examples of his generosity are many, including his encouragement of little-known monks to take prominent roles at major meetings that he held for Zen followers.[8]

Suiō was fond of painting, and he developed his own variations of the style of Hakuin's "early" period. Suiō was also a friend of the Nanga master Ike Taiga, and he was influenced by Taiga's choice of subject matter and style of brushwork.[9] Thus Suiō painted literati landscapes and plant subjects as well as Zen figures, adding his own personal charm to the artistic traditions that he followed. One of his most characteristic works is a portrait of Rinzai (Chinese: Lin-chi, plate 75), the T'ang dynasty monk from whom the Rinzai sect took its name. In Zen art, Rinzai was usually shown as a fierce master, his hands clenched in his lap and his face tightened as if he were about to shout "Katsu" at some unlucky (but ultimately fortunate) pupil. Rinzai was indeed an influential if unorthodox teacher, famous for shocking his followers into enlightenments beyond the confines of their everyday minds. Many of Rinzai's sayings were renowned: "Understanding and not understanding are both wrong. . . . On meeting a Buddha slay the Buddha. . . . Bring to rest the thoughts of the ceaselessly seeking mind. . . . Do you want to know the Patriarch-Buddha? He is none other than you who stand before me."[10] It was Rinzai who answered the kōan "What was the purpose of the Patriarch's coming from the West?" with the comment "If he had a purpose, he couldn't have saved even himself."[11]

The portrait that Suiō created of this venerated but irascible patriarch is unexpected; the old Chinese monk leans on his hoe (a reference to his practice of planting pine trees) and peers over his shoulder as though he were shy and retiring, an example of ironic humor on the artist's part. Nevertheless, there is an intensity in the crescent-moon shape of the figure that belies the mildness of the pose. His eyes, although looking out at us, seem to be staring into his own head. Suiō emphasized the face of Rinzai by the gray cowl behind his head and by thickening the line of his shoulder as it reaches his cheek. A marvelous emptiness is suggested by the large white space outlined by the robe, while a firm structure for the painting is achieved through the use of thick gray strokes at the lower part of the robe and the strong outlines of the feet. The variety of wet and dry gray ink tones in this work shows the influence of Taiga, but the strength, humor, and charm of the portrait are characteristic of Suiō.

A favorite Zen painting subject has long been the pair of Chinese eccentrics Kanzan and Jittoku (Chinese: Han-shan and Shih-te). Suiō often depicted them, pointing to the moon with happy or gleeful faces (plate 79). He also followed the Zenga practice of representing figures merely by their attributes. Jittoku, who was a kitchen sweep at a Chinese mountain temple, would sometimes carry scraps of food in a bamboo tube to his poet friend Kanzan. To an audience familiar with Zen, Suiō's depiction of a broom and a bamboo vessel is immediately recognizable as representing attributes of Kanzan and Jittoku (plate 74). Suiō's brushwork is fresh, gentle, and spontaneous. Although ranging only from light to dark gray, the ink seems to reverberate gently in its tonal variety, creating a sense of spiritual calm with its misty, shadowy beauty. The strong composition of the painting, organized in verticals and diagonals, also gives a sense of vibrant movement to the scroll that belies its simplicity.

74. *Suiō (1717–1789)*
ATTRIBUTES OF KANZAN AND JITTOKU
Ink on paper, 44 × 10¹/₂"
Private Collection

Suiō's inscription says, "This too is Kanzan and Jittoku." Was this merely to clarify his subject? Or is the artist drawing our attention not only to the play between figures and their attributes but also to the entire question of what a painting is? Zenga is nothing more than ink on paper or silk, yet we can feel the joy of Kanzan, the meditation of Daruma, the intensity of Rinzai, the humor of Hotei. Sensing the personal character of the artist through his brushwork adds another level of reality to the painting. The goal of Zenga is communication between artist and viewer, which demands active participation on both sides. Suiō painted an evocative image, but unless we recreate the pair of figures in our own minds, it will have no life. When we do, we share the Zen spirit not only of Kanzan and Jittoku, but also of Suiō.

The modest and amicable character of Suiō Genro sometimes led to misunderstandings and criticism. He once called upon a Confucian samurai named Yanada Zeigan (1672–1757). While they were talking, Zeigan's sixteen-year-old son came in and bowed to his father. Suiō nodded politely to him, whereupon the young man said, "I have bowed to my father, why should I bow to a Buddhist monk?" Suiō patted the young man on the back and said he was a prodigy. Zeigan later criticized Suiō, calling him vulgar in comparison with Hakuin, who would never flatter anyone. When the monk Myōki of Kyōkuen-ji heard about this, he said that Zeigan was ignorant and confused by not understanding that Hakuin was like thunder beating against a mountain while Suiō was like the soft clouds at its summit. Their "ink traces" bear out this astute assessment.

When the occasion arose, however, Suiō could be as patient and ultimately as firm as his teacher. One day a monk from Ryūkyū (Okinawa) came to visit Suiō for his instruction. Suiō gave him the "one hand clapping" *kōan* to meditate upon, and the monk stayed for three years. At the end of that time he came to Suiō and lamented that he had not yet reached enlightenment and that he had to return home to show his "same old face." Suiō felt sympathetic and told him not to worry but to sit in intense *zazen* for seven days. The monk followed his advice but returned to report that he had still not reached satori. Suiō again told him to meditate for seven days, but again the monk failed to achieve enlightenment. Suiō said that some masters in the past had needed twenty-one days of *zazen,* therefore he must try once more. The monk did so, but the result was no better. Suiō then told him to meditate for five days. The monk returned and said, "Again the same; no satori." This time Suiō told him, "If you cannot reach enlightenment in three days, you will die." The monk then meditated "to the death," and was finally able to penetrate the "one hand clapping" *kōan.* He and Suiō were both elated, and the monk was authorized to carry on his master's teachings.

Toward the end of Suiō's life, a pupil of Hakuin and Tōrei named Gazan Jitō (1727–1797) became known as an outstanding Zen teacher. In the summer of 1789, Gazan organized a Zen meeting on the *Hekiganroku* in Edo at Kishō-in. Although he was in poor health, Suiō decided to attend, despite his followers' entreaties. On the return to Shōin-ji, he suffered a stroke, and by the end of the year he was in critical condition. His followers asked for a final poem; at first he refused, but then he wrote the following verse, closed his eyes, lay on his side, and died peacefully:

I have deceived the Buddha
For seventy-three years;
At the end, there remains only this—
What is it? What is it? Katsu!

75. Suiō (1717–1789)
RINZAI
Ink on paper, 35 ¹/₄ × 11 ³/₈"
New Orleans Museum of Art

76. Reigen (1721–1785)
SKULL
Ink on paper, 34 × 10 ¹/₂"
L. Wright Collection

Gazan apparently felt somewhat responsible for Suiō's stroke, and later inscribed on a portrait of the master the following pair of memorial verses. In the second poem, he uses the words "floating island," which is one of Suiō's names:[12]

A beacon of light in a dark cavern,
This old monk shines like the blade of a pickax.
The earth receives the sun's blessing,
Never troubled by its appearance and disappearance.
His scolding fist reverberates among his students,
His fiery shout smashes the palace of the devil.
Amidst the vast ocean of suffering,
At the end, there remains only this—

Over the billowing waves of the ocean of suffering,
The moon shines on a floating island;
Through a thousand pine trees
Moves the sighing wind.

Gazan's poems suggest his reverence for the master's Zen achievements. He offers a different image of the monk's life than the one we gain of Suiō through his art, which is gentle and humorous, but inner strength can appear in many guises. Suiō's breadth of spirit was recognized by all who knew him; it shines through his ink paintings like the blade of the pickax in Gazan's verse.

REIGEN ETŌ (1721–1785)

Reigen was born to the Kojima family in Kizu, Tango, not far from Kyoto. His life is not clearly documented, but it is known that he entered Buddhist orders under the guidance of the monk Kōgoku at Zenshō-ji in Mineyama (Tamba). Hearing of Hakuin's teachings, Reigen went to Shōin-ji to study, but upon learning of Kōgoku's death, Reigen returned to Zenshō-ji. He then retired into the sacred mountains of Kumano, where Shinto and Buddhist rituals were practiced, to live as a hermit for more than ten years. One day he heard that Hakuin would be lecturing on the *Hekiganroku* at Rurikō-ji in Mino, not far from Kumano. Reigen decided to attend the meeting and was inspired to resume his training under Hakuin.

Reigen was an extremely reticent person. He did not live at Shōin-ji, but daily he made the long walk from his distant hut to Hakuin's temple with his hands crossed over his chest and an intense expression in his eyes. When he met another monk along the way, he simply bowed without a word. One day his fellow novices in training at Shōin-ji gathered together to discuss Reigen. They agreed that he seemed to be a good monk, but they could not tell the depth of his Zen understanding. Therefore, the next day a few of the monks stopped Reigen on the path to the temple and asked him to elucidate a *kōan*. Reigen simply bowed and walked on.

After a long period of study and meditation, Reigen became sick with a tumor (or ulcer) in his stomach. Following one hundred days of sickness, he suddenly reached enlightenment, which is said to have been very deep, and received *inka* from Hakuin. This probably occurred in 1759. He then returned once more to Zenshō-ji in his new capacity as the temple's ninth abbot. Hakuin's influence upon Rinzai Zen was steadily growing, and monks in the Kyoto area began to have more and more study meetings for advanced train-

ing. Reigen's own lectures on the *Hekiganroku* were so well received that he opened a monks' training hall at Zenshō-ji, where he taught a number of followers. He was invited in 1767 to Tenryū-ji, one of the major temples in Kyoto, to supervise the monks' training hall. This was the first time a follower of Hakuin had received such a post at an old established Kyoto monastery. In 1769 Reigen became the fifteenth abbot of the Tenryū-ji subtemple Rokuō-in. From this time on the Zen methods developed by Hakuin began to dominate the training of Rinzai monks.

Although Reigen was usually reticent, his comments were penetrating. One day a monk on a journey to Kyoto came to Reigen and proudly announced that he was Kaimon, pupil of Daishū. Reigen held out his hands and asked, "Why are my hands like those of the Buddha?" The surprised Kaimon couldn't come up with an answer, and thereupon returned to his temple to redouble his efforts.[13]

Reigen was not very interested in poetry or literature, but he created a few paintings that evoke his personality. One work that evinces his terse but pungent style is his painting of a skull *(plate 76)*. This was not a new theme in the Far East; skulls had long served to suggest the evanescence of human life. In the past, Zen monks such as Ikkyū had delighted in parodying human activities in "bare-bones" style. Nevertheless, Reigen's interpretation is unique. The ink is gray, suggesting rather than defining the skull lying along the side of a hill; grasses grow not only beside it but also through one eye socket. Reigen paused with his brush when drawing the broad, rough line describing the hillside, suggesting a grisly smile.[14] The skull is facing us directly, as though to communicate Reigen's laconic inscription:

77. Reigen (1721–1785)
HUT AND CROWS
Ink on paper, 13 × 21 7/8″
Man'yō-an Collection

What,
 what,
 WHAT?

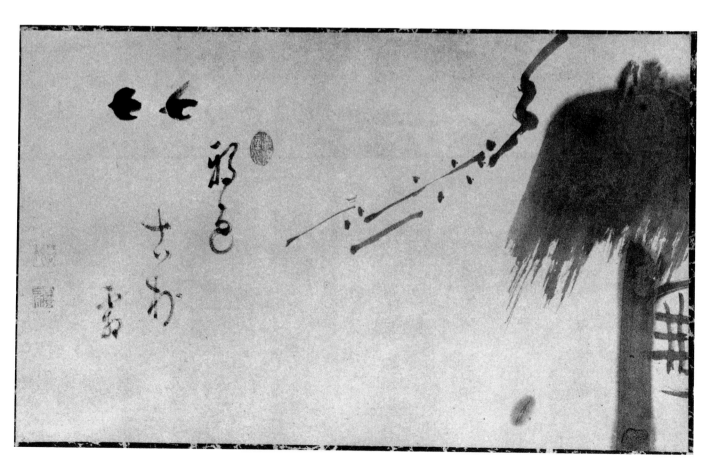

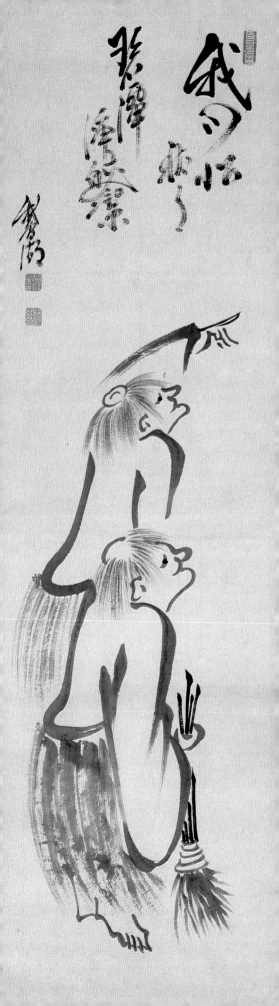

The shape in the foreground is somewhat mysterious. Might it be bones?[15] Whatever it may represent, it continues the diagonal of the grasses and the calligraphy, which is countered by the groundline. Everything seems to be leaning precariously, as if there were no stability—even to earthly decay. The image may seem frightening, but it suggests we free ourselves from attachments to life and death.

A gentler image was created by Reigen in *Hut and Crows (plate 77)*. One may find a sense of terse melancholy in this painting, which shows two crows flying past a thatch hut; one branch reaches out, seeming to join together the calligraphy and the image. The five-word inscription is written in three columns:

Crows pass
 Old village —
 Frost

What might this have meant to Reigen? The words had been written at least three times by Hakuin, once as a calligraphy,[16] once on a painting of Sakyamuni, and once with only the two crows painted at the top of a long vertical scroll.[17] The horizontal format, however, and the inclusion of the old hut and branch seem to have been invented by Reigen. The image of crows, which occurs more often in haiku than in the more formal *waka* or Chinese-style poetry in Japan, can symbolize affection and melancholy (crows supposedly cry when someone dies). A crow is also a homely image; it does not have the beautiful shape of a heron or the lovely song of a warbler. There could be nothing more everyday than the scene painted by Reigen, yet a frozen moment in time is created by both words and painting. A moment later and the crows will be gone, but just now, just as they are, they create a world of immediacy.

Reigen continued his active Zen teaching to the end of his life. He founded the temple Yōkō-in near Lake Hirosawa in Nara in 1778. Seven years later, at the age of sixty-five, he died, probably at Seigan-ji in Ōmi (Shiga), although other accounts suggest he died in Edo. As an artist, Reigen was less dynamic than Tōrei and less charming than Suiō, but his works have a subtlety and depth that repay repeated viewings. His modest brushwork and his choice of cinerescent gray ink tones fully express his inner calm.

GAKO (1737–1805)

Known more formally as Tengen Chiben, Gako was a "grandpupil" of Hakuin, meaning that he belonged to the second generation of monks in the Hakuin tradition. Born in Uehara village in Higashi Chikuma (Nagano), Gako received his training from Hakuin's pupil Daikyū Ebō (1715–1774). After receiving *inka* from Daikyū, Gako went to live in Onsen-ji ("Hot Springs Temple"), near Lake Suwa in Shinano (present-day Nagano), for twenty-seven years. Lake Suwa was locally called "Goose Lake" (*Gako*), and the young monk adopted it as his name. In 1774 he asked his master Daikyū to conduct a Zen meeting at Onsen-ji, but Daikyū suddenly died on his way to the temple, so Gako was forced to conduct the session. He went on to lead many more Zen meetings thereafter.

Gako also reestablished and supervised the restoration of Kōgaku-ji in Kai (Yamanashi), helping to spread the teachings of the Hakuin lineage of Zen. In 1801 Gako obeyed a request to supervise the *Sōdō* (monks' training hall) at

78. Gako (1737–1805)
KANZAN AND JITTOKU
Ink on paper, 39 × 11 ¹/₈"
Private Collection

79. Suiō (1717–1789)
KANZAN AND JITTOKU
Ink on paper, 62 × 12 ¹/₂"
Seattle Art Museum

Nanzen-ji, one of the leading temples in Kyoto. This was one more indication of how Hakuin's teachings were spreading through the Rinzai Zen establishment. Three years later Gako officially turned over his position at Onsen-ji to his pupil Gan'ō Zentei and retired to Kōgaku-ji. In the spring of 1805, however, Gako fell ill and returned to Onsen-ji, where he died on the seventeenth day of the seventh month.

Gako was a strict teacher, admonishing his followers to obey Buddhist precepts and not to leave the temple until they had achieved an awakening. He was compassionate to the people in his region, and he exhibited a sense of humor that is readily apparent in his paintings. There are two revealing inscriptions that Gako used on his self-portraits.[18] The first ends in laughter, the second with a Zen shout:

I swallowed up the Buddhas and Patriarchs
And covered heaven with my eyelids;
With the flimsiest of line, out of a thousand-foot well
I pulled out a huge snapping turtle and carried it home
Ha ha ha!

I smile at spring mountains
And frown at frozen lakes:
This? Not this?
Each little thing is the entire truth,
TOTSU!

Although known for his teachings, Gako has been most celebrated for his paintings, which follow the style of Suiō but have a special vigor and dynamic simplicity of their own. It seems that Gako's favorite subject was the two Chinese eccentrics Kanzan and Jittoku *(plate 78)*. Although he sometimes depicted them on paired scrolls, he also painted them on a single sheet of paper; here their backs are joined by the two brush lines. Jittoku leans back, holding his kitchen broom in one hand and clutching the earth with his toes, while Kanzan leans forward and points upwards to the moon. Gako's inscription comprises the first two lines of Kanzan's most famous poetic quatrain:

My heart is like the autumn moon
Pure and unsullied on the blue green pool

The final two lines of Kanzan's original poem, however, belie this famous metaphor with the understanding that words alone will not suffice:

No, this comparison is not right—
How in the world can I explain it?

Japanese Zen artists have utilized the first line of this poem not only for inscriptions on paintings of Kanzan and Jittoku but also at times to accompany the Zen circle, *ensō*. The heart (the same character means "mind") is like the moon reflecting light or like a mirror, reflecting all that comes before it; it is also the void, shown by the circle. Although Kanzan claims he can't explain it, his own understanding of the heart/mind may be inferred from his poetry. More than three hundred verses attributed to Kanzan are preserved, as well as a few by Jittoku. Kanzan often wrote about the reclusive life he chose for himself:

I settled at Cold Mountain long ago,
Already it seems like years and years.
Freely drifting, I prowl the woods and streams
And linger watching things themselves.
Men don't get this far into the mountains,
White clouds gather and billow.
Thin grass does for a mattress,
Blue sky makes a good quilt.
Happy with a stone underhead,
Let heaven and earth go about their changes.[19]

Although most of his poems are about his life as a hermit, one of Kanzan's most specifically Buddhist verses shows Zen spirit:

Talking about food won't make you full,
Babbling of clothes won't keep out the cold.
A bowl of rice is what fills the belly;
It takes a suit of clothing to make you warm.
And yet, without stopping to consider this,
You complain the Buddha is hard to find.
Turn your mind within! There he is!
Why look for him abroad?[20]

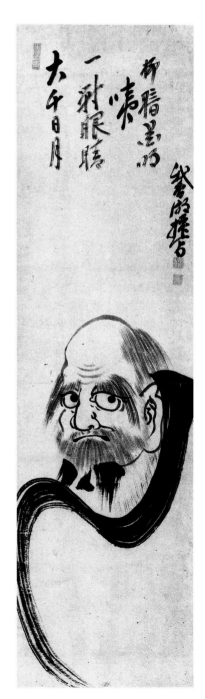

80. Gako (1737–1805)
DARUMA
Ink on paper, 38³/₄ × 10³/₄"
Private Collection

Gako shared the spirit of Kanzan's poems with his lively and individualistic brushwork. He used gray tones except for the poem, the brush, and particularly the eyes. Just two single dots show the wild, gleeful intensity in their eyes as they gaze upward. The sweep of Kanzan's arm is echoed by the calligraphy, the opening character of which is strongly inked to draw our attention again to it.

Gako modeled this painting after a design by Suiō, who painted the two eccentrics several times in similar poses.[21] In one such example *(plates 78 and 79)*, the compositions at first seem identical, but a close viewing shows many subtle differences between the ink tones and brushwork. The biggest distinction is in the individual brushstrokes defining the body and facial expressions; Suiō portrays a kind of manic joy for Kanzan and wonderment for Jittoku, while Gako expresses intensity in the gaze of both figures.

Monk-artists often repeated the same theme, each example embodying the particular spirit of the artist on that day, at that very moment. As one examines these paintings over a period of time, the small differences become large, and the individual character of each monk becomes apparent. The paintings of Kanzan and Jittoku by Suiō, Gako, and others show different aspects of the spirit of the Chinese eccentrics, a spirit fundamentally expressed in Kanzan's poem:

The everyday way is fine for me—
Like vines wrapped in mist along rocky ravines,
I am free in a vast wilderness,
Drifting, drifting with my friends, the white clouds.
There is a path, but it does not lead to the world of men;
Mindless, there is nothing to arouse my thoughts.
Alone at night, I sit on a bed of stone,
While the round moon climbs up Cold Mountain.

Gako occasionally painted subjects other than Kanzan and Jittoku. The touchstone of a Zen artist is his rendition of the first patriarch, and Gako occasionally brushed portraits of Daruma (plate 80). The inscription on this work has been translated:

81. Shunsō (1750–1839)
DARUMA. 1828
Ink on paper, 49 3/4 × 20 5/8″
Private Collection

He peers into eons
With his clear-eyed gaze.
 YES!!
Dark willows, bright flowers.

John Stevens, a scholar of Japanese Zen art, has offered the following interpretation of Gako's painting:

The inscription contains a risqué pun. "Dark willows, bright flowers" was originally a Zen metaphor for Buddha-nature, but then it quickly became a euphemism for "pleasure quarters." The slang nickname for courtesans was "Daruma" because they were like the legless Daruma toy dolls that always sprang back ready for more, each time they were placed on their backs. In short, Gako tells the viewer that Daruma may as well be encountered in a brothel as in a monastery, and that one should not seek him exclusively in "religious" edifices. In keeping with that theme, Gako's Daruma appears rather cagey; wide-eyed and alert, this Daruma is impossible to deceive. However, he seems more tolerant and understanding of human frailties than Hakuin's fierce Patriarchs.[22]

Gako has supported the head of Daruma with three blunt, axlike strokes. He then brushed a long sweeping line to suggest the patriarch's robe. Enlivened by these dramatic brushstrokes, Daruma's expression is rich in emotion. It is up to each viewer to define what the dominant feeling may be—is it cagey, alert, tolerant, understanding, quizzical, reproachful, apprehensive, questioning, compassionate? Gako's painting may thus be treated as a kōan. As in all Zen art, the activity begins with the painter but comes to life each time the work is sympathetically viewed.

SHUNSŌ SHŌJŪ (1750–1839)

It is one of the many paradoxes in Zen that monks, who presumably have gone beyond ego and selfhood, nevertheless reveal such different personalities in their brushwork. Born in Saganoseki, Ōita, Shunsō (like Gako) became a pupil of Daikyū in the Hakuin lineage, although Shunsō went on to receive his inka from Suiō. Despite their similar backgrounds, the paintings of Gako and Shunsō are surprisingly dissimilar. This is clearly shown by Shunsō's Daruma (plate 81), in which the patriarch is depicted in the same pose as in the painting by Gako, but otherwise the two works are very different. Shunsō built up the strong lines beneath the head in an architectonic structure, emphasizing vertical movement with slightly varied tones of gray black ink. His lines are more numerous, wetter, and more formally composed than those of Gako. They suggest solidity and power rather than exuberant movement. Shunsō's depiction of Daruma's face is also different, although the style stems from the same Hakuin tradition. Shunsō's patriarch has a bulging forehead without wrinkles, a powerfully conceived nose with no nostrils, and two separate dots for the mouth rather than a continuous line. Most distinct of all is the expression in the eyes, which is fierce, almost malevolent, revealing the forcefulness of Shunsō's personality. The inscription, which begins on the upper left, is a couplet attributed to Daruma himself:

82. Hakuin (1685–1769)
DEVIL'S ROD
Ink on paper, 50³/₈ × 10⁷/₈″
Private Collection

A single flower opens to five petals,
And bears fruit according to its own nature.

For some reason, Shunsō left out one character from the second line, but there is no change in the meaning. On the upper right he added the date, which corresponds to 1828, and his signature. The total effect of the work is monumental; it may well be that of all the followers of Hakuin, Shunsō painted Daruma with the most forcefulness.

Shunsō was ordained as a monk, at age eleven, at Jizō-ji in Kyushu. At eighteen, he began Zen training under Ranzan Seiryū (1718–1797) at Kaizen-ji in Buzen (present-day Fukuoka) and then traveled to receive instruction from various Zen masters, including Daikyū and two other direct pupils of Hakuin, Reigen and Tengei (1723–1794). After concluding his training under Suiō, Shunsō became the ninth abbot of Jikō-ji in Awa (Tokushima) at the age of thirty-five. He later attained the position of *dai ichiza* (first monk) at Myōshin-ji, the head temple of his lineage. In 1814 Shunsō received the purple robe at Myōshin-ji from the emperor; he went on to restore the monks' training hall at Empuku-ji, Yamashiro, and returned to Myōshin-ji at the age of seventy-three.

One of the most dramatic of Shunsō's paintings is *Devils' Rod (plate 83)*. It is believed in some forms of Buddhism that demons will beat sinners on the way to hell with such a rod; the subject had been portrayed by Hakuin *(plate 82)* with the inscription "Whosoever fears this rod will be on the way to paradise."²³ By contrast with Hakuin's boldly curved, multitonal brushwork, Shunsō painted with dry, black, angular lines that are less massive than sharp, less expansive than tense and taut. The effect is thunderous and may well have struck the fear of hell into its viewers.

For his inscription to the right of the image, Shunsō added the same Buddhist text that Ikkyū brushed three hundred and fifty years earlier in his pair of calligraphic scrolls *(plate 7)*:

Refrain from all evil, practice only the good

In contrast to Ikkyū's dry and blunt brushwork full of "flying white," Shunsō wrote his inscription in more fluent and curvilinear script, ending with a long, dynamic, twisting, vertical stroke; his signature and seals on the left conclude the work.

Although Shunsō also painted less fearsome subjects, his finest works are those that reveal his rough-hewn personality. His surviving paintings and calligraphy testify to the importance he invested in brushwork as a means of conveying his insights. Like the work of most Zen monks, his paintings come almost exclusively from his later decades, and dated examples of his work show a continuous increase in power and clarity through his final years. He died at Banshō-an on the first day of the second month of 1839, at the age of eighty-nine.

Tōrei, Suiō, Reigen, Gako, and Shunsō are only five of the many important monks who carried out the expansion of the Hakuin tradition. These monk-artists—and their pupils for generation after generation—continued the rigorous *kōan* study, sutra chanting, *zazen,* and public teaching that Hakuin promulgated. They assured the future of Rinzai Zen by renovating temples, presiding over monks' training halls, holding large-scale Zen meetings on texts such as the *Hekiganroku,* and by reaching out to both their pupils and the wider public through the visual impact of paintings and calligraphy.

83. Shunsō (1750–1839)
DEVIL'S ROD
Ink on paper, 34⁵/₈ × 10⁷/₈″
Borsook Collection

THE LATER EDO PERIOD: JIUN RYŌKAN AND GŌCHŌ

Zen monks are captivated

by the autumn moon and

springtime blossoms;

But when satori comes,

there's no need for spring or fall.

Although followers of Hakuin in the Rinzai sect created most of the Zen paintings and calligraphy of the later Edo period, three major masters of other sects appeared, each of whom brought a significant personal vision to the Buddhist world. One was a Sōtō Zen monk; the other two were members of the esoteric Shingon and Tendai Buddhist sects. The three were fine poets and individualistic calligraphers who produced some of the most powerful, most personal, and most dramatic brushwork of the Zenga tradition. Furthermore, each took a different attitude toward the general state of Buddhism at the time.

In central Japan, the Shingon monk Jiun Sonja stressed the deep study of the original texts of Buddhism and promoted strict adherence to the corpus of rules that governed a monk's life. He believed that the raising of monastic standards would create a firm foundation for the renewal of Buddhist faith among the populace. His strength of character is revealed in the indomitable boldness of his dry-brush calligraphy. In the Niigata area of northern Japan, the Sōtō monk Ryōkan abjured temple life in favor of a reclusive existence; he did not try to instruct anyone but himself, and yet his life, poetry, and calligraphy became models for others. His brushwork has a modest purity and a childlike gentleness that is unique within the Zen tradition. In Kyushu and later in Nagoya, the Tendai monk Gōchō took an entirely different course from Ryōkan, trying hard to reach the populace through such means as incantations and faith healing as well as art. His calligraphy and painting embody the wide range of subjects he needed to communicate with his broad spectrum of followers.

JIUN SONJA (1718–1804)

Although Jiun was a monk of the Shingon sect, his work has long been regarded as Zenga. This is due both to the spontaneous and powerful nature of his brushwork and to the Zen content of much of his calligraphy. Jiun was born in Osaka, the seventh of eight children from a rōnin family (masterless samurai). His father, who worked at a granary, maintained an active interest in Buddhism, Shinto, and Confucian philosophy; Jiun's mother was a devout Buddhist. As a child, Jiun received the education in Confucianism and the martial arts that was typical for the sons of the samurai class. Hearing criticisms of Buddhism from his family's tutor, Jiun at first disliked monks and thought that the historical Buddha had been a false leader. Just before Jiun's father died, however, he made a last request that the thirteen-year-old Jiun become a monk (perhaps to ease the responsibility of his mother in caring for eight children). Jiun was entrusted to the Shingon sect priest Ninkō Teiki (1671–1750) at the temple Hōraku-ji in southeast Osaka. At first the young monk was resentful of his new life-style:

My father's last wish was that I enter the Buddhist clergy, and all of my relatives encouraged it. Since it was unavoidable, I took the tonsure, but to myself I thought, "The Buddhist Dharma is false and deceitful. After I have studied it for ten years and have understood the reasons for this, I will return to lay life, crush the Buddhist Dharma and establish the way of the [Confucian] teacher Chu Hsi."[1]

Despite his negative attitude, Jiun was impressed with the intelligence, sincerity, and kindness of his teacher Teiki. Jiun learned the tenets of esoteric Buddhism and was introduced to the Sanskrit syllabary known as Siddham, which in Japan was used primarily to write the names of the many deities

extolled in Buddhism. Teiki was one of the few monks who knew more than the token amount of Sanskrit required to read, write, and chant the names of deities in Shingon rituals. Jiun was fascinated by the Indian script and resolved to study it thoroughly. At the age of fifteen, he had an unexpected experience. It occurred while he was undertaking a series of esoteric meditations in which the practitioner performs certain ritual gestures (mudras) that help to invoke a particular deity:

In the initial rites and prostrations, I simply followed custom. I did not believe in what I was doing even for a moment. But when I came to the meditation upon Nyōirin Kannon involving the use of the eighteen mudras, I had a rather strange sensation, and when I actually carried out this practice, I was deeply moved. [2]

Jiun immediately wrote a letter to his mother, thanking her for having forced him to become a monk; he plunged into his Buddhist studies with new vigor. His teacher Teiki recommended that Jiun acquire as broad an education as possible, however, and so the next year he was enrolled in the "Ancient Learnings" Confucian school of Itō Jinsai (1627–1705), where he studied under Jinsai's son Itō Tōgai (1670–1736). The young monk mastered Confucian texts as well as Chinese prose and poetry. The focus of this school was upon the original teachings of the Chinese classics rather than later interpretations of them. This was directly opposed to the educational doctrines of the powerful Neo-Confucianist Chu Hsi school which was supported by the shogunate because it stressed duty and loyalty. The importance of studying original texts was to prove seminal in Jiun's thinking, although it would be applied to Buddhism rather than Confucianism.

Three years after Jiun entered the Itō academy, Teiki became sick, so Jiun journeyed back to Hōraku-ji. Although his teacher soon recovered, Jiun did not return to the Confucian school. Instead he was invested with a series of precepts, and at age twenty-one he pledged to uphold the full *vinaya,* the strict corpus of rules that formally governs a monk's life.

At the age of twenty-two, Jiun became a Shingon abbot; Teiki retired in that year and Jiun succeeded him at Hōraku-ji. Not satisfied with his own spiritual progress, however, Jiun gave up his post after two years and entered into full-time Zen practice under the Sōtō-sect monk Hōsen Daibai (1682–1757) at Shōan-ji in Shinshū (present-day Nagano prefecture). Jiun realized that the study of Buddhist texts was not sufficient in itself to liberate him from the cycle of birth and death, and so he determined to enter a life of meditation. He seems to have attained at least a partial enlightenment under Daibai at the age of twenty-five, but he did not formally convert to the Sōtō sect. Rather than devoting himself completely to Zen, Jiun returned to Hōraku-ji in 1743 and lived the rest of his life as a Shingon monk who also seriously practiced Zen meditation. In addition to this unusual combination, he continued his Confucian studies and took a deep interest in Shinto. He initiated a new religious movement in 1749 (not officially recognized by the government until 1786) that combined features from various sects and systems of thought. Rising above sectarian lines, the Shōbōritsu movement soon attracted many earnest young monks and nuns. In his teaching, Jiun stressed that the strict rules of the *vinaya* were the essence of the Buddhist life and that meditation was the source of true understanding. Throughout his life, Jiun's sermons and writings were centered upon these same two points: the necessity for monks to uphold meticulously all Buddhist regulations and the importance of the intuitive wisdom that comes from Zen practice.

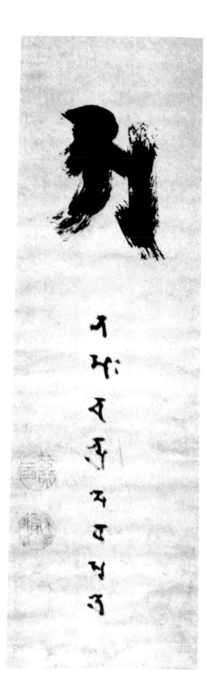

84. *Jiun (1718–1804)*
THE SANSKRIT LETTER A
Ink on paper, 32¹/₄ × 10"
Kinami Collection

Jiun and his chief disciples refurbished two old temples near Osaka, Chōei-ji and Keirin-ji, in order to teach his growing band of followers. After more than a decade of activity, however, the deaths of several people close to him (including his teachers Teiki and Daibai) led Jiun to retreat to the mountains. He spent the years from 1758 to 1771 at the Sōryū-an ("Two Dragon Hut") on Mount Ikoma, immersed in meditation and Sanskrit studies. His deep love of nature also motivated his move to the mountains, as he made clear in a poem:

Weary, I yearn for the forest and hills;
Against my will, ten years have I spent in the world of men.
Burning incense, I take leave of the assembly,
* shunning worldly affairs, I depart.*
The mist invites me and I know that it is time to rest.
Men of little talent are not guests fond of mountains.
Men of little virtue do not make companions for gathering leaves.
Should someone ask, "When will you come back?"
I would reply, "The white clouds and the green water are boundless and serene."[3]

During this period Jiun continued to give lectures and to teach his followers. He also made great progress in his Sanskrit studies, reaching a point where he could read even the most abstruse early sutras without any difficulty. His interest in studying original writings, stimulated by Itō Tōgai, spurred him into becoming the greatest Sanskrit scholar that East Asia has known.[4] He felt that because monks read only translations of fundamental texts from India, many of the fine points of Buddhism had been lost or misinterpreted. His commitment to reform the clergy, allied to his belief in the *vinaya*, was also a result of his Sanskrit studies. On occasion, Jiun wrote out Sanskrit texts, sometimes in the "single-line calligraphy" format that had been popularized by Zen monks.

One such scroll is *The Sanskrit Letter A (plate 84)*. This is the first and most important letter in the Sanskrit alphabet and is the source of all vowels and consonants. Furthermore, Chinese and Japanese monks often wrote a single Sanskrit letter to represent a deity's name, a form of acrology that was common in cultures where a single graph was an entire word. The letter *A* represents the supreme universal Buddha (and sun god) Dainichi and is therefore used for meditation in esoteric Buddhism.[5] After performing a set of rituals, including hand gestures and chants, the believer sits in lotus position, pronounces the *A* sound with each breath, and visualizes the deity within his inner being. This practice is aimed at uniting the worshiper with the Buddha; the equivalent in Zen is finding the Buddha-nature within the self.

In this scroll Jiun has written the letter *A* in large, rough brushstrokes at the top of the paper so it dominates the composition. The two opposing diagonals forming the bottom of the *A* open out to an empty space that leads to the smaller column of Sanskrit letters below. These form the mantra: *namah candhara diva putra* ("Hail to the Moon, Child of Heaven"). Since the seed syllable *A* represents Dainichi, the sun god, it is unusual to see the mantra below referring to the moon. This may have been Jiun's method of balancing the two celestial beings. Rather than signing the scroll, Jiun honored these deities by imprinting two seals that are, appropriately, both round rather than square in shape.

Jiun's activities during his "retirement" were manifold; he not only continued his sermons and writings, but he also intensified his efforts to reform Buddhist practices that had lost their original significance. He stressed partic-

ular attention to Buddhist precepts and distributed properly designed clerical robes based upon original Indian models. Some of these robes still exist, and they exhibit a modest formality that is far from the highly colored and decorated robes worn on ceremonial occasions by Buddhist prelates.[6]

In 1771, five of Jiun's followers purchased the Amida-dera in Kyoto and persuaded Jiun to abandon his mountain hermitage in order to become abbot of the temple. He lived there for the next five years, preaching to monk and lay followers and writing a series of special sermons at the request of members of the imperial family. In 1774 these sermons were published as a popular text, *Jūzen hōgo* ("The Ten Buddhist Precepts"), in which he denounced the evils of killing, stealing, committing adultery, lying, using frivolous language, slandering, equivocating, exhibiting greed or anger, and holding erroneous views.[7] This book was printed in a number of editions and served as Jiun's most important teachings to the general public.

Jiun's greatest scholarly achievement, however, was his thorough study and explication of Sanskrit grammar and texts, the *Bongaku shinryō* (Guide to Sanskrit Studies). Handwritten, this moliminous work totaled one thousand volumes and was too extensive to be published even in the *Jiun Sonja zenshū* ("Complete Works of Jiun Sonja"), which contains only its table of contents. The *Bongaku shinryō* catalogs a great deal of information on Indian history, geography, and customs as well as all of the preserved Sanskrit sources that Jiun found; he included both complete and partial texts in Sanskrit and dictionaries and grammars of the language. Within this magnum opus, Jiun was able to unravel past mistakes and to clarify many early Buddhist sutras and other texts.

In addition to his importance as a Buddhist scholar, Jiun became one of the most impressive calligraphers of the Edo period, producing a large number of scrolls displaying his unique style of calligraphy. Jiun's *Fumai* ("Not Deluded"; *plate 85),* expresses an important Zen phrase about overcoming illusion. The two large Chinese characters are firmly weighted in space, with heavy horizontal, vertical, and diagonal strokes. There is no possibility of avoiding Jiun's message; the characters are written in bold, clear regular script, and the force of the brushwork instantly attracts attention. Jiun may have used a special brush, perhaps of split bamboo, to achieve the combination of thick lines and frequent "flying white" dry-brush effects. The short horizontal

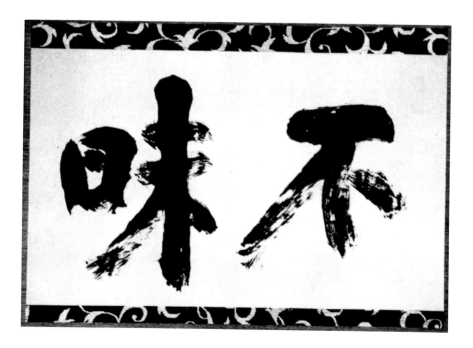

85. Jiun (1718–1804)
FUMAI
Ink on paper, 13⁵/₈ × 20¹/₄"
Kinami Collection

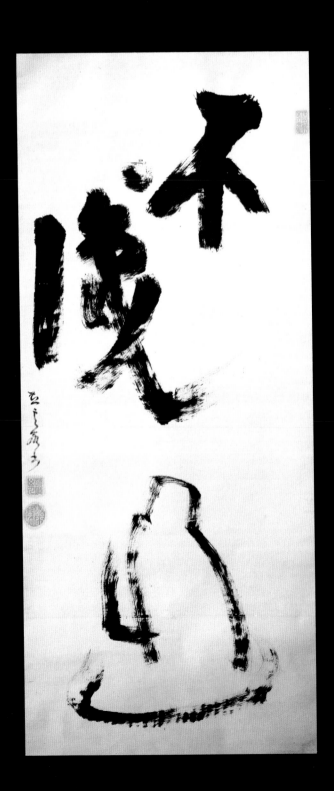

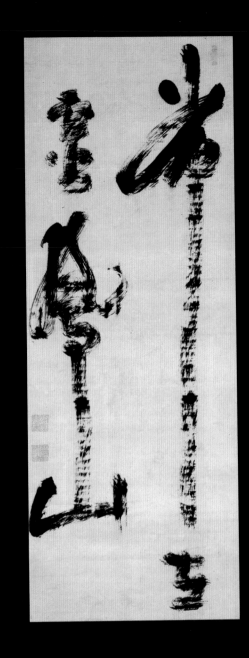

strokes contrast with longer diagonals moving down to the left, leading the eye to the squared "sun" [日] form, which seems to shine forth at the end of the scroll. Thus within the "not deluded" proclaimed by the calligraphy, there is a final illumination of satori.

Jiun produced most of his artistic work in his final years; after his retirement from the Amida-dera in 1776 he spent the last twenty-eight years of his life at the small temple Kōki-ji in the Kongō mountains of Kawachi, not far from Osaka. Here he continued his activities, including the preparation of clerical robes, one of which he sent to the dying Emperor Gomomozono in 1779. Jiun also continued to officiate at ceremonies and to give sermons at various temples, including Kyoto's Daitoku-ji, where he spoke on the *Rinzairoku*. One of his most remarkable scrolls, probably from this period, shows his vision of the Zen patriarch Daruma *(plate 86)*. This large work depicts the patriarch meditating in front of a wall; seen from behind, Daruma sits in a curiously angled position rather than the symmetrically balanced pose in which he is usually depicted. Perhaps Jiun was portraying the intense inner energy of the patriarch responding to the profound *kōan* created in powerful calligraphy above him. The two characters represent the final words Daruma had uttered to Emperor Wu: when asked who he was, the monk replied that he did "not know." The meaning of this statement has long been pondered. Since Daruma's next nine years were spent in meditation, the reply to the emperor certainly refers to the entire question of the self and enlightenment.

In this monumental work, Jiun represents two different events in Daruma's life, answering the emperor and meditating, as unified in a single dynamic moment. Everything is in motion: the first character, for "not" [不], tilts sharply to the right, while the second character, for "know" [識], spins and hooks down towards the figure. The image of the patriarch seems to vibrate with inner animation and is balanced only by the strong rough line at the bottom. The scroll displays the Japanese penchant for dramatic asymmetry; compared with Nobutada's version of the same subject *(plate 8)*, it suggests that Jiun viewed meditation as a state of internal wrestling rather than harmonious serenity.

Even more than understanding Zen, Jiun was committed to the universality of Buddhist truth, which went beyond sect, beyond place, and beyond time. He wrote out several times a significant passage from the *Lotus Sutra* about eternal and universal Buddhahood, proclaiming that the historical Buddha did not give his sermon on the "Vulture Mountain" only at a single historical moment, but beyond the concept of time. Jiun wrote the words of the Buddha, "I Am Always on the Vulture Peak," with great force and conviction *(plate 87)*. The first word, "always" [常], begins with a wet, lustrous dot, but moves quickly to a greatly extended vertical line. Hakuin had created much the same effect with the same character *(plate 61)*, but the differences are striking. While Hakuin had maintained a wet gray tone, Jiun preferred his unique version of "flying white." When writing, he had put the paper directly on the tatami (reed matting) in his room, and by this method he achieved the horizontally banded texture of his brushstrokes.

Hakuin and Jiun both show a thick, massive strength in their calligraphy, but the Rinzai master seems to present a slower, rounder, more serene style of writing than the dynamic force of Jiun. Hakuin's subsidiary characters are relatively equal in size, while Jiun's range from small and crunched to large and expansive. The final character in Jiun's calligraphy, "mountain" [山], concludes with a horizontal stroke supported by a smaller vertical on each end,

much like the final strokes of the *Daruma* scroll *(plate 86)*. The conclusion to this calligraphy is even more decisive, however, as though there could be no doubt about the universality of the Buddha's presence. Jiun's work in calligraphy was one of the outstanding aspects of his later life—a direct expression of his trenchant and indomitable spirit, honed and refined through Buddhist practice and meditation.

Jiun's practice and studies of Buddhism were far-reaching, but he also published writings on Shinto in his later years, continuing to stress his belief in the "Ten Precepts." Thus he was able to show protonationalists who claimed that Buddhism was a "foreign religion" that correct moral behavior was a universal value that had existed in Japan even before the advent of Buddhism.[8] Furthermore, in his final years Jiun tried to reconcile the approaches of Shingon and Zen, the two forms of Buddhism closest to his heart. By the time of his death in 1804, Jiun had instructed several hundred pupils, and his Shōbōritsu movement was adopted by more than two dozen temples. His greatest contributions, however, were his voluminous writings on Sanskrit, Buddhism, and Shinto, and his legacy of calligraphy that radiates with spiritual force.

RYŌKAN (1758–1831)

The Sōtō monk Ryōkan, sometimes known by the name Daigu ("Great Fool"), which he awarded himself, took a very different approach to Buddhism from Jiun. Having no ambition to be a reformer, Ryōkan lived an extremely simple and modest life in the "snow country" of northern Japan. Born in the village of Izumozaki in what is now Niigata prefecture, Ryōkan spent almost all his life in that cold and remote district, far from the religious and cultural centers of Kyoto and Edo (Tokyo). Yet his poetry and calligraphy have become among the most treasured of Zen expressions.

Ryōkan was not originally destined to become a monk. His father had inherited the posts of headman of Izumozaki and keeper of the village Shinto shrine; he was also a haiku poet of some note and a passionate supporter of the emperor. As a child, Ryōkan was expected to follow in his father's career. He attended the local Confucian academy, where he was particularly attracted to both Chinese and Japanese poetry. He later wrote a Chinese-style quatrain about these youthful studies:

I recall when I was a youth,
I would read, alone in the empty hall—
Filling the lamp with oil again and again,
I never noticed the long winter night.

Although Ryōkan was expected to become the family heir, at the age of eighteen he entered the local Zen temple, Kōshō-ji, and his younger brother replaced him in the family succession. The reasons for Ryōkan's decision are not entirely clear. Perhaps he found the administrative duties of village headman, for which he had apprenticed, burdensome—according to one story he failed as a mediator during disputes because he conveyed the opinions of the various participants too honestly. Another suggestion is that his parents had contracted a marriage for him that quickly proved to be unhappy; still another local tale is that he was shocked into concentrating upon questions of

birth and death by witnessing the beheading of a criminal.[9] In any event he made a decision that was rare for the eldest son of a village headman, but he never wavered in his determination to follow the religious life from that moment forward.

In 1779 the Zen master Kokusen visited Kōshō-ji, where Ryōkan had been in training for four years. The young monk immediately decided to become Kokusen's disciple and followed him to his home Sōtō temple, Entsū-ji, in Okayama; Ryōkan studied there for the next twelve years. As well as practicing Zen, Ryōkan must also have continued his studies of Chinese and Japanese poetry and calligraphy:

Since I first came to Entsū-ji,
How many winters and springs have passed—
In front of the gate, a village of a thousand homes,
But I do not know a single person.
When my robe is dirty, I wash it myself,
When I run out of food, I go out begging.
I used to read the lives of the great monks:
They spent their lives in the goodness of poverty.

Ryōkan's later calligraphy of this poem, written in a rather delicate regular script, shows his individualistic spirit *(plate 88)*. The characters at first seem almost childlike, but they are based upon a thorough grounding in both Chinese and Japanese calligraphy. The most immediate precursor of this style is the regular script of the literatus Ike Taiga, who also left unusual spaces between strokes, utilized a rather thin line, and expressed a seemingly naive charm that masked a rigorous understanding of Chinese masters such as the T'ang-dynasty calligrapher Chu Sui-liang. Ryōkan's calligraphy reveals his own balance between clarity, self-effacement, inner serenity, and gentleness.

Ryōkan received *inka* at Entsū-ji in 1790, but after his teacher's death the following year he embarked on a period of wandering and pilgrimage. In 1795 Ryōkan's father visited Kyoto. Evidently in a fit of despair at the powerless situation of the emperor, he drowned himself in the Katsura River. Ryōkan traveled to Kyoto to participate in a memorial service, then returned to his native Niigata, where he remained for the rest of his life.

In 1804, Ryōkan settled down in a little one-room hut built high on the slopes of Mount Kugami, a few hours' walk from his original home. The hut was called the Gogō-an (Five Rice-Bowl Hermitage), as the previous monk who had lived there received a daily ration of rice from a nearby temple. Ryōkan, however, had to beg for his food. He stayed at the Gogō-an for thirteen years; his way of life is best recounted in his own simple but deeply personal poetry:

The springtime breathes a quiet melody;
Swinging my staff, I enter the eastern town.
Newly green willows fill the gardens,
Buoyantly floating plants cover the ponds.
My bowl is fragrant with rice from a thousand hearths,
My heart renounces power and glory.
Following the path of past Buddhas,
I beg for food and travel on.

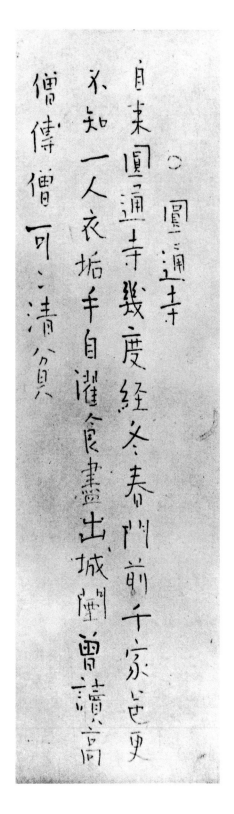

88. *Ryōkan (1758–1831)*
ENTSŪ-JI POEM
Ink on paper
Private Collection

Finishing a day of begging,
I return home through the green mountains.
The setting sun is hidden behind the western cliffs
And the moon shines weakly on the stream below.
I stop by a rock and wash my feet.
Lighting some incense, I sit peacefully in zazen.
Again a one-man brotherhood of monks;
Ah . . . how quickly the stream of time sweeps by.[10]

It was a very solitary life that Ryōkan chose for himself, and two of the poems that he wrote in the Japanese classical *waka* style show his mixed reactions to being alone. Most of the time, he welcomed his circumstances:

Yo no naka ni	*It's not that*
majiranu to ni wa	*I never mix*
aranedomo	*with men of the world—*
hitori asobi zo	*but really I'd rather*
ware wa masareru	*amuse myself alone.*[11]

Occasionally, however, he felt solitude was painful; sometimes this occurred when he observed the bustling life of his fellow countrymen.

Kono sato no	*Here in this village*
yukiki no hito wa	*there are so many people*
amata aredo	*coming and going—*
kimi shi masaneba	*but when you aren't one of them*
sabishikari keri	*it can be very lonely.*

One way that Ryōkan found company was by playing with village children. Together they enjoyed a game called *temari*, played with a ball made of wound-up yarn, or he would even play mock battles with grasses and weeds:

First days of spring—blue sky, bright sun.
Everything is gradually becoming fresh and green.
Carrying my bowl, I walk slowly to the village.
The children, surprised to see me,
Joyfully crowd about, bringing
My begging trip to an end at the temple gate.
I place my bowl on top of a white rock and
Hang my sack from the branch of a tree.
Here we play with the wild grasses and throw a ball.
For a time, I play catch while the children sing;
Then it is my turn.
Playing like this, here and there, I have forgotten the time.
Passersby point and laugh at me, asking,
"What is the reason for such foolishness?"
No answer I give, only a deep bow;
Even if I replied, they would not understand.
Look around! There is nothing besides this.[12]

During the winter, the most arduous and lonely of times, Ryōkan enjoyed reading books of poetry and composing verses in his direct, unassuming style:

Midwinter, the eleventh month.
Wet snow falls unceasingly,
All the mountains have become the same color;
On the myriad paths, human tracks are few.
My past journeys now all seem like dreams,
The door to my grass hut is deeply covered.
All night long I burn small chunks of wood
And silently read poems by masters of the past.

Ryōkan would not give up this life of seclusion that he had chosen for himself, but he also wrote honestly about the melancholy that he felt at times:

Bleak and lonely, my little hut;
All day long, no friends to see—
I sit alone by my window
And hear only the sound of falling leaves.

In 1809, Ryōkan was visited by the Confucian scholar and poet-painter Kameda Bōsai (1752–1826), who had journeyed to Niigata to visit former students, friends, and patrons in the area.[13] According to one story, Ryōkan and Bōsai were drinking one evening at the Gogō-an, but they ran out of sake. Ryōkan declared he would walk down the mountain to a wineshop and buy another bottle. After some time had gone by and the monk had not yet returned, Bōsai started down the path to search for his friend. He found Ryōkan sitting on a stone, utterly absorbed in the beauty of the moon.

The two friends were also among the finest calligraphers Japan has known, and although their styles are similar, particularly in cursive script, their different personalities are reflected in their brushwork. Bōsai's calligraphy is slightly more ornate and vigorous; Ryōkan's more subdued and simple. According to one anecdote, during his sojourn in Niigata Bōsai was requested to write a banner for a Shinto festival; the cloth was being prepared when

89. Ryōkan (1758–1831)
AUTUMN LEAVES
Ink on decorated paper
Takashi Yanagi Collection

90. Ryōkan (1758–1831)
I-RO-HA *and* ONE, TWO, THREE
Ink on paper, each 50 1/4 × 17 1/4"
Private Collection

Ryōkan happened to visit. Bōsai asked the monk if he would like to write the banner, whereupon Ryōkan picked up the brush and inscribed *Hachiman-sama* (the name of a Shinto deity) in the native *kana* syllabary rather than the more complex Chinese-style characters that Bōsai had expected. By using the less prestigious native script, Ryōkan made the banner readable to everyone, not just the highly educated elite. He then wrote out *Gosairei* (Shinto Festival) on the second banner, again in *kana,* and Bōsai clapped his hands in delight.[14] When the scholar-poet finally left Niigata to return to Edo in 1811, it was a sad moment for the two friends.

Calligraphy was an important activity for Ryōkan, to the point that he half-seriously complained in one of his poems that he was repeatedly asked for examples of his brushwork by various friends and acquaintances. He rarely painted, but he did upon occasion write poems on decorated paper. *Autumn Leaves (plate 89)* shows Ryōkan's delicate but flowing calligraphy on paper embellished with red maple leaves. This work was probably written for an educated friend; he wrote his Japanese *waka* verse using Chinese characters purely for their sound values rather than for their meaning (this was an early form of script called *man'yōgana* utilized in Japan before the native *kana* script had been developed):

Ashibiki no	*From the mountain slope,*
yama no momiji o	*glistening maple leaves*
utsushite wa	*are here enclosed—*
aki wa sugu tomo	*when the autumn passes,*
katami naramashi	*will they be its memento?*

The calligraphy is arranged in five columns of cursive script that almost—but do not quite—follow the five lines of the poem (the *mo* that ends the fourth line of the *waka* begins the fifth line of calligraphy). To the far left, the work is balanced and anchored by the signature "Written by Ryōkan." Although modest and relaxed, this work shows in its structure and lineament Ryōkan's

thorough calligraphic training, modified and ultimately transformed by his unique personality and Zen spirit. His writing, although praised by scholars and treasured by collectors, is very different from most Zen works, which are admired for their power and strength.

There are three main attributes to Ryōkan's calligraphy. The first is clarity. There is no attempt to impress the viewer with technical finesse, with large characters, or with dramatic brushwork. Instead, the characters seem almost to have formed themselves, and yet one can find no trace of weakness or imbalance. Second, there is a subtle combination of sureness and freedom in his writing that has impressed viewers ever since his own time. The characters are firmly composed, the brushstrokes are beautifully controlled as they swell and narrow, and the ink is lustrous. Yet there is no trace of effort or careful premeditation; the works seem to be spontaneous expressions of Ryōkan's inner spirit. Third, there is a sense of flowing motion in his work that goes beyond the beauty of the individual characters to the mood or impression that Ryōkan has been able to evoke. This sense of movement is created within a spatial structure that emphasizes not only the shapes of the characters individually and in combination, but also the negative spaces around them.

These qualities can be seen in their most pristine form in a pair of large works by Ryōkan in which he brushed the two most simple texts to be found in Japan: on the left is *I-ro-ha*, the first three symbols of the Japanese *kana* syllabary, and on the right are the characters *One, Two, Three*, composed of one, two, and three horizontal lines *(plate 90)*. Ryōkan's relaxed, graceful brushstrokes almost seem too frail to fill the large space in which they are set, and yet they have a combination of movement and balance that fully occupies the surface. On the right, "one"[一] is created by a single modulating line that shows no less than four minor and major pressure points. The ultimate model for such an undulating line is the Sung dynasty calligrapher Huang T'ing-chien, but Ryōkan has given this brushstroke his personal touch by beginning with a heavy wet dot and moving diagonally upwards to the right before hooking back slightly at the end of the stroke. The "two" [二] is created rather differently: a short horizontal on a downward diagonal ends with a hook that leads invisibly to the curving line below, which thickens as it reaches its balanced conclusion. "Three" [三] combines elements of the first two characters, the hook-back near the beginning and the strong ending diagonal, with new elements such as the continuous motion linking the first two horizontals and the fact that the brush barely remains on the paper almost all the way to the final line. Compositionally, from the wide "one" to the narrower "two" and "three," the increasing complexity of each character is balanced by decreasing size. In order to create a sense of continuously flowing writing, the ending of each stroke hints or proclaims that the brush is already moving down to the left for the next stroke, until the final horizontal resolutely ends with a slight rounding motion toward the right. The signature, modestly rendered in "dry-brush" style, fills the lower left and adds to the total balance of the work.[15] By comparison, when Jiun wrote out the first seven *kana* symbols of the *I-ro-ha* *(plate 91)*, he gave them thick, rich, wet brushstrokes. He began by spattering ink from the first two strokes and then filled much of the paper surface with the asymmetrically arranged syllables. The two different personalities of the monk-artists could not be more clearly revealed than in these most basic of all Japanese calligraphic forms.

At the age of sixty Ryōkan found the difficult climb up Mount Kugami to the Gogō-an too arduous, and so he moved to a hut at the Otogo Shrine at the foot of the mountain, where he lived for the next decade. In his writings from

91. Jiun (1718–1804)
I-RO-HA
Ink on paper
Private Collection

this time he mocks himself for his lack of accomplishments but still shows his love of a solitary life in nature:

As a boy I studied literature, but was too lazy to become a Confucian;
In my young days I worked at Zen, but got no Dharma worth handing down.
Now I've built a grass hut, act as custodian of a Shinto shrine,
Half a shrine man, half a monk.[16]
—
Sixty years have passed for this frail old monk
Living in a shrine hut, far from the world of men.
At the base of the mountain I'm nestled in during the evening rain;
The lamp flickers brightly in front of my old window.

Despite his characteristic modesty, Ryōkan continued to explore his inner landscape, in which he could find understanding, not only of himself but also of the world. He wondered how people, engrossed in their daily activities, could find a reason for their own existence:

Humans born into this floating world
Quickly become like the roadside dust:
At dawn small children,
By sunset already grown white-haired,
Without inner understanding,
They struggle without cease.
I ask the children of the universe:
For what reason do you pass this way?
—
I see people endlessly striving,
All wrapped up in themselves like silkworms.
Entirely motivated by a love for money,
They allow themselves no leisure;
As time passes, they lose their own self-nature,
Year after year they become more foolish.
One day they will travel to the Yellow Springs
Where they can't take any of their precious possessions.
Now others will enjoy the fruits of their efforts,
While even their names are forgotten.
There are so many people like this—
Ah, I can't bear even to talk about it!

According to Ryōkan, people bring problems on themselves by constantly making moral judgments of others, creating the poles of "good and evil." Zen teaches its practitioners to go beyond these distinctions toward a unity within which the endless variety of the world can be celebrated:

Our human hearts are all different,
Just as our faces are never exactly the same.
When we judge people by a fixed standard,
We create the alternations of right and wrong.
When someone is similar to us, wrong becomes right;
When different from us, right becomes wrong.
Good is seen from our own viewpoint,

Evil is judged by our own standards.
Thus right and wrong begin within ourselves—
Fixing "The Way" does not come from nature.
Like trying to reach the bottom of the ocean with a pole,
We merely exhaust ourselves uselessly, losing our innate perception.
—

We speak of falsehood as completely false
And of truth as completely true;
But outside of truth there is no falsehood
And outside of falsehood, no special truth.
How can those who practice the Way
Diligently search for the truth?
If we examine the depths of our own hearts,
There is delusion, and there is truth.

Ryōkan was able to discover within himself that even the greatest divisions, such as universal values opposed to individual perceptions or delusion opposed to satori, were unified. Like Zen masters of the past, he found that Buddhist truth was fully contained within his everyday life. Ryōkan expressed this understanding in the form of poetry:

Illusion and enlightenment depend on each other,
Principle and actuality are ultimately the same—
All day long, sutras without words,
Through the night, Zen without sitting.
Warblers sing in the willow grove by the river,
A village dog barks at the moon.
I have no one to share my feelings
So I just write what is in my heart.

Ryōkan did not take an active part in the Buddhism of his day. His only promising pupil had died young; he did not seek other followers, nor did he wish to take part in temple life. In many ways he was like his Sōtō Zen predecessor Fūgai Ekun, living not only far from the world but also at a distance from the orthodox Buddhist establishment. Each of the major Zen masters of the Edo period took a different approach to the problems of the day: increased secularism, government control of all phases of life, including religion, and the constant issue of sectarianism even among the most devout Buddhist clergy and laymen. Ryōkan chose not to become involved in direct action about these problems, but his feelings were made clear in one poem about the twelve sections into which the Buddhist scriptures were divided:

Buddhas preached the twelve divisions,
Each division full of purest truth.
East wind—rain comes in the night,
Making all the forests fresh and new.
No sutra that does not save the living,
No branch in the forest not visited by spring.
Learn to understand the meaning in them,
Don't try to decide which is "valid" and which is not![17]

The metaphor here is particularly striking; it would be ridiculous to imagine nature choosing only a single branch of a tree to blossom, and yet Buddhists

were forever arguing about the supremacy of one sect or one teaching over another. Ryōkan, although a Zen monk, did not disdain other beliefs. For example, he had no hesitation in recommending the chant of the *nembutsu* to the dying:

Ryōkan ni *If Ryōkan is asked*
jisei aru ka to *to give his final words to*
 hito towaba *people leaving this world—*
Namu Amida Butsu *you can tell them that he says*
to iu to kotaeyo Namu Amida Butsu!

He also praised the bodhisattva Kannon, again in terms of nature, which he knew so well from his own life.

The wind is still, but blossoms fall,
Birds sing in the quiet of the mountain.
This is Kannon's wondrous wisdom:
Ah!

Finding the wisdom of the bodhisattva to exceed the power of language, Ryōkan surely knew that the ancient Taoist sage Chuang-tzu had said that if you understand the meaning, you may forget the words. A closer model for Ryōkan was the Chinese poet who gave up his official position to live quietly in nature, T'ao Yuan-ming (also known as T'ao Ch'ien, 326–397), who ended his fifth "Poem after Drinking" with the quatrain:

The mountain air sparkles as the sun sets,
Birds in flocks return together.
In these things there is a fundamental truth,
But when I start to explain it, I lose the words.

That this verse was a reference and model for Ryōkan is clear from another poem in which the monk describes his inexpressible emotion for his simple life lived in nature:

A cold evening in my empty room—
Time flows by like the incense smoke arising.
Outside my door, a thousand stalks of bamboo,
Above my bed, how many books—
The moon has come to whiten half my window,
The only sound in any direction is the singing of insects.
In this there is boundless feeling—
But as I encounter it, there are no words.

When Ryōkan reached the age of sixty-nine, living in his hut became too difficult, so he moved into a renovated storehouse at the home of his friend and patron, Kimura Motoemon, in the village of Shimozaki. There Ryōkan encountered the nun Teishin (1798–1872), who was to become his disciple. She was only twenty-nine when they met, and they seem to have immediately loved each other. They spent as much time as possible together, enjoying discussions of religion, writing poems for one another and forming a deep affection that must have given the old monk and the young nun great happiness. She was with Ryōkan when he died in 1831, and four years later

she edited *Hachisu no tsuyu* ("Dew of the Lotus"), a book of poems that they had exchanged. This was the first step in establishing his fame throughout Japan.

Ryōkan lived very much like Hotei, preferring an existence begging and playing with children to life in temples. Hotei also represents Maitreya, the Buddha of the future, residing in Tusita Heaven until his final rebirth on earth. Ryōkan's poem can thus serve as his own epitaph:

At the crossroads: Hotei
Set free from entanglements—how many years?
With the boundless freedom that no money can buy,
He will ultimately return to Tusita Heaven.

GŌCHŌ KANKAI (1749–1835)

Like Jiun, Gōchō was not a monk of the Zen sect, but his art has been accepted as Zenga due to its frequent use of Zen themes. Gōchō was born as the second son of a Shin sect monk who served as abbot of Senkō-ji in Higo, on Japan's southern island of Kyushu. Because his older brother was destined to succeed to Senkō-ji, Gōchō was taken by his father at the age of seven to Reigen-ji in the nearby town of Hachiman-mura to be interviewed by the abbot Gōgyoku. Observing that the young boy was both intelligent and dedicated, Gōgyoku admitted him to the temple, which was of the Tendai sect.

Gōchō immediately began his study of esoteric Buddhism, and over the next few years he progressed rapidly. In 1763 Gōgyoku turned over the Reigen-ji to his disciple Kaigan and moved to Jufuku-ji in Takase with Gōchō as his principal student. The following year, however, Gōgyoku realized that he was not qualified to teach his talented pupil the ultimate esoteric rites and rituals, so he sent Gōchō to the headquarters of Tendai Buddhism on Mount Hiei, north of Kyoto. There Gōchō met the venerable monk Gōjō, who had achieved the highest Tendai rank of *Daisōjō* and was well versed in both Buddhist scholarship and the semimagical rites of esoteric Buddhism.

For the next twelve years Gōchō diligently pursued his studies with Gōjō at the Shōkaku-in on Mount Hiei. Gōchō also practiced Tendai-style Zen meditation whenever he had free time; it was said that he hardly knew his pillow, as he often meditated far into the night. As a result of his diligence, he achieved ever-higher ranks in the Buddhist hierarchy, first in 1767, when he was appointed *Gonrisshi* (assistant superintendent) and given the name of Gōchō, and again in 1769, when he received *inka* and was given the title *Hōin* (seal of the dharma). Gōchō eventually was accorded the rank of *Risshi* (superintendent), and it was by this name that he was often known.

The young monk might have continued his studies further, but in 1776 he heard that his original teacher, Gōgyoku, had become seriously ill, so Gōchō returned to Higo. There he found his teacher in his final days; despite Gōchō's care, Gōgyoku died on the seventh day of the seventh month. After a series of memorial services, Gōchō intended to return to Mount Hiei, but following his father's advice and responding to the entreaties of parishioners, he finally agreed to remain as abbot of Jufuku-ji. He proved to be a stern disciplinarian; gathering all the ceramic vessels used in serving and drinking sake, he broke them in a huge mortar. He prohibited the drinking of rice wine at the temple and strictly enforced all Buddhist commandments among the monks who came to study with him.

Personally, Gōchō was extremely austere. It is said that he never loosened his robe, even in the worst heat of the Kyushu summer, and he refused to use a mosquito net, although he was bitten until the blood flowed down his body. He drank only the water that had been used to wash the buckwheat flour and possessed only three robes and a single bowl. He gave away to the poor the rice the temple had previously accumulated in its storehouse and diligently followed the six *paramitas* (virtuous practices) of charity, moral conduct, patience, devotion, contemplation, and study.

Gōchō frequently went out among the populace, preaching the Buddhist law and also performing incantations and faith healing for all who asked him. His success in faith healing in various areas of Kyushu, as well as his resolute devotion to Buddhism, gained him fame among commoners and nobles alike; he converted many people not previously committed to Buddhism.

One example of Gōchō's faith-healing abilities demonstrates not only his own powers, but his place in the society of the time.[18] The second half of the eighteenth century was an era of great cultural achievement in Kyushu, especially in the Higo area under the leadership of the Hosokawa family. Hirose Tansō (1782–1856), who was destined to become one of Japan's finest Chinese-style poets, entered the celebrated Kamei Confucian academy at the age of sixteen. After two and a half years, however, he returned unhappy and seriously ill to his family home in Hita. Tansō was nursed diligently by his younger sister Tokiko, but as his disease worsened, his family began to doubt if he would survive. Seeing his pain and her parents' deep distress, Tokiko resolved to do whatever necessary to help him recover.

At that time Gōchō was making one of his occasional visits to the Hirose family's ancestral temple, Daichō-ji. Tokiko had heard about the monk's merits from her parents, and one night she secretly went to the temple to attend his lecture. When his sermon ended, Gōchō sensed that there was someone in the crowd who had made an unusual vow. He asked this person to come into a private room to explain his or her entreaty. Tokiko mastered her fear enough to appear before the great monk, explaining that she had resolved to give up her own life if only her brother could be spared. Gōchō was impressed by the young woman's determination and began a series of incantations to help restore her brother's health. Tansō's illness lessened day by day, and slowly but surely he completely recovered his health. The story continues that Tokiko rejoiced, and in completion of her vow she told her family of her wish to become a nun. Since her grandmother could not bear to see Tokiko cut her hair and enter a temple, the young girl resolved never to marry and went to serve at a Shinto shrine presided over by a court lady. In 1805, however, this lady died despite Tokiko's faithful nursing. Sorely distressed, Tokiko herself passed away shortly thereafter at the age of twenty-two. Tansō, now a promising young scholar and poet, gave his sister the posthumous name of Kōtei Restujo, "Heroine of Filial Piety."

Gōchō traveled throughout his life. In 1789 he took his aging mother on a trip to Mount Hiei, carrying her on his back up the mountain (as far as women were allowed) to see the sacred precincts that had been the site of his most serious study. Upon returning to Kyushu, he took up his staff and walked through several provinces, preaching and continuing his faith-healing practices. When he returned to the Kyoto area at the end of the eighteenth century, his reputation had grown sufficiently for him to be given the opportunity to cure a nobleman of a serious illness. This led to an audience at court, where he was given various gifts, including an ink stone from Emperor Kōtaku, who also conferred on him the name Kankai Daishi (literally, Great Teacher

92. *Gōchō (1749–1835)*
ONE BRANCH OF SPRING
Ink on paper, 33 × 11 5/8"
Private Collection

168

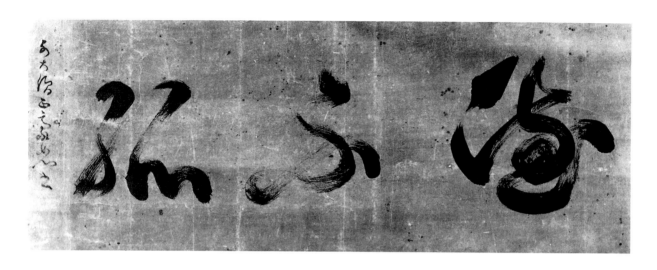

93. Gōjō (dates unknown)
VIRTUE IS NOT ALONE
Ink on paper, 10 ⁵/₈ × 22 ¹/₂″
Private Collection

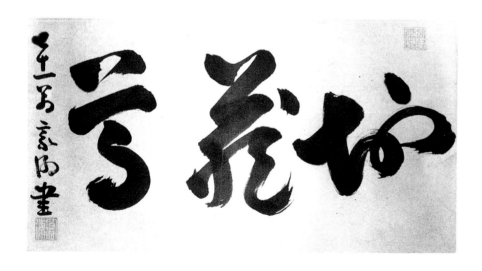

94. Gōchō (1749–1835)
JIZŌ-SON
Ink on paper, 11 ³/₄ × 9 ⁷/₈″
Man'yō-an Collection

Kankai). When Gōchō returned to Higo, the Hosokawa daimyo forbade him to leave Kyushu again, fearing that he might not come back.

In the early years of the nineteenth century, Gōchō embarked upon a project of constructing special "treasure-casket" pagodas of various sizes, both for temples and for family shrines. Some of these were carved in stone, with a magic Sanskrit (Siddham) syllable or charm inscribed, while others were made of bronze, ceramic, or wood. Many of these pagodas still survive, some containing Gōchō's calligraphy consisting of a sacred forty-phrase chant in Sanskrit written in gold on dark blue paper.[19] The purpose of the pagodas was to create 84,000 prayers to counter the evils and sins of the world and to send all ancestors to paradise; Gōchō sometimes signed his works *"Hachiman Yonsen Bonnō Shujin"* (Master of 84,000 Evil Passions).

After the Hosokawa daimyo's edict, Gōchō continued to travel, but now only through the provinces of Kyushu. He would stay for a few days at local temples, offer services, and preside at public meetings. Gōchō had a broad understanding of Buddhism in all its various forms. On one of his travels he visited a Jōdo sect monk, and upon his return he sent the monk a poem about the different but compatible methods of Japanese Buddhists, including chants, incantations, and meditation.

For the future life, "Namu Amida Butsu" is sufficient;
Beyond this you need have no concern.
Shingon monks follow the practice of incantation;
Dew, bestowed upon the grasses of the autumn fields,
Gradually soaks in the reflection of the moon.
Zen monks are captivated by the autumn moon and springtime blossoms;
But when satori comes, there's no need for spring or fall.

Gōchō wrote a number of poems, both in Chinese style and in Japanese *waka* and haiku forms, always expressing his Buddhist spirit. He was also called upon for both paintings and calligraphy, sometimes for temple use and more often for the edification of his parishioners. His earliest extant paintings date from his thirties and forties; they include portraits of Buddhist deities such as Dainichi and Monju, depicted in either a finely detailed, fully colored technique or a simple ink-painting style. It was the latter, more dynamic form of brushwork that Gōchō continued to develop.[20] He seems to have had no painting teacher, but he created his own technique, expanding on his knowledge of calligraphy, to depict an ever-increasing variety of Buddhist subjects.

Calligraphy was Gōchō's principal medium, and he brushed a large number of works throughout his life. His style reveals the influence of his teacher Gōjō, with whom he had studied on Mount Hiei. One of the rare extant works of Gōjō, *Virtue is Not Alone (plate 93)*, shows a preference for strong, continuously curving lines and shapes with the occasional use of "flying white," features that were to become characteristic of Gōchō's style as well.[21] *Jizō-son* ("Lord Jizō," *plate 94)* was brushed by Gōchō when he was seventy-one to honor the bodhisattva of the underworld. It still retains the curvilinear movement and the rapidly brushed strokes of "flying white" that can be seen in the work of his teacher. The main difference is that Gōchō boldly enlarged his forms to cover more of the paper surface with ink.

One of the strongest examples of Gōchō's calligraphy, probably brushed in his early to mid-seventies, is the three-character scroll *One Branch of Spring (plate 92)*. It is an expression of great freedom, born of discipline and study and

invigorated by meditation and inner confidence. The first stroke is the character "one" [一]. With the brush unevenly loaded with black and gray ink, Gōchō created a short, vigorous horizontal dash rising to the right, where a spray of ink indicates that he continued the gesture after the brush had left the paper. The next character, "branch" [枝], combines two vertical motions, the second bending down to the left, with a curved stroke ending with a diagonal down to the right. Here the brush hairs have split, creating "flying white" that seems to divide the line into parallel movements; the negative spaces within the character, as in all good calligraphy, can be admired for their asymmetrical balance. The final character, "spring" [春], is continued from the previous word by a single thin line where the brush did not completely leave the paper surface. Then, beginning with a short, stubby horizontal that recalls the opening character, the brush continued in a vigorous sweep of clockwise and counterclockwise circles, ending with a firm, circular "closed-tip" punctuation. Each of the three characters has a different tilt and balance, and each shows an unusual range of ink tonalities and wet-to-dry brushwork, so that the total composition is rhythmically dynamic. Gōchō's signature, nestled in the left of the scroll, again shows his predilection for the circular forms he learned from Gōjō. "One branch of spring," perhaps referring to the buds of a white plum tree appearing while there was still snow on the branches, signifies new life emerging from the cold of winter. The tonal and compositional richness of the three-character calligraphy demonstrates Gōchō's unique command of his medium.

The close relationship between calligraphy and painting can be seen in Gōchō's *Wild Duck Kōan (plate 96)*. The tonally varied, twisting and curving lines of Gōchō's calligraphy are very similar to those that define the two figures. The subject of this painting is the fifty-third *kōan* of the *Hekiganroku:*

When Ba Daishi (Baso) was out walking with Hyakujō, he saw a wild duck flying past. Daishi said, "What is it?" Hyakujō said, "It is a wild duck." Daishi said, "Where is it?" Hyakujō said, "It has flown away." Daishi at last gave Hyakujō's nose a sharp pinch. Hyakujō cried out with pain. Daishi said, "There, how can it fly away?"[22]

Below the calligraphy, Hyakujō peers upwards while Daishi gives his nose a sharp pinch. The artist's inscription sums up the *kōan* in a single phrase: "Tell me, where has the wild duck flown?" This kind of mysterious question, accompanied by an unusual action, is typical of Zen; one must go beyond normal patterns of thought and behavior in order to see the everyday world in an enlightened way. If the pupil thinks that a wild duck has flown away, he has missed it. What, then, has he missed?

Gōchō's fame, resting primarily upon his faith healing, gradually spread well beyond his home province in Kyushu. In 1817 the Tokugawa daimyo in Owari (Nagoya) became seriously ill, and the best efforts of local doctors were not able to cure his disease. The daimyo had great trust in an eccentric monk of the Sōtō sect named Zuikō Chingyū (1743–1822). After working in a fish shop as well as serving in temples in Edo (Tokyo) and Mino, Chingyū had settled in the temple Banshō-ji, near Nagoya Castle. Since he had grown up with Gōchō in Kyushu, the two monks had been lifelong friends, and Chingyū recommended Gōchō to the daimyo, who immediately wrote to the lord of Higo for permission to invite Gōchō to Owari. The Higo daimyo, however, was loath to let Gōchō leave, fearing he would not return. It was not until after some complex negotiations (and perhaps some political strings

95. *Gōchō (1749–1835)*
SAKYAMUNI RETURNING
FROM THE MOUNTAINS. *1829*
Ink and color on silk, 78 × 26 1/2"
Man'yō-an Collection

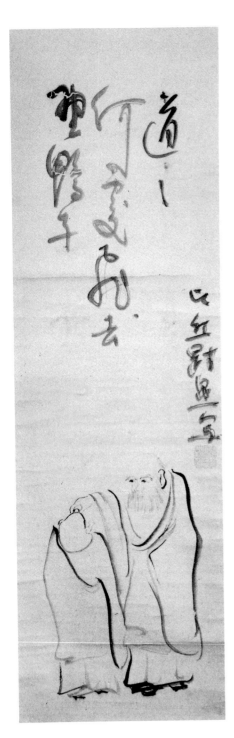

96. *Gōchō (1749–1835)*
WILD DUCK KŌAN
Ink on paper
Tomioka Museum, Tokyo

pulled by the powerful Tokugawa family) that the Higo daimyo reluctantly gave his permission, with the stipulation that Gōchō should return within three years.

For the sixty-nine-year-old Gōchō, this was a momentous occasion. Upon his arrival in Owari, he first stayed at Banshō-ji with his old friend Chingyū and exorcised the daimyo's disease through prayers and incantations. The daimyo recovered his health and was so impressed with the Kyushu monk that he resolved not to let him leave. He appointed Gōchō to the position of abbot of Gankutsu-ji in southern Owari in 1819. Because this temple was in disrepair, Gōchō raised funds for its restoration, in part by constructing another series of small pagodas in various materials for well-to-do patrons.[23] Within the temple's own pagoda he was delighted to discover many treasures, including a complete Sung dynasty set of Buddhist sutras consisting of more than 5,460 scrolls. He also found altar equipment that had been commissioned by Kōbō Daishi, the founder of the Shingon sect in Japan, which included a "diamond bowl" that Gōchō inscribed with his own calligraphy in honor of his illustrious predecessor. Due to Gōchō's energetic activities and the fame of his incantations, Gankutsu-ji found itself in a new era of prominence, and many converts to the Buddhist life entered its portals.

In 1820 Gōchō had served his three years in Nagoya and was supposed to return to Higo, but the Tokugawa daimyo wrote to Kyushu that Gōchō was experiencing health problems and could not travel. This message was repeated after a few months, and eventually the Higo daimyo seems to have become resigned to the fact that Gōchō would not return. Perhaps as a symbol of his permanent home in Owari, a life-size stone portrait of Gōchō was carved for Gankutsu-ji in 1821; it was later installed at his tomb.

Gōchō was not to remain at his newly restored temple for long. Gankutsu-ji was almost forty miles from Nagoya Castle, and the daimyo wished to have Gōchō nearer to him. In 1823 the temple Chōei-ji, which guarded the castle to its northeast (the direction from which it was believed that evil spirits attacked), was restored and Gōchō was invited to become its abbot. He was now seventy-five years old, but still at the height of his mental, spiritual, and artistic powers. As well as serving at ceremonies at his temple and at the castle, Gōchō continued to travel; in 1825, for example, he journeyed with six of his disciples to Chōrō-ji in Gifu, where he conducted a memorial service and performed incantations at nearby temples and outdoors for the populace; it is said that ten thousand people were converted to an ardent belief in Buddhism because of his visit.[24]

Much of Gōchō's finest brushwork dates to his late years. He not only wrote out bold calligraphy, he also painted some elaborate scrolls for use in temple ceremonies. One of his most ambitious late works is *Sakyamuni Returning from the Mountains (plate 95)*. This theme of the historical Buddha returning from the snowy mountains has been an important subject in Zen painting since at least the Northern Sung period in China, when the literatus Li Kung-lin (1049–1106) was known to have depicted the subject. The oldest work now extant is a famous painting by the Southern Sung dynasty master Liang K'ai (active in the early thirteenth century) preserved in the Tokyo National Museum. Both professional artists and Zen masters in Japan often painted this episode. A scroll showing Sakyamuni descending from the mountains is traditionally hung in Zen temples on the yearly anniversary of the Buddha's enlightenment.

Gōchō's large scroll was painted in silk with ink and light colors in 1831, when he had reached the age of eighty-one (by Japanese count). Icono-

graphically, there has been some dispute whether Sakyamuni had actually reached enlightenment when he left the mountains; in this case the halo around the figure suggests that the enlightenment has already occurred. Gōchō's poem also indicates the Buddha's all-encompassing satori:

After six years of austerities
He swallowed the universal emptiness
And disgorged the three thousand worlds,
Creating a wind which fills the sky and circles the earth.

The long earlobes of the Buddha are the result of his having worn, in princely style, heavy earrings since childhood. Since the Buddha gave away all his jewelry when he embarked upon the religious life, however, it is unusual to see the large round earring portrayed here. Gōchō clearly considered this work important, devoting much time and care to its composition and execution. He first outlined the robe in gray ink and then again in darker tones. The face and beard were then fully elaborated, red color was added (now mostly visible at the lips), and gray wash brushed near the lines of the robe, creating a sense of volume. The contrast of the heavy, rough, broken lines on the robe and the more precise and delicate depiction of the face is traditional, but Sakyamuni has seldom been rendered with such monumental power.

As he reached his late eighties, Gōchō's health finally began to fail. On the eighth day of the seventh month of 1835, he gathered his disciples around him for a final session of teaching and admonitions. Then, after cleansing his body, he put on a robe and sat erect, chanting a final prayer:

Farewell:
Even in the midst of ultimate nothingness
There is this memento: Namu Amida Butsu!
Namu Amida Butsu! Namu Amida Butsu *at birth.*
Namu Amida Butsu *at death.*

Gōchō took a very different approach to Buddhism from that of Jiun or Ryōkan, and one wonders what would have happened if they had ever met. Yet the strictness of Jiun, the modesty of Ryōkan, and the flamboyance of Gōchō were each responses to a similar problem: the decline of religious belief among the general populace. Jiun advocated the correct training of monks, Ryōkan felt that he must follow his lonely personal path, and Gōchō appealed to the broad public with faith healing and exorcism. Paradoxically, the solitary Ryōkan has had the longest-lasting influence in Japan, as his poems are beloved by a large number of people. All three monks, however, live on in their calligraphy and paintings. Their individual expression of strongly personalized brushwork continues to fascinate and inspire viewers.

The political and intellectual ferment at the end of the Edo period, followed by the invasion of Western culture during the Meiji (1868–1912) and Taisho (1912–1926) periods, had profound effects upon almost every aspect of Japanese life. Although the internal cohesion and self-reliance of Zen masters helped them to hold fast to their beliefs at a time when all traditional values were called into question, Zen and Zen art were not entirely immune to the changes that were taking place in Japan.

The leading Zen master and artist at the end of the Edo period was Sengai Gibon, who turned to brushwork in his later years after a long and distinguished career as monk and abbot. Like Hakuin, Sengai invented many new subjects for Zenga. He did not have the powerful brushwork of the earlier master; instead, his works display a delightful wit and risorial humor that place them among the most popular paintings in Zen history.

Born in 1839, the year after Sengai's death, Nantembō Tōjū lived through the turbulent Meiji and Taisho periods, upholding the strict Zen traditions while responding to the new pressures of a rapidly changing, Westernizing Japan. He traveled throughout the country, furiously challenging monks to verbal jousts, leading public Zen meetings, and establishing training centers for novices. Like Sengai and so many of the other Zen monk-artists, Nantembō turned to brushwork in his later years. He created most of his paintings and calligraphy when he was in his late seventies and early eighties. The unbridled vigor and trenchant humor of his personality are clearly apparent in his brushwork, which is fully representative of Zen art in the first quarter of this century.

SENGAI GIBON (1750–1838)

Sengai was born to a farming family in Taniguchi village in Mino (Gifu prefecture). At the age of eleven he became a monk under the abbot Kūin in the nearby temple Seitai-ji. At the age of nineteen, to further his training, he began to study with Gessen Zenne (1701–1781), one of the outstanding Zen teachers of the later eighteenth century, at the Toki-an in Nagata (near Kamakura). After several years of Zen practice, Sengai was inspired by meditating upon the famous *kōan* "Why did the patriarch come from the West?" When he achieved enlightenment, he wrote a poem celebrating ordinary human existence:

Sakyamuni entered extinction two thousand years ago;
Maitreya won't appear for another billion years—
Sentient beings find this hard to understand,
But it's just like this—the nostrils are over the lips.

Sengai showed this poem to his teacher Gessen, who recognized Sengai's satori and awarded him *inka,* testifying to his enlightenment. Sengai remained with Gessen until the latter's death and then began pilgrimages through central and northern Japan, visiting famous temples and testing his Zen with well-known monks. For a time he settled in Mino, his home province, but he spoke out against the mismanagement of the clan government and was expelled. However, he left behind a poem with two puns. One is on the word *kasa,* which can mean both an umbrella and a monk's bamboo hat (and by inference the monk himself), and the other is on *Mino,* which can be either the province or a straw raincoat:

SENGAI AND NANTEMBŌ

All the wandering monks
throughout the world—
Their begging bowls resound
like thunder!

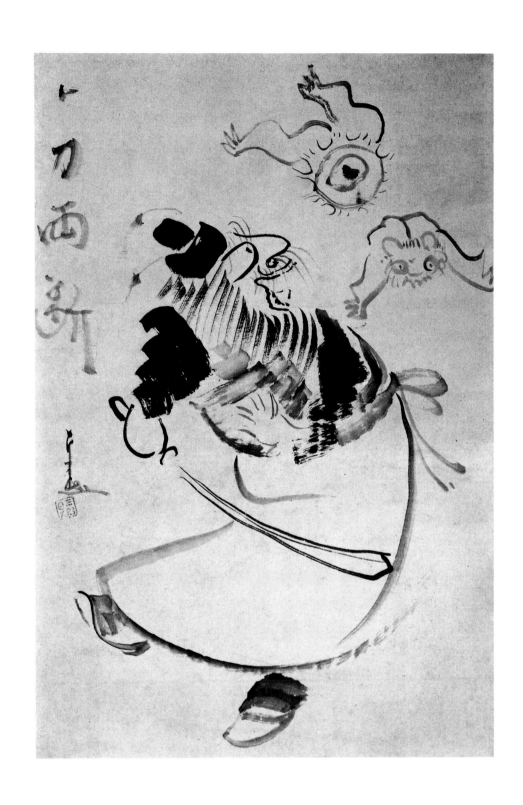

97. *Sengai (1750–1838)*
SHŌKI KILLING A DEMON
Ink on paper, 34 × 23"
Sansō Collection, USA

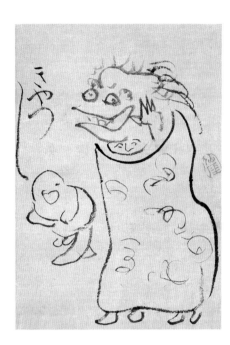

98. *Sengai (1750–1838)*
LION DANCE
Ink on paper, 14¹/₄ × 9⁷/₈″
Private Collection

Under an open kasa,
Even if it rains down from the heavens,
There's no need to rely on Mino!

In 1788, at the age of thirty-nine, Sengai received an invitation to visit Kyushu from the monk Taishitsu, who had been a fellow pupil under Gessen. When Sengai arrived, Taishitsu introduced him to the abbot Bankoku of Shōfuku-ji, which had been established in 1195 as the first Zen monastery in Japan. Sengai became *dai ichiza* (first monk) at Shōfuku-ji under Bankoku and soon was ordained as the 123rd abbot of the temple. This was a most prestigious post, but the temple was in a rundown condition. Sengai fulfilled his obligations diligently. He reestablished the monks' hall in 1800, and two years later he founded the Senzen-dō. He not only taught a number of monk pupils, but he also spent much of his time propagating Buddhism among the farmers and merchants of the area. The authorities at Myōshin-ji, the head temple of his branch of Rinzai Zen, repeatedly offered him the purple robe awarded to abbots, but Sengai always declined and instead wore a plain black robe. He was content with a single bowl, from which he ate his meals, and he did not disdain to go begging with the same bowl; when it was full he would refuse further contributions. There are many parallels between the lives of Sengai and Hakuin: both eschewed honors, both lived in country temples training students, and both reached out to the populace with their teachings through painting and calligraphy.

More anecdotes are told about Sengai than about any other Zen monk, due in part to his kindly nature and in part to his irrepressible wit. There is a story that Sengai once discovered a pupil was sneaking out of the temple every evening to visit a prostitute in the local entertainment district. Sengai realized that the rock that his disciple used to climb over the monastery wall was sometimes slippery and dangerous. One morning, just before dawn, the disciple stepped off the wall and noticed that the "rock" was warm — Sengai had bent over near the temple window to assure his pupil a safe foothold. Nothing was said, but the young monk thereupon desisted from his nightly exploits.[1]

Sengai also had to use unorthodox methods to enlighten high officials. The local scholar for the Kuroda clan of Hakata, Kamei Shōyō (1773–1836), taught the daimyo both the Confucian classics and elements of Western botany. The daimyo was especially interested in flowers (he compiled a book on botany and wrote out elaborate manuscripts on peonies and chrysanthemums, the latter totaling ten volumes). Indeed, he was so fond of mums that he grew many varieties in his garden, but one day the gardener's dog trampled on several fine plants. The daimyo became so angry that he said he would have the gardener put to death. Sengai heard about the situation and secretly stole into the garden that evening, cutting down all the chrysanthemum plants with a scythe. The next day he appeared at the castle and said to the furious daimyo: "I have cut down all the plants, so please have me killed. But which is more important, the lives of humans or flowers? In this province the farmers are poverty-stricken because of a rice shortage, yet you do nothing to help them, preferring to enjoy your garden and to entertain guests at parties. Your domain depends upon the workers in the fields, so please think about this." The lord was wise enough to reflect upon Sengai's advice and took measures to help the farmers; he also gave Sengai a favorite plum tree, which was replanted at Sengai's temple, where it flowered for many years.

In 1811 Sengai turned his position as abbot of Shōfuku-ji over to his disciple Tangen and retired to the small subtemple Kohaku-in. He lived his final

twenty-six years teaching, traveling, receiving visits from people of all social classes, and brushing Zen paintings and calligraphy that were immediately popular. His humor was gently mocking but never unkind. Sengai's distrust of officialdom may be among the motivations for one of his most dynamic paintings, *Shōki Killing a Demon (plate 97)*. The subject of Shōki is traditional, referring to a T'ang dynasty official who came back from the dead to save the emperor from a wicked imp. Shōki thereafter was beloved in Chinese and Japanese folklore as a demon-queller.[2] He is depicted in scrolls and prints presiding over (or chastising) demonic creatures, but Sengai's painting is unique in showing Shōki slicing the imp in half; the inscription reads, "One stroke, two pieces." The joyous glee of Shōki as he views the results of his swordsmanship, the surprised but not unhappy expression of the demon, and the lively action create a humorous dynamism that is reinforced by the twisting figure of Shōki. Sengai was certainly satirizing those who take up the sword as the answer to their problems, but on another level he was also graphically representing the instant of total concentration in which one may cut oneself off from all attachment and all illusion—the moment of satori.

The painting is so boldly and simply brushed that one may not notice its artistic qualities, including its great variety of lineament and tonal range, its adroit composition, and its confident alternation of wet and dry brushwork. In particular, this painting demonstrates Sengai's effortless skill in rendering tones of gray and black within a single brushstroke, evident most clearly in the lines defining Shōki's robe. Sengai's technique was the kind that hides skill. As he once remarked, his method was no method at all. His finest paintings demonstrate he was a true master of brushwork that served his expressive purpose without drawing attention to his style.

Sengai's works became so popular that he was besieged with requests for them. People from all walks of life came to his little subtemple—which was nothing more than a simple country hut—bringing paper on which they hoped he would paint or create calligraphy. Sengai wrote a poem about these constant requests:

99. Sengai (1750–1838)
BAMBOO IN THE WIND
Glaze on ceramic
Idemitsu Museum, Tokyo

Urameshiya	To my dismay
waga kukurega wa	I wonder if my small hut
setchin ka	is just a toilet—
kuru hitogoto ni	since everyone who comes here
kami oite yuku	seems to bring me more paper!

Sengai at times even put up a sign in front of his subtemple that said, "Absent Today." One afternoon a visiting samurai of the Kuroda clan called in a loud voice, "Are you in your hut?" Sengai came out and pointed to the sign, saying, "Look at this!" The samurai exclaimed, "But you are here." Sengai replied, "As the owner of the hut, I myself have said, 'Absent Today.' Nothing is more certain than this." Sengai then went back inside.

Some of the requests for paintings from Sengai went well beyond instructional purposes. Nevertheless, Sengai usually complied. A man named Sōhei, who owned a sake shop, was a follower of Sengai, but he applied his studies of Zen and of Chinese military strategy to his business in order to make more money. Sōhei knew that Sengai loved yams and would bring them to the master and ask for paintings in return. Sengai used to chide him, saying half in jest, "You are only interested in profit." In his last years Sengai wrote a haiku on the bottom of a tray that he presented to Sōhei:

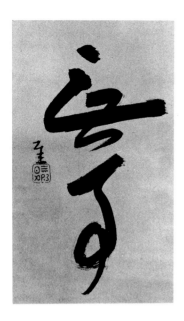

100. *Sengai (1750–1838)*
BUJI
Ink on paper, 14¹/₄ × 8³/₈"
Idemitsu Museum, Tokyo

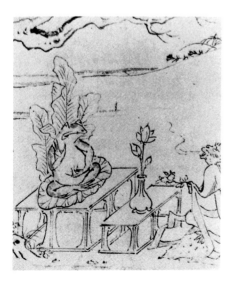

101. *Anonymous*
FROLICKING ANIMALS SCROLL *(detail)*
Ink on paper, height 12¹/₂"
Kōzan-ji, Kyoto

Oboru no yo *Don't be so haughty—*
tsuki no marusamo *even the full of the moon*
 tada ichiya *only lasts one night*

Sōhei was very proud of this admonition and displayed the tray in his shop. He eventually became so successful that he was made an official merchant to the Kuroda daimyo and lent money to high officials. He was thought to be too ambitious, but during years of famine he gave rice to the poor; people then realized that Sengai's teachings had reached Sōhei's heart.

Although he was sometimes reluctant to paint for the wealthy and high-born, Sengai indulged children. One of his most delightful works is a representation of a "Lion Dance" *(plate 98),* showing a two-man team dancing in a lion mask worn at the New Year or on other special occasions. At one side, a child laughs from a heart-shaped mouth. The inscription reads simply, "Gya-gya," the sound of a baby's gurgling. At first glance one may wonder if this spontaneous and childish cartoon is art at all, but more concentrated viewing brings forth increased admiration for Sengai's artistic skill as well as for his ability to communicate ideas. The mask faces upon the calligraphy, the calligraphy leads to the child, the child turns back to the dancers, and a dancer even peers out at us, waving his hand in friendship. The seal, carved from a bamboo root, echoes the posture of the child, while calligraphic flourishes on the dancers' robes suggest the circling, prancing nature of the dance itself. In this scene Sengai has conveyed the wonder and joy of a child who views the world with a fresh vision—a vision similar to enlightenment.

This is one of many works by Sengai on the question of what is real and what is not. The lion dancers, for example, are men imitating an animal they had never seen, and at the same time they are reveling in their humanity. Are they really men, or an animal, or just ink on paper? In a poem, Sengai wrote:

A dream that is
dreamt in a dreamy world
 is not really a dream—
but the dream that is not dreamt
is truly a dream!

Because Sengai was admired for his brushwork, he was frequently asked for his calligraphy of time-honored "serious" themes. There was a man who called on Sengai one day and asked him to write the "Thousand-Character Essay," an early Chinese text that utilizes exactly one thousand different words. This essay had long been a favorite with traditional calligraphers and was also used for study purposes. The visitor was certainly being greedy in his request, as a complete version by Sengai would be extremely valuable (especially since he generally wrote only short inscriptions). Sengai was not the type to refuse, however, and he calmly wrote out the first twenty-eight characters, before adding the words, "I forgot the rest."

Indeed, Sengai's works became so valuable in his own day that there were said to have been at least ten contemporaries producing fakes of his paintings. The best of them, called Aoki Sengai, was so good that Sengai reportedly lent him his seals, making later connoisseurship even more difficult than usual. An anecdote shows that this was also a problem at the time. An official of the Kuroda clan named Kawamura Jōzan called on Sengai and asked him to paint a "bamboo in the wind." Sengai did so, but Jōzan then asked for an inscription to help authenticate the work. Sengai wrote, "This is surely a painting by

Sengai because I have done it right now in front of your eyes."

Although there can be no such sureness today, one of the most interesting works by Sengai is his *Bamboo in the Wind (plate 99)*. On a *mizusashi*, a large ceramic vessel used for serving fresh water during the tea ceremony, Sengai painted an image of bamboo by using iron pigment over a gray white glaze. The other side of the *mizusashi* is a rich brown with olive and white glazes dripping down from the lip. Within the vessel, olive glaze has created rivulets and then puddled at the bottom. The outside foot is a plain darkish gray, as the various colors have not reached the base. The result is a marvelous design in which thrusting clumps of bamboo reach out to Sengai's signature. The luscious glazes are balanced by the simple force of the bamboo, which symbolizes the "gentleman" who endures, just as bamboo bends in the wind but remains fresh and green through the winter.

Another powerful work by Sengai is his calligraphy of *Buji (plate 100)*. The two characters literally mean "no thing," representing the peacefulness that comes from nonattachment. The first character, which is otherwise pronounced *Mu* [無], is dominated by the strong horizontal that almost eliminates the spirals of activity around it. The second character, "thing" [事], by contrast, begins with a horizontal stroke but then spirals down with a strongly vertical thrust, providing a base for the first *Mu*. Sengai's signature and seal fit nicely within a small open area on the left. The firmness of each brushstroke in this work, beginning with a dot and ending with a swirling circle, makes the calligraphy monumental in spirit despite its relatively small size.

Although Sengai's brushwork is known more for its charm than for its power, a pair of scrolls representing the early Zen masters Baso and Rinzai *(plate 104)* displays an impressive fierceness. On the right is Baso (Chinese: Ma-tzu, 709–788) and the inscription "One *Katsu*, three days," referring to the time when a single great shout from Baso rendered his pupil Hyakujō (Chinese: Pai-chang, 730–814) deaf for three days. Sengai portrayed the master with intense eyes and a mouth shaped rather like a flying bat. To suggest the force of his shout, the shape is then repeated and echoed in lines defining the jowl, the ear, and the robe over the monk's shoulder. Tonal variations in the ink add subtlety to this dynamic portrait.

On the left is Rinzai (Chinese: Lin-chi) clenching his fist with a humorous look of distress on his face. After being hit three times by his teacher Obaku (Chinese: Huang-po) every time he inquired after the nature of the Buddha, Rinzai was finally enlightened when his next teacher, Daigu (Chinese: Tai-yu), told him he had been treated with a mother's kindness. After satori, Rinzai exclaimed, "There's not much in Obaku's teachings!"—whereupon Daigu called him shameless. Rinzai then struck Daigu three times with his fist. Upon returning to Obaku, he told his story and ended up slapping Obaku in the face. Thus we have Sengai's inscription here: "The fist strikes the progenitor."

Rinzai is often portrayed in Zen art with a tightly clenched fist and a fierce scowl, but Sengai added the dismayed look in Rinzai's eyes. The contrast between the open mouth and slitted eyes of Baso and the closed frown and rounded eyes of Rinzai is compounded by the wriggling lineament of Rinzai's robes and the more decisive delineation of Baso. Baso is perhaps shouting at Rinzai, who may yet give him a punch if he doesn't stop!

Another work in which Sengai added a new twist to a familiar scene is *Frog and Banana Plant (plate 101)*. The plant suggests the name of the poet Bashō (literally, "banana plant"), and the frog refers to his famous haiku, which Sengai gently parodies:

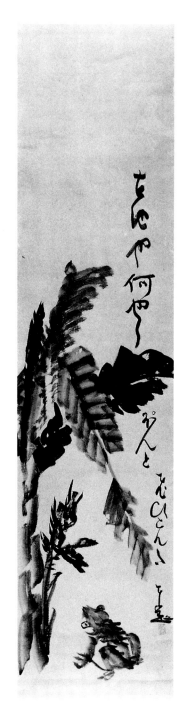

102. *Sengai (1750–1838)*
FROG AND BANANA PLANT
Ink on paper, 50 3/8 × 11"
Idemitsu Museum, Tokyo

104. Sengai (1750–1838)
BASO AND RINZAI
Ink on paper, each 46³/₈ × 16¹/₄"
Idemitsu Museum, Tokyo

Furu ike ya	An old pond,
Nani yarapon to	*something has—PLOP!*
tobikonda	*just jumped in*

Other versions of this poem by Sengai are: "An old pond, Bashō jumps in, the sound of water" and "If there were a pond, I'd jump in myself, and let Bashō hear!" Sengai noticed that the natural sitting position of the frog is akin to that of *zazen*. He therefore portrayed in one of his most celebrated works a smiling frog *(plate 103)* with the inscription: "If a human can become a Buddha through practicing *zazen* . . ."

The smile of the frog certainly suggests enlightenment, or is it only a foolish grin? Is just sitting in *zazen* enough to reach satori? The notion of a frog as a Buddha occurs in Japanese art as early as the twelfth-century *Scroll of Frolicking Animals (plate 101)*, in which satire is the predominant element. In Sengai's work there is also an expression of loving kindness that urges us not to take ourselves too seriously and yet looks with compassion on our foibles and ambitions, including Buddhist ambitions for high honors. Among the notable features in this painting are the varied tones that can be seen in each brushstroke and the way that the calligraphy nestles around the front of the frog with Sengai's signature to the rear. The frog is certainly looking at us—but why is it smiling?

Sengai occasionally depicted landscapes, often with views of actual scenes near his temple in Kyushu. One of these is the *Hakozaki Hachiman Shrine (plate 105)*, painted in 1830. This scene is located near the city of Hakata, already by Sengai's day an extremely busy port, but the landscape depicted is quiet and peaceful. The beach of Sode shown here may refer to Sengai's own life, as he once wrote in a poem:

My fleeting life spent as a monk
is like a deserted boat on Sode's beach.[3]

In this painting Sengai has depicted the environs of the Hakozaki Hachiman Shrine (represented by the large torii in the lower right) as the gateway to China. The calligraphy of Sengai's poem seems to support the tiny sailboats, as though the words were sent forth from the lighthouse in the center of the painting:

When we look into the distance,
ancient China, which lies
beyond the clouds,
becomes a nearby island mountain
in the middle of the ocean

The idea of a mountain in the midst of the ocean suggests the "isle of the immortals" of Taoism, the abode of enlightenment. Sengai's varied tones of black and gray ink (sometimes within a single stroke—such as that defining the edge of the nearer shore), his use of wet and dry ink, and his unusual asymmetrical composition give this landscape a sense of individuality. It evokes a particular place at a particular time. In this way the painting differs from the universalized views of nature more often depicted in China; it also symbolizes the new spirit of Zenga as opposed to the Japanese ink-painting tradition of the Muromachi period.

The scroll by Sengai that has evoked the most mystery and wonder is his simple *Circle, Triangle, and Square (plate 115)*. Various interpretations have been suggested, including the possibility that it symbolizes the single-story pagoda (*tahoto*) of esoteric Buddhism, which is constructed of a triangle over a circle over a square.[4] Sengai's image is claimed to be a picture of the universe,[5] and it is certainly primordial: the circle itself forms an *ensō*. Furthermore, the circle and square appear in the original stupa form, in the mandala, and ultimately in prehistoric geomancy representing heaven and earth and therefore the cosmos. Other interpretations suggested for the three forms include enlightenment, *zazen,* and the temple; infinity, humanity, and phenomena; or Zen, Shingon, and Tendai.[6] Nevertheless, it is not as symbols that these forms attract our eye, but as particular shapes, brushstrokes, and tones.

One notable feature of the painting is how the forms slightly overlap; the central triangle touches the square on its left and hooks into the circle on its right. This powerful sense of connection between basic forms is given immediacy by the varied tones of black and dark and light gray, which individualize each shape. Sengai inscribed on the left, "Japan's first Zen temple." This is the formal name of his home temple of Shōfuku-ji, and therefore it has been considered a form of signature. It might also be considered an inscription, since the basic forms of circle, triangle, and square are the geometric building blocks of temple architecture and therefore suggest the original force and basic nature of Zen.

Sengai's paintings range from the erotic to the everyday to the sublime. He brushed scenes of farming and festivals as well as traditional subjects such as Daruma and Kannon. Following the lead of his predecessor Hakuin, Sengai opened up the world of Zen painting, using humor to penetrate all barriers. Sengai had a playful touch and a sense of warm humanity that make his wit especially delightful. The sheer quantity of his output, even allowing for the prevalence of imitations, demonstrates how frequently he took up the brush in his later years. At the end of his life, however, he was once more called into administrative duties. His follower Tangen incurred the displeasure of the authorities in 1837, so at the age of eighty-eight Sengai was reappointed abbot of Shōfuku-ji. Later that year Sengai became ill, and he died on the seventh day of the tenth month. Through his teaching and his brushwork, he was probably the most beloved Zen master in Japanese history.

NANTEMBŌ TŌJŪ (1839–1925)

One of the leading monks who carried Zen into the present century was Nantembō (Nakahara Zenchū), whose name means "nandina staff." His Zen beliefs, his eventful life, and his approach to art were clearly documented in his many books, which contain extensive autobiographical writings. Through his indomitable sense of purpose, he maintained the standards of Zen training during a period of social turmoil such as Japan had not seen since the introduction of Buddhism and Chinese culture in the sixth century. The impact of the West was so profound during the Meiji and Taisho periods that all religious, cultural, educational, political, and artistic values were called into question, and many traditions were abandoned. Self-reliant, Nantembō expressed in both his life and his brushwork the inner force that allowed Zen to survive amid the radical new ways of thought and patterns of behavior that carried Japan into the modern world.

Nantembō was born on the third day of the fourth month of 1839 to the Shioda family, of samurai background, in Ogasawara, Karatsu (Hizen), in Kyushu.[7] According to legend, the birth of the historical Buddha had been the occasion for many supernatural events, including an episode in which the infant took seven steps in each direction, pointed to the heavens, and said, "In heaven above and the earth below, I alone am the honored one." Nantembō, by contrast, wrote of his birth, "When I was born there were no remarkable occurrences or special rays of light. I did not take seven steps or call out to heaven and earth, I just cried like a baby, 'gya-gya.' "[8] He went on to comment that records of Chinese patriarchs exaggerated their virtues and embellished their lives with miraculous legends, but that these stories were harmful rather than helpful to Zen.

When Nantembō was seven years old his mother died, an event that profoundly shocked the young boy. Seeing the transience of life, he resolved to become a monk; on his own, he went to visit his mother's grave every day. His father renamed his son "Kōjirō" (using the character for filial piety), but would not at first allow him to enter a temple. By the time Nantembō was eleven, however, his father relented, and Nantembō joyfully began his training at Yūkō-ji in Hirado, where he received the name Nakahara Tōjū. In 1850 at the age of twelve, he formally entered the Buddhist priesthood on Daruma's anniversary day. After six years of studying Buddhist texts, Sanskrit chants, the Confucian classics, and Chinese poetry, he was allowed to travel to Kyoto, to enter the Yamashiro Hachiman Daruma-dō, and to practice at the monks' training hall at Empuku-ji.

Nantembō's training was very strict; he not only welcomed the difficult regimen, he added to its severity. He devotedly studied the records of Zen patriarchs, especially favoring the *Rinzairoku* ("Records of Lin-chi"). He chanted the preface every morning before his Buddhist invocations and memorized almost the entire text. One night he was filled with such deep emotion that he could not sleep, so he opened the volume at random and came upon the following passage:

Those who follow the Way must study. . . . I myself once delved deep into the sutras, but when I realized that they were prescriptions for salvation and doctrines codified in words, I threw them all away and practiced meditation. Still later I met great teachers, and could discern the true masters from the false. After exhaustive investigation and discipline, in an instant I knew the truth within myself.[9]

Nantembō immediately realized that reading Zen texts was different from truly experiencing Zen. Even the finest books were "someone else's treasure; painted rice-cakes!"[10] He therefore determined to go on pilgrimage. At first his teacher would not consent to let him go, so Nantembō fasted for three days and three nights. He decided that it was better to die than not to find the Way. Seeing that Nantembō could not be swayed, his teacher gave him permission to leave, and Nantembō wrote half a century later that he was "completely happy. Even now I cannot forget that moment."[11]

On this early pilgrimage, Nantembō went to Osaka and Fushimi. His Zen master Seki-ō had given him the *Mu kōan,* and he meditated upon it fiercely; it was to be his chief teaching tool for the rest of his life. At the age of twenty, he planted a pine seedling at Empuku-ji with the pledge that if it survived, he too would flourish; if it withered, so would he; yet if it died, he would still live until the age of eighty.[12]

For three years, beginning when he was twenty-two, Nantembō visited the monk Bunjō, who was considered the most severe Zen teacher in Japan. Every time Nantembō left a meditation session, Bunjō would pinch him hard. The young monk tried to stay alert in order to escape but was always defeated, and his buttocks became "as red as a monkey's ass . . . throughout my life I have remembered this extreme strictness, and even now my tears flow at the memory. These are tears of thankfulness."[13]

Another story that Nantembō wrote about Bunjō illustrates the use of calligraphy in Zen encounters:

One day Bunjō wrote out the character shikaru *[meaning "rebuke"] on a large piece of paper. First he wrote the left side and then started the main stroke on the right. He asked me, "Does this stroke bend to the left or to the right?" I answered, "to the right," but he exclaimed, "I won't be tricked again" and drew it to the left.*[14]

To the left was incorrect, but we may infer that Nantembō had tricked him before, and that the relationship had an element of gamesmanship that ultimately demanded the full and absolute alertness of both teacher and pupil.

In 1863 Seki-ō died, and Nantembō moved to Bairin-ji, where he studied with Razan for six years. During this time, Nantembō was said never to have slept on his futon, instead going out every night to meditate. He naturally grew sleepy and tried various means to combat drowsiness. First he pricked his thigh with an awl, as the Chinese master Tz'u-ming (Japanese: Jimin, 987–1040) had done, but this method did not work for long. Then he tried meditating on a rock in the cemetery behind Bairin-ji; but even when the snow made a miniature mountain on his folded hands, he could not keep his eyelids from growing heavy. Finally he remembered a *kōan* in which a man is caught in a well with serpents below and stampeding elephants above him, so Nantembō decided to set up a wooden matting over a "bottomless well" near Bairin-ji. If he fell asleep he would topple over and fall to his death. This method allowed him to meditate all night long. He felt that his spirit was rising to the heavens and later wrote that in this period of his youth, his body was tough, but it was his strength of spirit that allowed him to achieve enlightenment. Although it might have seemed madness to choose such a dangerous place for meditation—another monk tried it and quit after ten minutes—Nantembō believed that for someone sincerely seeking the truth, it was "a cup of tea."[15]

After receiving *inka* from Razan in 1865, Nantembō determined to experience both the Inzan and Takujū branches of the Hakuin tradition.[16] He

continued to make pilgrimages, eventually visiting twenty-four famous Zen masters. He later felt that these encounters were vital to his understanding of Zen. When he reached the age of thirty-one, Nantembō had become celebrated enough to be offered his own temple, Daijō-ji in Yamaguchi prefecture. He immediately went to the main temple and tested his Zen by a series of questions and answers with other monks, using direct quotations from patriarchs of the past. He found that while others were much more adept than he was at Chinese-style verse, he was the most committed to constant Zen training: "Although to others my poetry wasn't worth half a cent, no one else had achieved my state of mind."[17]

At the age of thirty-five Nantembō happened upon a farm in Miyazaki, Kyushu, where a splendid nandina tree grew next to a cattle barn. Nantembō immediately wanted to make a short *shippei* (staff or club) from this shrublike tree and begged the farmer to let him cut it down. The farmer replied that the tree was planted by his ancestors and highly prized by his family, but if the young monk wanted it so badly, he could have it. Nantembō was overjoyed, recited the *Heart Sutra* three times, and offered other prayers for the farmer's family. The staff (*bō*) that he cut from this nandina (Japanese: *Nanten*) tree he used to instruct his pupils, sometimes whacking them with it. It became so famous that he was soon known by the name Nantembō.

From 1874 to 1876 Nantembō made the rounds of Zen temples throughout Japan, debating with abbots and challenging the monks he met to deepen their experience of Zen. He began to receive invitations to lecture at temples such as Empuku-ji and Bairin-ji, but at first he did not like these talks, feeling that they were "like the drum that announces the sumo match [rather than the actual wrestling]. But I was soon considered such a preacher that I had to talk until my teeth rattled."[18]

In 1885 Nantembō taught at the training hall at Sōkei-ji in Tokyo, where many military leaders attended his sessions. While lecturing on the *Mumonkan,* Nantembō first met Yamaoka Tesshū (1836–1888), the Zen layman who was a government adviser, master swordsman, and noted calligrapher. The two had previously corresponded, but now Tesshū came to the Zen lecture sessions and also had daily private meetings with Nantembō. According to Nantembō's later account, in these personal interviews Nantembō challenged Tesshū with the *Mu* of Jōshū, asking him how to act upon it humbly and sincerely, saying, "Don't merely repeat the word, come on, come on!" Even though Tesshū knew the general arguments about *Mu,* he was at a loss to penetrate "even this simple everyday matter."[19] Tesshū had satisfied other Zen masters with his understanding, but "he had trouble at my place, so he came every day and night; he was the most brave of the brave and the most fierce of the fierce. Therefore we became completely devoted to each other, and our association became closer and deeper. Tesshū vowed to assist me in making Zen prosper."[20]

Followers of Tesshū dispute Nantembō's account, feeling that the roles were reversed and Tesshū acted as the master and Nantembō the student.[21] Nevertheless, the two joined together in an effort to provide strict guidance for Zen pupils. Due to the lack of cooperation they received from other monks, it was not easy for Tesshū and Nantembō to establish a Zen training center, but in 1886 Tesshū persuaded the Toda family in Ushigami to donate its ancestral temple Dōrin-ji in order to establish a *Sōdō.* In 1887 Tesshū wrote out the calligraphy for the framed signboard to the meditation hall. (The fact that he did not sign his name to this work was evidence of his depth of spirit, according to Nantembō.[22]) Tesshū also wrote out the regulations for daily

106. *Nantembō (1839–1925)*
DARUMA. *1911*
Ink on paper, 66¼ × 35″
Private Collection

Zen life that had been composed by Nantembō's teacher Razan, beginning with the words "Following the Way of Zen is urgent business." This calligraphy was also hung in the meditation hall.

Nantembō's teachings were strict, and he promoted some unusual practices at Dōrin-ji that occasionally aroused criticism. For example, his followers were required to repeat the word *Mu* during meditation sessions. Nantembō defended this practice, saying that his pupils who criticized him did not understand his Zen aspirations, deviated from his teachings, and ended up apologizing repeatedly. In insisting that his followers say *Mu*, Nantembō felt that all Buddhist mantras resided within it:

If saying Mu Mu *becomes a hindrance to them, they cannot attain activity within quietness, sound within silence, and silence within sound, and they cannot become the* Mu *themselves. Those who can only meditate in the deepest mountains and the most secluded valleys where no wind blows and no stream sings, how can they help the world? Not helping the world, why should they leave the world?*[23]

In 1891, when he was fifty-three, Nantembō was recognized as an eminent Zen teacher, and he was made abbot of Zuigan-ji in Matsushima, the temple that had become a major Zen monastery under the monk Ungo (see Chapter Two). Nantembō's harsh methods of teaching did not make him popular, however, and his years there were stormy. Eventually, a peculiar incident occurred that gave his enemies a chance to rally public opinion against him.[24] A wooden statue of the former daimyo Date Masamune was kept at the temple and displayed publicly only one day a year. In 1897, on one of these occasions, the crowd was terribly congested. A young man came with a lamp in order to see the statue more clearly. He was pushed by the crowd, the flame from the lamp touched the nose of the statue, and the wood started to smolder. An acolyte of the temple hurriedly tried to wipe the statue, but accidentally chipped off the end of its nose. This caused a sensation.

The former samurai of Sendai, who had lost their favored status at the advent of the Meiji period, were ready for a row. Somehow they thought that the incident had occurred intentionally, and they spread exaggerated rumors throughout Sendai and Matsushima, blaming Nantembō for this act of disrespect to the former daimyo. No matter what he said, Nantembō was not believed by those predisposed against him, and he realized that the acolyte's error was fundamentally his responsibility. Various satiric verses were composed and written on walls for all to observe:

Nanten no	*Taller than*
bō yori takaki	*Nantembō's staff—*
hana no saki	*the tip of the nose*

Nantembō closeted himself in a subtemple and quietly wrote a book on meditation, but the incident had caused such a stir that the leaders of his home temple, Myōshin-ji, decided to appoint a new abbot; when he arrived, Nantembō left and went to Daibai-ji.

In the following years Nantembō led an increasingly active life teaching and proselytizing Zen. In 1902 he became abbot of both Bairin-ji and Kaisei-ji; the latter temple was to be his home base for the rest of his life. In 1908 he received his highest honor, becoming the 586th patriarch of Myōshin-ji, a position that was for him primarily ceremonial. He traveled relentlessly throughout Japan, leading Zen meetings and writing a number of books on Zen subjects. He

also began to take up brushwork in earnest; although a few works remain from his days at Zuigan-ji, the great majority of his paintings and calligraphy date from his later years.

One of Nantembō's favorite subjects was Daruma. He was frequently asked to paint this figure, and although he commented that "you can't grasp the innards through a painting," he was beseeched to "paint, paint" until he finally gave in.[25] Thereupon further troubles arose—people said his representations did not look like Daruma, but like owls or octopuses! He wondered how people could know—who had actually seen Daruma in the flesh? Nantembō, however, had made a study of Daruma paintings, noting the various themes (Daruma crossing the river, Daruma meditating, Daruma facing the wall, broken-tooth Daruma, bearded Daruma, red-robed Daruma, answering-the-emperor Daruma, and even signboard Daruma for advertising paper stores or tobacco shops). Where was the true patriarch? He concluded that "trying to count the forms of Daruma has made my shoulders stiff—please give me a cup of tea!"[26]

Although Nantembō wrote that he admired the Daruma paintings of Hakuin and Sengai, his own depictions are typically different. His largest known painting, executed when he was seventy-four at the request of a man named Utsumi, shows Daruma *(plate 106)* with a startled frown; he has an earring, but no nose! The black line defining the patriarch's robe was begun with so much force that it tore the paper (which was repaired in the mounting process) and drops of ink were dramatically splashed to the side. Yet this heavy wet stroke ended with such rapid energy that the brushwork shows "flying white" as it swings down to the lower left of the painting.

The boldness and humor in this painting are both personal characteristics of Nantembō that appear frequently in his works. Nantembō must have received some formal training in calligraphy, as he demonstrates well-controlled "upright" rather than "slanted" brushwork (his brush was held perpendicular to the paper). His style is perhaps ultimately derived from the work of Hakuin, but instead of the earlier master's rich merging of ink tones, Nantembō

107. Nantembō (1839–1925)
KATSU. *1911*
Ink on paper, 59 × 69¹/₂″
Museum für Ostasiatische Kunst,
Berlin

achieved a luster in his ink that suggests the shining surface of black lacquer. Nantembō's visual humor has been compared with Sengai's, but the latter had a more gentle wit by comparison with Nantembō's blunt forcefulness. In the direct look of amazement depicted here in the patriarch's face, for example, Nantembō gave his own interpretation to this most traditional of Zen subjects. His inscription is a couplet attributed to Daruma (and previously seen on the *Daruma* by Shunsō, *plate 81*):

A single flower opens to five petals
And bears fruit according to its own nature

108. Nantembō (1839–1925)
FOUR FANS
Ink on paper, each 18³/₄" wide
Private Collections

Because of his Zen teachings and his brushwork, Nantembō was besieged with requests for paintings.[27] Despite his busy schedule, traveling, leading Zen sessions, and testing monks and laymen alike with Zen questions, he nevertheless found time to create a large number of works. The largest and grandest calligraphy that Nantembō brushed was when he was asked to compose a text for a monument to General Nogi Maresuke (1849–1912), a national hero who had studied with Nantembō for many years before committing ritual suicide on the night of the funeral of the Meiji emperor. Nantembō was extremely honored to write out an inscription honoring his friend, so he began his preparations by ordering a silk banner six by twenty-one feet, a brush five feet long, and several gallons of ink. The sponsors of the monument came to Kaisei-ji to see the gigantic seven-character calligraphy being written. They arrived at midafternoon of the twenty-seventh day of the twelfth month of 1916. According to Nantembō's own account, when he delayed, they asked him to "please hurry up and write," but first he drank a huge amount of sake to get into the proper frame of mind. Finally, standing up and throwing down his cup, he said, "Now, let's begin." Hitching up his robe, he took up the brush in both hands, splashed it into the bowl of ink, had it squeezed partly dry by an attendant, took a breath deep into his stomach, and called out *"Katsu!"* He gathered together his body and spirit like a sumo wrestler toeing the mark: the brush moved with the sound "sa-sa-sa" and droplets of ink splattered on the faces of the onlookers.

As he finished the last stroke of the first character *No* ("*Nogi*"), he suddenly kicked the brush with his right foot, splashing the ink all the way up to the ceiling boards of the temple. He had not planned it, but the mighty kick was a spontaneous Zen occurrence that invested his calligraphy with tremendous force. When he finished the seven huge characters, he said, "Now Nogi's spirit can rest in peace."[28]

Nantembō felt that true calligraphy comes from the gut, just as the Japanese believe true swordsmanship is guided by inner instincts. Characters must be more than good or bad writing. They must come from the force of a concentrated spirit. When merely written by the brush, the characters are dead. When Nantembō did calligraphy, "The brush is me, I am the brush. When this happens, the hand is the foot and the foot is the hand. One does it with the entire body."[29]

Although the original of this great calligraphy is lost and the monument was never erected, Nantembō used the remaining ink to create eight large *fusuma* for Kaisei-ji, with one huge character on each panel.[30] He also wrote out the immense character *Katsu* on three joined pieces of silk *(plate 107)*. The sound of a Zen shout, so often occurring both in master-pupil dialogues and in Zen poetry, had never been written out so large. Ink seems to fly from his brush, and we can sense the energy and concentration with which the calligra-

phy was created. The *Katsu* is composed asymmetrically, balanced on the scroll by the inscription at the upper right, which notes that the work was done with ink left over from the memorial inscription, and gives the artist's signature and age (seventy-six). His large square seals are at the lower left. The sound of a great shout has been captured in ink.

Nantembō did not write only large-scale works. Unlike most monks, he also utilized the small shape of a folding fan for his painting and calligraphy. Four fans, made when he was in his seventies, show the variety he achieved within this medium. On one he has written his favorite character, *Mu*, together with a poem, a *katsu,* and an inscription *(plate 108)*. The large character on the right is composed in a short, stubby, angular manner, giving it a sense of compressed force. This contrasts with the more flowing script of the poem, a Chinese *kōan* from the Sung dynasty, in the center. There follows a solitary *katsu* and an inscription explaining that Nantembō wrote the work for a lay pupil in memory of General Nogi:

MU

Jōshū brings forth a sword
And cold frost shines on the blade
Just ask how to imitate this,
And you will be cut in two.

There's no place to hide from Nantembō's stick!

KATSU!

This is the kōan *that, through constant training and practice, led to General Nogi's enlightenment; therefore in his memory I have written this, and respectfully present it to Saitō Daishin.*
—NANTEMBŌ AT THE AGE OF SEVENTY-FOUR

The fan is an example of Nantembō's devotion to General Nogi and of his dedication to *Mu*. His belief in *Mu* is even more graphically illustrated in a four-line poem that he composed with true Zen simplicity:

Mu Mu Mu Mu Mu
Mu Mu Mu Mu Mu
Mu Mu Mu Mu Mu
Mu Mu Mu Mu Mu

Nantembō then commented that "Chuang-tzu had said that heaven and earth are contained in one finger, the myriad creatures in one horse. Now heaven and earth are united in this poem . . . isn't that marvelous? What a great poem it is! What a huge *Mu!* Who needs the *T'ang Poetry Collection?*"[31]

A second fan, which Nantembō inscribed at the age seventy-nine, has the large character *Diligence (plate 108)* emblazoned on it. Nantembō was directly following a model, as he explained in his *Nantembō zenwa:* "Hakuin once wrote out the large character 'Diligence' with the inscription, 'Heroes on this earth, and saints and sages past and present, follow only this one word to become great.' This is my own utmost principle. No extra thoughts are needed, just living Zen without searching outside oneself."[32] On this fan, Nantembō slightly altered Hakuin's words for the inscription written to the left of the large character:

Past and present heroes on this earth
Earn wealth and honor
From following just this one word

The long diagonal stroke that ends the large character sweeps down towards the area of the fan that Nantembō has left blank, so that the smaller characters of the inscription seem anchored in space. "Diligence" visually as well as metaphorically supports those who can maintain it. Nantembō's signature at the far left, including the artist's characteristic cipher at the end, completes the composition.

A third fan combines two of Nantembō's most delightful themes, Mount Fuji and Snow Daruma *(plate 108)*. It bears an inscription to the right of Fuji:

The distant mountain has limitless layers of green

Like the previous calligraphy, this work was brushed on a completed folding fan, rather than on paper later mounted as a fan. The line depicting Mount Fuji breaks with the folds then reaches a strong, jagged summit near the top of the fan.[33] To its left, a snowman Daruma looks out with a humorously sad frown. The curving line below him, ultimately derived from the line of Daruma's robe, echoes in reverse the shape of Mount Fuji.

Daruma's legs, according to one legend, withered away during his nine years of meditation. The snowman, because he has no legs, has been called "Snow Daruma" in Japan; by depicting this subject with a simplified face and a brief suggestion of a robe, Nantembō created one more variant of the Daruma theme. On his larger representations of the Snow Daruma *(plate 109)*, Nantembō usually added a poem by Tesshū:

109. *Nantembō (1839–1925)*
SNOW DARUMA. *1917*
Ink on paper, 53 1/2 × 12 3/4"
Private Collection

Tsumitateshi	*A Daruma made*
yuki no Daruma mo	*of piled-up layers of snow —*
hi kazoete	*as the days pass by,*
doko e yukaramu	*where has he gone? . . .*
ato kata mo nashi	*no traces of him remain*

There are several meanings that one can find in this poem. Tesshū and Nantembō may have been referring to their concern that the true spirit of Daruma was disappearing in Japan, due to laxity in the training of monks. On the other hand, the vanishing forms and traces may also refer to the state of nirvana, which Daruma achieved by becoming enlightened to his own Buddha-nature.

The most characteristic subject of all for Nantembō is the *Nanten* staff, which he painted on a fan in his seventy-eighth year *(plate 108)*. The inscription recalls the famous saying of the Chinese master Te-shan (Japanese: Tokusan, 782–865): "If you speak, thirty blows; if you can't speak, thirty blows." Nantembō, who also whacked his followers when he felt it might awaken their spirit, wrote: "If you speak, Nanten's staff; if you can't speak, Nanten's staff." However, in place of the last character, *bō* (staff), he drew the staff itself—the painting is a calligraphy, the calligraphy is a painting. Another translation would be: "If you speak, Nantembō; if you can't speak, Nantembō." Once again the folds of the fan interrupt the heavy ink of the staff,

110. *Nantembō (1839–1925)*

NANTEN STAFF

Ink on paper, 59¹⁄₈ × 16¹⁄₂″

L. Wright Collection

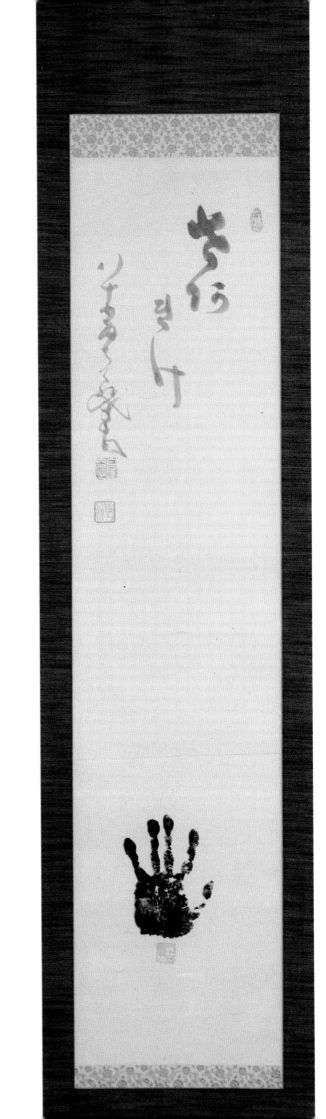

111. Nantembō (1839–1925)

HAND. 1923

Ink on paper, 54 1/2 × 12 1/4"

Howie Collection

which was brushed with tremendous force. The calligraphy follows the upper curve of the format; on the right is the signature and double-seal, while in the lower left is a pictographic seal in the shape of a skull.

Nantembō also painted his "If you speak" staff many times in scroll format, usually brushing the staff vertically as a dragon. One lively, undated example of the *Nanten Staff* has an energetic main stroke from which the ink flies off in every direction, suggesting the scales of a dragon's skin *(plate 110)*. One can almost imagine the mouth and horns and sense the dragon moving, restrained only by the tassels at its waist. These tassels are reinforced by the calligraphy on either side, with the opening seal and inscription to the right and the signature, cipher, and final seals to the left. The end of the cipher (reading "*Tōjū*") also has a long vertical stroke, echoing the staff itself.

Like many other monk-artists, Nantembō was an opsimath, learning late in life to utilize painting and calligraphy as means of Zen expression that went beyond words. He believed that there were three ways of teaching: in silence, with words, and with the brush. He felt that every form of writing was potentially worthy, including commentaries on Zen texts, essays, magazine and newspaper articles, and private letters.[34] He got up every morning at 3:00 A.M. and wrote letters until dawn to people from all walks of life. He felt the crucial point was sincerity and that any writing that did not move people's emotions was of no use. He kept the letters that people sent him (except those from famous men, which he gave away upon request), commenting that he had more than twenty-five pounds of letters piled up like a mountain in his study, all sorted by year and month. He would give blessings daily to all who wrote him. Even if he could not remember their names, he would pray in front of their letters. Nantembō expected to die at the age of eighty, and he asked that he be buried with the letters packed into his coffin. If they did not all fit, they should be soaked in sake and stuffed around his body. He noted that it was because of the letters he had received, as well as those he had sent, that he was known as "Letter Tōjū."[35]

Nantembō, when he did not die upon becoming eighty, felt that to have lived longer than the historical Buddha was improper. He therefore decided to act as though he were dead and planned a full-scale funeral ceremony. When the day came, he climbed into a coffin, and an elaborate service was led by the monk Mokuden. Nineteen other Zen masters, more than one hundred and fifty monks, almost three hundred training monks, and hundreds of other visitors attended and burned incense: "What fun! Inside the coffin it was really another world, with the voices outside reciting sutras resounding like thunder and shaking the universe . . . Sakyamuni still lives, Daruma still lives, for I am Sakyamuni, I am Daruma, it is all one eternal law."[36] Thereafter, Nantembō felt as though he had truly died to the world, so he had the complete freedom of a second life. In Zen, as in other religions, a sense of rebirth is possible, but it is certainly rare to have had an opportunity to enjoy one's own funeral.

Nantembō spent most of his mature life in travel, lectures, Zen meetings, meditation, writing, painting, and calligraphy. One day he was told that someone had been caught making fakes of his brushwork; he was asked to admonish the offender, and the man was brought before him. "Ho, is this your calligraphy?" Nantembō asked. "It's better than mine! My own writing is worth one yen, but since yours is more skillful it must be worth three yen. If you are in need of money, don't sell it but bring it to me, and I'll pay you three yen." The forger was never heard from again. There are a number of copies of Nantembō's works extant, but probably from other hands.[37] Another story

about Nantembō's kindness (despite his fierce and brusque manner) derives from when he was called to a police station in Osaka to confront a thief. The policeman told Nantembō that his wallet had been found in this young man's hands. "I don't recognize it," said the monk. "But it has your name cards in it," said the policeman, "so please don't let this thief get away." Nantembō, however, refused to prosecute, saying, "My prayers are meant to send even the dead to paradise, how could I send a living person to hell?"

While his attitude toward miscreants was forgiving, Nantembō had nothing but scorn for fellow monks who misrepresented their attainments. He even suggested that certified monks be tested regularly throughout their lives on their Zen understanding. This idea, not surprisingly, was stoutly resisted. Since Zen monks were allowed to marry, their temple positions often became hereditary; eventually many of the smaller temples in Japan were run by men who had become monks because it was the family tradition, rather than because they had conviction in their religion.[38]

On his journeys around Japan, Nantembō liked to engage in Zen debate with other monks in order to test their mettle as well as his own. He met once with a high-ranking Sōtō sect prelate who suddenly took off his monk's round bamboo hat and threw it on the ground, saying, "Do you meditate within the circle or outside the circle?" Nantembō immediately sat down on the hat and replied, "I sit within the circle." The monk was at first confused but then traced a large circle on the ground and asked, "Even the Masters of the Three Worlds could not escape from this circle; how would you get out? Speak quickly, speak quickly, or if you are a false monk, wipe out the circle and leave!" Nantembō was not troubled by this and replied that he couldn't be tricked so easily. Eventually the Sōtō monk thanked Nantembō, saying that he had never had such a stimulating encounter.[39]

The circle (*ensō*) here represented *samsara,* the world of birth and death in which we are all enclosed. Nantembō meditated within this circle, but having died to the world, he was not bound by it. He often painted the *ensō,* with inscriptions such as "Is this a cake? A dumpling? The ring around a bucket?" or "Eat this and drink a cup of tea!" *(plate 112).* He wrote that "if you become like a child, you can understand."[40] The direct and immediate world of a child, according to Nantembō, had much in common with Zen. He noted: "There's no one as strong as a child. As the proverb has it, 'You can't defeat a landlord or a crying baby.' There's a Zen truth in this; those who know, know. If you don't understand, ask a child!"[41]

In case number eighty of the *Hekiganroku,* a monk asks Jōshū if a newborn baby possesses the six senses (including consciousness) or not. Nantembō commented that for the first two or three years, a baby is fully in tune with its own nature:

It cries, it laughs, when not pleased it gets angry. It cries without thinking of crying, it laughs without thinking of laughing. Therefore can you say it has consciousness? If you say it has not, then on what basis is it active? If you say it has, then it is unselfconscious like a tree or rock. But this non-consciousness only temporarily dwells in a child, and should not be compared with a dead tree or a cold rock because it can bring forth many understandings. Monks often have a mistaken view of this. Non-consciousness means that by forgetting itself, it can be universally active. One eye cannot see the other, consciousness cannot see consciousness, gold cannot value gold. . . . There is nothing to hamper it, so non-consciousness is free to change and develop. That is why Rinzai said, "If [Daruma] had a purpose, he could not even have saved himself."[42]

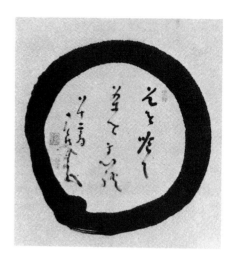

112. *Nantembō (1839–1925)*
ENSŌ
Ink on paper

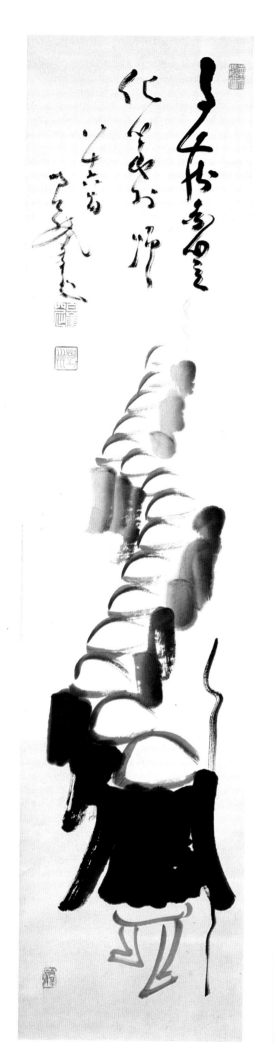
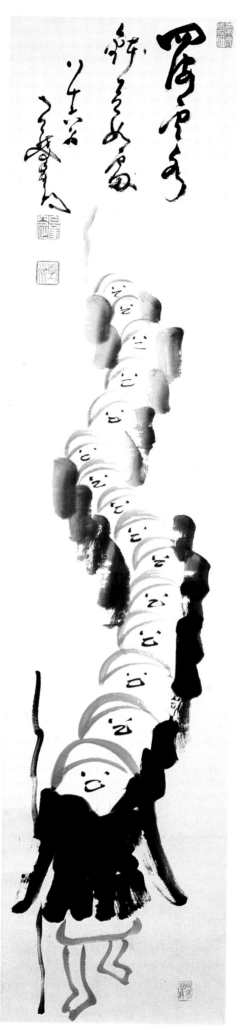

113. Nantembō (1839–1925)
PROCESSION OF MONKS. 1924
Ink on paper, each 51 × 11·³/₄″
Man'yō-an Collection

200

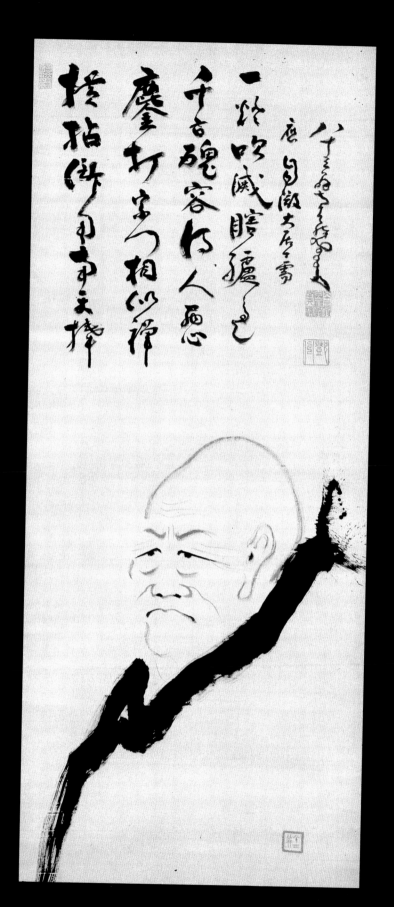

114. *Nantembō (1839–1925)*
SELF-PORTRAIT. *1921*
Ink on silk, 49 × 20 1/2"
Private Collection

The purpose of Zen art is to awaken the viewer. One of Nantembō's works from his eighty-fifth year is as simple and direct a command as could be imagined. It is merely an imprint of his hand *(plate 111)* dipped in ink and pressed on the paper, with a great deal of empty space around it. Nantembō's inscription says merely:

Now Listen!

This work is not unique in Japanese or Buddhist art. Hand prints had been used with calligraphy in the Edo period, and Tibetan abbots sometimes pressed their hands on the back of *thanka* scrolls in order to certify their blessings. In Zen art, Hakuin depicted a Hotei-like figure with one hand raised *(plate 62)* or sometimes represented only a single hand to suggest the famous *kōan*. Nevertheless, this work by Nantembō is the most immediate and resolute of all. In a very direct way, it is Nantembō himself. The painting and calligraphy of Zen monks, called "ink traces" in Japan, have long been considered to reveal their individual personalities. This is a unique form of self-portrait that simultaneously invokes the eternal. Can a scroll evoke a soundless sound? Listen!

Beyond the staff and the hand, both of which symbolize Nantembō as a teacher, he also occasionally painted his own visage in the same pose seen in depictions of the meditating Daruma. One such self-portrait from Nantembō's eighty-third year evokes a remarkably intense impression of the monk meditating *(plate 114)*. Written at the request of one of his lay pupils, the painting gains strength from its dynamic composition and contrasting brushwork. The robe begins with Nantembō's characteristic flying-ink stroke, moving diagonally down to the left, with a second diagonal stroke reinforcing the first. The prelate's head is sensitively depicted upon the silk, with thin lines creating semicircles for the head, eyebrows, eye-pouches, nostrils, wrinkles, mouth, chin, and ear. Cutting across the face are straight lines that define the eyes, within which black pupils gaze piercingly into himself and out at the viewer. The expression shows Nantembō's legendary determination and perhaps also a haunting touch of sadness that may remind us of a very different monk, Fūgai Ekun in his *Self-Illumination (plate 21)*. In both cases, there is a visual parallel with Daruma paintings; the two monk-artists have suggested their inheritance of Daruma's task.

The poem that Nantembō added above his portrait expresses his view of both his life and his mission. We may remember that Hakuin's *Self-Portrait (plate 68)* also used the word "annihilate," which Nantembō much admired. Here the inscription, like the painting, expresses Nantembō's fierce attitude not only toward teaching but also toward his inner self:

Striking and pounding with the Nantembō,
I annihilate all false Zen;
This ugly old shavepate arouses hate for a thousand ages,
Extinguishing the transmission like a blind donkey.

The transmission of the flame symbolizes the essential duty of the Zen master to train at least one follower who will carry on the tradition; Nantembō, as his life neared its end, awaited his successors. In this way his self-portrait became a powerful inducement for his followers to break through to enlightenment and continue the unbroken line of transmission that stretches back to Daruma and ultimately back to the historical Buddha.

In his eighty-sixth year, Nantembō brushed one of his most delightful subjects, the *Procession of Monks (plate 113)*. The figures are depicted with a minimum of lines. The nearest and farthest figures in each scroll carry staffs; the ink tones get lighter as the monks disappear into the distance, and a sense of movement is conveyed by the marvelously positioned feet of the near figures and the twisting curves of the monks leading up toward the calligraphy. The figures with their backs to us have a sense of fulfillment:

In the autumn, in their round hats
They return from the villages with their alms-baskets.

The monks that face us, however, invite us to look and to listen:

All the wandering monks throughout the world —
Their begging bowls resound like thunder.

The lively humor, childlike simplicity, rhythmic strength of brushwork, and immediacy of expression make this pair of scrolls a fitting conclusion to a survey of Zen painting and calligraphy of the Edo, Meiji, and Taisho periods. Two years after the scrolls were painted the Showa era began, heralding further profound changes in Japan. Yet, it is pleasant to suppose that the young monks pictured begging in these scrolls may now be the venerable abbots of our own day. The sight of monks walking through the streets and pathways is still a feature of Japanese life; they represent the continuing history of Zen itself, forever capable of fresh and spontaneous vision within the increasingly complex world around us.

In the second month of 1925 Nantembō knew his death was imminent; he said that he had been born on the birthday of Jimmu, Japan's first emperor, and he would die on the emperor's death anniversary (February 12). On the eleventh, Nantembō ate his favorite *udon* noodles, arranged his robe, took his normal evening drink of sake, and sat in meditation. With a single call of "uun" he slipped into a coma, but a court physician was on hand to give him an injection that kept him alive until six minutes into the following day. In this manner, Nantembō's prediction became true.

Nantembō's art demonstrates how a true master in any age can follow tradition and yet contribute his own brushwork and new subjects to Zenga. His work, influenced by that of Tesshū, has the blunt power that may recall the art of Hakuin and Shunsō and a sense of humor that may be compared to Sengai's, but the individual spirit of Nantembō is clearly apparent in all of his paintings and calligraphy. Perhaps his most distinctive qualities were the verve and energy that convey his sheer spontaneous enjoyment in the act of painting. He used traditional subject matter and brushwork, but the rough, raw, earthy style that he displayed matches his unusual life and character. By living in the modern age, he had to contend with many ideas and customs that Japan had borrowed from the West, yet he was able to utilize new methods to carry his Zen teachings throughout the country. By taking advantage of improved communication systems such as trains and the postal service, he could reach more people over a wider area than any Zen monk before him. He is certainly not the only twentieth-century Zen artist of note, but in his life and works he represents Zen coming to terms with the modern age. Like monk-artists before him, he conveyed universal Zen insights; at the same time he expressed the dilemmas of his own age and his unique efforts to confront them. All his works are self-portraits, and all are Zen teachings.

Epilogue

Zen and Zen art have continued unabated since 1925. In some ways the age-old traditions have remained the same, with calligraphy, *ensō,* and paintings of Zen figures coming from the brushes of venerable abbots at temples throughout Japan. As always, however, there are new circumstances to be considered. For example, laymen have increasingly taken on leadership roles in Japanese Zen. Daisetz Suzuki was an example of this trend. He also promoted the teaching of Zen in the West. Recent decades have seen a substantial growth of Zen studies in both America and Europe; a surprisingly large number of books and articles have been published in English (leading some to wonder if this is truly a "wordless teaching"). Many of these publications have gone beyond the appeal of the exotic to communicate Zen history and precepts and to provide intimations of the Zen experience.

Art has continued to be a vital part of Zen. Monks have found that brushwork can express the inexpressible, and through their works people can still discover that Zen is timely and timeless, representing a long tradition in the eternal here and now. When a monk named Saibai recently wanted to express his joy that a lay pupil had achieved enlightenment, he brushed an *ensō* with the explanation that his pupil had broken through the *kōan* of "one hand clapping" while sitting on a toilet. In the tradition of Zenga, there is nothing precious or "artful" about this work—it is merely the natural expression of a monk awarding *inka* to a pupil.

Since it is not a product for elite sensibilities, some Japanese scholars in the past have been unwilling to consider Zenga as "art" and have therefore omitted it from their surveys and textbooks. That attitude has changed in recent years, perhaps due to Action Painting, Conceptual Art, and other contemporary forms of visual expression that seem to have been foreshadowed by Zenga, as well as due to a greater understanding of the sheer visual power of the works themselves. Particularly in the past decade, the paintings and calligraphy of outstanding monks of the Edo, Meiji, and Taisho periods have been appearing in major publications and exhibitions throughout Japan.

Zenga has already had an effect in the West, being seriously collected by individuals as well as museums. It has inspired a number of artists. Franz Kline, for example, has done many remarkable large-format black-and-white paintings in calligraphic brushwork. Robert Motherwell recently paid homage to Zenga in a small, intense lithograph *(plate 116)* of the three basic forms that had been previously depicted by Sengai *(plate 115).* Most important, Westerners are showing a surprising interest in the brushwork of monks and abbots of the past. Zen paintings and calligraphy have conveyed the spirit of Far Eastern masters to a completely different culture, time, and place.

Zen art continues to be an awakening.

115. *Sengai (1750–1838)*
CIRCLE, TRIANGLE, AND SQUARE
Ink on paper, 11 ¹/8 × 19"
Idemitsu Museum, Tokyo

116. *Robert Motherwell (b. 1915)*
UNTITLED. *1987*
Monoprint, 11 ¹/4 × 12"
Courtesy M. Knoedler & Co., Inc.

INTRODUCTION

1. A clear distinction has not yet been made between works by Zen monks, works depicting Zen subjects, and works in a "Zen" style. Japanese professional artists have often painted in the Zen tradition, but can these works also be considered Zenga? Here, a stricter definition is preferred: Zenga is the brushwork of leading Zen monks or occasionally of other monks and laymen who have studied Zen deeply enough to be imbued with its spirit.

2. For a historical discussion, see Heinrich Dumoulin, *Zen Enlightenment* (New York and Tokyo: Weatherhill, 1979).

3. *Japanese Zen Monk Artists: A Biographical Dictionary* is now being completed, edited by this author; it will include short biographies of more than five hundred monks of all three sects, along with short comments on their brushwork and lists of where their works are illustrated.

4. From Hakuin's *Orategama,* reprinted in *Hakuin Oshō zenshū V* (Tokyo, 1967). For a complete translation of the *Orategama,* see Philip B. Yampolsky, *The Zen Master Hakuin* (New York: Columbia University Press, 1971).

1. THE CREATION OF ZENGA

1. For more information on Ikkyū see Sonja Arnzen, *Ikkyū and the Crazy Cloud Anthology* (Tokyo: University of Tokyo Press, 1986); Jan Carter Covell and Sobin Yamada, *Unravelling Zen's Red Thread* (Elizabeth, New Jersey: Hollem International Corporation, 1980); and James H. Sanford, *Zen-Man Ikkyū* (Chico, California: Scholar's Press, 1981).

2. According to various accounts, Nobutada was supposed to have brushed portraits of Tenjin either daily or eighty-eight times or one hundred times during the year 1609. See Haruna Yoshie, *Kan'ei no sampitsu* [Three Calligraphers of the Kan'ei Period] (Tokyo: Tankōsha, 1971), p. 160.

3. The Tokiwayama Bunko Collection in Kamakura specializes in portraits of Tenjin; see Hisao Sugahara, *Japanese Ink Painting and Calligraphy* (New York: The Brooklyn Museum, 1967).

4. Since artists often included their age with their signature, we will follow the Japanese system in which a baby is considered one year old at birth.

5. The Japanese phrase is *Kan'ei no sampitsu,* which literally means "three brushes of the Kan'ei era." Since Nobutada died in 1614, ten years before the Kan'ei era began, the phrase is a misnomer.

6. Quoted from Takuan's *Nyusa ikō* in Omori Sogen's "Zen Sword: Comments on the *Fudōchi-shimmyōroku* of Zen Master Takuan," *Chanoyu Quarterly* 30 (Tokyo; 1982), p. 53.

7. This letter is in the Eisei Bunko collection.

8. The cultural value of the tea ceremony is still significant. Although a young Japanese adult might purchase a Mercedes as a status symbol, there is nothing so distinguished as a collection of fine, old tea-ceremony wares to establish a politician or *nouveau riche* businessman as a man of culture and good taste.

9. For a study of Takuan's life and writings, see Dennis Eugene Lishka's dissertation for the University of Wisconsin at Madison, *Buddhist Wisdom and its Expression as Art: The Dharma Teachings of the Zen Master Takuan* (Ann Arbor: University Microfilms, 1976).

10. Takuan Sōhō, *The Unfettered Mind,* translated by William Scott Wilson (Tokyo: Kodansha International, 1986), pp. 42, 52, 53.

11. Ibid., pp. 19, 22, 28, 33, 34, 35.

12. Anonymous translation.

13. Takuan, *The Unfettered Mind,* op. cit., p. 12.

14. Ibid., pp. 60, 72.

15. Sōkyū served the warlords Oda Nobunaga and Toyotomi Hideyoshi and was one of the organizers of a gigantic tea ceremony held by Hideyoshi in Kyoto in 1587.

16. This passage may also mean "The follower of Zen scoffs at drooping eyebrows."

17. For a study of Shōkadō's art, see Kendall H. Brown, "Shokado Shojo as 'Tea Painter,'" *Chanoyu Quarterly* 49 (1987), pp. 7–40.

18. For the original text, see Ruth F. Sasaki, *The Record of Lin-chi* (Kyoto: Institute for Zen Studies, 1975), pp. 41–42 and 49. For an account of Fuke's influence upon Zen music traditions, see Samu Sunim, "From Handbell to Shakuhachi," *Spring Wind* 5, no. 3 (Fall 1985), pp. 1–14.

19. Shōkadō often wrote in the "Daishi" style, based upon the works of Kōbō Daishi (Kūkai), which emphasized decoratively curved flourishes of the brush.

20. Another painting of Fuke by Shōkadō is illustrated in *Kokka* 861 (1963).

21. See *Nihon bijutsu zenshū,* volume 21 of *Rimpa* (Tokyo: Gakken, 1979), plate 49.

22. Because they were the preferred choice at tea meetings, Shōkadō's paintings were often forged, making a study of his style difficult; his finest works show his thorough training in calligraphy.

23. Gudō's poem is dated the third day of the seventh month of 1644.

24. In a revised manuscript of this poem the third line is "I used to allow people to rob me of this hidden pleasure."

25. See *Kinsei zenrin bokuseki* (Kyoto: Shibunkaku, 1974), first Rinzai volume, biographies p. 3.

26. Isshi's paintings became especially popular among collectors in the late nineteenth and the early twentieth centuries, due in part to his imperial connections. It was probably at this time that a large number of attractive paintings were created under his name; these forgeries tend to have a much more elaborate use of varied ink tones and wash than his genuine works.

27. Translated by Yoel Hoffmann in *Japanese Death Poems* (Rutland, Vermont, and Tokyo: Tuttle, 1986), p. 112.

2. THE EARLY EDO PERIOD

1. See *Bokubi* 101 (Kyoto; 1960).

2. The other two are Tōkō Shin'etsu's pupil Fūgai Enchi (1639–1712), who does not seem to have been a painter, and Fūgai Honkō (1779–1847), who painted in both Zen and Nanga styles and was strongly influenced by the works of Ike Taiga (1723–1776). The name "Fūgai," which these three monks shared, signifies an existence beyond the cares of everyday life.

3. This information is given in Yamazaki Yoshinari, *Meika ryakuden* [Brief Biographies of Famous People] (Edo, 1841) but is not otherwise confirmed. The early accounts about Fūgai have been gathered and reprinted in Takase Shingo, *Fūgai Ekun Zenshi to sono sakuhin* (The Zen Master Fūgai Ekun and His Artworks; Tokyo: Hiratsuka, 1960).

4. For this reason he is often referred to as "Ana Fūgai" (Cave Fūgai).

5. This story appears in several early accounts of Fūgai's life; see note 4 of this chapter.

6. In Taoist mythology a number of "immortals" gained special powers through meditative practices.

7. This kind of identification with spiritual forebears is rare but not unique; the monk Ikkyū portrayed himself as an incarnation of an earlier Chinese monk upon whom he modeled his teachings. Further, there is a Zen saying, "To paint Daruma one must become Daruma," indicating that every Zen painting is a form of self-portrait; see Chapter Seven for a further discussion of this point in relation to Nantembō.

8. This story appears in the *Getsuba Zenshi goroku* [Analects of the Zen Master Getsuba] (Edo, 1680).

9. For more information, see Richard Edwards, "Pu-tai-Maitreya and a Reintroduction to Hangchou's Fei-lai-feng," *Ars Orientalis* 14 (1984).

10. Translation by Jonathan Chaves.

11. There is a theory that Fūgai's mother died when he was very young; if this is true, the stone portrait of his mother may be an imaginary creation, or it may represent his stepmother.

12. This and other calligraphy by Fūgai is reproduced in *Bokubi* 104 (1961), p. 61.

13. Fūgai sometimes wrote poems alongside his depictions of Daruma crossing the river, including the following quatrain:

A dragon-cloud covers the country of the Liang emperor—
When asked the reason, the violent thunder roars.
Carried over the river by the whirlwind on a reed,
[Daruma] flies easily to the Shao-lin temple.

14. Fūgai's quatrain was based upon a passage by the Sung dynasty monk Hung-chih Cheng-chueh from the *Tsung-jung lu*, a *kōan* collection. It forms part of the second case, Daruma's meeting with the Liang emperor; the final two lines of Fūgai's poem are directly borrowed from Hung-chih.

15. This story is given in Reinan Shūjo, *Nihon dōjō rentōroku* [Records of Japanese Monks] (preface dated 1727).

16. The later ban on Christianity was so strictly enforced that in the *Ungo Kiyō nenjo* (Yearly Records of Ungo Kiyō) Kanesada's name was recorded as Yorifusa to avoid any taint of Christianity. This and other biographical information about Ungo is contained in Hirano Sōjō, ed., *Ungo Oshō nempu* [Chronology of the Monk Ungo] (Kyoto: Shibunkaku, 1983).

17. Among the colleagues Ungo met on his travels were Gudō Tōshoku (1577–1661) and Daigu Sōchiku (1584–1669), both of whom were to become outstanding Zen masters.

18. According to one story, Ungo had been sent on pilgrimage when the government forces came to arrest him. Itchū was therefore taken in Ungo's place; when Ungo heard about this he immediately gave himself up to the *bakufu*. The shogun, admiring this act of loyalty, thereupon freed both monks.

19. This poem is included in the compilation of Isshi's writings, *Kokuyaku Zenshū sōsho* series 2, volume 10 (Tokyo: Dai-ichi Shoten, 1974), p. 272.

20. One might well ask if the wish is to convey emptiness, why not just have a blank sheet of paper? The answer may be that unless it is examined very carefully, the blank sheet is not empty enough.

21. As the signature style is similar to that of the previous work, this scroll was probably also brushed during Ungo's early years in Matsushima.

22. A recent volume of Ungo's works edited by Hirano Sōjō, *Ungo Oshō ibokushū* [Collected Ink Traces of the Abbot Ungo] (Sendai: Zuigan-ji, 1985) includes twenty dated works, ranging from 1636 to 1658.

23. *Ungo Oshō nempu,* op. cit., p. 29.

24. Quoted in the earliest account of Gesshū's life, the 1704 *Zenshū kaizan Gesshūrō Oshō gyōjō* by Gesshū's follower Sōgen Tekisui, published in the *Gesshū Oshō iroku* (Posthumous Records of the Monk Gesshū) of 1705, pp. 18–19.

25. Quoted from the *Gesshū Oshō gyōjō* [An Account of the Abbot Gesshū] by Terayama Tanchū in "Sho to hito, Gesshū Sōko Oshō," *Chōryū* 8 (1984), p. 24.

26. Chinese poems have rhymes at the ends of appropriate lines; writers would often pay homage to a poet they admired by writing verses with words that rhymed with their model. Japanese poets found it more difficult to follow this practice unless they possessed a real expertise in the Chinese language.

27. The final two lines refer to a poem by the Chinese Zen master T'ien-t'ai (Japanese: Tendai, 891–972) which ends with the couplet:

Outside the mind, not a thing exists;
The green mountains fill the eye.

See R. H. Blyth, *Zen and Zen Classics II* (Tokyo: Hokuseido Press, 1964), pp. 76–77.

28. Manzan was also an excellent calligrapher; but out of respect for Gesshū's abilities in large-character writing, Manzan limited himself to smaller calligraphy.

29. In the *Ts'an-t'ung-ch'i* (Japanese: Sandōkai) of Shih-t'ou (Japanese: Sekitō, 700–790), there is the line, "The absolute works together with the relative like two arrows meeting in mid-air," referring to the story of two archers whose skill was so great that when they shot at each other, their arrows met and fell to the ground. Ibid., p. 150.

30. For a full study of Bankei's life and teachings, see Norman Waddell, *The Unborn* (San Francisco: North Point Press, 1984), from which much of the following biographical material is drawn. Another recent book on Bankei is Peter Haskel's *Bankei Zen* (New York: Grove Press, 1984).

31. Waddell, op. cit., p. 45.

32. Ibid., p. 10.

33. Ibid., p. 12.

34. Ibid., p. 123.

35. Ibid., pp. 133 and 70.

36. Ibid., p. 103.

37. Haskel, op. cit., p. 34.

38. An inscription on the back by Bankei's follower Haryō of Ryūmon-ji assures us that this is a genuine work by the master; the brushwork in Bankei's unique style leaves no doubt as to authorship.

39. Norman Waddell, "Unnecessary Words: The Zen Dialogues of Bankei Yōtaku," Part II, *The Eastern Buddhist* XVII, no. 1 (Spring 1984), p. 112.

40. For an example of Dōshagen's calligraphy, see Stephen Addiss, *Obaku: Zen Painting and Calligraphy* (Lawrence, Kansas: Spencer Museum of Art, 1978), plate 19.

41. Waddell, "Unnecessary Words," op. cit., p. 124.

42. Waddell, *The Unborn,* op. cit., p. 23.

3. OBAKU ZEN

1. For more information on Obaku art and culture, see Stephen Addiss, *Obaku: Zen Painting and Calligraphy,* op. cit.

2. This story and verse, as well as anecdotes about other monks discussed in this chapter, can be found in Mori Tairyō, *Kinko Zenrin sōdan* (Tokyo: Zōkai Shoin, 1919).

3. See *Bokubi* 234 and 235 (1974).

4. The signboards at Mampuku-ji are now all registered as "Important Cultural Properties" by the Japanese government.

5. See Nishimura Nangaku, "Obaku Kōsō no bokuseki o tankyū shite," *Bokubi* 105 (1961), p. 16.

6. Katsuki Sekida, *Two Zen Classics* (New York and Tokyo: Weatherhill, 1977), p. 110.

7. For examples, see the *Obaku* catalog cited in the first note to this chapter.

8. An inscription carved on the back indicates the date was the fifteenth day of the seventh month of 1704 and the monk who was in charge of having the boards incised was Ikka Genkai. He was a pupil of Dokutan's disciple Hōgen Dōin, the son of Gomizuno-o. Thus it can be seen that the imperial connection with Obaku, begun when Gomizuno-o donated land to Ingen, continued for several generations.

9. Quoted in Hayashi Yukimitsu, "Tetsugyū Dōki," *Zen bunka* 70 (1973), p. 95.

10. These blocks are still being used in Uji to print copies of the Buddhist canon.

11. Six thousand *ryō*.

12. Mampuku-ji was originally not included, and Tetsugyū successfully protested on behalf of Obaku Zen.

13. For further information, see Robert van Gulik, *The Lore of the Chinese Lute* (Tokyo: Sophia University, 1940). For an example of a Japanese *ch'in*-player, see Stephen Addiss, *Tall Mountains and Flowing Waters: The Arts of Uragami Gyokudō* (Honolulu: University of Hawaii Press, 1987).

14. This phrase is sometimes interpreted as referring to five schools of Zen.

15. The most comprehensive information on Ryōnen's life is given in Nagata Tairyū, *Shijitsu Ryōnen-ni* [A Factual Account of the Life of Ryōnen] (Kyoto: Kiyomizushi, 1984).

16. Kōsen, who was much admired by the emperor, was able to complete the construction of the monastery Mampuku-ji during his final years, when he served as the fifth patriarch of the Obaku sect. He was also an outstanding painter and calligrapher in the Obaku styule.

17. The name of the new temple came from the name of the Taiun-in, where Haku-ō's father had served.

18. For reproductions, see Nagata Tairyō, *Ryōnen-ni monogatari* [The Story of Ryōnen] (Kyoto: Kiyomizushi, 1984).

19. Translation by Jonathan Chaves.

20. This passage of Buddhist metaphysics can be interpreted to mean that the Dharma body is itself not a single thing, but rather the source of all things possessing in themselves the eternal Buddha, or that once one realizes that one's own body is the Buddha-body, there is nothing at all but the absolute *Mu*, the infinite store from which all things appear. For a translation and explication of the entire "Song of Enlightenment," see Charles Luk, *Ch'an and Zen Teaching* (London: Rider and Company, 1962), pp. 103–145.

21. This stone is now preserved at the Dōun-ji.

22. The interesting use of slightly puddling ink on a sized paper suggests the technique of *tarashikomi*, which was utilized by painters of the Rimpa School. It also raises the question as to whether Hakuin, who used a somewhat similar technique, might have seen Taihō bamboo paintings—such as this early example.

23. See Stephen Addiss, ed., *Japanese Quest for a New Vision* (Lawrence, Kansas: Spencer Museum of Art, 1986), pp. 50–53.

24. Among the major calligraphers influenced by Obaku style were Kitajima Setsuzan (1636–1697), Hosoi Kōtaku (1658–1735), and Gion Nankai (1677–1751).

4. HAKUIN EKAKU

1. See, for example, Philip B. Yampolsky, *The Zen Master Hakuin: Selected Writings* (New York: Columbia University Press, 1971), which includes an appendix describing Hakuin's major writings; R. D. M. Shaw, *The Embossed Tea Kettle* (London: George Allen & Unwin, 1963); Norman Waddell, *Hakuin's Poison Words for the Heart* (Kyoto: Boroan Press, 1980); Waddell, "Wild Ivy," *The Eastern Buddhist* XV, no. 2 (Autumn 1982) and XVI, no. 1 (Spring 1983); and Kazuaki Tanahashi, *Penetrating Laughter: Hakuin's Zen and Art* (Woodstock, New York: The Overlook Press, 1984).

2. Waddell, "Wild Ivy," op. cit., p. 11.

3. Yampolsky, op. cit., p. 116.

4. Waddell, "Wild Ivy," op. cit., p. 18.

5. Another version of this incident relates that the calligraphy was by the monk Daigu Sōchiku (1584–1669).

6. Yampolsky, op. cit., p. 118.

7. Waddell, "Wild Ivy," op. cit., p. 28.

8. Throughout his life Hakuin considered Dōkyō his primary teacher. Born in Iiyama, Dōkyō was a Zen pupil of Shidō Munan (1603–1676), who had studied with Gudō Tōshoku (1579–1661) of the Myōshin-ji branch of Zen. Hakuin also considered himself a spiritual heir of Hsu-t'ang Chih-yu (Japanese: Kidō Chigu, 1185–1269), whose teachings were brought to Japan by his disciple Nampo Jōmyō (Japanese: Daiō Kokushi, 1235–1308).

9. Waddell, "Talks by Hakuin Introductory to Lectures on the Records of Old Sokkō," *The Eastern Buddhist* XVIII, no. 2 (Autumn 1985), pp. 88–89.

10. Waddell, "Wild Ivy," op. cit., p. 108.

11. Since Hakuyū is supposed to have died in 1709, there is some question as to whether Hakuin visited the hermit earlier or in fact if Hakuin ever met him at all; it may be that Hakuin utilized the name of Hakuyū in order to stress the importance of health to his pupils.

12. Translation adapted from that of Shaw, op. cit., pp. 36–41.

13. The secret policeman Kaishun visited Hakuin in 1733.

14. Waddell, "Talks by Hakuin," op. cit., pp. 87–88.

15. These and the following quotes are taken from Waddell, *Poison Words for the Heart*, op. cit., pp. 8–39.

16. Tanahashi, op. cit., pp. 123–124.

17. This story appears in a slightly different form in the *Tales of Six Perfections Sutra;* the legend reached Japan at least as early as the twelfth century, where it appears in the *Konjaku monogatari* (Stories Ancient and Modern), a compilation of tales from India, China, and Japan. I am grateful to Pat Fister for her assistance in clarifying this and other folk themes of Hakuin.

18. Here Hakuin is referring to the folktale of the female ogre who had her arm cut off by a hero. She retrieved it while disguised as an old lady and then ran off transformed again into her demonic shape. See Juliann Wolfgram, "Oni: the Japanese Demon," in *Japanese Ghosts and Demons: Art of the Supernatural,* edited by Stephen Addiss (New York and Lawrence, Kansas: George Braziller and the Spencer Museum of Art, 1985) pp. 91–102

19. Kameyama Takurō, in his *Hakuin Zenshi no e o yomu* [Reading Hakuin's Paintings] (Kyoto: Zen Bunka Kenkyūjō, 1985), believes this painting to be a forgery as it does not match his interpretation of the inscription.

20. Shaw, op. cit., p. 143.

21. Yampolsky, op. cit., pp. 63–64.

22. Otafuku is also equated with the Shinto goddess Okame.

23. Waddell, "Wild Ivy," op. cit., p. 122.

24. Kobō Daishi discovered a well with waters that had magical powers.

25. For the oldest extant version of this theme, see Komatsu Shigemi, ed., *Nihon emaki taisei 25* (Tokyo, 1979). For other examples, see Midori Deguchi, "One Hundred Demons and One Hundred Supernatural Tales" in *Japanese Ghosts and Demons,* op. cit., pp. 15–23, and Miyeko Murase, *Tales of Japan* (New York and Oxford: Oxford University Press, 1986), pp. 134–137. A thorough discussion of this theme can be found in Melinda Takeuchi, "Utagawa Kuniyoshi's *Minamoto Raikō and the Earth Spider:* Demons and Protest in late Tokugawa Japan," *Ars Orientalis* XVII (1987), pp. 4–6.

26. Shaw, op. cit., p. 160.

27. Yampolsky, op. cit., p. 47.

28. Ibid., p. 39.

29. *Poison Words from the Heart*, op. cit., p. 15.

30. Yampolsky, op. cit., p. 58.

31. Yampolsky, p. 81. This statement by Hakuin deliberately recalls a famous passage from the *Analects* of Confucius: "At fifteen, I set my heart on learning. At thirty, I planted my feet firmly on the ground. At forty, I no longer suffered from confusion. At fifty, I understood the biddings of heaven. At sixty, I listened with docile ears. At seventy, I could follow my own heart, for what I desired no longer overstepped the boundaries of what was right."

32. See Rosenfield, Cranston, and Cranston, *The Courtly Tradition in Japanese Art and Literature* (Cambridge, Mass.: Fogg Art Museum, 1973), pp. 45–59, for a discussion of the importance of this sutra in Japanese culture and art.

33. Yampolsky, p. 105.

34. Yampolsky, pp. 126–127.

35. This form of "reverse painting" was also done by Okumura Masanobu (1686–1764) and Itō Jakuchū (1716–1800). Was Hakuin following, or did he start, an artistic trend?

36. However, it seems from more formal *chinsō* that Hakuin's own head was round, not oval.

37. Shaw, p. 153.

38. Ibid., p. 152.

39. Yampolsky, p. 134,

40. Ibid., p. 135.

41. Ibid., pp. 163–164.

42. "Under the Sala trees" is where the historical Buddha entered nirvana.

43. *Poison Words from the Heart*, op. cit., p. 21.

44. Translation by John Stevens; the following commentary is based upon his research.

45. John Stevens, "Circles of Enlightenment: Ensō in the Hakuin School," *Tōhoku Fukushi Daigaku kiyō* 10, no. 13 (1986), p. 139.

46. Nantembō (see Chapter Seven) wrote that he much admired this inscription, especially the use of the word "annihilate" (*Nantembō zenwa*, op. cit., p. 41). For his own *Self-Portrait* with a somewhat similar inscription, see plate 114.

47. Yampolsky, pp. 58–59.

48. By the Western calendar, it was early in 1769.

49. Shaw, p. 177.

50. Ibid., p. 127.

51. A number of forgeries of Hakuin's paintings have appeared, particularly in the last century. Some of these were done by a man named Uryū Rōjin, a son of the artist Kawanabe Kyōsai (1831–1889) by his second wife. Uryū was a sign painter in the town of Numazu, not far from the temple Ryūtaku-ji. During the early years of this century, Uryū borrowed works by Hakuin from the Tanaka Collection to copy at night; he specialized in portraits of Daruma with short Vandyck beards, and depictions of Kannon. At the same time, an artist named Matsumoto in Nagano was also painting copies of Hakuin's works. Although the forgeries are very close in composition, they have neither the lively brushwork nor the inner intensity of genuine paintings.

5. THE FOLLOWERS OF HAKUIN

1. This story is given in Nishimura Nangaku, "Tōrei no zensho" (Tōrei's Zen Calligraphy) Bokubi 100 (Kyoto, 1960), p. 37.

2. See Kageyama Haruki and Christine Guth Kanda, Shinto Arts (New York: 1976), p. 15.

3. The following stories are given in Mori Taikyō, Kinko zenrin sōdan, op. cit., pp. 424–426.

4. This poem had also been used by Hakuin on a few much less dramatic depictions of the same subject.

5. See Nangaku Nishimura, "Suiō no zenga," Bokubi 100 (1960), p. 2.

6. One version of the name Suiō means "old drunkard," although he later used another character instead of "drunkard" that is pronounced the same way. According to legend, this happened after he was told that his name was not proper for a Zen monk.

7. For this and the ensuing stories, see Mori, op. cit., pp. 414–421.

8. For example, Suiō invited his old friend Kaigan to lecture at a meeting held for eight hundred monks and laymen on the seventeenth anniversary of Hakuin's death, and on another occasion Suiō allowed the visiting monk Jikugen from Sanuki (Shikoku) to write a poem for the opening lecture at a Hekiganroku meeting at Seiken-ji in Kōtsu.

9. There have been various theories about the artistic influences among Taiga, Hakuin, and Suiō. One suggestion has been that Hakuin was influenced by Taiga, perhaps through the intermediary of Suiō. The paintings and calligraphy of Hakuin, however, do not bear this out. Another theory is the reverse, that Hakuin influenced Taiga's art. It is known that Taiga was deeply impressed upon hearing Hakuin lecture in Kyoto in 1751, and after that time many of Taiga's works display a new boldness and what might be called a Zen spirit, but there seems to be no direct influence from Hakuin's brushwork to that of Taiga. That Taiga influenced Suiō, however, is clear; their friendship is documented by anecdotes of Taiga painting a landscape for Suiō. Furthermore, Taiga's style of creating variations of tone within a single brushstroke can be seen in a number of paintings by Suiō.

10. Ruth F. Sasaki, The Record of Lin-chi (Kyoto; 1975), pp. 5, 7, 25.

11. Ibid., p. 33.

12. For a reproduction of this portrait with the two poems, see Bokubi 100, op. cit., p. 3.

13. See Mori, op. cit., p. 427.

14. This basic composition also may suggest the paintings of Amida Buddha crossing the mountains to receive a dying soul, but here there is no glorious future, only dissolution.

15. John Stevens in "The Appreciation of Zen Art," Arts of Asia 16, no. 5 (1986), p. 74, suggests that the shape may be a vajra, the power symbol of tantric Buddhism, with the skull being the fourth orb.

16. For a reproduction, see Daihōrin 52, no. 10 (1985), p. 15.

17. For a reproduction, see Takeuchi Naoji, Hakuin (Tokyo: Chikuma Shoten, 1964), p. 143.

18. Both translations by John Stevens.

19. Translated by Gary Snyder in Riprap, & Cold Mountain Poems (San Francisco: Four Seasons Foundation, 1969).

20. Burton Watson, Cold Mountain (New York: Grove Press, 1962).

21. Suiō inscribed various poems on these works; in this example it is the couplet:

The white sun floats over the green peaks,
Clear clouds wash the deep pools.

22. Translation and commentary by John Stevens.

23. Hakuin includes a pun on the character for "rod," which can also mean "king's road." The ultimate meaning might be equivalent to the Christian saying "The fear of the Lord is the beginning of wisdom."

6. THE LATER EDO PERIOD

1. Translated by Paul B. Watt in *Jiun Sonja (1718–1804): Life and Thought* (Ann Arbor: University Microfilms, 1982), p. 54.

2. Ibid., p. 69.

3. Translated by Paul B. Watt; ibid., p. 104.

4. For a thorough discussion of this topic, see Robert van Gulik, *Siddham: An Essay on the History of Sanskrit Studies in China and Japan*, Sarasvati-Vihara series no. 36 (New Delhi: Jayyed Press, 1936).

5. For further information, see John Stevens, *Sacred Calligraphy of the East* (Boulder, Colorado: Shambala, 1981), pp. 1–70.

6. One of Jiun's Indian-style robes is now in the Kinami Collection in Hirakata.

7. For a study of this work, see Paul B. Watt, "Jiun Sonja and Buddhist Reform" in *Confucianism and Tokugawa Culture* (Princeton, New Jersey: Princeton University Press, 1974), pp. 200–212.

8. In Jiun's day nationalist scholars who decried both Buddhism and Confucianism as "foreign" creeds were on the rise.

9. Burton Watson, *Ryōkan: Zen Monk-Poet of Japan* (New York: Columbia University Press, 1977), p. 2.

10. Translated by John Stevens in *One Robe, One Bowl* (New York and Tokyo: Weatherhill, 1977), p. 55.

11. Translated by Burton Watson, op. cit., p. 53.

12. Translated by John Stevens, op. cit., p. 42. Burton Watson translates the final line: "From the beginning, just this! just this!" (op. cit., p. 74).

13. For more information, see Stephen Addiss, *The World of Kameda Bōsai* (New Orleans and Lawrence, Kansas: New Orleans Museum of Art and The University Press of Kansas, 1984).

14. This anecdote is given in several sources including Sugimura Eiji, *Kameda Bōsai* (Tokyo: Sanju Shobō, 1978), p. 114.

15. What can be seen in this famous example of Ryōkan's writing is also visible in a more complex manner in all of his calligraphy, becoming one of the comparisons that help determine a genuine work from the many forgeries and copies in existence. Since he did not use seals, it is even more difficult than with other artists to detect the best copies from originals, but the ultimate test, as always, is in the brushwork.

16. Translated by Burton Watson, op. cit., p. 99.

17. Ibid., p. 103.

18. This story is recounted by Gotō Zesan in "Gōchō Risshi," *Bokubi* 95 (1960), pp. 13–14.

19. This prayer was attributed to King Asoka, who had made Buddhism a state religion in India more than two millenniums earlier.

20. For reproductions of Gōchō's works, see the *Gōchō Risshi ibokushū* (Tokyo: Kabushiki, 1982), which contains 166 plates as well as a biography of the artist, and the catalogue *Gōchō* (Kumamoto: Kenritsu Bijutsukan, 1981), which has 134 plates as well as seal and signature photographs and a short text.

21. There may also be some influence to be seen here from the "Daishi-ryū" style, modeled upon the calligraphy of Kōbō Daishi. This style is distinguished by long curving lines that sometimes sweep decoratively upwards.

22. Translated by Katsuki Sekida, *Two Zen Classics* (New York and Tokyo: Weatherhill, 1977), p. 293.

23. Although the goal of constructing a total of 84,000 pagodas was impossible to reach, several thousand were built; the pagoda constructed for Banshō-ji (now kept at the Sōji-ji) bears an inscription that more than 2,000 had already been completed.

24. See the *Gōchō Risshi ibokushu*, op. cit., p. 179.

7. SENGAI AND NANTEMBŌ

1. For anecdotes about Sengai, see Mori Taikyō, *Kinko Zenrin sōdan*, op. cit., pp. 484–488, and Ishimura Zen'yū, *Sengai hyakuwa* (Tokyo: Bunken Shuppan, 1980).

2. See Matthew Welch, "Shōki the Demon-queller," in *Japanese Ghosts and Demons*, op. cit., pp. 81–90.

3. See Furuta Shōkin, "Sengai: Among Cherry Blossom, Rivers, and Willows" in *Chanoyu Quarterly* 22 (1979), pp. 49–59, for an account of Sengai's *waka* collection.

4. Melinda Takeuchi suggested this interpretation, while Pat Fister has noted that the small openings in the stone walls of Himeji Castle have exactly these same basic geometric shapes.

5. Daisetz T. Suzuki, *Sengai, The Zen Master* (Greenwich, Conn.: New York Graphic Society, 1971), p. 36.

6. For these and other interpretations by John Stevens, see his article "Brushstrokes of Enlightenment: The Interpretation and Appreciation of Zen Art," *The Transactions of the Asiatic Society of Japan* 1, p. 107.

7. In some accounts it was the fourth day.

8. Nantembō Tōjū, *Nantembō zenwa* (1915; reprint ed., Tokyo: Kokusho Kankōsha, 1978), p. 102.

9. Translation by the author; see Ruth Fuller Sasaki, *The Record of Lin-chi*, op. cit., for both Chinese and English texts in complete form.

10. *Nantembō zenwa*, p. 105.

11. Ibid., p. 106.

12. See Kasumi Bunshō, "Nantembō Rōshi o tatteru" in *Meiji no Zenshō* (Kyoto: Zen Bunka Kenkyūjō, 1981), p. 201. The tree was killed by lightning after Nantembō's death, but a replacement is still flourishing at the temple, with a stone marker inscribed with this story.

13. *Meiji no Zenshō*, op. cit., p. 202.

14. Ibid.

15. Nantembō Tōjū, *Nantembō angyaroku* (1915; reprint ed., Tokyo: Heika Shuppansha, 1967), pp. 66–67.

16. Both Takujū (1760–1833) and Inzan (1754–1817) were pupils of Hakuin's disciple Gazan. They developed Hakuin's teachings into two main branches of the later Rinzai tradition and were called "sharp Inzan and scrupulous Takujū."

17. Ibid., p. 126.

18. Quoted in *Meiji no Zenshō*, p. 203.

19. This anecdote is given in the *Nantembō angyaroku*, pp. 189–191. Nantembō continues that even if Tesshū had said, "Both on earth and in heaven we must instigate the Buddha spirit in order to see the *Mu*," the monk would have challenged him with "What about people who would die that evening, or who don't have time to practice Zen?" Nantembō concludes: "If we encounter tea, we drink tea; if we encounter rice, we eat rice. When we are alive, we live completely, when we die, we die wholeheartedly. In these, there is no room for extra thought, we must face what we encounter, this is most important. It is, in fact, the secret of the Zen interview."

20. Ibid.

21. See, for example, Ōmori Sōgen in *Meiji no Zenshō*, op. cit., p. 165; for a full account of Tesshū's life and art, see John Stevens, *The Sword of No Sword* (Boulder, Colorado, and London: Shambala, 1984).

22. *Nantembō angyaroku*, p. 219.

23. Ibid., p. 238.

24. Ibid., pp. 270–271.

25. Ibid., p. 349.

26. *Nantembō Zenwa*, pp. 201–205. See also the *Nantembō angyaroku*, op. cit., pp. 349–350, and *Meiji no Zenshō*, op. cit., p. 204.

27. For a translation, see Miura and Sasaki, *Zen Dust* (New York: Harcourt, Brace & World, 1966), pp. 251–253.

28. *Meiji no Zenshō*, p. 207.

29. This story is given in the *Nantembō angyaroku*, op. cit., pp. 356–359, and in *Meiji no Zenshō*, p. 205.

30. Ibid., p. 205. Nantembō goes on to tell a story of the famous calligrapher Ichikawa Beian (1779–1858) being criticized by a *jōruri* chanter for not continuing the initial gesture of his brushwork through the entire character for "dragon," leaving it without life.

31. Reproduced in *Nantembō ibokuten* (Nishinomiya: Mainichi Shinbunsha, undated), pp. 7–9, and in *Bokubi* 14 (Kyoto, 1952), pp. 5, 7, and 11–14.

32. *Nantembō zenwa*, op. cit., p. 173.

33. Ibid., p. 123.

34. Nantembō himself climbed Mount Fuji at the age of fifty.

35. See the *Nantembō zenwa*, op. cit., pp. 19–20.

36. Ibid., pp. 59–60.

37. *Meiji no zenshō*, p. 210.

38. Ibid., p. 208.

39. This development had many ramifications; the lack of complete dedication on the part of many monks opened the way for the emergence in the past century of outstanding laymen (such as Tesshū and, more recently, Daisetz Suzuki) as Zen leaders.

40. *Nantembō zenwa*, op. cit., pp. 138–139.

41. Ibid., p. 138.

42. Ibid.

43. Ibid., pp. 139–140.

Annotated Bibliography

Addiss, Stephen. "Hakuin, Tōrei, and Jiun: Calligraphy as Mantra." In *Calligraphy of China and Japan: The Grand Tradition,* edited by Stephen Addiss. Ann Arbor: The University of Michigan Museum of Art, 1975. Compares works by the three masters.

———. "The Life and Art of Fūgai Ekun." *The Eastern Buddhist* XIX, no. 1 (1986). Includes 8 illustrations.

———. "Obaku: The Art of Chinese Huang-po Monks in Japan." *Oriental Art* XXIV, no. 4 (1978). Includes 15 plates of Obaku art.

———. "Obaku: The Calligraphy of Zen." *Orientations* X, no. 7 (1979), pp. 41–48. Includes 8 plates.

———. *Obaku: Zen Painting and Calligraphy.* Lawrence, Kansas: Spencer Museum of Art, 1978. Exhibition catalogue with 64 illustrations.

———. "The Revival of Zen Painting in Edo Period Japan." *Oriental Art* XXXI, no. 1 (1986). Surveys Zenga in the Edo period.

———. *Zenga and Nanga.* New Orleans: New Orleans Museum of Art, 1976. The first catalogue of the Gitter Collection; includes 28 works of Zenga.

———. "Zen malereit i Obaku-secten." *Stupa* VI (Denmark; 1983). A short history of Obaku art.

Addiss, Stephen, ed. *A Myriad of Autumn Leaves.* New Orleans: New Orleans Museum of Art, 1983. The second catalogue of the Gitter Collection; includes 15 works of Zenga.

Awakawa, Yasuichi. *Zen Painting.* Tokyo: Kodansha International, 1970. Includes 139 plates of Zen brushwork.

Barnet, Sylvan, and Burto, William. *Zen Ink Paintings.* Tokyo: Kodansha International, 1982. Focuses on earlier masters but includes Hakuin, Jiun, and Sengai.

Brasch, Kurt. *Hakuin und die Zen Malerei.* Tokyo: Japanisch-Deutsche Gesselschaft, 1957. Text in German; includes 28 plates of works by Hakuin.

———. *Zenga.* Tokyo: Japanisch-Deutsche Gesselschaft, 1961. A history of Zenga in German with 108 plates.

Brinker, Helmut. *Zen in the Art of Painting.* London: Arcana, 1987. Discusses Zen painting in China and Japan in its early stages; includes Hakuin.

Brown, Kendall H. "Shōkadō as Tea Painter." *Chanoyu* 49 (1987). A discussion of Shōkadō's art in relation to the tea ceremony.

Dumoulin, Heinrich. *A History of Zen Buddhism.* New York: Pantheon Books, 1963. The history of Zen in China and Japan.

———. *Zen Enlightenment.* New York and Tokyo: Weatherhill, 1979. Historical study of Zen.

Fister, Patricia. *Japanese Women Artists, 1600–1900.* Lawrence, Kansas: Spencer Museum of Art, 1988. Exhibition catalogue including Ryōnen.

Fontein, Jan, and Hickman, Money. *Zen Painting and Calligraphy.* Boston: Museum of Fine Arts, 1970. Exhibition catalogue; centers on earlier works with 5 entries on monks of the Edo period.

Haskel, Peter. *Bankei Zen.* New York: Grove Press, 1984. Translations from the "Record of Bankei"; with his portrait.

Hisamatsu, Shin'ichi. *Zen and the Fine Arts.* Tokyo: Kodansha International, 1971. Includes Hakuin, Jiun, and Ryōkan.

Hoffmann, Yoel. *Japanese Death Poems.* Rutland, Vermont, and Tokyo: Tuttle, 1986. Includes death poems of Zen monks.

India-ink Drawings by the Famous Zen Priest Sengai. Oakland, California: Japanese Cultural Festival, 1956. Exhibition catalogue with 22 plates.

Legett, Trevor. *A First Zen Reader.* Rutland, Vermont, and Tokyo: Tuttle, 1966. Includes an extensive commentary on Hakuin's "Song of Meditation."

Lishka, Dennis. *Buddhist Wisdom and Its Expression as Art.* Ann Arbor, Michigan: University Microfilms, 1977. A dissertation on the life and writings of Takuan.

Miura, Isshū, and Sasaki, Ruth Fuller. *Zen Dust.* New York: Harcourt, Brace, 1966. Essays on Zen, including discussions of the teachings and works of Hakuin.

———. *The Zen Kōan.* New York: Harcourt, Brace, 1965. Writings on Zen in the Hakuin tradition, later reprinted in *Zen Dust.*

Ōmori Sōgen and Terayama Katsujō. *Zen and the Art of Calligraphy.* London: Routledge and Kegan Paul, 1983. Includes 55 plates of Zenga.

Rosenfield, John R., ed. *Song of the Brush.* Seattle: Seattle Art Museum, 1979. Catalogue of the Sanso Collection with 11 works of Fūgai, Hakuin, and Sengai.

Sengai the Zen Master. Sidney: Art Gallery of New South Wales, 1985. Exhibition catalogue of 60 works of Sengai on loan from the Idemitsu Museum, Tokyo.

Shaw, R. D. M. *The Embossed Tea Kettle*. London: George Allen and Unwin, 1963. Translations of writings by Hakuin.

Shimizu, Yoshiaki, and Rosenfield, John. *Masters of Japanese Calligraphy*. New York: Asia Society and Japan Society, 1984. Exhibition catalogue; includes 17 works of Zenga.

Stryk, Lucien, and Ikemoto, Takashi. *The Penguin Book of Zen Poetry*. London: Penguin Books, 1981. Includes poems of Zenga masters.

————. *Zen Poems of China and Japan*. Garden City, New York: Anchor Books, 1973. Includes poems by Edo period monks.

————. *Zen Poems, Prayers, Sermons, Anecdotes, Interviews*. Garden City, New York: Anchor Books, 1965. Surveys Edo period monks and includes 5 plates of paintings by Sengai.

Stevens, John. "The Appreciation of Zen Art." *Arts of Asia* 16, no. 5 (1986). Includes 27 illustrations of Zenga.

————. "Brushstrokes of Enlightenment." *Transactions of the Asia Society of Japan*, fourth series, no. 1 (1986). A discussion of Zenga.

————. *One Robe, One Bowl*. New York and Tokyo: Weatherhill, 1977. Translations of Ryōkan's poems.

————. *Sacred Calligraphy of the East*. Boulder, Colorado: Shambala, 1981. Includes many plates of Zenga.

Suzuki, Daisetz T. *Sengai, the Zen Master*. Greenwich, Connecticut: New York Graphic Society, 1971. Introduction and 119 plates of works by Sengai with commentary.

————. *Zen and Japanese Culture*. Princeton, New Jersey: Princeton University Press, 1959. Text on various Zen-influenced arts.

————. *Zen Buddhism*. Garden City, New York: Anchor Books, 1956. Includes a chapter on Zen arts.

Tanahashi, Kasuaki. *Penetrating Laughter*. Woodstock, New York: Overlook Press, 1984. 77 plates of works by Hakuin with commentary, biography, and poems.

Waddell, Norman. *Hakuin's Poison Words from the Heart*. Kyoto: Boroan Press, 1980. A translation of Hakuin's commentary on the *Heart Sutra*.

————. *The Unborn*. San Francisco: North Point Press, 1984. The life and teachings of Bankei.

————. "Unnecessary Words; the Zen dialogues of Bankei Yōtaku." *The Eastern Buddhist* XVII, no. 1 (1984). Translation of Bankei's teachings.

————. "Wild Ivy." *The Eastern Buddhist* XV, no. 2, and XVI, no. 1 (1983 and 1984). Translations of writings by Hakuin.

Watson, Burton. *Ryōkan: Zen Monk-Poet of Japan*. New York: Columbia University Press, 1977. Translations of Ryōkan's poetry.

Watt, Paul. "Jiun Sonja and Buddhist Reform." In *Confucianism and Tokugawa Culture*, edited by Peter Mosco. Princeton, New Jersey: Princeton University Press, 1974. Discusses Jiun's moral teachings.

————. *Jiun Sonja: Life and Thought*. Ann Arbor, Michigan: University Microfilms, 1982. A doctoral dissertation on Jiun.

Wilson, William Scott. *The Unfettered Mind*. Tokyo: Kodansha International, 1986. Translations of 2 works by Takuan.

Yampolsky, Philip B. *The Zen Master Hakuin*. New York: Columbia University Press, 1971. Translations of selected writings by Hakuin.

Yuasa, Nobuyuki. *The Zen Poems of Ryōkan*. Princeton, New Jersey: Princeton University Press, 1981. Translations of poems, biographical sketch, and 7 plates of Ryōkan's poetry.

WORKS IN JAPANESE AND CHINESE

Addiss, Stephen. "Shin'etsu no geijutsu." In *Kameda Bōsai no sekai*. Tokyo: Sanju Shobō, 1985. On the art of Shin'etsu.

Awakawa Yasuichi. *Hakuin*. Kyoto: Maria Gabo, 1956. Includes 26 works by Hakuin, 3 by Tōrei, and 1 by Suiō.

————. *Zenga no kokoro*. Kyoto: Yūkonsha, 1970. A collection of essays on Zenga.

Awazu Norio. *Sengai no Zenga*. Tokyo: Nichibō Shuppansha, 1984. Contains 137 plates with (sometimes incorrect) readings of the inscriptions.

Bokubi (Kyoto; 1951–1977). A journal with many issues devoted to Zenga.

Brasch, Kurt. *Zenga to Nihon bunka*. Tokyo: Mokujisha, 1975. Collected articles with text illustrations.

Daitoku-ji bokuseki zenshū. Tokyo: Mainichi Shuppansha, 1986. Volume III contains 381 portraits, ink paintings, and calligraphic works by Daitoku-ji monks, 1600–1940; includes seal and signature details.

Daitoku-ji kinsei bokusekiten. Kyoto: Daitoku-ji, 1983. Exhibition catalogue with 93 illustrations of Daitoku-ji monks' brushwork.

Daitoku-ji rekidai bokuseki seisui. Tokyo: Yomiuri Shinbunsha, 1977. Includes 275 plates of calligraphy by Edo period Daitoku-ji monks and a seal appendix.

Edo no meisō: Takuan. Tokyo: Shinagawa Rekishikan, 1985. Exhibition catalogue with 39 works by Takuan.

Fukushima Shunnō and Katō Shōshun. *Zenga no sekai*. Kyoto and Tokyo: Tankōsha, 1978. Short biographies and illustrations of works by 128 monks, primarily from the Edo period.

Furuta Shōkin. *Hakuin: Zen to sono geijutsu*. Tokyo: Mokujisha, 1978. Text on Hakuin and his art with 54 plates.

———. *Kinsei no Zenshatachi*. Kyoto: Heiraku-ji Shoten, 1956. Includes works of Takuan, Kōgetsu, Bankei, Hakuin, and Sengai.

———. *Kōgetsu Oshō iboku*. Tokyo: Benridō, 1950. A short text on Kōgetsu with 15 plates.

———. *Sengai*. Tokyo: Idemitsu Bijutsukan, 1966. A short text on Sengai with 138 pages of illustrations.

———. *Sengai*. Tokyo: Tankōsha, 1979. A text on Sengai as a calligrapher with 38 plates.

Gōchō. Kumamoto: Kumamoto Kenritsu Bijutsukan, 1981. Exhibition catalogue with 134 plates, seal and signature photos, and short articles on Gōchō.

Gotō Tōkei, ed. *Tōrei Enji no shogai*. Kyoto: San'yūsha, 1970. Includes 94 pages of illustrations of works by Tōrei.

Haga Kōshirō. *Takuan*. Tokyo: Tankōsha, 1979. Text and 40 plates on Takuan as a calligrapher.

Hakuin iseki. Kyoto: Bokubisha, 1977. Reprinting in one volume of *Bokubi* issues 77, 78, 79, and 90; includes 388 plates of Hakuin's works with short articles.

Hakuin no Zenga. Tokyo: Nichibō Shuppansha, 1985. Includes 164 illustrations with (sometimes mistaken) readings of the inscriptions, plus a seal appendix.

Hakuin Oshō ibokushū. Tokyo: Shiyūsha, 1914. Contains 85 plates of works by Hakuin, 23 by Suiō, and 6 by Tōrei.

Hakuin: sakuhin to sono kokoro. Niigata: BSN Bijutsukan, 1981. Exhibition catalogue with 70 illustrations of works by Hakuin.

Hakuin: Zen no geijutsu. Mishima: Sano Bijutsukan, 1986. Exhibition catalogue with 59 plates of works by Hakuin with explanations and seals.

Haruna, Yoshie. *Kan'ei no sampitsu*. Tokyo: Tankōsha, 1971. Includes long sections on Nobutada and Shōkadō.

Hayashi Yukimitsu. *Obakuzan Mampuku-ji rekidai gazōshū*. Uji: Mampuku-ji Bunkaden, 1983. Biographies with portraits of all Mampuku-ji abbots.

Hirakubō Akira. *Ingen*. Tokyo: Yoshikawa Kōbunkan, 1962. A life of Ingen with 2 plates and text illustrations.

Hirano Sōjō. *Ungo Oshō nempu*. Kyoto: Shibunkaku, 1983. The life of Ungo; includes 3 plates.

Hosoda Genkichi. *Bankei Kokushi den*. Tokyo: Hokkai Shuppansha, 1942. The life and teachings of Bankei; includes 3 plates.

Ishida Gōcho, ed. *Gōchō Risshi ibokushū*. Tokyo: Kabushiki, 1982. A short life of Gōchō with 166 plates of his works.

Ishimura Zen'yū. *Sengai hyakuwa*. Tokyo: Bun Shuppan, 1980. One hundred stories and anecdotes about Sengai.

Isshi Oshō ibokuten. Tokyo: Kōgeisha, 1926. Exhibition catalogue with 94 plates and accompanying text booklet on Isshi.

Jiun Sonja. Kyoto: Kinki Bankakai, 1980. Text on Jiun with 26 plates.

Jiun Sonja ihō. Tokyo: Nichibō Shuppansha, 1980. Two volumes of illustrations of the works of Jiun.

Kasumi Bunshō. "Nantembō Roshi o tatteru." In *Meiji no Zenshō*. Tokyo: Zen Bunka Kenkyūjō, 1981. An account of Nantembō's life by a former student of the Zen master.

Katō Shōshun. *Hakuin Oshō nempu*. Kyoto: Shibunkaku, 1985. The life of Hakuin; includes 3 plates and text illustrations.

———. *Hyakunin no Zensō*. Kyoto and Tokyo: Tankōsha, 1979. Biographies, with illustrations, of 100 monk-artists.

Kawabe Shinzō. *Kinsei Zensōden*. Tokyo: Sekishobo, 1943. Discusses the lives of major Edo period monks; includes portraits of Takuan and Hakuin.

Kinami Takuichi. *Jiun Sonja hōgoshū*. Tokyo: Sanmitsudō Shoten, 1961. Jiun's Buddhist writings and 10 plates of his works.

———. *Jiun Sonja shogai to sono kotoba*. Tokyo: Sanmitsudō Shoten, 1976. Includes 10 plates of Jiun's works and text illustrations.

———. *Jiun Sonja wakashū*. Kyoto: Sanmitsudō Shoten, 1976. The collected *waka* poems of Jiun; includes 24 plates of his calligraphy.

———. *Sanze no hikari*. Kyoto: Kyōwa Insatsu, 1980. Includes 17 plates of the works of Jiun.

Kino Kazuyoshi. *Meisō retsuden*. Tokyo: Bungei Shunshū, 1973. Includes a biography of Takuan.

Kinsei kōsō ibokushū. Kyoto: Art-sha Shuppan, 1976. Includes 158 plates of works by Japanese monks.

Kinsei no Zengaten. Mishima: Sano Bijutsukan, 1983. Exhibition catalogue with 76 works of Zenga, primarily from the Hosokawa Collection.

Kinsei Zenrin bokuseki. Kyoto: Shibunkaku, 1974. Three large volumes with 645 plates of works by Zen monks, 1600–1940, with biographies; the fundamental publication in Japan for the study of Zenga.

Kinsei Zenrin genkōroku. Tokyo: Nihon Tosho Senta, 1977. Biographies of monks from Hakuin to Tekisui; no plates.

Kinsei Zenrin sōhōden. Kyoto: Baiyōshoin, 1887. Three volumes of biographies of Zen monks; no plates.

Koji junrei: Kyoto Mampuku-ji. Tokyo: Tankōsha, 1977. A history of Mampuku-ji with 74 plates, including 28 of Obaku Zenga.

Kokuyaku Zenshū gyōsho (Tokyo), series 2, vol. X. (1974). A collection of Isshi's writings; no plates.

Miura Yasuhiro. *Jiun*. Tokyo: Tankōsha, 1979. Text on Jiun as a calligrapher with 64 plates.

———. *Jiun Sonja: hito to geijutsu*. Tokyo: Nigensha, 1980. Discusses Jiun as an artist; includes 99 plates and text illustrations.

———. *Jiun Sonja ihōten*. Tokyo: Junior Art Dealer's Association, 1987. Exhibition catalogue with 192 photos of works by Jiun, a short biography, and seal photos.

Miya Eini. *Ryōkan*. Tokyo: Tankōsha, 1979. Text on Ryōkan as a calligrapher with 81 plates.

Miyake Mikidō. *Hakata to Sengai*. Tokyo: Bunken, 1978. On Sengai, with 30 plates and text illustrations.

Mokuan. Kyoto: Shibunkaku, 1983. Includes 115 plates of works by Mokuan and his circle.

Mori Taikyō. *Kinko Zenrin sōdan*. Tokyo: Zōkei Shoin, 1919 (reissued in Kyoto: Zen Bunka Kenkyūjō, 1986). Biographies of Zen monks with many anecdotes; no plates.

Nagata Tairyō. *Ryōnin-ni monogatari*. Kiyomizushi: privately published, 1984. The life story of Ryōnen with illustrations.

———. *Shijitsu Ryōnen-ni*. Kiyomizushi: privately published, 1983. Text with illustrations on the nun Ryōnen.

Nakahara Tōjū. *Nantembō angyaroku*. 1915. Reprint. Tokyo: Heika Shuppansha, 1967. Autobiographical writings by Nantembō.

———. *Nantembō Zenwa*. 1915. Reprint. Tokyo: Kokusho Kankōsha, 1978. Zen writings of Nantembō.

Nantembō ibokuten. Nishinomiya: Mainichi Shinbunsha, 1978. Exhibition catalogue with 103 plates.

Naoki Kōgen. *Hakuin shoga no sashinshū*. Tokyo: Ryūginkai, 1957. Includes 109 plates of works by Hakuin and 6 by his followers.

Nishimura Eshin. *Tōrei Oshō nempu*. Kyoto: Shibunkaku, 1982. On Tōrei's life; includes 3 plates and text illustrations.

Nishimura Tadashi. *Obaku gazōshi*. Tokyo and Osaka: Sōgensha, 1934. A history of Obaku portraits with 27 plates and many text illustrations.

Obaku bijutsu. Kyoto: Shibunkaku, 1982. With 166 plates of works by Obaku artists.

Obaku bunka. Kyoto: Bokubisha, 1970. Contains 109 plates of works by Obaku artists.

Obaku ibokujō. Uji: Mampuku-ji, 1967. Includes 142 examples of Obaku brushwork with short essays and biographical information.

Obaku to sono iboku. Niigata: BSN Museum, 1976. Exhibition catalogue; includes 64 plates of Obaku works.

Ogisu Jundō. *Takuan Oshō nempu*. Kyoto: Shibunkaku, 1982. A life of Takuan with 3 plates of his works.

Ryōkan. Tokyo: Shibundō, 1976. Includes 117 plates of the works of Ryōkan.

Ryōkan. Tokyo: Chikuma Shobo, 1975. With 450 pages of plates of works by Ryōkan along with an explanatory text.

Ryōkan. Tokyo: Chuō Koronsha, 1975. Contains 158 plates of works by Ryōkan.

Ryōkan Kinenkan. Washima: Ryōkan Kinenkan, 1985. Includes 66 plates of works by Ryōkan in a memorial museum.

Ryōkan ten. Niigata: BSN Museum, 1980. Exhibition catalogue; includes 255 illustrations of Ryōkan's brushwork.

Sengai. Tokyo: Idemitsu Bijutsukan, 1959. A short text on Sengai with 66 plates.

Sengai. Tokyo: Kokusai Bunka Shinkokai, 1961. Exhibition catalogue; includes 80 plates.

Sengai bokuseki. Kyoto: Art-sha Shuppan, 1954. Short text on Sengai with 121 plates.

Sengai ibokushū. Kyoto: Tessaidō, 1977. Exhibition catalogue on Sengai with 116 plates and a brief text.

Sengai Oshō shoga ishū. Fukuoka: Fukushima Shi Bijutsukan, 1981. Includes 85 plates of works by Sengai with short explanatory text.

Sengai ten. Fukuoka: Bijutsukan, 1986. Exhibition catalogue; includes 179 works by Sengai.

Shibayama Zenkei. *Ensō*. Tokyo: Shunshūsha, 1969. Includes 36 illustrations of *ensō* with biographies of the artists and explanatory texts.

Takahashi Chikumei. *Ingen Mokuan Sokuhi*. Tokyo: Kokusho Kankōkai, 1978. Biographies of the three Obaku monks; no plates.

Takase Shingo. *Fūgai Ekun Zenshi to sono sakuhin*. Hiratsuka: Nishioka Insatsuki, 1980. Extensive biography of Fūgai Ekun; includes 102 plates.

Takeuchi Naoji. *Hakuin*. Tokyo: Chikuma Shoten, 1964. The definitive study of Hakuin's art; includes 556 plates and commentaries.

——. *Kinsei no Zenrin bijutsu*. Tokyo: Shibundō, 1972. A history of Zenga with 165 plates.

Takuan. Niigata: BSN Museum, 1974. Exhibition catalogue; includes 67 plates of works by Takuan and 24 by his contemporaries.

Takuan, Kōgetsu to sono jidai. Sakai: Sakai Shi Hakubutsukan, 1983. Exhibition catalogue; includes 146 illustrations of works by Takuan, Kōgetsu, and their contemporaries.

Takuan, Isshi. Kumamoto: Kenritsu Bijutsukan, 1979. Exhibition catalogue; includes 43 plates of works by Takuan and 30 by Isshi.

Takuan to Isshi meisakuten. Tokyo: Kokuritsu Hakubutsukan, 1949. Exhibition catalogue; includes 18 plates of works by Takuan and 21 of Isshi.

Tōkō Shin'etsu. Ibaragi: Kenritsu Rekishikan, 1982. Exhibition catalogue; includes 68 plates of works by Shin'etsu.

Tōkō Zenshū. Tokyo: Zensho Kankōkai, 1911. Two volumes on Shin'etsu; includes 18 plates of his works.

Tōrei Enji. Otsu: Biwako Bunkakan, 1972. Exhibition catalogue; includes 59 plates of works by Tōrei.

Tōrei Zenshi ten. Mishima: Mishima Insatsujo, 1986. Exhibition catalogue; includes 83 works by Tōrei.

Tsuji Nobuo. *Edo no shūkyō bijutsu*. Tokyo: Gakken, 1979. Includes Hakuin, Sengai, and Ryōkan.

Ungo Oshō bokusekishū. Sendai: Zuigan-ji, 1985. Includes 142 plates of works by Ungo with commentaries.

Van Gulik, Robert. *Tung-kao Ch'an-shih chi-k'an*. Chungking: The Commercial Press, 1944. A study of Shin'etsu in Chinese.

Yamanouchi Chōzō. *Hakuin-san no kaiseppō*. Tokyo: Taihō Rinkakuhan, 1984. Short text with 95 plates of works by Hakuin and 8 by his followers.

Yamanouchi Chōzō. *Hakuin: sho to e no kokoro*. Tokyo: Gurafuikkusha, 1978. Includes 155 plates of works by Hakuin with commentaries.

Yanagida Seizan and Katō Shōshun. *Ensō*. Tokyo: Mainichi Shinbun, 1986. Contains 107 plates of *ensō* and biographies of the artists.

——. *Hakuin*. Tokyo: Tankōsha, 1979. Discusses Hakuin as a calligrapher; includes 61 plates.

Zen bunka. Kyoto: Zen Bunka Kenkyūjo, 1955–1988. A journal with many issues containing information on monk artists and plates of Zenga.

Zen no sekai to Hakuin. Nagoya: Kabushiki, 1982. Includes brief articles and 101 plates of works by Hakuin.

Zen no sekai to Sengai ten. Tokyo: Tokyū Hakkaten, 1986. Exhibition catalogue; includes 69 pages of plates of works by Sengai.

Index